P9-CJF-328

Library
University of Texas
at San Antonio

WITHDRAWN
UTSA Libraries

# Web Site
# CONSTRUCTION
## Tips & Tricks

### Richard Schwartz

JAMSA
P · R · E · S · S
...a computer user's best friend®

ONWORD PRESS
THOMSON LEARNING

Australia Canada Mexico Singapore Spain United Kingdom United States

Library
University of Texas
at San Antonio

ONWORD PRESS
★
THOMSON LEARNING ™

# Web Site Construction Tips and Tricks
By Richard Schwartz

**Business Unit Director:**
Alar Elken

**Acquisitions Editor:**
James Gish

**Editorial Assistant:**
Jaimie Wetzel

**Executive Marketing Manager:**
Maura Theriault

**Channel Manager:**
Mona Caron

**Executive Production Manager:**
Mary Ellen Black

**Project Editor:**
W. K. Cheung

**Senior Production Coordinator:**
Toni Hansen

**Art/Design Coordinator:**
Rachel Baker

**Cover Design:**
Alan Giana
*Venture Media Group*

COPYRIGHT © 2001 by OnWord Press, OnWord Press is an imprint of Thomson Learning

Printed in Canada
1 2 3 4 5 XXX 05 04 02 01 00

For more information contact
OnWord Press
an imprint of Thomson Learning,
PO Box 15015,
Albany, NY 12212-5015

Or find us on the World Wide Web at
http://www.onwordpress.com

ALL RIGHTS RESERVED. No part of this work covered by the copyright hereon may be reproduced or used in any form or by any means—graphic, electronic, or mechanical, including photocopying, recording, taping, Web distribution or information storage and retrieval systems—without written permission of the publisher.

For permission to use material from this text or product, contact us by
Tel    (800) 730-2214
Fax   (800) 730-2215
www.thomsonrights.com

Library of Congress Cataloging-in-Publication Data
ISBN: 1-8841-3319-3

## NOTICE TO THE READER

Publisher does not warrant or guarantee any of the products described herein or perform any independent analysis in connection with any of the product information contained herein. Publisher does not assume, and expressly disclaims, any obligation to obtain and include information other than that provided to it by the manufacturer.

The reader is expressly warned to consider and adopt all safety precautions that might be indicated by the activities herein and to avoid all potential hazards. By following the instructions contained herein, the reader willingly assumes all risks in connection with such instructions.

The Publisher makes no representation or warranties of any kind, including but not limited to, the warranties of fitness for particular purpose or merchantability, nor are any such representations implied with respect to the material set forth herein, and the publisher takes no responsibility with respect to such material. The publisher shall not be liable for any special, consequential, or exemplary damages resulting, in whole or part, from the readers' use of, or reliance upon, this material.

# WEB SITE CONSTRUCTION TIPS & TRICKS

## UNDERSTANDING THE WORLD WIDE WEB

A common misconception among users is to confuse the World Wide Web (also called "Web" or "WWW") with the Internet, though the WWW is a subset of the Internet itself. The World Wide Web is the universe of network-accessible information, the embodiment of human knowledge available via electronic means. The Web was born in 1990 in the European lab for Particle Physics at CERN, on a Unix-based computer using the NeXTStep operating system. Using Internet standards such as TCP/IP protocol as the vehicle for moving data between sites, Tim Berners-Lee and Robert Cailliau set out to create a graphical environment that would let scientists in the physics community share their data. This graphical interface (the original screen shot shown below) was termed a Web Browser and Web documents were stored on a Web server. The HTML language and Hypertext Transport Protocol (HTTP) were all developed under the original specification.

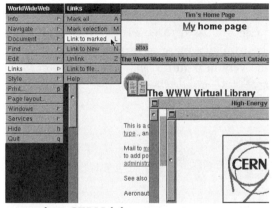

*The first WWW browser created at CERN labs.*

While the Web browser is far different from its predecessors that allowed only static text and images, underlying technologies, such as HTTP, are not radically different nor are the visions of information sharing at a global level. The World Wide Web is the playground of the mind and the new horizon for business served by the Internet and client server technology.

For the purposes of this book, the World Wide Web is defined as a system of content servers that support the retrieval of specially formatted documents. Shared resources are available through the use of servers and are based on Internet standards, such as the TCP/IP protocol.

Although the Internet is a global network, in many ways it resembles a small town, with the same type of services found there. Suppose, for example, you want to send or receive mail. The Internet has electronic post offices called e-mail servers. Maybe you want to read a magazine or do some research. You can find online libraries to use any time of the day or

night, with millions of books and periodicals with unlimited browsing. Search engines have replaced the card catalog as the means to find information. You can also enjoy socializing in online chat rooms. With the explosive growth of the World Wide Web, you can shop, order a pizza, preview a movie, and listen to radio stations around the world.

In the real world, you can travel to different places over the same network of roads, but using different modes of transportation. You might use a car for one purpose and a truck for another. Getting around on the Internet works much the same way.

To understand the Internet, it is helpful to realize that many different kinds of communication go on at the same time. You use different software programs to accomplish different tasks: for example, a Web browser to access shopping sites and an e-mail program, to send and receive messages.

Some programs, such as Netscape Communicator, contain more than one kind of program. Communicator has a Web browser, called Netscape Navigator, an e-mail program and a newsreader.

In short, the World Wide Web is an electronic world, a virtual world if you will, in which many of the common things you used to do in the absence of the electronic world are now carried out. With the continually merging media types—television, telephone, and the Internet—no doubt in the very near future all of our day-to-day tasks will somehow involve the use of this technology.

## UNDERSTANDING THE INTERNET

The Internet is a global network of interconnected computers that use a common set of platform-independent protocols to communicate. As is the case with many of the commonplace technologies in use today, the Internet finds its roots in government technologies. The Internet grew out of an experiment begun in the 1960's by the U.S. Department of Defense. The DOD wanted to create a computer network that would continue to function in the event of a disaster, such as a nuclear war. If part of the network were damaged or destroyed, the rest of the system still had to work. This failsafe network was commissioned by the DOD and developed by the Advanced Research Projects Agency (ARPA) using packet switching technology which today is known as the combination of the Transmission Control Protocol/Internet Protocol (TCP/IP), clients, servers, and routers, devices that move packet-based data.

Successful transmission and reception would not surface until the early 1970's. By 1973, it was discovered that nearly seventy-five percent of all of the traffic on the ARPANET was electronic mail. From the 70's and through the 80's, the technology that had begun as a military technology reached a fevered pitch as research and hardware grew to accommodate

the small but heavily trafficed ARPANET. Spawn networks grew and connected to the original system and many of the major universities were participating in the global network. European networks began to take interest as well and were joined via satellite links. The Internet was truly taking shape.

By the late 80's the number of "hosts" on the network passed 10,000 and later, in 1990, the ARPANET project fizzled out with the military's network already in place and growing. In parallel, universities began growing the public Internet. Where many universities had used gateways to the network, these institutions moved to an IP addressing scheme where the INTERNIC doles out a series of addresses, which are registered to individuals or organizations, giving each host on the network a unique numerical identifier and a unique address. During this time, the World Wide Web was developed at CERN labs in Europe as a textual and graphical means for sharing data over the Internet.

By the mid 1990's, millions of people were "surfing" the Web using Internet Web browsers. Today, the use of Internet e-mail, the most dominant form of Internet usage, drives businesses to work more efficiently and multimedia brings a variety of content to Internet users. It is almost impossible to imagine communication without the Internet.

## UNDERSTANDING INTRANETS

The use of Internet technologies was developed originally by ARPA to conduct business across the scientific community. There was a stage in the Web's infancy where the majority of its content was created either by universities, students, hackers, or the occasional nerd. The roots of the Internet, however, are steeped in business, and it did not take long for the business community to exploit this virtually uncharted marketing medium. Still, as Internet technologies advanced with the advent of more complex forms of the Internet programming language, HTML, and advances in Web server technology, businesses found that moving toward electronic publishing internally not only saved time, it added functionality and saved money at the same time.

Thus, the intranet, or Internal Internet was born. An intranet consists of the same components found on the Internet, a Web server, Web-based content, a Web browser, and so forth. However, its information is not public as it is on the Internet. Instead, it is locked within a private network. The use of an intranet provides a central resource for companies to disseminate information to all points in the company that are connected via a network and the TCP/IP protocol.

Today, it is not uncommon to find that each division of a company hosts its own internal Web site or Web page in order to keep other areas of the company apprised as to what is happening in that division. Further, organizations are using the intranet as an information

gathering tool to survey users on how to improve the way business is carried out, giving the employee a voice in company matters. Another initiative is to move offices to a "paperless" office where all forms are used in electronic format and found on the intranet through a Web browser.

Internet technologies have revolutionized the way that businesses do business today. With the advances in Internet technology and with larger bandwidth available, many organizations are using multimedia, or "streaming media," to broadcast seminars and board meetings to employees. Potentially, workers may be able to work from home by simply dialing into the corporate network or using virtual private networking by way of the Internet to connect to the corporate network and, ultimately, the intranet, where all of the tools to communicate and conduct business may be found.

## INTERNET COMMUNICATION BASICS

The reason that so many different types of computers can interact with each other, sending e-mail, chatting in chat rooms, and interacting with Web sites, is largely based on standards. These standards are a common and agreeable set of communication protocols. These protocols define a common format for the data that is transmitted and received. At the very least, a communication protocol must define the rate of transmission, the transmission mode which may be synchronous or asynchronous, and either half or full duplex. In addition, a protocol may define a specification for data integrity or delivery assurance to recover in the event of an interruption of the data stream. Such technology makes packet-based communication far more efficient in that if the data stream is broken, the stream is resumed from the breaking point rather than back at the beginning with a rebroadcast.

At the lowest level of Internet communication lies Internet Protocol (IP) which specifies the format of the packets or datagrams that form the basis of all Internet communications. IP deals with the handling of a packet itself and is integral in the packaging of the data for travel over data lines which might include standard analog phone lines, high-bandwidth digital lines such as DSL or ISDN, or over network cables on an internal network. In addition to the packaging of data, IP also defines the addressing scheme used to deliver data between hosts. A unique dotted decimal number is assigned each Internet host and represents a unique identifier for each host on the Internet similar in nature and function to a postal address. While IP communication allows the transmission and reception of packets of data, it is only part of the Internet communication protocol bundle that lets two Internet hosts communicate.

While IP handles the packaging and addressing of data over the Internet, Transmission Control Protocol (TCP) and User Datagram Protocol (UDP) provide the negotiated connection handling of the data stream itself. TCP is popular because of its ability to guarantee delivery of the packet. Because of the topology of the Internet, that is that all data travels from point to point until it reaches its ultimate destination, packets have the tendency to get lost or discarded along the way and fail to reach their destination. Fortunately, the TCP protocol has built in fail safes to handle such an event. TCP manages the connection state itself and has a system for guaranteeing the arrival of the packet through packet sequencing and packet acknowledgements. Packets are labeled with a unique identifier, and each subsequent packet with the next identifier in the sequence. These fragmented packets may or may not arrive in sequence but may be arranged into the proper sequence due to the unique and sequenced numbers given each datagram.

The Transmission Control Protocol (TCP), documented in Request for Comment (RFC) 793, makes up for IP's deficiencies by providing reliable, "stream-oriented" connections that hide most of IP's shortcomings. The protocol suite gets its name because most TCP/IP protocols are based on TCP, which is, in turn, based on IP.

TCP adds a great deal of functionality to the IP service it is layered over, as shown in the following examples:

1. **Streams.** TCP data is organized as a stream of bytes, much like a file. The datagram nature of the network is concealed. A mechanism (the *Urgent Pointer*) exists to let out-of-band data be specially flagged.

2. **Reliable delivery.** Sequence numbers are used to coordinate which data has been transmitted and received. TCP will arrange for retransmission if it determines that data has been lost.

3. **Network adaptation.** TCP will dynamically learn the delay characteristics of a network and adjust its operation to maximize throughput without overloading the network.

4. **Flow control.** TCP manages data buffers and coordinates traffic so its buffers will never overflow. Fast senders will be stopped periodically to keep up with slower receivers.

### Full-duplex Operation

No matter what the particular application, TCP almost always operates full-duplex. The algorithms described below operate in both directions, in an almost completely independent manner. It is sometimes useful to think of a TCP session as two independent byte streams, traveling in opposite directions. No TCP mechanism exists to associate data in the forward and reverse byte

streams. Only during connection start and close sequences can TCP exhibit asymmetric behavior (data transfer in the forward direction but not in the reverse, or vice versa).

### Sequence Numbers

TCP uses a 32-bit *sequence number* that counts bytes in the data stream. Each TCP packet contains the starting sequence number of the data in that packet, and the sequence number (called the *acknowledgment number*) of the last byte received from the remote peer. With this information, a sliding-window protocol is implemented. Forward and reverse sequence numbers are completely independent, and each TCP peer must track both its own sequence numbering and the numbering being used by the remote peer.

TCP uses a number of control flags to manage a connection. Some of these flags pertain to a single packet, such as the URG flag indicating valid data in the Urgent Pointer field, but two flags (SYN and FIN) require reliable delivery as they mark the beginning and end of the data stream. To ensure reliable delivery of these two flags, they are assigned spots in the sequence number space. Each flag occupies a single byte.

### Window Size and Buffering

Each endpoint of a TCP connection will have a buffer for storing data that is transmitted over the network before the application is ready to read the data. This lets network transfers take place while applications are busy with other processing, improving overall performance.

To avoid overflowing the buffer, TCP sets a *Window Size* field in each packet it transmits. This field contains the amount of data that may be transmitted into the buffer. If this number falls to zero, the remote TCP cannot send more data. It must wait until buffer space becomes available and it receives a packet announcing a non-zero window size.

Sometimes, the buffer space is too small. This happens when the network's bandwidth-delay product exceeds the buffer size. The simplest solution is to increase the buffer size, but for extreme cases the protocol itself becomes the bottleneck (because it doesn't support a large enough Window Size). Under these conditions, the network is termed an LFN (Long Fat Network—pronounced *elephant*). RFC 1072 discusses LFNs.

### Round-Trip Time Estimation

When a host transmits a TCP packet to its peer, it must wait a period of time for an acknowledgment. If the reply does not come within the expected period, the packet is assumed to have been lost and the data is retransmitted. The obvious question—How long do you wait? —lacks a simple answer. Over an Ethernet, no more than a few microseconds should be needed for a reply. If the traffic must flow over the wide-area Internet, a second or two might be reasonable during peak utilization times. If you're talking to an instrument package on a satellite hurtling toward Mars, minutes might be required before a reply. There is no one answer to the question—How long?

All modern TCP implementations seek to answer this question by monitoring the normal exchange of data packets and developing an estimate of how long is "too long." This process is called Round-Trip Time (RTT) estimation. RTT estimates are one of the most important performance parameters in a TCP exchange, especially when you consider that on an indefinitely large transfer, *all* TCP implementations eventually drop packets and retransmit them, no matter how good the quality of the link. If the RTT estimate is too low, packets are retransmitted unnecessarily; if too high, the connection can sit idle while the host waits to timeout.

UDP, documented in RFC 768, provides users access to IP-like services. UDP packets are delivered just like IP packets—connectionless datagrams that may be discarded before reaching their targets. UDP is useful when TCP will be too complex, too slow, or just unnecessary.

UDP provides functions beyond that of IP, as shown below:

1. **Port Numbers.** UDP provides 16-bit port numbers to let multiple processes use UDP services on the same host. A UDP address is the combination of a 32-bit IP address and the 16-bit port number.
2. **Checksumming.** Unlike IP, UDP does checksum its data, ensuring data integrity. A packet failing checksum is simply discarded, with no further action taken.

All communications over the Internet use these protocols to provide a platform—independent method for such communication. As long as each vendor's TCP/IP stack adheres to the same standards outlined in the RFC's for the TCP, UDP, and IP protocols, then logic would have it that this communication will be seamless across all platforms and computer types.

## INTRODUCING HTTP

Understanding that TCP/IP is the communication protocol that any Internet host uses to communicate, it is important to grasp the other higher-level protocols that allow the transfer of actual data types. Data types are the classified in Web terms by the three most popular methods of transferring knowledge or data:

**HTTP.** Hyper Text Transfer Protocol is the underlying protocol used by the World Wide Web to serve and view Web Pages written in Hyper Text Markup Language (HTML). HTTP defines how messages are formatted and transmitted over the Internet and is dependent on the TCP/IP protocol suite to operate. The act of entering a Uniform Resource Locator (URL) into the address section of a Web browser preceded by http:// sends a command to a Web

server directing it to locate and transmit the Web page requested. HTTP is a stateless protocol as each command is executed in an independent manner. This makes using straight HTTP a barrier to interactive Web pages and has given birth to a variety of scripting tools and languages, such as PERL, JAVA, and ActiveX, as a means to fill these shortcomings. Several versions of the HTTP protocol exist, the most current being HTTP 1.1 which streamlines data connections by offering persistent connections to the Web server so that all data may be passed along a single connection.

**FTP.** File Transfer Protocol (FTP) is used primarily in the transfer of files from one host to another.

**SMTP/POP3.** Simple Mail Transfer Protocol and Post Office Protocol version 3 are the two primary mail transport protocols in use today for the sending and receiving of mail respectively.

## UNDERSTANDING WEB CONNECTIONS

Like most network protocols, HTTP uses the client-server model: An *HTTP client* opens a connection and sends a *request message* to an *HTTP server*; the server then returns a *response message*, usually containing the resource that was requested. After delivering the response, the server closes the connection (making HTTP a *stateless* protocol, in other words, not maintaining any connection information between transactions).

The format of the request and response messages is similar and English-oriented. Both of these messages consist of:

1. An initial line.
2. Zero or more header lines.
3. A blank line.
4. An optional message body (a file, query data, query output).

Put another way, the format of an HTTP message is:

```
<initial line, different for request vs. response>

Header1: value1

Header2: value2

Header3: value3

<optional message body goes here, like file contents or query
data; it can be many lines long, or even binary data>
```

### Initial Request Line

The initial line is different for the request than for the response. A request line has three parts, separated by spaces: a *method* name, the local path of the requested resource, and the version of HTTP being used. A typical request line is:

```
GET /path/to/file/index.html HTTP/1.0
```

A breakdown of the above statement is:

1. **GET** is the most common HTTP method. It says "give me this resource." Other methods include **POST** and **HEAD**.
2. The path is the part of the URL after the host name, also called the *request URI* (a URI is like a URL, but more general).
3. The HTTP version always takes the form "**HTTP/x.x**", uppercase.

### Initial Response Line (Status Line)

The initial response line, called the *status line*, also has three parts separated by spaces: the HTTP version, a *response status code* that gives the result of the request, and an English *reason phrase* describing the status code. Typical status lines are:

```
HTTP/1.0 200 OK
```

or

```
HTTP/1.0 404 Not Found
```

The above responses are defined as:

1. The HTTP version is in the same format as in the request line, "HTTP/x.x".
2. The status code is meant to be computer-readable. The reason phrase is meant to be human-readable, and may vary.
3. The status code is a three-digit integer, and the first digit identifies the general category of response:

   a. **1xx** indicates an informational message only
   b. **2xx** indicates success of some kind
   c. **3xx** redirects the client to another URL
   d. **4xx** indicates an error on the client's part
   e. **5xx** indicates an error on the server's part

The most common status codes are:

```
200 OK
```

The request succeeded, and the resulting resource (file or script output) is returned in the message body.

```
404 Not Found
```

The requested resource doesn't exist.

```
301 Moved Permanently

302 Moved Temporarily

303 See Other
```

*(HTTP 1.1 only)* The resource has moved to another URL (given by the **Location:** response header), and should be automatically retrieved by the client. This is often used by a CGI script or built in server function to redirect the browser to an existing file.

```
500 Server Error
```

An unexpected server error. The most common cause is a server-side script that has bad syntax, fails, or otherwise can't run correctly.

**Header Lines**

Header lines provide information about the request or response, or about the object sent in the message body.

The header lines are in the usual text header format: one line per header, of the form "**Header-Name: value**". This same format is used for e-mail and news postings, defined in RFC 822, section 3.

Details about RFC 822 header lines include:

1. The header name is not case-sensitive (though the value may be).
2. Any number of spaces or tabs may be between the ":" and the value.
3. Header lines beginning with space or tab are actually part of the previous header line, folded into multiple lines for easy reading.

Thus, the following two headers are equivalent:

```
Header1: some-long-value-1a, some-long-value-1b

HEADER1:    some-long-value-1a,

            some-long-value-1b
```

HTTP 1.0 defines 16 headers, though none are required. HTTP 1.1 defines 46 headers, and one (`Host:`) is required in requests. The following are common request headers used in a Web dialog:

1. The "From:" header gives the e-mail address of whoever is making the request, or running the program doing so. (This must be user-configurable, for privacy concerns.)

2. The "User-Agent:" header identifies the program that's making the request, in the form "Program-name/x.xx", where x.xx is the (mostly) alphanumeric version of the program. For example, Netscape 4.0 sends the header "User-agent: Mozilla/4.0Gold".

These headers help Webmasters troubleshoot problems. They also reveal information about the user. On the server end, the following are common response headers:

1. The "Server:" header is analogous to the User-Agent: header: it identifies the server software in the form "Program-name/x.xx". For example, one beta version of Apache's server returns "Server: Microsoft-IIS/4.0".

2. The "Last-Modified:" header gives the modification date of the resource that is being returned. It is used in caching and other bandwidth-saving activities. Use Greenwich Mean Time, in the format "Last-Modified: Fri, 31 Dec 1999 23:59:59 GMT"

### The Message Body

An HTTP message may have a body of data sent after the header lines. In a response, the requested resource is returned to the client (the most common use of the message body), or perhaps explanatory text if there's an error. In a request, user-entered data or uploaded files are sent to the server.

If an HTTP message includes a body, there are usually header lines in the message that describe the body.

1. The **Content-Type:** header gives the MIME-type of the data in the body, such as **text/html** or **image/gif**.

2. The **Content-Length:** header gives the number of bytes in the body.

## A Sample HTTP Exchange

To retrieve the file at the URL:

```
http://www.somehost.com/path/file.html
```

open a socket to the host *www.somehost.com,* port 80 (the default port of 80 is typically the TCP/IP port number used for HTTP transactions of the 65,532 ports available on an IP host). Once the communication channel is established, the following representation might be passed to the Web server:

```
GET /path/file.html HTTP/1.0

From: someuser@jmarshall.com

User-Agent: HTTPTool/1.0

[blank line here]
```

The server should respond similar to the following, sent back through the same socket:

```
HTTP/1.0 200 OK

Date: Fri, 31 Dec 1999 23:59:59 GMT

Content-Type: text/html

Content-Length: 1354

<html>

<body>

<h1>Happy New Millennium!</h1>

(more file contents)

   .

   .

   .
```

```
</body>

</html>
```

After sending the response, the server closes the socket.

**Other HTTP Methods**

Besides GET, the two most commonly used methods are HEAD and POST.

**The HEAD Method**

A HEAD request is just like a GET request, except it asks the server to return the response headers only, and not the actual resource (no message body). This is useful to check characteristics of a resource without actually downloading it, thus saving bandwidth. The response to a HEAD request must *never* contain a message body, just the status line and headers.

**The POST Method**

A POST request is used to send data to the server to be processed in some way, such as by a CGI script. A POST request differs from a GET request in the following ways:

1.  A block of data is sent with the request, in the message body. Extra headers usually describe this message body, like **Content-Type:** and **Content-Length:**.
2.  The *request URI* is not a resource to retrieve. It is usually a program to handle the data you're sending.
3.  The HTTP response is normally program output, not a static file.

The most common use of POST, by far, is to submit HTML form data to CGI scripts. In this case, the "**Content-Type:**" header is usually "**application/x-www-form-urlencoded,**" and the "**Content-Length:**" header gives the length of the URL-encoded form data. The CGI script receives the message body through STDIN, and decodes it. Below is a typical form submission using POST:

```
POST /path/script.cgi HTTP/1.0

From: rschwartz@hypercon.com

User-Agent: HTTPTool/1.0

Content-Type: application/x-www-form-urlencoded

Content-Length: 32

home=razamatazz&favorite+flavor=flies
```

A POST request may be used to send whatever data you want, not just form submissions, though the sender and the receiving program must agree on the format.

## INTRODUCING URL's

A URL is a Uniform Resource Locator. Think of a URL as a networked extension of the standard *filename* concept: not only can you point to a file in a directory, but that file and directory can exist on any machine on the network, can be served via any of several different methods, and might be more complex than a file. URLs can also point to queries, documents stored deep within databases. The URL is entered in the Address field of the Web browser and uses the following syntax:

```
<type> <server name> <path> <filename><extension (type)>
```

where **<type>** is the requested format, **<server name>** is the friendly name given the server and translates to a host IP address using the Domain Name System (DNS), **<path>** is the directory file path to the requested file, and <**filename**> is the actual file requested. The following example shows how this identity might look in a browser's address field.

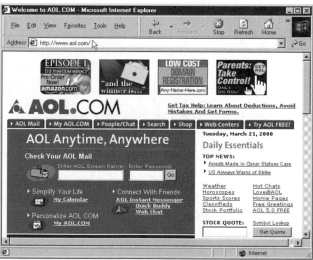

*The URL is entered into the browser's Address field to make a request.*

The following examples illustrate the most common types of URL's in use today:

**File URLs.** Suppose there is a document called foobar.txt which sits on an anonymous FTP server called ftp.yoyodyne.com in directory /pub/files. The URL for this file will be:

```
file://ftp.yo.com/pub/files/foobar.txt
```

The top level directory of this FTP server is simply:

```
file://ftp.yo.com/
```

The pub directory of this FTP server is:

```
file://ftp.yo.com/pub
```

**Gopher URLs.** Gopher URLs are more complicated than file URLs, since Gopher servers are trickier to deal with than FTP servers. To visit a particular gopher server (for example, the gopher server on gopher.yoyodyne.com), use the following URL:

```
gopher://gopher.yo.com/
```

Some gopher servers may reside on unusual network ports on their host machines. (The default gopher port number is 70.) If you know that the gopher server on the machine gopher.banzai.edu is on port 1234 instead of port 70, then the corresponding URL will be:

```
gopher://gopher.banzai.edu:1234/
```

**News URLs.** To point to a Usenet newsgroup (for example, rec.reading), the URL is:

```
news:rec.gardening
```

Often, if this URL is entered in the address line of the browser, a secondary or helper program may be launched to facilitate the use of NNTP communication as is the case with the two most popular Web browsers out today.

**HTTP URLs.** HTTP stands for Hyper Text Transport Protocol. HTTP servers are commonly used for serving hypertext documents, as HTTP is a low-overhead protocol that capitalizes on the fact that navigation information can be embedded in such documents directly and the protocol itself does not have to support full navigation features like the FTP and Gopher protocols do.

A file called index.html on HTTP server www.someserver.com in directory /pub/files corresponds to the following URL:

```
http://www.yo.com/pub/files/foobar.html
```

The default HTTP network port is 80. If an HTTP server resides on a different network port (for example, port 1234 on www.yoyodyne.com), then the URL becomes:

```
http://www.yo.com:1234/pub/files/foobar.html
```

**Partial URLs.** Once you are viewing a document located somewhere on the network, for example, the document:

```
http://www.someserver.com/pub/afile.html
```

you can use a *partial*, or *relative*, URL to point to another file in the same directory, on the same machine, being served by the same server software. If another file exists in that same directory called anotherfile.html, then anotherfile.html is a valid partial URL.

This provides an easy way to build sets of hypertext documents. If a set of hypertext documents are sitting in a common directory, they can refer to one another via hyperlink by just their filenames—however, if a reader gets to one of the documents, a jump can be made to any other document in the same directory by merely using the other document's filename as the partial URL. The additional information (access method, hostname, port number, directory name, and so on) will be assumed based on the URL used to reach the first document. The path to a file in another directory may be linked using the path and the filename along with the dotted notation for change directory where the link path may look like:

```
./etc/filename.html
```

for a file in a directory just above the current directory or, in the case of a directory, located off of the root:

```
../pub2/new/filename.html
```

Alternatively, the entire URL may be used as well to redirect the reader to the new document.

URL's provide a standard format for file retrieval over the Web. The nomenclature uses Unix style directory listings that may or may not be familiar to many users of Microsoft Windows or DOS-based operating systems.

# INTRODUCING HTML

HTML is an acronym for HyperText Markup Language and was developed as part of the Web specification, born in 1990 in the European lab for Particle Physics at CERN, on a Unix-based computer using the NeXTStep operating system. Tim Berners-Lee and Robert Cailliau set out to create a graphical environment that would let scientists in the physics community share their data. HTML is the language they developed for use with Web browsers that uses a system of opening and closing markers, or "tags," to format the content of the body text in a Web document. Before a technical description of the language, some history of the language is discussed to better understand the strides made over the last twenty years.

HTML 1.0 developed under the original Web specification circa 1989-1992. The infant stages of the language provided very basic formatting ability for Web-based documents, much like the formatting that might be found in a word processor program that provides bold, italics, or underline capabilities, as well as, text sizing and heading markers. The idea of posting HTML documents on a Web server has a one-to-many function where many users may share or collaborate on documents from one resource. HTML let scientific minds from around the world share ideas and proposals by posting these documents to a single source on the Web and further linking to other relevant documents .

HTML 2.0. HTML version 2.0 was outlined and accepted as a standard in RFC 1866 between 1993 and 1994 and built off of the original specification to add further text formatting (such as block quotes, lists, and bulleted lists), as well as, the ability to add Internet–based images, such as GIF and JPEG.

HTML 3.0. This version of the HTML life cycle was introduced in 1994-1995, but it was never standardized. It did introduce tables and mathematical formatting to the HTML language.

## UNDERSTANDING HTML TAGS

In its simplest form, HTML documents are plain text (also known as ASCII) files that can be created using any text editor (for example, Emacs or vi on Unix machines, SimpleText on a Macintosh, and Notepad on a Windows machine). You can also use word-processing software if you remember to save your document as text only with line breaks.

The formatting of text beyond the basic font is accomplished using HTML "tags," a system of markers that are interpreted by the Web browser and further translated into formatted text.

An *element* is a fundamental component of the structure of a text document. Some examples of elements are heads, tables, paragraphs, and lists. You use HTML tags to mark the elements of a file for your browser. Elements can contain plain text, other elements, or both.

To denote the various elements in an HTML document, you use *tags*. HTML tags consist of a left angle bracket (<), a tag name, and a right angle bracket (>). Tags are usually paired (for example, <H1> and </H1>) to start and end the tag instruction. The end tag looks just like the start tag except a slash (/) precedes the text within the brackets.

Some elements may include an *attribute*, which is additional information that is included inside the start tag. For example, you can specify the alignment of images (top, middle, or bottom) by including the appropriate attribute with the image source HTML code.

Not all tags are universally supported by all World Wide Web browsers. If a browser does not support a tag, it will simply ignore it. Any text placed between a pair of unknown tags will, however, still be displayed.

## THE BASICS OF HTML DOCUMENT CONSTRUCTION

Every HTML document should contain certain standard HTML tags. Each document consists of head and body text. The head contains the title, and the body contains the actual text that is made up of paragraphs, lists, and other elements. Browsers expect specific information because they are programmed according to HTML and SGML specifications.

Certain HTML tags are required of a basic Web document and are outlined as follows:

**HTML.** This element tells your browser that the file contains HTML-coded information. The file extension .html also indicates this is an HTML document and must be used. (If you are restricted to 8.3 filenames (for example, home.htm, use only .htm for your extension.)

**HEAD.** The head element identifies the first part of your HTML-coded document that contains the title. The title is shown as part of your browser's window (see below).

**TITLE.** The title element contains your document title and identifies its content in a global context. The title is typically displayed in the title bar at the top of the browser window, but not inside the window itself. The title is also displayed on someone's hotlist or bookmark list, so choose something descriptive, unique, and relatively short. A title is also used to identify your page for search engines, such as Infoseek or Lycos. Generally, you should limit your titles to 64 characters or less.

**BODY.** The second—and largest—part of your HTML document is the body, which contains the content of your document (displayed within the text area of your browser window). The tags explained below are used within the body of your HTML document.

These four main elements are the basic building blocks of any Web-based document, though only the HTML and HEAD tags are required. TITLE and BODY help to define the style and content.

## DESIGNING A SIMPLE HTML DOCUMENT

Basic HTML documents are easy to create. Required elements of a Web page are shown in this sample bare-bones document:

```
<html>

<head>

<TITLE>A Simple HTML Example</TITLE>

</head>

<body>

<H1>HTML is Easy</H1>

<P>Welcome to the world of HTML.

This is the first paragraph. While short it is

still a paragraph!</P>

<P>And this is the second paragraph.</P>

</body>

</html>
```

The required elements are the <html>, <head>, <title>, and <body> tags (and their corresponding end tags). Because you should include these tags in each file, you might want to create a template file with them. (Some browsers will format your HTML file correctly even if these tags are not included. Some browsers won't, however, so you should make sure to include them.)

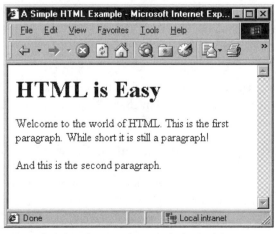

*What the Web browser output for the above code sample looks like.*

## UNDERSTANDING THE <HEAD> TAG

Now that the required elements have been defined, a broader discussion of these and other common tags is prudent. The HTML tag simply defines the document. The header —enclosed by the <head> and </head> tags—contains information about a page that won't appear on the page—the title or information about the page itself such as author, subject, and so forth. This extended information is contained in a special tag designated by a <meta> denotation.

## UNDERSTANDING THE <META> TAG

The **META** tag in HTML is not a required tag when creating your Web pages; many pages do not use the tag at all. In brief, the META tag is used by indexing search engines (those that "crawl" the Web searching for new documents) to let them more accurately list a site or page in their indexes.

Many Web search engines require that a URL be registered first before it is "spidered." Each of the search engines handles this in a slightly different manner. Often, the way that a document is indexed varies as well. AltaVista, for example, will index all relevant words (relevant in that it uses a dictionary to pick out discretionary words) in a document, though it only displays the first 250 characters in its description field. For more information, see Altavista, Lycos, Yahoo, Infoseek, and Excite on the WWW for a detailed description of how each works.

Regardless of how detailed the process is on any given engine, there are ways to exert a certain amount of control over how your site is indexed by the use of the META tag. Many search engines use the information contained in these tags to categorize and index a site by relevance.

**What does a meta tag look like?**

In most cases, the META tag element is located at the top of an HTML document, just after (with exception) the <TITLE> element. The META tag is a singular tag and requires no closing element, as shown below:

```
<META name="something" content="something else">
```

It is important to make sure that each tag does not include any line breaks as some search engines will fail to parse the line correctly.

**What can I include in a meta tag?**

There are basically four major META tags that you can use:

```
<META name="content-type" content="text/html">
```

The main resource type used for HTML documents is text/html which describes the MIME type of the document (discussed later). This is the only tag that you need to put in for indexing purposes, though use of the other types will help search engines determine relevance in their indices.

```
<META name="description" content="a description of your page">
```

Depending on the search engine, this will be displayed along with the title of the page in an index such as those found on Lycos or Infoseek. Content could be a word, sentence, or paragraph to describe the page. The idea is to keep this reasonably short, concise, and to the point. However, don't be so lean with the description that it is not an appropriate reflection of the contents of the page.

```
<META name="keywords" content="a, list, of, keywords">
```

Choose whatever keywords are appropriate to describe the page (these are later used as the keywords for searching the indices of the search engine), separated by commas. Remember to include synonyms and other relative words. If a Web page was created about cars, keywords would then include words such as car, cars, vehicles, automobiles and so on.

```
<META name="distribution" content="one of several">
```

Content should contain either global, local, or iu (for Internal Use). This is used in respect to Internet, intranet, or personal use and is a distinction of the document type.

**Are there optional tags?**

Several optional tags that an author may find useful are listed below:

```
<META name="copyright" content="copyright statement"
```

The following tag covers copyrighted material and the disclaimer statement:

```
<META HTTP-EQUIV="varname" content="data"
```

This binds the varname to an HTTP header field. An HTTP server uses this to process a document. If you include the following example:

```
<META HTTP-EQUIV="keywords" content="car,cars">
```

then, as part of a GET command, the server would include the words car and cars in the HTTP response header.

```
<META HTTP-EQUIV="refresh" content="0"; url=homepage.htm"
```

This can be used in the HEAD section of the index.html file to redirect it to homepage.htm. The integer after content= is the time in seconds that the browser waits before moving on.

## INTRODUCING MIME

MIME is an acronym for Multipurpose Internet Mail Extensions. MIME is a specification for formatting non-ASCII messages so that they can be sent over the Internet. Many e-mail clients now support MIME, which enables them to send and receive graphics, audio, and video files via the Internet mail system. In addition, MIME supports messages in character sets other than ASCII. MIME was defined in 1992 by the Internet Engineering Task Force (IETF). A new version, called *S/MIME,* supports encrypted messages.

In addition to e-mail applications, Web browsers also support various MIME types. This enables the browser to display or output files that are not in HTML format. There are many predefined MIME types, such as GIF graphics files and PostScript files, as well as common productivity types such as Microsoft's Word and Excel. It is also possible to define your own MIME types for new document formats for recognition by Web clients and servers.

## DETERMINING THE POSSIBLE MIME TYPES AN HTML PAGE MAY CONTAIN

To determine the MIME type of a document, the source of the HTML document must be viewed (this is available through many browsers using the view source option) as the description of the type is found in the META section of the document between the <HEAD> tag, and the <TITLE> tag as outlined below:

```
<html>

<head>

<META http-equiv="Content-Type" content="text/html; charset=iso-
8859-1">

<TITLE>Welcome to MSN.COM</TITLE>
```

The following table outlines tested common MIME types that might be found in the META headers of an HTML document:

| | |
|---|---|
| text/richtext – Rich Text Document | image/x-emf – EMF image file format |
| text/html – HTML Document | image/x-wmf – WMF image file format |
| audio/x-aiff – AIFF audio format file | video/avi – AVI video formatted file |
| audio/midi – MIDI audio file | video/mpeg – MPEG video formatted file |
| audio/wav – WAV audio format file | application/postscript – Postscript file (UNIX) |
| image/gif – GIF formatted image | application/base64 – Encoded file format |
| image/jpeg – JPEG formatted image | application/macbinhex40 – Mac encoded file |
| image/pjpeg – PJPEG image format (less common) | application/pdf – Portable document format (Adobe) |
| image/tiff – TIFF image file format | application/x-compressed – Unix compressed file |
| image/x-png – PNG graphics file format | application/x-zip-compressed – ZIP compressed file |
| image/x-xbitmap – Xbitmap graphics file format | application/x-gzip-compressed – GZIP compressed file |
| image/bmp – Bitmap image file format | application/java – Java application |
| application/x-msdownload | |

## Using the <TITLE> Tag

Just as every written document should have a title, so too should a Web page. The TITLE tag is contained within the HEAD tags of the document and should contain some description of the page being developed. Alternatively, the description can remain the same for each page of the site. You should keep the title under 64 characters, otherwise it will not fit entirely within the title bar of the Web browser itself.

Use of the TITLE tag is outlined in the following code example, and the result is displayed in the following example:

```
<HTML>

<TITLE> My first html page </TITLE>

<B>This is my first HTML page!</B><P>
```

```
I can write in <I>Italic</I> or <B>Bold</B><BR>

<HR>

<B><I>Or I can write in both</I></B><BR>

<HR>

<TT>...and that's all</TT>

</HTML>
```

*The output in the title bar of the browser window.*

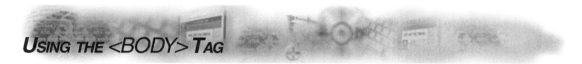

## USING THE <BODY> TAG

The body tag is used to define the body or text (and other content) of the HTML document. Items such as scripting are not found within the area designated as the body. The following code sample outlines the use of the BODY tag in an HTML document:

```
<HTML>

<HEAD>

<TITLE> My first html page </TITLE>

</HEAD>

<BODY>

<B>This is my first HTML page!</B><P>

I can write in <I>Italic</I> or <B>Bold</B><BR>

<HR>
```

```
<B><I>Or I can write in both</I></B><BR>

<HR>

<TT>...and that's all</TT>

</BODY>

</HTML>
```

The above text would appear similar to the following screenshot shown below:

*Using the BODY tag to define the text portion of an HTML document.*

## USING THE ALIGN OPTION

The ability to add text to a Web page without the ability to space or format the text would suffice in a humdrum world, although it might be difficult to read at times. A common formatting tag used in most Web pages is the ALIGN option that may be used in conjunction with many of the text based HTML tags, such as the heading or block quote types.

The ALIGN=left|center|right attribute may be used in the following manner (heading tag used in this example):

```
<H1 ALIGN=center>This is a centered heading</H1>
```

and would align a heading of style 1 in the center of the page.

## USING THE <BR> TAG

The <LINE BREAK> tag is used in the <BODY> section of an HTML document. It effectively forces a carriage return (a new line) at the place in the document where the <BR> is located. Please note that this differs from the <P> (paragraph) <HTML> tag.

This attribute lets text be truly wrapped around an image that has its align attribute set. For example, if you have an image aligned left, and the text is wrapping along the right side of that image, when it reaches an area underneath the image, you can use a **<BR CLEAR=LEFT>** to force the text to start as far left as possible. **CLEAR=NONE**, which does nothing, is the default. The following example shows this:

| | | | |
|---|---|---|---|
| **This** | **is** | **line** | **one<BR>** |
| **This** | **is** | **line** | **two<BR>** |
| **This** | **is** | **line** | **three<BR>** |

**This is line four<BR>**

| | | | |
|---|---|---|---|
| This | is | line | one |
| This | is | line | two |
| This | is | line | three |

This is line four

Instead of all four of the lines being strung together, a new line begins after each one.

## USING THE <NOBR> TAG

The <NOBR> element stands for **NO BR**eak. This means all the text between the start and end of the <NOBR> elements cannot have line breaks inserted. While <NOBR> may be essential for those character sequences that don't want to be broken, it should be used carefully—long text strings inside of <NOBR> elements can look odd, especially if, during viewing, the user adjusts the page size by altering the window size.

## USING THE <HR> TAG

A Horizontal Rule element is a divider between sections of text, such as a full width horizontal rule or equivalent graphic (the bar is displayed as a graphic but is interpreted

and drawn by the browser and should not be confused with a graphic that is placed in a Web page).

Example of use:

```
<                     H                    R                    >
<ADDRESS>August 20<SUP>th</SUP>, 1999, Schwartz</ADDRESS>
</BODY>
```

would appear in the browser as shown below:

August 20th, 1999, Schwartz

The <HR> element specifies that a horizontal rule of some sort (the default being a shaded engraved line) be drawn across the page. Recent browsers have added new attributes to this element, which can be used to describe the coloring, size, and position of the horizontal rule, as shown below:

```
<HR SIZE=number>
```

The SIZE attribute allows the author give an indication of how thick he or she wishes the horizontal rule to be.

```
<HR WIDTH=number|percent>
```

The default horizontal rule is always as wide as the page. With the WIDTH attribute, the author can specify an exact width in pixels or a relative width measured in percent of document width.

```
<HR ALIGN=left|right|center>
```

Since horizontal rules do not have to be the width of the page, it is necessary to let the author specify whether they should be pushed up against the left margin, the right margin, or centered in the page.

```
<HR NOSHADE>
```

For those times when a solid bar is required, the NOSHADE attribute lets the author specify that the horizontal rule should not be shaded at all.

```
<HR COLOR>=name|#rrggbb
```

Internet Explorer allows the specifying of the hard rule color. Accepted values are any of the **Internet Explorer** supported color names (see <BODY BGCOLOR=...>, or any acceptable rrggbb hexadecimal triplet.

```
TITLE="informational ToolTip"
```

The **Internet Explorer** 4.0 (and above) specific TITLE attribute is used for informational purposes. If present, the value of the TITLE attribute is presented as a ToolTip when a user's mouse hovers over the <HR> section.

```
LANG="language setting"
```

The LANG attribute can be used to specify what language the <HR> element is using. It accepts any valid ISO standard language abbreviation (for example en for English, de for German, and so on). For more details, see the Document Localization section.

Examples of the supplemental horizontal rule attributes are shown below:

```
<HR>
<HR SIZE="5">
<HR WIDTH="50%">
<HR WIDTH="50%" ALIGN="right">
<HR WIDTH="50%" ALIGN="center" NOSHADE>
```

# USING THE <P> TAG

The Paragraph element indicates a paragraph of text within the document. No specification has ever attempted to define exactly the indentation of paragraph blocks and is a function of other elements, such as style sheets. Typically, paragraphs should be surrounded by a vertical space of between one and one and a half lines. With some HTML browsers, the first line in a paragraph may be indented.

You can use the Paragraph element in several ways, as shown below:

```
<H1>The Paragraph element</H1>
<P>The paragraph element is used to denote paragraph blocks</P>
<P>This would be the second paragraph.</P>
```

# UNDERSTANDING HYPERLINKS IN HTML DOCUMENTS

One of the most useful and powerful features of an HTML document is the ability to link other HTML documents or areas of the document at relevant points within the text. References to outside resources or other areas of a large text are usually displayed by a different color and underlined as well. Using a pointing device, such as a mouse, the reader may jump to these references by simply clicking on them.

A hyperlink tells the browser what type of server is being used to present the file, the address of the machine the file is located on, and where it is on that machine. It also includes a label with which to select the hotlink.

Links to other documents and files appear as highlighted text in a unique style when a page is viewed. When the user using the browser selects the link, the browser is automatically transferred to the file the link points to. The actual location of the file is trivial, as is how it should be retrieved. The file may be located anywhere in the world on any server. A user viewing a document doesn't need to know how or where a resource is stored or what server is used to present it, he or she only needs to select a hotlink and the file is automatically transferred to their machine.

Clicking on a hyperlink will invoke one of three reactions by the browser:

1. The browser itself will display the file (if it is a text file, another HTML document, or a type of image the browser is capable of displaying).

2. If the browser is configured properly, and recognizes what type of file is being sent to it, a program capable of viewing the file will be launched and the incoming file will be automatically loaded into it (for example, a video or sound clip).

3. If the browser does not recognize what type of file is being sent to it, or it has not been told what type of program to use to view the incoming file, the user will be told this, and asked whether or not he or she wants to download the file.

## USING THE <A> TAG

A hyperlink is created using the anchor tag set and designates text between highlighted text in the browser (for example, a click-able link). This marked text is the start and destination of a hypertext link. The <A> tag defines anchor elements. It also accepts several attributes, though either the NAME or HREF attribute is required to be used along with the tag.

The following describes the usage of the anchor tag in HTML :

**HREF.** If the HREF attribute is present, the text between the opening and closing anchor elements becomes a hypertext link. If you select the link, you will be transported to the document or location specified by the value of the attribute, as shown in the following example:

```
Visit <A HREF="http://somehost.com/">The Somehost Web Site</A>
for all of your Web needs
```

In this example, selecting **The Somehost Web Site** takes the reader to a document located at *http://somehost.com/*.

Several other forms of the HREF attribute are permitted by browsers, as shown below:

```
<A HREF="http://...">
```

Makes a link to another document located on a World Wide Web server.

```
<A HREF="ftp://...">
```

Makes a link to an FTP site. Within an HTML document, normally a connection to an anonymous FTP site would be made. Recent browsers allow connections to private FTP sites. The Anchor would take the form *ftp://jdoe@somehost.com*. The browser would then prompt the user for a password.

```
<A HREF="gopher://...">
```

Makes a link to a gopher server.

```
<A HREF="mailto:...">
```

Activating such a link would bring up the browser's mailing dialog (or application associated with Internet mail) letting the user send mail messages to the author of the document or to whatever address follows the mailto attribute. Most browsers today support the use of a subject line to add convenience to the link. It lets the author specify the subject of the mail message that will be sent. Netscape allows specification of the subject line by using the following syntax:

```
<A HREF="mailto: rschwartz@hypercon.com?subject=1001 Web Site
Construction Tips is fantastic">link text</A>.
```

**Internet Explorer** 4.0 and above, meanwhile, supports and extends the above possibility, letting various mail fields be automatically filled in, by using the following syntax:

```
<A HREF="mailto:rschwartz@hypercon.com?subject=Subscribe to
mailing list&cc=rschwartz@hypercon.com&body=I'd like to sub-
scribe to the mailing list please">Subscribe</A>
```

Note that spaces are allowed in the mail fields:

```
<A HREF="news:...">
```

Makes a link to a newsgroup. Care should be taken in using such links because the author cannot know what newsgroups are carried by the local news server of the user.

```
<A HREF="newsrc:...">
```

Makes a link to a specific *newsrc* file.

```
<A HREF="nntp://...">
```

Can be used to specify a different news server to that which the user may normally use. This is useful if you want to link to a newsgroup that a user's local news server may not carry (see above).

```
<A HREF="telnet://...">
```

Activating such a link would initiate a Telnet session (using an external application) to the machine specified after the Telnet:// label.

## HYPERLINKING WITHIN THE CURRENT DOCUMENT

The HREF attribute may reference a link to another part of the document itself (for example, the glossary), and take the form **HREF="#identifier"**, as shown in the following example:

```
See the <A HREF="doc.html#glossary">glossary</A> for definitions
of common terms used in this document.
```

In this example, selecting **glossary** takes the reader to another anchor (**<A NAME="glossary">Glossary</A>**) in the document *doc.html*. The NAME attribute is described below. If the anchor is in another document and the HREF attribute provides a partial URL, the new document will be resolved from either the present document, or from any specified base address.

## USING A HYPERLINK TO LET THE USER SEND E-MAIL

**<A HREF="mailto:...">** is the syntax used to interject a mail hyperlink into an HTML document. Activating such a link would bring up the browser's mailing dialog (or an application associated with Internet mail, such as Eudora or Microsoft's Outlook Express), letting the user send mail messages to the author of the document, or to whatever address follows the mailto attribute. Most browsers today support the use of a *subject line* to add convenience to the link. It lets the author specify the subject of the mail message that will be sent. Netscape allows specification of the subject line by using the following syntax:

```
<A HREF="mailto: rschwartz@hypercon.com?subject=1001 Web Site
Construction Tips is fantastic">link text</A>.
```

The figure below shows the final product in a browser window.

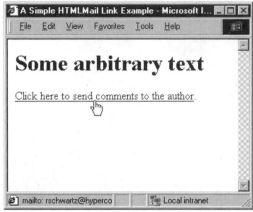

*The link in the browser window.*

The result is shown below, where the mail program is launched.

*The result is (usually) the launching of an e-mail program with the subject filled in.*

## PASSING VALUES WITH A HYPERLINK REFERENCE

As shown above, a hyperlink may send various values to the browser or supporting program to provide an automated facility for the end reader. Another example of this might be a hyperlink that allows a seamless login to a Web resource, such as a File Transfer Protocol (FTP) server or

an HTTP (Web) server. The following code sample shows how this might be accomplished using HTML. The graphics following the code show the link on the HTML page in the browser window and then the result.

```html
<html>

<head>

<meta http-equiv="Content-Type" content="text/html;
charset=windows-1252">

<title>Logon Page</title>

</head>

<body>

<center><H1>Logon Portal</H1></center>

<p>

<hr>

<A HREF="rschwartz:password@www.technelogic.com>Click Here to
Log on!</A>

<hr>

</body>

</html>
```

*The resulting HTML page.*

*The resulting auto-logon page.*

# USING GRAPHICS WITHIN AN HTML DOCUMENT

Two dominant image formats are supported in HTML documents: the Graphics Image Format (GIF) and the Joint Photographic Expert Group (JPEG or JPG) format. To use an image in an HTML page, the image must be called using the IMG HTML attribute. The Image element, which is empty (no closing element), has the following attributes:

**ALIGN**="left|right|top|texttop|middle| absmiddle|baseline|bottom|absbottom"

ALIGN=left image will float the image to the left margin (into the next available space), and subsequent text will wrap around the right hand side of that image.

ALIGN=right will align the image with the right margin, and the text wraps around the left.

ALIGN=top aligns itself with the top of the tallest item in the line.

ALIGN=texttop aligns itself with the top of the tallest text in the line (this is usually, but not always, the same as ALIGN=top).

ALIGN=middle aligns the baseline of the current line with the middle of the image.

ALIGN=absmiddle aligns the middle of the current line with the middle of the image.

ALIGN=baseline aligns the bottom of the image with the baseline of the current line.

ALIGN=bottom aligns the bottom of the image with the baseline of the current line. (Essentially, this is the same as ALIGN=baseline).

ALIGN=absbottom aligns the bottom of the image with the bottom of the current line.

**ALT**="Alternative Text". Optional text as an alternative to the graphic for rendering in non-graphical environments. Alternate text should be provided for whenever the graphic is not rendered (That is, if the user has image loading turned off). Alternate text is mandatory for Level 0 documents. **Internet Explorer** and **Netscape** (4.0 and above) also use any ALT text set as a ToolTip to be displayed when the user's mouse pauses over the image, as shown in the following example:

```
<IMG SRC="triangle.gif" ALT="Warning:"> Be sure to read these
instructions.
```

**ISMAP.** The ISMAP attribute identifies an image as an image map. Image maps are graphics in which certain regions are mapped to other documents. By clicking on different regions, different resources can be accessed from the same graphic, as shown in the following example use:

```
<AHREF="http://machine/htbin/imagemap/sample">
<IMG SRC="sample.gif" ISMAP></A>
```

*Note:* To be able to employ these type of image maps in HTML documents, the HTTP server which will be controlling document access must have the correct *cgi-bin* software installed to control image map behavior. The document must have access to an image map handling script and the map file defining the graphic 'hot-spots'.

A simpler form of image map, known as client-side image maps, is also possible. Currently, this type of map is a proposed extension to HTML.

**SRC="URL of image".** The value of the SRC attribute is the URL of the image to be displayed. Its syntax is the same as that of the HREF attribute of the <A> element. SRC is the only mandatory attribute of the <IMG> element. Image elements are allowed within anchors. The basic syntax is:

```
<IMG SRC="warn.gif">Be sure to read the instructions.
```

or if the image exists in some other directory or server:

```
<IMG SRC="http://someserver/somevirtualdirectory/warn.gif">Be
sure to read the instructions.
```

The SRC attribute can accept fully qualified, or partial, relative URL's, or just image names (providing the image is located in the same directory as the HTML document).

```
<IMG ALIGN="left" SRC="mosaic.gif" HSPACE="20" ALT="Mosaic
logo"> Mosaic, from the <B>N</B>ational <B>C</B>entre for
<B>S</B>upercomputing <B>A</B>pplications represents the
original graphical browser which Netscape development was
based on.
```

```
<BR CLEAR="all">
<HR>
<IMG ALIGN="right" SRC="netscape.gif" HSPACE="20" ALT="Netscape
logo"> Netscape, from <B>Netscape Communications</B>, after
initial development from Mosaic, stormed away and became more
or less the <I>de facto</I> Web browser.
<BR CLEAR="all">
<HR>
<IMG ALIGN="left" SRC="iexplore.gif" HSPACE="20"
ALT="Internet Explorer logo">Internet Explorer, from
<B>Microsoft </B>, exhibits Microsoft's serious intentions in
the Web browser market and compete head-to-head with Netscape,
offering the same functionality...and then some more.
<BR CLEAR="all">
<HR>
```

## USING <A HREF> TOGETHER WITH IMG SRC TO CREATE GRAPHICAL LINKS

Images may also be used as hyperlink references within an HTML document extending their functionality to more than just a relevant photo, image, or icon. To accomplish this, the <a> (anchor) tag and associated HREF hyperlink reference attribute are used in conjunction with the IMG and SRC attribute, combining to form a clickable image that references either some other HTML document or place within the current document. The following code links the NCSA Mosaic image on the left to *www.ncsa.comI,* as shown in the resulting browser window below.

```
<html>

<head>

<meta http-equiv="Content-Type" content="text/html;
charset=windows-1252">

<meta name="GENERATOR" content="Microsoft FrontPage 4.0">

<meta name="ProgId" content="FrontPage.Editor.Document">

<title>Mosaic</title>

</head>

<body>
```

```
<a href="http://www.ncsa.org"><img src="../Figures/mosaic.gif"
align="left"</a>Mosaic, from the <strong>N</strong>ational Center
for <strong>S</strong>upercomputing

<strong>A</strong>pplications represents the original graphi-
cal browser which Netscape development was based on

</body>

</html>
```

*The browser output showing graphics that are also hyperlinks.*

## UNDERSTANDING THE POWER OF HYPERLINKS

The basic use of the hyperlink is a powerful tool, adding so much more to the overall reading experience of an HTML document in that references may be accessed immediately. It is so powerful that it is often difficult to remain focused on the original document! Hyperlinks may be used in a myriad of ways making hypermedia a powerful tool for creating online toolsets for a corporate intranet or communities on the Internet. In a corporate intranet, a user may logon to the main site page and link to all of the server-based applications used by the company. For example, many corporations use productivity software, such as Microsoft Office or Corel's Perfect Office, in a manner where the applications are not installed on a local machine, rather they are launched from an application server. Such a page might include convenient links to these applications and others, providing a single point of contact for all such applications and simplifying the user experience. In Internet communities, a hyperlink may launch a JAVA-based chat application that lets users across the world communicate with each other. The use of hyperlinks and what they might link or launch is limited only to the operating system itself, that is, Microsoft Windows based PCs cannot run Unix-based programs. Additionally, the MIME type or an associated program may not be defined.

## VISUALIZING A WEB SITE'S LAYOUT

It is conceivable that a Web site can consist of a singular Web page that makes no reference to other pages and runs on endlessly. Such a Web document would be a waste of the power of HTML and its features. In creating a Web site, it is important to draft an overall plan for the site in order to understand the site map as a whole and, further, to create a link map to all areas or pages of the site.

Some HTML editors offer the ability to visualize the site before, during, and after the creation of the site itself. Such environments are termed with the acronym WYSIWIG which stands for, "What you see is what you get." Microsoft's FrontPage product offers such a feature, as shown below.

*Microsoft's FrontPage 2000 WYSIWIG HTML Editor.*

## UNDERSTANDING THE <BASE> TAG

The Base element lets the URL of the document itself be set to help browsers in situations where the document may be read out of context. It is especially useful in letting browsers determine any partial URL's, or relative paths (paths that are not fully qualified URLS), that may be specified (for example, in <A HREF> elements, or paths pointing to <IMG SRC=…> (images)). The <BASE> Element should appear within the bounds of the <HEAD> element.

Where the base address is not specified, the HTML user agent uses the URL it used to access the document to resolve any relative URLs.

The Base element uses the HREF attribute, which identifies the URL and should be a fully qualified URL, as shown below:

```
<BASE HREF="http://www.myhost.com/">
```

which specifies *www.myhost.com* to be the base from which all relative URLs should be determined.

## USING THE <BASE> TAG TO SIMPLIFY URLS

Once the <BASE> element is used, relative paths may be used in the document to reference other pages that reside within the document. For example, if the <BASE> element defines the URL of the document as *www.myhost.com*, you would append this to all subsequently placed relative paths, such as /images/mypicture.gif, to produce www.myhost.com/images/mypicture.com.

```
<BASE TARGET="default_target">
```

## UNDERSTANDING THE HEADING FORMATS

Most document creation environments offer the ability to apply various heading levels to a document or sections of a document. Such headings serve to sub-divide document sections as titles and sub-titles. HTML is no different in this regard, offering a series of tags that format text from a very large (approximately 26 point, though this depends on the interpretation of the browser and perhaps other factors) to miniscule level. Such text is represented in browsers as bold text as well.

## USING THE HEADING <H1> FORMAT TAG

The largest of the heading tags is the <H1> element that renders text as approximately 26 point text. The <H1> tag is usually used to display a document title, followed by subheadings in the text, as discussed below. The basis of these headings is found in internationally accepted style guides that outline how documents should be broken down. This is a feature commonly found in many popular word processor programs on the market today.

## USING ALL OF THE HEADING FORMATS IN A SINGLE DOCUMENT

Other than the <H1> heading definition, HTML defines six levels of headings in all to distinguish subsections of text in a document. A Heading element implies all the font changes, paragraph breaks before and after a paragraph, and white space necessary to render the heading.

The highest level of headings is <H1>, followed by <H2>...<H6>, as shown in the following example:

```
<H1>This is a first level heading heading</H1>
Here is some normal paragraph text
<H2>This is a second level heading</H2>
Here is some more normal paragraph text.
```

The rendering of headings is determined by the Web browser and further by defining fonts, but typical representations resemble the following:

# HEADING 1

## HEADING 2

### Heading 3

#### Heading 4

##### Heading 5

###### Heading 6

Although heading levels can be skipped (for example, from H1 to H3), this practice is not recommended as skipping heading levels may not represent the proper subheading resulting in confusion to the reader.

Included, since the HTML 3.2 specification, is the ability to align Headings. The ALIGN="left|center|right" attribute was added to the <H1> through <H6> elements, as shown below:

```
<H1 ALIGN=center>This is a centered heading</H1>
```

This code would align a heading of style 1 in the center of the page.

## USING THE <B> TAG TO EMBOLDEN TEXT

The Bold element specifies that the text should be rendered in boldface type, where available (text-based browsers are precluded from these representations). Bold text is usually used to exemplify a point much like italics.

```
The instructions <B>must be read</B> before continuing.
```

would be rendered as :

The instructions **must be read** before continuing.

## USING THE <I> TAG TO ITALICIZE TEXT

Another tag used to manipulate HTML text is the <I> element. The italic element specifies that the text should be rendered in italic font, where available.

Anything between the <I>I elements</I> should be italics.

would render as :

Anything between the *I elements* should be italics.

## USING THE COLOR MODIFIER TO CHANGE TEXT COLOR

There may be times where alternate colors of text may be necessary to distinguish different areas in the document, such as in the transcript of an interview or a screenplay. Utilizing color in an HTML document may occur via two methods. The most difficult to master uses hexadecimal representations in the format rrggbb (r=red, g=green, b=blue) to change the text color. The second, and more simplistic approach, calls the color by name, such as red, green, or blue. Despite which method is used, the <FONT> tag must be used in conjunction with the COLOR attribute to manipulate the text. The following code samples illustrate the use of each method:

```
<FONT COLOR="#FF0000">This text is red.</FONT>
```

or

```
<FONT COLOR="Red">This text is also red.</FONT>
```

These color names can be used for the LINK and VLINK attributes of the <BODY> element as well, where LINK describes the initial color of hyperlink text in the document and VLINK is the color of a visited hyperlink. Use of these attributes are defined in the <HEAD> portion of the document.

## USING THE <STRONG> TAG

The Strong element can be used to indicate strong typographic emphasis and is typically rendered in a bold font. If developing HTML through the use of a text editor, it may be easier to use the <B> tag in place of this tag.

The instructions **<STRONG>**must be read**</STRONG>** before continuing.

would be rendered as :

The instructions **must be read** before continuing.

## FORMATTING TEXT POSITION WITHIN THE HTML DOCUMENT

Another powerful aspect of HTML is its ability to position text in the document to make text stand out or for special emphasis. Examples of this would be centered, right aligned, or left aligned text.

Aligning or formatting HTML elements (alignment is not limited to text only) may be accomplished via different tag or attribute methods. Bear in mind that many HTML tag elements use the ALIGN attribute as an add-on to manipulate the placement of text in the browser window. The short list of these tags include <P>, <H1-6>, <IMG SRC>, and so forth. The ALIGN attribute is used in conjunction with the identifiers LEFT|CENTER|RIGHT in order to format the text. The following code samples demonstrate this. The graphic following the code shows how the resulting code might look in a browser window for each.

```
<P ALIGN=LEFT>Text aligned in to the <B>left</B> of the document
</P>
```

All text within the paragraph will be aligned to the left side of the page layout. This setting is equal to the default <P> element.

```
<P ALIGN=CENTER>Text aligned in to the <B>center</B> of the
document</P>
```

All text within the paragraph will be aligned to the center of the page.

```
<P ALIGN=RIGHT>Text aligned in to the <B>right</B> of the docu-
ment </P>
```

All text within the paragraph will be aligned to the right side of the page layout.

```
<H1 ALIGN=CENTER>Heading text aligned in the center of the
document</H1>

<IMG ALIGN=CENTER SRC="sample.gif">
```

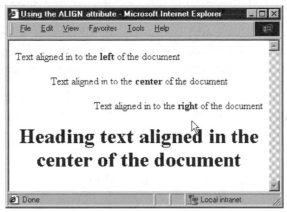

*The multiple alignment options using the ALIGN attribute.*

## CREATING AND USING TABLES WITHIN HTML DOCUMENTS

Tables, though found prior to the HTML 3.2 specification, are relative newcomers to the HTML game. It is easy to get caught up in the notion that tables are only useful for displaying tabular data, such as financial information or even sports scores. For a great amount of time in print media, this was the case for readers exposed to this form of data representation. Tables are a necessary communication format for logical data. For anyone who has ever worked behind the scenes in editing print media, the tabular format is far more a layout adversary than a communication format. Indeed, you would be hard pressed to find many sites on the

Web today that do not utilize the table element as a layout tool. Tables gained popularity over frames early on as many browsers did not support the frames specification (frames are described later in the book).

Both utilization methods of the table are appropriate in Web construction. The basic HTML tag elements of a table are:

**`<TABLE>`** -These HTML tags are the containers for the rest of the table data.

**`<TR>`** -Each row in the table is contained by these tags. You can optionally leave off the closing `</TR>` tag.

**`<TD>`** -Defines a cell. Table data is contained within these tags. You can also nest additional tables within a single cell. You can optionally leave off the closing </TD> tag.

**`<TH>`** -These table header tags are used to define headers, usually in the first row or column of the table. You can optionally leave off the closing </TH> tag.

In addition to the basic tags shown here, some other attributes should be noted:

**BORDER** –By using the BORDER attribute of the <TABLE> tag, borders are put around the table. You set the value of this attribute to the number of pixels wide you want the border, as follows: `BORDER=1`. If you set this attribute to 0, the browser will not display a border.

**ALIGN** –The ALIGN attribute can be specified in the <TABLE> tag with possible values of LEFT, RIGHT, and CENTER (the default is LEFT). HTML 4.0 specifies a new value for ALIGN or CHAR, which implements alignment on a specified character, such as a decimal point.

**Table heads**-In most browsers, table heads enclosed by the <TH> tag are emphasized and centered (see tip 44) .

**Table data**-In most browsers, table data enclosed by the <TD> tag is shown in the normal font and are left justified.

## SETTING A TABLE'S CAPTION

Just as in a document, a table should have a caption to describe the table's function. This provision is made in HTML using the **CAPTION** attribute in conjunction with the <TABLE> element. The **CAPTION** element should be a child of the **TABLE** element, that is, follow

the <TABLE> tag. The **CAPTION** element is a block element and requires a closing tag. The following example uses the **CAPTION** element to provide a brief description for a table:

```
<TABLE>

<CAPTION VALIGN=BOTTOM>

This caption will appear below the table.

</CAPTION>

<TBODY>

<TR>

<TD>

This text is inside the table.

</TD>

</TR>

</TBODY>

</TABLE>
```

How this might look in a browser window is shown below:

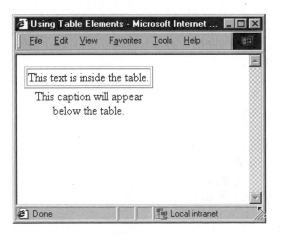

*The resulting table.*

## DEFINING A TABLE'S HEADER

A table header serves a dual role. It may be used as a caption for the table, or it may serve as a definition of the columns that reside underneath, meaning it supersets those columns. The **THEAD** element is a block element and requires a closing tag. Valid tags within the **THEAD** element include:

- <TD>
- <TH>
- <TR >

This example uses the THEAD element with the TABLE, TBODY, TD, and TR objects to create a table with the first row in the table header and the second row in the table body.

```
<TABLE>

<THEAD>

<TR>

<TD>

This text is in the table header.

</TD>

</TR>

</THEAD>

<TBODY>

<TR>

<TD>

This text is in the table body.

</TD>

</TR>
```

```
</TBODY>

</TABLE>
```

How the HTML above might look in a browser is shown below:

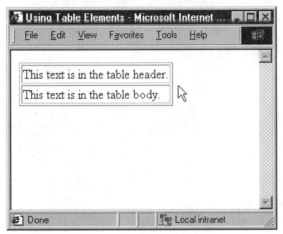

*The output in the browser window.*

## DEFINING A TABLE'S BORDER AND POSITION

There are two HTML elements that affect how a table itself appears in the browser window. The table BORDER attribute defines how the lines are drawn around the table and its cells. This attribute can be used to both control and set the borders to be displayed for the table. If present, then a border will be drawn around all data cells. The exact thickness and display of this default border is at the discretion of individual browsers. If the attribute isn't present, then the border is not displayed, but the table is rendered in the same position as if there were a border (thus allowing room for the border). It can also be given a value, such as BORDER=<value>, which specifies the thickness with which the table border should be displayed. The border value can be set to 0, which regains all the space that the browser has set aside for any borders (as in the case where no border has been set). Additionally, the ALIGN attribute may be used with the TABLE element to position the table to the left, right, or center of the page. The ALIGN attribute may also be used to set the position of the text within individual cells.

 The following text graphic below shows how the BORDER and ALIGN attribute syntaxes are used in HTML and their effect on a table in the browser (the CENTER function is used here and builds off of the markup code used in the previous Tip).

```
<TABLE BORDER=3 ALIGN=CENTER>

<THEAD>

<TR>

<TD>

This text is in the table header.

</TD>

</TR>

</THEAD>

<TBODY>

<TR>

<TD>

This text is in the table body.

</TD>

</TR>

</TBODY>

</TABLE>
```

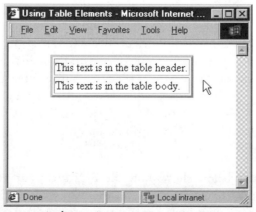

*The above table in the browser window.*

## DEFINING A TABLE'S SCREEN WIDTH AND HEIGHT

Additional formatting of a table may be accomplished using the WIDTH and HEIGHT attributes of the TABLE elements. The WIDTH="value or percent" attribute is used to specify either the exact width of the table in pixels, or the width of the table as a percentage of the browser display window from side-to-side.

The HEIGHT="value or percent" attribute is used to specify either the exact height of the table in pixels, or the height of the table as a percentage of the browser display window. Both of these attributes are particularly useful when using tables in layout and design of a Web page.

Use of the WIDTH and HEIGHT attributes can overcome, for the most part, the problem of trying to size a table for different screen resolutions.

## CREATING ROWS WITHIN A TABLE

The <TR> tag represents the HTML element used to create arrows in a table. This stands for table row. The number of rows in a table is exactly specified by how many <TR> elements are contained within it. The following code displays the <TR> element usage in HTML. Note the number of elements and how this results in the browser window, as shown below:

```
<TABLE>

<TBODY>

<TR>

<TD>

Row 1

</TD>

</TR>

<TR>

<TD>
```

```
Row 2

</TD>

</TR>

<TR>

<TD>

Row 3

</TD>

</TR>

<TR>

<TD>

Row 4

</TD>

</TR>

</TBODY>

</TABLE>
```

*The resulting table output.*

## CREATING A NEW CELL WITH THE <TD> ELEMENT

The <TD> HTML element symbolizes table data and specifies a standard table data cell. Table data cells may only appear within table rows. Each row does not need to have the same number of cells specified as short rows, as each will be padded with blank cells on the right. A cell can contain any of the HTML elements normally present in the body of an HTML document.

<TD ...> can accept the following attributes:

ALIGN="left|center|right"
This attribute controls whether text inside the table cell(s) is aligned to the left, right, or centered within the cell.

VALIGN="top|middle|bottom|baseline"
The VALIGN attribute controls whether text inside the table cell(s) is aligned to the top, bottom, or vertically centered within the cell. It can also specify that all the cells in the row should be vertically aligned to the same baseline.

WIDTH="value or percent"
This attribute can specify either the exact width of the data cell in pixels, or the width of the data cell as a percentage of the table being displayed. Only one data cell can set the width for an entire column, so it is good practice to specify all data cells in the same column as having the same width, if the attribute is set at all.

HEIGHT="value or percent"
This attribute can specify either the exact height of the data cell in pixels, or the height of the data cell as a percentage of the browser display window. Only one data cell can set the height for an entire row.

## CREATING COLUMNS WITH THE <TD> ELEMENT

The HTML element used to create a column in a table is the <TD> tag, which stands for *table data*. The number of columns in a table is exactly specified by how many <TD>elements are contained within it.

The <TD> element can have the following attributes:

ALIGN="left|center|right"
This controls whether text inside the table cell(s) is aligned to the left, right, or center of the cell.

VALIGN="top|middle|bottom|baseline"
This attribute controls whether text inside the table cell(s) is aligned to the top, bottom, or vertically centered within the cell. It can also specify that all the cells in the row should be vertically aligned to the same baseline.

BGCOLOR="#rrggbb|color name"
Internet Explorer and Netscape support use of this attribute (also supported in the<BODY> element). It lets the background colors of the table be specified, using either the specified color names, or a rrggbb hex representation.

The following code sample illustrates how the <TD> tag is utilized to create rows in a table and the result is shown in the graphic following the code.

```
<HTML>

<HEAD>

<TITLE>Column example using the <TD> tag</TITLE>

</HEAD>

<BODY>

<TABLE BORDER=1>

<TR>

<TD>This is the first column in the group.</TD>

<TD>This is the second column in the group.</TD>

<TD>This is the third column in the group.</TD>

</TR>

</TABLE>

</BODY>

</HTML>
```

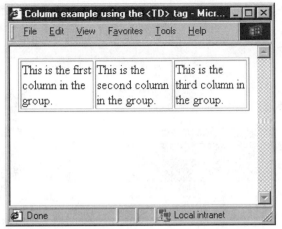

*The table as displayed in the browser window.*

## DISPLAYING A TABLE WITHOUT LINES

As you have already learned, tables may function beyond the simplistic use of displaying tabular data. Tables may also be used as a layout tool. The ability to control the border visibility attribute of a table lets <TABLE> features be used as a layout tool much the way the paper media lays out a magazine or newspaper page. The following screenshots display an example of a Web page that uses this technique and then the same page in Microsoft's FrontPage 2000, where the table elements are visible.

*A Web page using tables in a column format (no table lines are visible).*

*The same page in FrontPage 2000 showing the table grid.*

This design element is widely used to create Web pages that produce consistent results across multiple browsers where framed pages (described later) may not produce the same consistent result.

## USING THE <SUP> TAG TO DISPLAY SUPERSCRIPT TEXT

The Superscript element specifies that the enclosed text should be displayed as a superscript and, if practical, using a smaller font (compared with normal text). This is an HTML 3.0 element and may not be widely supported.

## USING THE NAME ATTRIBUTE TO CREATE IN-DOCUMENT REFERENCES

The NAME attribute is used in conjunction with the <A> (anchor) tag. If present, the NAME attribute lets the anchor be the target of a link (another <A HREF> element). The value of the NAME attribute is an identifier for the anchor. Identifiers are subjective (user defined) strings but must be unique within the HTML document. Also, note that the corresponding string is case sensitive within HTML documents and cannot contain spaces.

Example of use:

```
<A NAME="coffee">Coffee</A> is an example of...
An example of this is <A HREF="#coffee">coffee</A>.
```

Another document can then make a reference explicitly to this anchor by putting the identifier after the address, separated by a hash character:

```
<A HREF="drinks.html#coffee">
```

# USING *HREF* TO ACCESS NAMED DOCUMENT REGIONS

The HREF attribute is used in accompaniment with the <A> anchor element to hyperlink reference either some other section of the document, a supporting document, or to launch a supporting program, such as an e-mail link to launch a mail program. In the case of lengthy documents, the HREF attribute may be used to reference points of interest within the document itself, providing a helpful mechanism for navigating related topics.

To accomplish links within the same document, sections of the document to be accessed via internal document links must have markers that reference the targeted area of text and a hyperlink that calls that internal document link. The NAME attribute is used in conjunction with the HREF attribute along with a #reference marker.

The following code segments illustrate how these links are used in HTML. The graphic following the code shows how the resulting HTML document is laid out.

```
<HTML>

<HEAD>

</HEAD>

<BODY>

Use the <A HREF="document.htm#glossary">glossary</A> to define
terms used in the document.

<H1>HTML Documents</H1>

<H2>What an HTML Document Is</H2>
```

HTML documents are plain-text (also known as ASCII) files that can be created using any text editor (e.g., Emacs or vi on Unix machines; SimpleText on a Macintosh; Notepad on a Windows machine). You can also use word-processing software if you remember to save your document as "text only with line breaks".

```
<H2>HTML Editors</H2>
```

Some WYSIWYG editors are also available (e.g., Claris Home Page or Adobe PageMill, both for Windows and Macintosh). You may wish to try one of them after you learn some of the basics of HTML tagging. WYSIWYG is an acronym for "what you see is what you get"; it means that you design your HTML document visually, as if you were using a word processor, instead of writing the markup tags in a plain-text file and imagining what the resulting page will look like. It is useful to know enough HTML to code a document before you determine the usefulness of a WYSIWYG editor, in case you want to add HTML features that your editor doesn't support.

If you haven't already selected your software, refer to Tom Magliery's online listing of HTML editors (organized by platform) to help you in your search for appropriate software.

```
<H2>Getting Your Files on a Server</H2>
```

If you have access to a Web server at school or work, contact your *Webmaster* (the individual who maintains the server) to see how you can get your files on the Web. If you do not have access to a server at work or school, check to see if your community operates a *FreeNet*, a community-based network that provides free access to the Internet. Lacking a FreeNet, you may need to contact a local Internet provider that will post your files on a server for a fee. (Check your local newspaper for advertisements or check with your Chamber of Commerce for the names of companies.)

```
<A NAME="glossary">Glossary</A>

glossary

glossary

glossary

glossary

glossary

glossary

glossary
```

```
</BODY>

</HTML>
```

The net result in the browser is shown below:

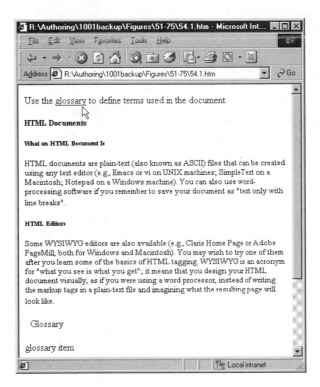

*The screen output.*

## UNDERSTANDING THE <LINK> TAG AND ITS ATTRIBUTES

The <LINK> element indicates a relationship between the document and some other object (for example, a large document may require many links to page between the entire document, such as a doctoral thesis or a novel). A document may have any number of <LINK> elements. The <LINK> element is empty (does not have a closing element) but takes the same attributes as the <ANCHOR> element.

The <LINK> element would typically be used to provide pointers to related indexes or glossaries. Links can also be used to indicate a static tree structure in which the document was authored by pointing to a parent, next, and previous document.

**Most browsers** support the `<LINK>` element and present the user with a toolbar populated with functional buttons for every `<LINK>` element specified. `<LINK  REL"..">` is one of the standard attributes used with this element. It will show the toolbar button with a pre-set graphic, together with whatever text is specified in the **TITLE** attribute, as the text on the button. The remote location, specified in the **HREF** attribute, is the location that the browser will link to when the button is clicked. The following is a list of the possible preset REL attributes that most browsers recognize:

REL="stylesheet". This details the stylesheet to be used for the current page (IE 3.x and higher and Netscape 3.x and higher only).

REL="home". This can be used to link to any page that the browser should consider the homepage of the current site. Mosaic supplies Home if no TITLE attribute is given.

REL="toc"|"contents". This directs users to the table of contents for your site. toc and contents are interchangeable as the REL attribute value and Mosaic supplies ToC if no TITLE attribute is given.

REL="index". This can be used to link to the index of your site. Mosaic supplies Index if no TITLE attribute is given.

REL="glossary". This creates a link to the glossary of your site. Mosaic supplies Glossary if no TITLE attribute is given.

REL="copyright". If your site contains a page detailing copyright attributions, it can be linked to by this REL attribute value. Mosaic supplies Copyright if no TITLE attribute is given.

REL="up"|"parent". This can be used to set the location of the current documents, parent document. For example, your site may conform to a fairly rigid navigation structure, and this attribute value can be used to link the current document to an overview of the current document set. Mosaic supplies Up or Parent if no TITLE is given.

REL="child". This can be used to set the location of the current documents, child document(s). For example, your site may conform to a fairly rigid navigation structure, and this attribute value can be used to link the current document to any of the documents in the level below, for example, from an overview document to a detail document. Mosaic supplies Child if no TITLE is given.

REL="next". As in the above case, this can be used to provide a link to the next document in the current document set. Mosaic supplies Next if no TITLE attribute is given.

REL="previous". This can be used to link to the previous document in the flow of the current document set. Mosaic supplies Previous if no TITLE attribute is given.

REL="last"|"end". This can be used to link to the last document in the current document set. Mosaic supplies End if no TITLE is given.

REL="first". This can be used to link to the first document in the current document set. Mosaic supplies Begin if no TITLE is given.

REL="help". If a site contains a help file (for example, tips on site navigation), then it may be linked to via this attribute setting. The REL attribute may be set to be anything user defined, as well as the above pre-set options.

## USING THE <LINK> TAG

The <LINK> tag syntax, as defined in the last section is used according to the following:

```
<HTML>

<HEAD>

<LINK REL="home"

REL="toc"

REL="index"

REL="glossary"

REL="copyright"

REL="up"

REL="child"

REL="next"

REL="previous"

REL="last"

REL="first"
```

```
REL="help">

<TITLE> Using the LINK HTML Element </TITLE>

</HEAD>

<BODY>

Text, Text, Text, Text, Text, Text, Text, Text, Text, Text,
Text, Text, Text, Text, Text, Text, Text, Text, Text, Text,
Text, Text, Text, Text, Text, Text, Text, Text, Text, Text,
Text, Text, Text.

</BODY>

</HTML>
```

The <LINK> tag may also be used to reference a style sheet (discussed later in the book) in the following format:

```
<HTML>
<HEAD>
<TITLE>Using the LINK tag to Reference a Stylesheet</TITLE>
<LINK REL="stylesheet"
TYPE="text/css"
HREF="../sheets/formal.css"
TITLE="formal">
</HEAD>
<BODY>
Text, Text, Text, Text, Text, Text, Text, Text, Text, Text,
Text, Text, Text, Text, Text, Text, Text, Text, Text, Text,
Text, Text, Text, Text, Text, Text, Text, Text, Text, Text,
Text, Text, Text.

</BODY>
</HTML>
```

## UNDERSTANDING THE <ISINDEX> TAG

Often a Web page may run many physical paper pages in length. To better facilitate finding information within these documents, the <ISINDEX> tag element was created. The <ISINDEX> element tells the HTML Web browser that the document is an index

document, therefore, in addition to reading it, you may use a keyword search. The document can be queried with a keyword search by adding a question mark to the end of the document address, followed by a list of keywords separated by plus signs. The <ISINDEX> element is usually generated automatically by a server. If added manually to an HTML document, the HTML user agent assumes that the server can handle a search on the document. To use the <ISINDEX> element, the server must have a search engine that supports this element.

Netscape browsers take the <ISINDEX> feature a step further, adding the PROMPT attribute. Netscape authors introduced PROMPT so that text, chosen by the author, can be placed before the text input field of the index. This lets any author's chosen message replace the default text, as shown below:

```
This is a searchable index. Please enter keywords.
```

The syntax is:

```
<ISINDEX PROMPT="Some_text_string : ">
```

where Some_text_String represents the text that the user wishes to be displayed before the input box. Another Netscape specific attribute is ACTION. When used in the <ISINDEX> element, it specifies the cgi script or program to which the text string in the input box should be passed, as shown below:

```
<ISINDEX ACTION="searching.cgi">
```

and will pass the text entered into the input box on the page to the cgi script searching. Internet Explorer no longer supports <ISINDEX> from version 4.0, though the browser does support text searching through the Edit menu (then Find).

## USING THE ISINDEX TAG

The <ISINDEX> element indicates that the browser must let the user search an index by entering keywords. This legacy element from early HTML is much less common now that complex form capability is possible. Although it can be placed in other areas of an HTML document, it is usually found in the HEAD section. The following code sample and resulting display demonstrate how the <ISINDEX> tag is used in an HTML document to facilitate searching:

```
<ISINDEX PROMPT="query message">
```

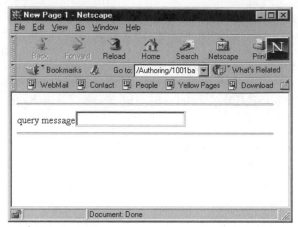

*The output in a Netscape browser.*

## PROBLEMS WITH ISINDEX

There are two key flaws with the <ISINDEX> tag as used in HTML documents. First, the tag is no longer supported under Microsoft browsers from version 4.0 on. Therefore, developers that are creating HTML pages that support cross-browser functionality should refrain from using this element. The second supportability problem with <ISINDEX> is that the actual server from which the page is being loaded must support search capability, for example, some sort of search engine technology, be it via CGI, ISAPI, or a third party application.

Because of the questionable nature of this legacy HTML element, its use should be restricted to those environments where it may be supported wholly.

## USING THE <BLOCKQUOTE> ELEMENT

The <BLOCKQUOTE> element usually indicates content quoted from another source. This block element should be used ideally only when the quotation is long and will likely span several lines (for shorter, in-line quotations, the new <Q> element is suggested.) It is usually rendered with a left indent and possibly an equal right indent as well.

Many authors use this element to indent text because the indenting is standard behavior on most browsers. In theory, you should not use this element for this purpose (it should only be used in situations where you wish to quote a source), but if this type of bulk indenting is truly needed, this element usually works well.

The <BLOCKQUOTE> tag is used in the following manner:

```
<HTML>

<HEAD>

<TITLE>Blockquote Example</TITLE>

</HEAD>

<BODY>

This is normal text aligned to the left of the page. This is
normal text aligned to the left of the page. This is normal text
aligned to the left of the page. This is normal text aligned to
the left of the page. This is normal text aligned to the left of
the page. This is normal text aligned to the left of the page.
This is normal text aligned to the left of the page. This is
normal text aligned to the left of the page.

<BLOCKQUOTE>

Text, Text, Text, Text, Text, Text, Text, Text, Text, Text,
Text, Text, Text, Text, Text. Text, Text, Text, Text, Text,
Text, Text, Text, Text, Text, Text, Text, Text, Text, Text.
Text, Text, Text, Text, Text, Text, Text, Text, Text, Text,
Text, Text, Text, Text, Text. Text, Text, Text, Text, Text,
Text, Text, Text, Text, Text, Text, Text, Text, Text, Text.

</BLOCKQUOTE>

</BODY>

</HTML>
```

The resulting output in the Web browser is shown below:

**63**

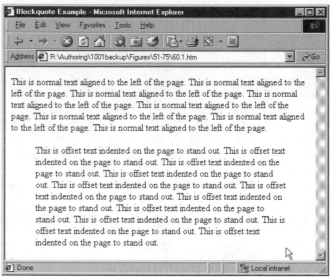

*<BLOCKQUOTE> text displays as an offset paragraph in the browser.*

## ADDING COMMENTS TO AN HTML DOCUMENT

Although HTML is not considered true programmers code, writing HTML follows many of the same principals, rules, and methods. One of the first lessons taught in programming 101 of any language is the practice of commenting code segments so that the author's intention may be readily assessed should the code be read in its native format.

HTML markup pages can become extremely complex, particularly with newer additions to the HTML specification, such as scripting and style sheets or Extensible Markup Language (XML).

Commenting within a code page not only helps other users that need to read the page in its native HTML, it also helps the author to sift through a mass of flat text.

Coding in HTML is accomplished through the use of a special ASCII code sequence, as shown below:

<!— The text within these special brackets are for commenting sections of the document, and these comments are hidden from the browser window—>

Notice the "<!—" sequence at the beginning of the above statement and the "—>" trailing. Use of the closing comment set is crucial as text may be hidden from the browser if this is dropped accidentally.

Commenting is a good habit to start early. For those considering a career as a Web designer, most companies that hire for this type of work will ask for samples and look for comments! The use of comments benefits everyone.

## CREATING AN E-MAIL HYPERLINK

Hyperlinks may be used to launch a variety of programs that are associated with Internet services, including mail. Most modern browsers have a mail program associated with them to facilitate the launching of hyperlinks that call to an e-mail address.

Consider the following example:

```
<HTML>

<HEAD>

<TITLE>A Mailto Hyperlink</TITLE>

</HEAD>

<BODY>
```

For further information regarding this topic, please send an <A HREF="mailto:schwartz@ hypercon.com">E-MAIL</A>. <HR>Please include your name and address information so that we may mail your information right away!

```
</BODY>

</HTML>
```

The result in the browser is a link that, when clicked, will launch an associated mail program (one must be installed first for this to work, such as Eudora and Microsoft's Outlook Express) with the associated e-mail address in the To field.

In a browser, the above code would look like that shown below:

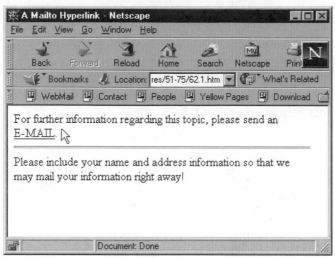

*An e-mail link looks and works just like any other hyperlink.*

## CREATING A LINK TO USENET NEWSGROUPS

There are thousands of newsgroups that exist on Internet news servers. These servers use the NNTP protocol and the conversation threads (messages that are posted along with replies to regarding the original message subject) may be read using a program that support this protocol Free Agent is an excellent choice, as well as Microsoft's Outlook Express, which supports mail protocols POP3 and SMTP, and NNTP. Web pages may want to link out to these Internet news servers as a reference source for the topic of the given page. Many times, a support page for a particular piece of software will use such links to a news server forum whose topic discusses bugs found in the software's code.

To create a hyperlink to a news server resource, the <A> tag must be used with the HREF attribute to call the mail link. The following demonstrates how this is accomplished using HTML:

```
<HTML>

<HEAD>

<TITLE></TITLE>

</HEAD>

<BODY>
```

```
<A HREF="news:alt.software.sun.solaris.7.support.bugs>Please
click here to report bug information on Sun's Solaris 7 operat-
ing system</A>

</BODY>

</HTML>
```

## CREATING A LINK TO FTP FROM A WEB PAGE

It may sometimes be necessary to point a reader to a file that is associated with the document at hand or to an FTP server for a choice of files. The files may be executable programs or other documents, and a link to such files located on an FTP server is accomplished using the <A> tag and the HREF attribute in the following manner:

```
<HTML>

<HEAD>

<TITLE>Netscape's FTP server</TITLE>

</HEAD>

<BODY>

<A HREF="ftp://ftp.netscape.com">Please click here to download
the latest Netscape products</A>

</BODY>

</HTML>
```

## CREATING A LINK TO A GOPHER SITE

Gopher is an Internet protocol that is somewhat dated and seldom used. Many government and educational facilites still use Gopher servers to display Internet information. Gopher servers display a directory tree much like FTP servers and are usually displayed in the browser window. Creating links to a Gopher site is accomplished using the <A HREF="…"> tag and attribute in the following manner:

```
<HTML>

<HEAD>

<TITLE>Our Gopher Site</TITLE>

</HEAD>

<BODY>

<A HREF="gopher:192.168.4.201:8080"> Please use our Gopher site
to download the latest syllabus for this class</A>

</BODY>

</HTML>
```

## REFERENCING A WAIS DATABASE FROM WITHIN A WEB DOCUMENT

Before the arrival of the Web, Wide Area Information Search (WAIS) servers were critical for letting users perform searches for key words in files. WAIS servers may be called from a Web page using the following HTML syntax:

```
<HTML>

<HEAD>

<TITLE></TITLE>

</HEAD>

<BODY>

<A HREF="wais:// www.ncsa.uiuc.edu:8001> Please click here to
search our WAIS server</A>

</BODY>

</HTML>
```

Search mechanisms in place today, such as publicly available sites like Infoseek and Lycos, have made this type of search mechanism obsolete, though it is still sometimes used in legacy environments.

## UNDERSTANDING IMAGE MAPS

The use of graphics in Web pages has revolutionized the way that these pages display graphical media to the end user. Furthering this technology is the use of image maps which let regions of a graphic have URLs associated with them, letting the user select a region of the map and launch some other triggered event, working much the way an <A> reference is used.

The development of image map technology has advanced a lot over the last several revisions of the HTML specification. The first image maps called on the Web server to process regions of the graphic. This technology was unfortunately difficult to use and standards were split between NCSA and CERN type Web servers, which used different formats to perform the same task.

To offload the processing from the server and unify the method used to create image maps, client- side image mapping was developed and set as a standard. These client-side image maps provide a way to define regions on a given graphic and the ability to plug in URL's directly to these regions. The net result is a mapping system that is easier for HTML programmers to use.

## USING THE <MAP> TAG

Image mapping is accomplished using a combination of several HTML tags and attributes. Adding the USEMAP attribute to an <IMG> element indicates that the image is a client-side image map. The USEMAP attribute can be used with the ISMAP attribute to indicate that the image can be processed as either a client-side or server-side image map (useful to ensure browser independence of HTML documents). The value used in the USEMAP attribute specifies the location of the map definition to use with the image, in a format similar to the HREF attribute on anchors. If the argument to USEMAP starts with a #, the map description is assumed to be in the same document as the <IMG> element.

```
Using the <MAP> Tag<IMG SRC="../images/image.gif"
USEMAP="maps.html#map1">
```

This would use the map described as map1 in maps.html as the overlay for the image file image.gif. The map definition (see below) can be included either within the HTML document itself where the image is embedded, or in a separate file.

The different active regions of the image are described using MAP and AREA elements. The map describes each region in the image and indicates the location of the document to be retrieved when the defined area is activated. The basic format for the MAP element is as follows:

```
<MAP NAME="name">
<AREA [SHAPE="shape"] COORDS="x,y,..." [HREF="reference"]
[NOHREF]>
</MAP>
```

## USING THE <AREA> TAG WITH THE SHAPE AND COORDS ATTRIBUTES TO DEFINE MAP HOTSPOTS

The ability to create "hotspots" on an image to facilitate navigability from the image is accomplished through the use of the <AREA> HTML element in conjunction with the SHAPE and COORDS attributes.

The <AREA> tag defines the areas of the image map that will serve as active regions on the image and is further tied into hyperlink references. Used along with the <AREA> tag are the SHAPE and COORDS attributes which define, first, the shape of the hotspot region being created, which may be a circle, square, or polygonal, and then specific coordinates further define these shapes through the use of pixel definitions.

The syntax of these elements might look like this example:

```
<html>

<head>

<title>Celestial Products Corporation</title>

</head>

<body bgcolor="#CDDFC9">
```

```
<p align="center"> </p>

<p align="center"><font face="Arial Black" size="6">Celestial
Products

Corporation</font></p>

<p align="center"> </p>

<p align="center"> </p>

<p align="center">

<map name="FPMap0">

<area href="http://www.celestial.com" shape="rect" coords="13,
18, 141, 59">

<area href="http://www.celestial.com/inv" shape="rect"
coords="45, 68, 441, 107">

<area href="http://www.celestial.com/about" shape="rect"
coords="85, 121, 308, 160">

<area href="http://www.celestial.com/prod" shape="rect"
coords="145, 178, 352, 217">

<area href="http://www.celestial.com/contact" shape="rect"
coords="204, 234, 440, 275">

</map>

<img border="0" src="68.1.jpg" usemap="#FPMap0" width="470"
height="316"></p>

</body>

</html>
```

The map definition is found toward the end of the HTML document. The final document looks like the one shown in the Web browser below. There are five distinct hotspot regions on the image map. Notice the HREF attribute in use for each of the <AREA> regions.

*The final product is a graphical map with hyperlink regions.*

The COORDS attribute gives the co-ordinates of the shape, using image pixels as the units. For a rectangle (SHAPE="RECT"), the COORDS are expressed as left-x,top-y,right-x,bottom-y. For a circle (SHAPE="CIRCLE"), the COORDS are expressed as centre-x, centre-y, radius, and for a polygon (SHAPE="POLY") (an irregular shape), the COORDS are expressed in pairs of coordinates (i.e. x1,y1,x2,y2,x3,y3...) which defines the pixel coordinates of the various points of the polygonal image hotspot.

## USING THE IMAGE MAP WITH A GRAPHIC

An image map would be of little use without the incorporation of an actual image. The image is defined in the HTML document using the <IMG> element in conjunction with the USEMAP attribute, which tells the browser to use the map definitions of the file named in the NAME attribute of the <MAP> element definition.

The <IMG> image tag and image file are usually located after the map coordinates defined by the <MAP> and <AREA> tags. The following HTML segment illustrates the syntax used in defining an image for an image map:

```
<IMG border="0" src="myimage.jpg" usemap="Map1" width="470"
height="316">
```

## CREATING A SIMPLE IMAGE MAP

There are two major elements to creating an image map:

- The map definition
- The image file

The first step in creating an image map is to create or select the actual image, then define it within the HTML document. This is accomplished using the the <IMG> element along with several helper attributes. The definition of the image file would look similar to the following example:

```
<IMG border="0" src="image_map.jpg" usemap="Map1" width="470"
height="316">
```

The BORDER attribute defines the appearance of a hyperlink border around the image. Setting this default to 0 removes this border, which is often considered an eyesore. SRC defines the path to the actual image file and USEMAP calls the actual map definition to use, which has the name called here.

Following the image definition is the map definition file (this may exist anywhere in the document). The <MAP> and <AREA> tags are used to define the hotspots on the image that represent the clickable areas of the map and further produce some action. The following HTML segment represents three defined regions on the image defined above:

```
<map name="Map1">

<area href="http://www.mysite.com" shape="rect" coords="13, 18,
141, 59">

<area href="http://www.mysite.com/me" shape="rect" coords="45,
68, 441, 107">

<area href="http://www.mysite.com/links" shape="rect" coords="85,
121, 308, 160">

</map>
```

## USING IMAGE MAP DEFINITION FILES

In server-side image maps, the actual definitions of the area and coordinates are laid out in a separate file that is located on the Web server itself. When a user clicks an image map on a Web page, the browser determines the coordinates of the graphic (in pixels) that describe where the user clicked. The browser then passes these numbers to the map server program, along with the name of the file that contains the URLs that correspond to these coordinates.

NCSA Imagemap, then, simply accepts the coordinates and looks them up in the database file that defines the hot zones for that image map. When NCSA Imagemap finds those coordinates and their associated URL, it sends a connect to URL command (just as a hypertext link does) that causes your browser to load the appropriate HTML document. To determine which parts of the image map are linked to which URLs, the map server program must have a map definition file at its disposal. This file is generally a text file with the extension MAP, stored somewhere in the CGI-BIN directory for your Web site. Exactly where this file is stored depends on the combination of your Web server and map server. You'll need to consult your server's documentation or your ISP. You can create this file and save it as a standard ASCII text file, with the appropriate extension; fortunately, you probably won't have to.

Just as in client-side mapping, the definition of different shapes is crucial—these shapes correspond to the shapes of the hotspots that overlay the graphic used. Each set of coordinates creates a point on the graphic. The coordinates are expressed in pixels, with each pair of numbers representing the number of pixels to the right and down, respectively, from the top-left corner of your graphic.

The shapes require a different number of points to define them. Rectangles require two points, for example, and polygons require as many points as necessary. The number of points involved is irrelevant. Simply using a map-editing program, the file is automatically created and the map definitions are defined for the server and CGI program.

The map definition file contains lines similar to the following example:

```
rect http://www.server.com/user/first.html 38,38 78,105

rect http://www.server.com/user/second.html 82,38 15,105
```

## TESTING IMAGE MAPS

After an image map is complete, it is important to test the functionality of the map, just as it is important to test the functionality of hyperlinks throughout an HTML document. Most browsers provide a mechanism that changes the cursor image to indicate an active link within an HTML page. Therefore, logic would have it that after the page has loaded in the browser window, moving the mouse quickly over the image should produce a cursor change.

Of course, after it has been determined that the actual links are hot, that is active, each of the links on the map should be tested for integrity. In the case of server-side image mapping, the cursor may not change as the user performs a mouse-over on hot spots in the map. The user may receive an error, typically HTTP 404, Not Found, if an area of the map is clicked that is not associated with a hyperlink (the entire map is "hot"). The next section describes how to resolve such issues.

## USING A DEFAULT LINK TO AVOID IMAGE MAP ERRORS

Image maps may be based on large images that take up half or more of the browser window and consist of dozens of hot zones. In client-side image maps, the user should be able to tell if the link is hot because of the change in the cursor representation. This may not be true for server-side maps which are processed after the user clicks on a region of the image map and the cursor changes over the entire image rather than just in hot zones.

To rectify this, the map definition file may include a link to either a default location or an error page instructing the user to select another region of the map. The default definition is typically the first line of the file and would look similar to the following:

```
default http://www.server.com/user/default.html

rect http://www.server.com/user/first.html 38,38 78,105

rect http://www.server.com/user/second.html 82,38 15,105
```

To prevent such errors from occurring, try and define larger regions around the target area. This will reduce the chances of a user mistakenly clicking outside of a zone.

## PROVIDING USERS WITH A NON-GRAPHICAL ALTERNATIVE TO THE IMAGE MAP

Developing Web pages takes some forethought. Several years ago when browsers lacked sophistication, it was easy to create pages in such a way that content looked the same from one browser to the next. Unfortunately, Internet access methods have not kept up with the current sophistication found on the current HTML specification. Large images are often used in Web pages that may take users connected via analog modems quite some time to download. Therefore, it is considered good manners among users to provide an additional set of text-based hyperlinks under an image map for easy and rapid access to the links provided in the map. The example illustrated below shows the use of this technique:

*A non-graphical alternative to image maps shows good design skills.*

## PRINCIPLES OF GENERIC PAGE DESIGN

The capabilities of many browsers have expanded considerably, modem speeds (thus, download times) are getting faster, and a host of browser supported Active-X controls and JAVA applets are available for supporting a wide range of content options. While these advances are

allowing designers to create unique sites that cater to their target audience, there are many basic design issues affecting functionality and convenience that should always be considered.

## Colors & Backgrounds

The importance of Web site color selections can't be stressed enough. Different monitors and systems display colors at different contrasts. It is very important to make sure the colors used contrast well with one another. Too much contrast can make a page difficult to read. For example, if the background is black, it's better to use a light grey color for your text than it is to use bright white.

## Page Length

Try to keep the physical length of your pages appropriate to your subject matter. A good rule of thumb is to keep your page length under three scrolling screens. That means that when a visitor has hit the Page Down key four times, he or she should reach the end of your page. If, for example, the content of the page developed contains a long story for visitors to read, break the story up into several similar length pages. Provide Previous and Next hyperlinks so that navigating the story will be as easy as turning a page in a book.

## Frames

Frames can be an asset to a site when they're used properly, but used improperly they can frustrate visitors. You should pay attention to links you have to other sites, and use the TARGET="_top" modifier on all outside links so that other sites aren't displayed inside of your Frames.

## Take The Time To Confirm How the Pages Look in the Browser

For your own peace of mind, this is possibly the most important thing you can do. Many types of browsers are available to potential visitors, and they all (without exception) display HTML content differently. Many don't support the more advanced features, like Java, at all.

If you want your pages to look as you expect them to look in all browsers, restrict your use of tables, frames, background images, text color, and the like. You can keep copies of the browsers you want to 'support' on your own computer, then view your pages as you develop your site.

A viable option for solving the browser incompatibility problem is to offer duplicate pages with tables, frames, and so forth, stripped out. Visitors that use out-of-date or poorly equipped browsers can access this alternate site. This means more work up front, but the result is a site that is accessible and readable by all browser types.

**Design Your Pages To Display Optimally For Different System Settings**

Remember that others use different system settings on their own computer than you might use. This is especially true of screen resolutions. Some users will view your page at a resolution of 640 X 480 screen pixels, many at 800 X 600, and a growing number at 1024 X 768 resolution. Besides those settings, visitors can also size their browser window to any size that's comfortable for them.

HTML lets Web browsers automatically format your page for current system resolution and browser window size. To see how the page will look with those settings and sizes, change the resolution and window size as the site is developed. To completely control how pages are displayed, use tables to define the layout. If you choose to use **variable** widths, the width of the Table and the Cells it contains will change **relative to the size of the browser window**. This comes in handy for handling various system resolution settings.

## DISPLAYING TEXT IN LISTS

Just as word processors offer the ability to create lists to structure or organize information, so too does HTML. Lists are created using the markup tags <UL> and <OL>, along with the <LI> tag.

The Ordered List element is used to present a numbered list of items, sorted by sequence or order of importance, and is typically rendered as a numbered list (this is as the discretion of individual browsers). Ordered lists can be nested. An ordered list must begin with the <OL> element, which is immediately followed by a <LI> (list item) element.

*Note:* The browser, when displaying the list, does not sort the list elements. This sorting should be done manually when adding the HTML elements to the desired list text.

## USING THE <OL> TAG TO CREATE ORDERED LISTS

Ordered lists are used to enumerate a set of points that may follow a timeline or order of importance. In the following example, the instructions must be followed in the proper order for the procedure to work properly:

```
<OL>
<LI>Click on the desired file to download.
<LI>In the presented dialog box, enter a name to save the
file with.
```

```
<LI>Click 'OK' to download the file to your local drive.
</OL>
```

- Click on the desired file to download.

- In the presented dialog box, enter a name, with which to save the file.

- Click OK to download the file to your local drive.

## EXTENSIONS TO THE <OL> TAG

The several accompanying attributes to the Ordered List tag may prove useful in creating complex lists, or more, to outlines. The Ordered List element can take the COMPACT attribute, which suggests that a compact rendering be used. That is, the text is fit much more compactly in the browser window to facilitate a better fit of the list from left margin to right margin.

In addition to the COMPACT attribute, the TYPE attribute provides alternative list representatives, where the average ordered list counts 1, 2, 3, and so on. The TYPE attribute lets authors specify whether the list items should be marked with:

(TYPE=A) — Capital letters, A, B, C, and so on.
(TYPE=a) — Small letters, a, b, c, and so on.
(TYPE=I) — Large roman numerals, I, II, III, and so on.
(TYPE=i) — Small roman numerals, i, ii, iii, and so on.
(TYPE=1) — Or the default numbers, 1, 2, 3, and so on.

A set of ordered lists that have been used to structure an outline are shown below.

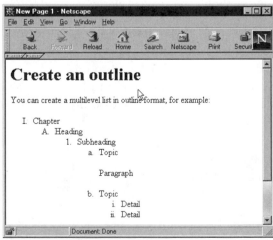

*The ordered list output in a browser for an outline.*

## USING THE <UL> TAG TO CREATE UNORDERED LISTS

The Unordered List element is used to present a list of items, which is typically separated by white space and marked by bullets, though this is at the discretion of individual browsers. An unordered list must begin with the <UL> element, which is immediately followed by a <LI> (list item) element. Unordered lists can be nested as well to produce complex list structures, as shown below:

```
<UL>
<LI>First list item
<LI>Second list item
<LI>Third list item
</UL>
```

The code above would look like this in a browser:

- First list item

- Second list item

- Third list item

## USING THE TYPE EXTENSION TO FORMAT UNORDERED LISTS

Normal ordered lists count 1, 2, 3, and so on by default. The TYPE attribute lets authors specify whether the list items should be marked with:

(TYPE=A) — Capital letters, e.g. A, B, C, and so on.
(TYPE=a) — Small letters, a, b, c, and so on.
(TYPE=I) — Large roman numerals, I, II, III, and so on.
(TYPE=i) — Small roman numerals, i, ii, iii, and so on.
(TYPE=1) — Or the default numbers, 1, 2, 3, and so on.

## CREATING MENU LISTS WITH THE MENU TAG

Menu lists are typically rendered as discrete items on a single line. A menu list is more compact than the rendering of an unordered list. Typically, a menu list will be rendered as a

bulleted list, but this is at the discretion of the browser. A menu list must begin with a <MENU> element, which is immediately followed by a <LI> (list item) element, as shown below:

```
<MENU>
<LI>First item in the list.
<LI>Second item in the list.
<LI>Third item in the list.
</MENU>
```

The code above would render as:

- First item in the list

- Second item in the list

- Third item in the list

## CREATING DEFINITION LISTS

A definition list is a list o f terms and corresponding definitions. Definition lists are typically formatted with the term flush-left and the definition, formatted paragraph style, indented after the term.

An example of a definition list is shown below:

```
<DL>
<DT>&lt;PRE&gt;<DD>Allows for the presentation of
preformatted text.
<DT>&lt;P&gt;<DD>This is used to define paragraph blocks.
</DL>
```

Would render as shown below:

<PRE> — Allows for the presentation of preformatted text.

<P> — This is used to define paragraph blocks.

If the <DT> term does not fit in the <DT> column (one-third of the display area), it may be extended across the page with the <DD> section moved to the next line, or it may be wrapped onto successive lines of the left hand column.

The opening list element must be <DL> and must be immediately followed by the first term (<DT>).

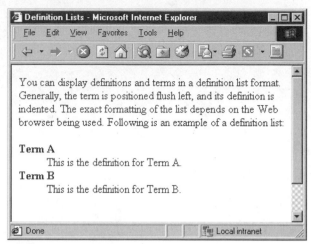

*The browser output for a definition list.*

## CHOOSING BETWEEN THE LIST TYPES

In using HTML to create Web-based documents, it is important to remember that the tools that have been provided in the HTML language and built upon through the years are a reflection of the same technology found in writing tools commonplace today, such as word processors. These tools have been created to reflect all of the proper writing elements found in writing style guides.

When you use an unordered list over an ordered list, and vice versa, may simply be a matter of preference and the elements of style never come into play. On the other hand, when presenting a formal document to users on the Web, an ordered list should be used to portray a list in order of, for example, importance or time, and an unordered list should be used to display a set of thoughts or ideas that need not take a particular order. Using this strategy will help to better drive home supporting points and to organize thoughts to readers.

## COMBINING LIST TYPES

Ordered and unordered lists may be used in conjunction with one another to create ordered lists with unordered elements beneath each of the numbered points. This creates an outline effect that may be used to develop intricate lists and sub-lists. The illustration below shows how this might look in a browser window.

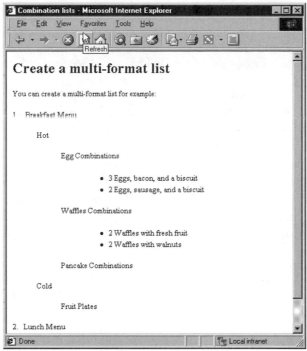

*The browser output for a combination list.*

## MANUALLY FORMATTING LISTS

Ordered lists using the <OL> tag must be manually formatted not only in the order that the list elements appear, but also as far as emphasizing the text represented in each line. Take, for example, a list of fruit that must have bolded text as the ordered elements and alphabetized text representing the items of each group. Each of the list items must be manually formatted as bolded text.

## UNDERSTANDING TABLES

The introduction of tables into the HTML specification represents a milestone for Web page design. As in printed publications, tables represent basic design principle. Tables are used to organize data into rows and columns, providing a design structure for a document. Most of the time in Web pages, where a page is laid out perfectly in columns and rows, resembling a

newspaper page, the underlying technology is an HTML table that is set to have its borders invisible. Beyond layout and design, a table may be used to organize data into structural rows and columns in order to present the data in a tabular way, like a spreadsheet. Until HTML 3.2 was created, tables were not part of the HTML specification.

HTML tables use several elements to provide the net result of a tabular format, much the same way that lists let multiple elements nest other elements. The <TABLE> element represents the parent tag or container for the other supported elements. These tables are composed by row, where a new row begins with the<TR> (table row) tag, and rows are divided into columns with either the <TH> (table header) or <TD> (table data) tags. Think of the <TR> tag as a line break, signaling that the following data starts a new table row. Table headers are generally shown in bold and centered by WWW browsers, and table data is shown in the standard body-text format. Whereas you can think of a row as a line in a table, a cell represents each box within the table.

The basic HTML table tags are as follows:

- **<TABLE></TABLE>** These HTML tags are the containers for the rest of the table.

- **<TR></TR>** Each row in the table is contained by these tags. You can optionally leave off the closing </TR> tag.

- **<TD></TD>** Defines a cell. Table data is contained within these tags. You can also nest additional tables within a single cell. You can optionally leave off the closing </TD> tag.

- **<TH></TH>** These table header tags are used to define headers, usually in the first row or column of the table. You can optionally leave off the closing </TH> tag.

In addition to these basic tags, other attributes may be added to further apply style to the table and table elements:

**BORDER** By using the BORDER attribute of the <TABLE> tag, borders are put around the table. You set the value of this attribute to the number of pixels wide you want the border, as shown here: BORDER=1. If you set this attribute to 0, the browser will not display a border.

**ALIGN** The ALIGN attribute can be specified in the <TABLE> tag with possible values of LEFT, RIGHT, and CENTER (the default is LEFT). HTML 4.0 specifies a new value

for ALIGN of CHAR, which implements alignment on a specified character, such as a decimal point.

## USING ROWSPAN AND COLSPAN WHEN WORKING WITH TABLES

Rows and columns can be spanned, that is, combined with adjacent cells to create larger cells. For example, in a table with five rows and five columns, the first row could be spanned across all five columns to create a banner header for the whole table. In the same table, each of the columns could have elements that spanned multiple rows. It is possible, through spanning, to create rectangular table elements that span both multiple rows and columns, up to the full size of the table.

To span two adjacent cells on a row, use the ROWSPAN attribute with <TH> or <TD>, as follows:

```
<TD ROWSPAN=3>
```

To span two adjacent cells in a column, use the COLSPAN attribute with <TH> or <TD>, as follows:

```
<TD COLSPAN=3>
```

## NESTING TABLES WITHIN TABLES

Part of the practical application of using tables as a layout tool is the ability to nest tables, one within the other, to form complicated structures from which come complicated layouts. The following illustration is an example of a complicated, nested table set that let the author(s) form a page layout that hosts images layered on images.

*The site at www.Egghead.com.*

Notice the complexity of the table structure in the code from the Egghead site:

```
<table width="100%" cellspacing="0" cellpadding="0" border="0">

<tr>

<td align="center" valign="top">

<table width="100%" cellpadding="0" cellspacing="0" border="0"
bgcolor="#FFFFFF">

<tr>

<td align="center">

<!--Start Nav Area-->

<table width="100%" border="0" cellspacing="0" cellpadding="0"
bgcolor="#FFFFFF">

    <tr>

        <td colspan="2"> <img src="http://reno.egghead.com/
afterburner/global/spcr.gif" width="1" height="1" vspace="4"
alt="" border="0"></td>

    </tr>
```

```
    <tr>

        <td colspan="2" align="center">

            <table width="650" border="0"
cellspacing="0" cellpadding="3">

                <tr>

                    <td align="left"><a href="http://
www.egghead.com/bus_center/bus_cent.htm?source=splash_1"><img
src="http://reno.egghead.com/bus_center/business_center.gif"
width="120" height="60" alt="Business Solutions Center" bor-
der="0" hspace="10"></a></td>

                    <td align="left"><a href="http://
www.egghead.com/homepage.htm"><img src="http://reno.egghead.com/
egghead/logo1.gif" width="463" height="60" alt="egghead + Onsale"
border="0"></a></td>

                    <td align="right"><a href="http://
www.egghead.com/promos/digital_cam/
dig_cam_give.htm?source=splash_1"><img src="http://
reno.egghead.com/daily/splash/Web_cam.gif" width="120"
height="60" alt="Win A Web Cam!!" border="1" hspace="10"></
a></td>

                </tr>

            </table>

        </td>

    </tr>

    <tr>

        <td colspan="2" align="center"><img src="http://
reno.egghead.com/egghead/submask.gif" width="706" height="17"
alt="" border="0"></td>

    </tr>

<!- Nav Tabs ->

    <tr>
```

```
        <td align="right"><img src="http://reno.egghead.com/
egghead/welcome.gif" width="350" height="29" alt="" border="0"
USEMAP="#mainnav_left"></td>

        <td align="left"><img src="http://reno.egghead.com/
egghead/default2.gif" width="356" height="29" alt="" border="0"
USEMAP="#mainnav_right"></td>

    </tr>

</table>

<table border="0" width="100%" cellspacing="0" cellpadding="2"
bgcolor="#6633CC">

  <tr>

  <td align="center"><font face="verdana" color="#FFFFFF"
size="1"><b><a href="http://www.egghead.com/helpinfo/
firsttime/about.htm?source=splash_15"
class="catlink">About Us</a>  |  <a
href="http://www.egghead.com/helpinfo/firsttime/
howto.htm?source=splash_16"
class="catlink">New Visitors</
a>  |  <a href="http://www.egghead.com/
cgi-bin/remap.cgi?https:/custserv/
register.htm?source=splash_17" class="catlink">Registration</
a>  |  <a href="http://www.egghead.com/
helpinfo/site_map.htm?source=splash_18"
class="catlink">Site Map</a>  |  <a
href="http://www.egghead.com/cgi-bin/remap.cgi?https:/
custserv/order_lu.htm?source=splash_19"
class="catlink">Order Status</
a>  |  <a HREF="http://www.egghead.com/
helpinfo/help_page.htm?source=splash_20"
class="catlink">Customer Service</
a>  |  <a href="http://www.egghead.com/
magazine/1199/graphicdesign/designer.htm?Source=Splash_21"
class="catlink">Magazine</a>  |  <a
href="http://www.egghead.com/bus_center/
bus_cent.htm?Source=Splash_22"
class="catlink">Business Center</a></b></font></td></tr>

</table>
```

Tables can become very complex and hard to manage, even with WYSIWIG editors. Use care in nesting tables too deeply to prevent getting lost in the structure.

## USING THE CELLPADDING ATTRIBUTE

CELLPADDING is the amount of white space between the borders of the table cell and the actual cell data (whatever is to be displayed in the cell). CELLPADDING defaults to an effective value of 1. CELLPADDING may also be used to omit the space altogether.

In the first illustration below, the CELLPADDING is set to 4, and in the second illustration, the same table is represented with a CELLPADDING value of 1.

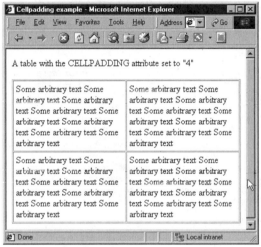

*The cellpadding attribute set to 4.*

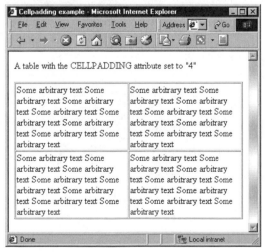

*The cellpadding attribute set to 1.*

## USING THE CELLSPACING ATTRIBUTE

CELLSPACING is the amount of space inserted between individual table data cells. CELLSPACING defaults to an effective value of 2, and 0 represents no spacing between the cells altogether.

Notice the difference in the following illustrations, where the <CELLSPACING> attribute has been set to 4 in the first example and 1 in the second.

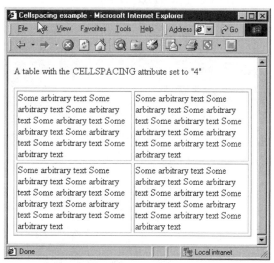

*The table with cellspacing set to 4.*

*The table with cellspacing set to 1.*

## USING LISTS TOGETHER WITH TABLES

Tables may be used creatively with other elements, such as lists, to provide, for example, a hierarchical view of tabular data. Consider the following HTML code and the results, as shown below.

*A combination of tables and lists.*

## INCLUDING GRAPHICS WITHIN TABLES

You have learned about the use of the <TABLE> element as a page layout tool. This is indeed one of the most profound and useful aspects of this tag. Coupled with the use of images, the <TABLE> element becomes a tool for laying out complete user interfaces on the Web and offers a site continuity when these layouts are used for subsequent pages. Consider the following example:

*Adding Graphics to tables.*

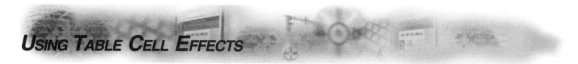

## USING TABLE CELL EFFECTS

One of the more powerful features of tables lies in the fact that each cell in the table may be manipulated individually (this may not be supported across all browsers). This includes the appearance of text, the cell background, and so forth. Consider the following example:

*Multiple cell formatting.*

## USING SPECIAL CHARACTERS FOR MATHEMATICAL EXPRESSIONS

In technical documents, it is often necessary to characterize mathematical expressions, particularly those beyond the +, -, and = characters. Other characters, such as the < less than and > greater than symbols are reserved for the markup tags themselves and cannot be used within text normally. HTML provides a way to integrate those characters that are not readily available on a keyboard or that have special exceptions. For example, it may be necessary to express complex mathematical expressions such as the following:

$3(4x^2 - 5x) + 2=20$

Most of the equation uses standard keyboard characters to generate the expression. However, the 2 raised in the equation requires a special open and close tag set <SUP>.

Beyond raising a numeral, complex equation in physics, you can use extended character sets, such as those found in the Greek alphabet.

### Some of the defined symbols in HTML

| Element | Symbols |
| --- | --- |
| &cent, &pound, &yen | ¢, #, ¥ |
| &deg | ° |
| &frac14, &frac12, &frac34 | 1/2 , 1/3, 3 /4 |
| &divide | ÷ |
| &pi | [Pi] |
| &le, &ge | <> |

## USING OTHER SPECIAL CHARACTERS

HTML 4.0 adds a whole list of new entities, or special symbols, that fall into three categories.

First is a set of international typography symbols that are necessary for creating Web sites that are truly worldwide. Though they aren't used in English, most Western languages couldn't get along without the o with an umlaut.

The second set of new entities are mathematical symbols. Long demanded by scientists and engineers, these new symbols let them put complex formulas inline with regular text. An integral equation is now almost as easy to create and display elegantly as a Shakespeare quote.

The final set of new characters included in the HTML 4.0 specification is a set of special characters that are included in Adobe's Symbol font, like daggers and fancy quotation marks.

## USING THE <ALT> TAG WITH GRAPHICS

The <ALT> attribute is used to display optional text as an alternative to a graphic for situations where rendering in non-graphical browsers or environments may occur. Generally, alternate text should be provided for when there is the possibility that a graphic may not be rendered, for example, if a user has image loading turned off on the browser to speed up access to Web pages. **Internet Explorer** and, **Netscape** (4.0 and above) also use any <ALT> text set as a ToolTip to be displayed when a users mouse pauses over an image. An example of how this attribute works is outlined in the following HTML segment:

```
<IMG SRC="triangle.gif" ALT="Warning:"> Be sure to read these
instructions.
```

## USING THE <ALT> TAG WITH GRAPHICS WITHIN TABLES

Although the current state of the Web and its supporting technologies sustain higher bandwidth and therefore more graphical sites, it may seem trivial to have to support users that do not have the bandwidth for such sites. The facts are, the majority of users that connect to the Internet outside of the corporate realm are users with average computers and average analog connections to the Internet. That being said, HTML makes a provision to add a preloaded textual title to a graphic prior to the actual image loading, which offers the user insight into what the link is.

If a page is being designed with tables as a layout tool, along with many images, the <ALT> attribute of the <IMG> tag is helpful to offer a textual alternative to the end user.

## UNDERSTANDING HTML FRAMES

The concept of frames was introduced at the midway point of the HTML evolution. Frames are a series of HTML pages displayed as individual adjoining frames in the browser. Each of the windows is a separate HTML page displayed simultaneously in the same browser window. The following illustration shows an example of how frames are displayed in the browser window.

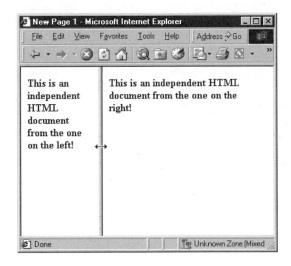

*A basic frame layout.*

Although frames are often over-used in Web site design, they are an extremely useful tool in managing page space. When frames were first introduced in Netscape 2.0, they changed the way in which content could be exhibited. Of course, most of the non-Netscape users were unhappy, as frames would, on occasion, crash their browser and, for the most part, be a major headache.

Since then, all popular browsers have had the ability to display frames. But most frames you see today are boring. As a rule, they have a header at the top, a table of contents at the side, and content in the middle. There are, however, several ways to make frames more interesting, as you will learn in this section.

Over the last few years, there have been some needed improvements to frames. With the introduction of Netscape 3.0 and Internet Explorer 3.0, you can now choose whether or not to have a border. If you do choose to have a border, you can define its width and color. This makes frames more attractive than the old gray frames.

Also, the Back and Forward buttons on newer browsers use Frame History which lets you cycle through the pages you view within the frames. Older browsers used Session History which, when clicking on these buttons, would take you to the page you visited prior to or after the frameset. All in all, frames have come a long way.

A simple use for frames can be putting a logo on a single page within the frameset, rather than on every page. Naturally, using frames to contain a menu or table of contents can be useful, as well. Some of the most compelling uses for frames require scripting. With the addition of a script, you can change multiple frames at one time, completely changing the look of your site in one click. Other items, such as Java applets and ActiveX controls, can be used along with the scripts to make frames even more interesting.

## CREATING A SIMPLE <FRAME> EXAMPLE

Creating a frame's page is simple once the architecture and relationship aspects are understood. Framed pages use a base frame reference page that defines the frame structure and references the other pages that actually provide the content of the frames. Therefore, it is logical to assume that at least three HTML pages must be created to create a framed page. Only the frame definition page is called in the browser window, with the other pages being called by the definition page.

The first page defines the actual frames, their width or height, and a name that references each of the frames. Additionally, each frame references some other HTML source for its content. The following code sample illustrates how a simple two-frame model is executed using HTML:

```
<html>

<head>

<title>Quotes</title>

</head>

<frameset rows="*,*">

    <frame name="top" src="http://quote.yahoo.com">

    <frame name="bottom" src="http://moneycentral.msn.com/
home.asp">
```

```
</frameset>

</html>
```

This example creates a framed page that is divided into two rows. The <FRAMESET> tag pair notifies the browser that the page is framed. The ROWS attribute defines the height of each frame row, using asterisks instead of number definitions for an even distribution between the two. Alternatively, percentages can be used to portion the frames in a direct ratio. If the frame definition is for columns, the COLUMNS attribute will replace ROWS.

Within the <FRAMESET> tags lay the <FRAME> tags, which are given a NAME attribute and a URL using the SRC (source) attribute.

In creating a framed site, the source attributes defined in the <FRAME> tags above will usually reference pages that exist on the local Web server. The figures in the following Tips show how the HTML might look, and the second shows the resulting page in a browser window.

## CREATING AN ADVANCED FRAME EXAMPLE

Frame pages may consist of intricate designs with numerous nested frames. Uses for such complex frame pages include the creation of multifunctional HTML GUI's or e-commerce sites, where many panes of information are necessary.

In the following example, the framed environment uses several frames to display information about the products and services that the company offers. There are a total of four frames, each of which may be called by some other navigable section in the GUI. That is to say, when a category is selected from the product categories section, the frame just to the right of it will display sub-categories, and the frame beneath displays particular items from the sub-categories.

The following HTML code is from the frames page (the page that defines the environment):

```
<html>

<head>

<title>TheShop.com</title>

<meta name="GENERATOR" content="Microsoft FrontPage 4.0">

<meta name="ProgId" content="FrontPage.Editor.Document">
```

```
</head>

<frameset framespacing="0" border="0" cols="*,82%"
frameborder="0">

   <frame name="bottom" src="http://technecom01/frame_demo/
nav.htm" scrolling="auto">

  <frameset rows="*,50%">

    <frameset cols="*,53%">

      <frame scrolling="no" src="product_selection.htm">

      <frame name="2" src="product_catagory.htm">

    </frameset>

              <frame    name="1"    scrolling="auto"
src="product_description.htm">

  </frameset>

  <noframes>

  <body>

  <p>This page uses frames, but your browser doesn't support
them.</p>

  </body>

  </noframes>

</frameset>

</html>
```

## SOME CONSIDERATIONS WHEN USING FRAMES

Frames are a powerful tool for segmenting a Web browser into several functional and inde-
pendent parts. However, even with the majority of modern browsers offering support for

frames, problems still exist. For example, frames may not display in many browsers. Provisions have been incorporated into the frame specification to overcome this problem, though it is considered a patch rather than a fix for cross-browser support. The <NOFRAMES> tag pair lets a text message be displayed by the browser if frames are not supported. From this page, a link may be added to a non-frames version of the site. The HTML is shown below:

```
<noframes>

<body>

 <p>This page uses frames, but your browser doesn't support
them.</p>

</body>

</noframes>
```

The text between the <P> paragraph tags is displayed in browser window to inform the user that the site contains frames, and this browser does not support them. The determination of support is read from the browser header.

Additionally, frames may not look the same across many browsers. For example, many of the frame tag attributes supported in Microsoft's Internet Explorer are not supported in Netscape's Navigator.

Another problem involves how HTML displays frames, which make it difficult for the user to print a page. A user selecting Print from Internet Explorer 4.0 can choose to print either a single page that is laid out in frames, or one selected frame, or each frame individually. From Netscape Navigator, the user can't even select the Print option until a frame has been selected, and the only option is to print that frame's contents.

## FRAMES AS A NAVIGATION TOOL

One of the strongest features of frames is the ability to create a user interface where a navigational toolbar remains throughout the user experience, creating a system whereby the entire site may be navigated by a single frame. The back and forward buttons are not used.

Perhaps the most important attribute in using this setup is the TARGET attribute, which tells the hyperlink to display the link in the frame window named by the TARGET attribute and defined in the frame's page. The frame's page defines both the navigational frame and the main frame.

The navigational frame is named "nav", and the main frame is called "main" as defined in the "NAME" attribute. Navigational links are selected on the left and displayed on the right. Every frame must have a NAME attribute. Without such a reference, other frames cannot link to it.

## USING THE HTML <SCRIPT> TAG

Scripting within HTML documents has come a long way since **Netscape** first introduced JavaScript in **Netscape** version 2.0. The fork in the road between IE and Netscape has taken such a different direction that in **Netscape**, recent JavaScript enhancements make a large proportion of the document content available through scripting, which allows significant display manipulation on the client side, saving slower trips back to servers to update pages. Microsoft has fully embraced and indeed extended scripting in HTML, including JScript and Visual Basic Script in **Internet Explorer**, also adopting various W3C specifications to the point where *everything* that is included in a document, that is, all elements such as tables, text, images and so forth, is available to be manipulated in various ways through either of Microsoft's supported scripting languages.

Scripting for **Internet Explorer** 4.0 exposes *every* element in a document for scripting manipulation, changing its position, color, style, adding or removing elements, and so on. **Netscape** has more limited scripting support, although the most important parts of a document are available for scripting.

To use Visual Basic Script within an HTML document, the code needs to be wrapped in <SCRIPT>...</SCRIPT> elements, just like JavaScript (or contained in a separate text file and referenced using the SRC="URL" attribute). As with JavaScript, the LANGUAGE attribute is required, in this case needing the value VBScript. Visual Basic Script comes into its own when used in conjunction with ActiveX OLE controls, which allow for full automation with any OLE compliant application, but can be used for almost any purpose on a page, allowing for truly interactive Web sites to be created easily.

*Note:* **Internet Explorer** only supports external Visual Basic Script files from 3.02 on. The script file is just a text file, containing the functions of the script required by the document and can have any extension (proper MIME type mapping is required to ensure the correct functionality).

The following code section assigns the action described in the script (a message box pops up when the button is pushed) to the button, named btnHello, which has been embedded within the page. The use of the NAME/VALUE systems to describe objects in the HTML document is referred to as name-value pairs and is also common to many object-oriented programming languages.

```
<SCRIPT                          LANGUAGE="VBScript">
<!- The comment tags are used to ensure that the browser does
not display the actual cod in the browser window
Sub                              btnHello_OnClick
MsgBox                                    "Hello!"
End                                           Sub
-                                              >
</SCRIPT>
```

## POSSIBLE USES FOR THE <SCRIPT> TAG

The use of the <SCRIPT> element is limited only to the limitations of the available scripting languages supported by the browser. In short, most supported languages, such as JAVA, JSCRIPT, and VBSCRIPT, add true programming functionality to the browser, much like those found in their more mature versions, such as C language, C++, and Visual Basic. Browsers that support scripting then let standard programming languages or derivatives be used in conjunction with HTML.

Today's Web pages, with the addition of scripting, allow for an incredible amount of complexity, including true program integration and connections to databases or data warehouses. Real world applications may be ported over to Internet technologies. This has been a popular solution toward moving dated mainframe applications from outdated and expensive hardware and software solutions to multi-tiered client-server platforms.

One of the best examples of this is Microsoft's Terraserver found at the URL *www.terraserver.com*. This site ties in a large database of satellite geographic images with a Web-based front end.

## CONSIDERATIONS WHEN USING SCRIPTS

Scripting is a fairly new technology, having surfaced several years ago with the introduction of JAVA by SUN Corporation. JAVA is an object-oriented programming language that is similar in structure to the C programming language.

One of the main problems in using scripting in an HTML document lies in supportability issues across browsers.

## USING THE HTML <FORM> TAG

Perhaps the biggest advance made in the HTML specification was the introduction of forms and the form element, which introduced user interaction and data gathering abilities to an HTML document. Form elements provide for the inclusion of objects like text boxes, choice lists, and so forth. This added functionality may be the pivotal moment that married the Web and business and has proven invaluable for HTML applications, particularly search engines and database query entry.

A form element alone, that is, the elements that create screen inputs, such as text boxes, are only part of the equation. HTML form elements can be used to easily define the presentation of the form to the user, though the real value behind any form is in what happens behind the scenes when the form is processed by some type of scripting, Active X control, CGI script, or JAVA servlet. For a form to do anything more than send a straight text dump of the form data (including control characters) to an e-mail address, the form data must be passed to one of these types of applications for processing. The following elements are used to create forms:

- <FORM>        A form within a document
- <INPUT>       One input field
- <OPTION>      One option within a Select element
- <SELECT>      A selection from a finite set of options
- <TEXTAREA>    A multi-line input field
- <LABEL>       Active Control Labels

Each variable field is defined by an INPUT, TEXTAREA, or OPTION element and must have a NAME attribute to identify its value in the data returned when the form is submitted.

A simple form for gathering user data is outlined in the following HTML code sample:

```
<H1 ALIGN="center">Comment Form</H1>

<FORM METHOD="POST" ACTION="http://www.myserver.com/
formprocess.cgi">

<CENTER>

Name: <INPUT NAME="name" size="20">

E-mail Address: <INPUT NAME="email" size="20">
```

```
<P>This site is:

<SELECT NAME="Choice">

<OPTION>Extremely Good

<OPTION>Very good

<OPTION>Good

<OPTION>Average

<OPTION>Below Average

<OPTION>Terrible

<OPTION SELECTED>Please select from this list

</SELECT>

<P>Additional comments may be entered here:<BR>

<TEXTAREA NAME="AddComments" ROWS="5" COLS="60">

</TEXTAREA>

<P><INPUT TYPE=SUBMIT> <INPUT TYPE=RESET>

</CENTER>

</FORM>
```

The CGI script formprocess.cgi called in the ACTION attribute of the <FORM> element performs the processing for the data.

## USING THE <ACTION> ATTRIBUTE

In the last section, you learned that form elements are of little use without the backend processing that actually performs some action to the data entered in the form, such as updating a database or generating or appending a text file. The FORM responsible for tying the form to the processing agent is the ACTION attribute. The ACTION attribute calls the client or server-based processing agent which, in turn, acts on the form data.

## USING THE <METHOD> ATTRIBUTE

Another mandatory attribute of the <FORM> element is METHOD. Generally, the METHOD attribute specifies a method of accessing the URL specified in the ACTION attribute and is followed by either GET or POST.

The GET method is typically used for form submission where the use of the form data does not require external processing. For example, with database searches, there is no real processing of the query of the form, that is, the query runs its search through the database and reports the results. However, when the form is used to provide information that is processed, as in an update, to the database, then the POST method should be used.

## UNDERSTANDING THE ROLE OF <FORM> ATTRIBUTES IN INTERACTIVE PROCESSING

The ACTION and METHOD attributes of the <FORM> element play critical roles in form processing. The following steps occur when form data is submitted and the key elements are tied to each step, for clarity, as shown in the first illustration below.

- The form is displayed in the browser window and form elements are displayed according to which of these elements have been specified.

- After form data is entered, the user depresses or clicks an action button.

- Processes the form via the ACTION and METHOD attributes outlined (see the HTML listing shown below in the second illustration).

## USING THE <SELECT> ELEMENT WITH INTERACTIVE PAGES

The <SELECT> element displays a drop-down list box in the browser window, offering a choice for the user to select, and is used in conjunction with the <OPTION> element,

which populates the <SELECT> list box. This is an effective tool for creating survey forms and the like.

## USING THE <OPTION> ELEMENT WITH INTERACTIVE PAGES

The <OPTION> element can only occur within a <SELECT> element. It represents a singular choice and can take the following attributes. The contents of the <OPTION> element are presented to the user to represent the option. It is used as a returned value if the VALUE attribute is not present.

**SELECTED** - Indicates that this option is initially selected.

**VALUE** - When present, indicates the value to be returned if this option is chosen. The returned value defaults to the contents of the <OPTION> element.

**NAME** - The NAME attribute is used to set the name of the <OPTION> element that is sent as the name/value pair when the form is submitted.

## UNDERSTANDING THE <VALUE> ATTRIBUTE

The <VALUE> attribute applies to all of the text-based form elements, such as a text box or listbox, and lets a default value be displayed. This is helpful in coaching users to fill in form fields.

## PUTTING TOGETHER THE INTERACTIVE ELEMENTS

Web-based forms may be complex devices for collecting data or querying databases. It is not uncommon to see all of the form elements used in a Web form. In the Web page shown below, the creator of this page has developed a form for users to enter resume information, using all of the currently defined form elements. Such complex forms are usually indicative of a front end where the data is stored in a complex database behind the scenes.

## SETTING THE MAXIMUM AGE OF YOUR WEB PAGES

One of the unfortunate aspects of the Internet and the Web is that Web technology often outpaces the connectivity technology to the Internet. To provide a smoke and mirrors approach to fixing this problem, browser developers decided to create a cache for the browser itself that would copy certain portions of a Web page to the local hard drive to make it appear that the Web pages were loading faster. This causes a problem for browsers that want to pull pages from cache rather than load a page that may have recently changed. Fortunately, there is a way to expire content on a page, forcing the browser to look for a newer page at the source.

The EXPIRES directive instructs the browser to get an item from the cache, instead of from the Web server, until such time as the content expires. The EXPIRES directive can be set either on the server or by using a <META> tag. If you set it on the server, you can set different expiration values for different items in a page. For example, you can expire an ad GIF immediately, so it always comes from the server, while setting the HTML page expiration date in the future so the next time the page is loaded, the text will come from the cache. See your server software documentation for details on how to set HTTP directives on a per-file basis.

The syntax for setting the EXPIRES directive using the <META> tag is as follows:

```
<META HTTP-EQUIV="expires"

   VALUE="Tue, 23 Jun 1999 01:46:05 GMT">
```

## FORCING THE USER'S BROWSER TO ALWAYS UPDATE THE WEB PAGE

There are two ways to control a browser's cache feature: through the Web page using the META-REFRESH HTML solution, or at the Web server by controlling the HTTP headers for the page.

To control page refresh automatically using HTML, a <META> tag is used in the <HEAD> section of the document in conjunction with the REFRESH option. The following example forces the browser to refresh its contents every time the page is loaded:

```
<html>

<head>

<meta http-equiv="refresh" content="0;url=index.html">

<Title>Auto Content Refresh</title>

</head>
```

The content="0;url=<URL>" section of this <META> tag tells the browser to wait 0 seconds before refreshing and redirects to the given URL (typically the same page). Using this method lets updated contents refresh every time the page is loaded.

This action may also be controlled at the Web server as well. Content managers can use time-sensitive headers to easily set an HTTP header that determines how long a Web page should remain in the client's cache. This is useful for setting a date in time-sensitive material, such as special offers or event announcements. The browser on the client's machine compares the current date to the expiration date to determine whether to display a cached page or request an updated page from the server.

## SPECIAL CONSIDERATIONS WITH HTML FRONT ENDS FOR DATABASES

There are a host of options available to the Web developer when connecting Web front ends to back end databases. Whether the back end be Microsoft's SQL Server, ORACLE, SYBASE, MySQL, and so on, there is a common technology that will allow Web developers access to any and all of these data sources: Open Data Base Connectivity or ODBC. Open Database Connectivity (ODBC) is a widely accepted application-programming interface (API) for database access. It is based on the Call-Level Interface (CLI) specifications from X/Open and ISO/IEC for database APIs and uses Structured Query Language (SQL) as its database access language. Though the topic of ODBC is beyond the scope of this book, there are several excellent resources on this subject available via the Web at *http://www.microsoft.com/data/odbc/*.

You can also try the unofficial ODBC FAQ at *http://www.roth.net/perl/odbc/faq/*.

Using HTML to create Web-based front ends means having a good command of HTML form elements as well as some database knowledge, including the SQL query language.

## UNDERSTANDING *LINK* ATTRIBUTES

You can choose the colors that a Web browser will use for displaying hyperlinks. There are three main attributes that define the way that hyperlink text color appears in the browser, and subsequently, three states for which a hyperlink may exist. You can select three colors to use for a hyperlink, depending on its status:

- **Hyperlink** — a hyperlink that has not been selected.

- **Active hyperlink** — a hyperlink that is currently selected.

- **Visited hyperlink** — a hyperlink that has already been followed.

Web browsers determine whether a hyperlink has been visited already according to a specified time period. For example, in Microsoft Internet Explorer, this time period is the Web browser *history*; you specify how long to keep a history of the pages you have visited, such as 20 days. If you have visited the page within 20 days, the hyperlink status will be *visited hyperlink*. If you have not visited the page in 20 days, or if you clear the history, the hyperlink status will be *hyperlink*. The default coloring of these is: LINK=BLUE (#0000FF), VLINK=PURPLE (#800080), and ALINK=RED (#FF0000). Again, the format for these attributes is the same as that for BGCOLOR and TEXT. Color names are also valid values of this attribute. The following example shows how these attributes are used:

```
<BODY LINK="#rrggbb" VLINK="#rrggbb" ALINK="#rrggbb">
Rest of document goes here
</BODY>
```

## UNDERSTANDING THE *BACKGROUND* ATTRIBUTE

When thinking of an HTML document, it is convenient to consider a blank HTML page as a piece of paper. A document created by hand may be laid out in any manner desired, as in a Web page. Additionally, a written document may be created on any number of paper types, for example, stationary or printed paper. This flexibility also exists in the HTML world through the use of the BACKGROUND property. The background property is contained within the <BODY> element and defines the background as a color, image, or watermark.

Use of the background property is straightforward. The color attribute may be set using the hexadecimal RGB format, as shown in the following example:

```
<BODY BACKGROUND="#rrggbb">
Rest of document goes here
</BODY>
```

## USING THE <CLEAR> ATTRIBUTE TO CONTROL TEXT FLOW

The Line Break element specifies that a new line must be started at the given point. The amount of line space used is dependent on the particular browser, but is generally the same as that used when wrapping a paragraph of text over multiple lines. Normal <BR> still just inserts a line break. To overcome this limitation, the CLEAR attribute was added to the <BR> element. Its usage is as follows:

- CLEAR=LEFT will break the line and move vertically down until you have a clear left margin (i.e. where there are no floating images).

- CLEAR=RIGHT does the same for the right margin.

- CLEAR=ALL moves down until both margins are clear of images.

*Note:* *The CLEAR attribute is currently only supported by* **Netscape** *and the* **Internet Explorer.**

## ADDING MULTIMEDIA SUPPORT TO A WEB PAGE

The HTML language and browsers have moved light years ahead in a relatively short amount of time, taking this communication medium beyond what any other has achieved, creating a cohesiveness of all media types, including print, video, and audio.

Multimedia is often used to define audio and video in a digital format, though Internet and Web technologies are used by multimedia as well. With the Web quickly becoming a contender to other communication mediums, the integration of sound and video into Web pages was an obvious next step.

Sound was the first to come to the Web, with sound bites being added to Web pages and, later, full length audio passages and music. Video followed soon after. In multimedia files and the Internet, multimedia application is not typically supported natively by the Web browser and requires some type of third-party application to \help the browser. This works much the way a mailto hyperlink launches the installed E-mail application associated with Web mail

and carries back to registered MIME types, discussed earlier in the book. To hear or see a particular format, a registered program must exist.

Today, there are literally dozens of supporting programs or Active-X controls that will play a variety of media, including audio clips, the new MP3 audio format, MIDI, AVI and MPEG movie formats, and streaming media, which is played via a TCP or UDP stream rather than downloading the entire file for play. Of course, you will need a sound card to hear the audio formats.

Most multimedia types may be linked from within an HTML document or played inline if there is an associated Active-X control. For more information regarding these and other multimedia technologies, visit *http://www.m2w.net/onlineref.html*.

## SELECTING A MULTIMEDIA FILE TYPE FOR VIDEO

Several video format technologies exist currently, and each has its own set of strengths and weaknesses. The common video file types found on the Web today include:

- QuickTime
- MPEG
- AVI

AVI stands for Audio Video Interleave. It is a special case of the RIFF (Resource Interchange File Format). AVI is defined by Microsoft. It is the most common format for audio/video data on the PC. AVI is an example of a de facto (by fact) standard. In Win16 and Win32, Microsoft created a partially unified system for handling multimedia. This system consists of the high level Media Control Interface or MCI Application Programming Interface (API) and associated MCI drivers. Playback of AVI files can be controlled through the high level MCI API and the MCIAVI.DRV MCI driver.

The Windows Multimedia System also provides a number of low level APIs, such as the WAVE API for waveform audio and associated device drivers, such as the WAVE device drivers for sound cards.

MPEG, pronounced *m-peg*, is short for Moving Picture Experts Group, and is a working group of ISO. The term also refers to the family of digital video compression standards and file formats developed by the group. MPEG generally produces better quality video than competing formats, such as Video for Windows, Indeo, and QuickTime. MPEG files can be decoded by special hardware or by software.

MPEG achieves high compression rate by storing only the changes from one frame to another, instead of each entire frame. The video information is then encoded using a technique called *DCT.* MPEG uses a type of *lossy compression,* since some data is removed. But the diminishment of data is generally imperceptible to the human eye.

There are two major MPEG standards: MPEG-1 and MPEG-2. The most common implementations of the MPEG-1 standard provide a video resolution of 352x240 at 30 frames per second (fps). This produces video quality slightly below the quality of conventional VCR videos.

A newer standard, MPEG-2, offers resolutions of 720x480 and 1280x720 at 60 fps, with full CD-quality audio. This is sufficient for all the major TV standards, including NTSC, and even HDTV. MPEG-2 is used by DVD-ROMs. MPEG-2 can compress a 2-hour video into a few gigabytes. While decompressing an MPEG-2 data stream requires only modest computing power, encoding video in MPEG-2 format requires significantly more processing power.

The ISO standards body is currently working on a new version of MPEG called MPEG-4 (there is no MPEG-3). MPEG-4 will be based on the QuickTime file format.

Quicktime is a video and animation system developed by Apple Computer. QuickTime is built into the Macintosh operating system and is used by most Mac applications that include video or animation. PCs can also run files in QuickTime format, but they require a special QuickTime driver. QuickTime supports most encoding formats, including Cinepak, JPEG, and MPEG. QuickTime is competing with a number of other standards, including AVI and ActiveMovie.

In February 1998, the ISO standards body gave QuickTime a boost by deciding to use it as the basis for the new MPEG-4 standard it is defining.

## PLAYING A SAMPLE AVI FILE

AVI is a standard video format developed by Microsoft and requires an external program to download on to run these files. As of the writing of this book, the latest offering from Microsoft for playing this media format is Windows Media Player version 6.4 (WMP). This program may be found at *www.microsoft.com*. WMP is capable of playing other formats as well, such as MPEG and Real Audio Content.

After a supporting program is installed that supports the AVI format, simply clicking an AVI link in the browser window will launch the application and begin the download process. Once downloaded, the video clip will automatically play.

## USING SOUND ON A WEB PAGE

Adding sound to Web pages may enhance your visit to a Web site. However, there is one thing you need to consider before you go forward. Some users may not be aware that you are loading a sound file and will get a preformatted warning that it is possible to get a virus from a file download. Users new to the Web may not understand that the author's attempt was to enhance the pages' presentation.

Several sound file types exist, though the most common are WAV and MIDI. WAV is the format for storing sound in files developed jointly by Microsoft and IBM. Support for WAV files was originally built into Windows 95, making it the current de facto standard for sound on PCs. WAV sound files end with a *.wav* extension and can be played by nearly all Windows applications that support sound. MIDI, pronounced *"middy,"* is an acronym for *musical instrument digital interface*, a standard adopted by the electronic music industry for controlling devices, such as synthesizers and sound cards that emit music. At minimum, a MIDI representation of a sound includes values for the note's pitch, length, and volume. It can also include additional characteristics. Most synthesizers support the MIDI standard, so sounds created on one synthesizer can be played and manipulated on another synthesizer. Computers that have a MIDI interface can record sounds created by a synthesizer and then manipulate the data to produce new sounds. For example, you can change the key of a composition with a single keystroke.

These files are embedded in a Web page using either the <BGSOUND> tag for Microsoft browsers and <EMBED> for Netscape.

## CREATING A LINK TO A SOUND FILE

There are two HTML tags used for adding sound files to Web pages. The <BGSOUND> tag for Microsoft browsers and <EMBED> for Netscape. These tags let you incorporate sound files into Web pages. The example below shows how these are structured:

```
<EMBED SRC="echoes.mid" width="144" height="60" autostart="false"
loop="true">

<BGSOUND  SRC="echoes.mid"  width="144"  height="60"
autostart="false" loop="true">
```

MIDI file is used to produce background music but a wav or other file type is acceptable as well. The HIDDEN attribute can be set to true or false, false being the default, which means

that the console will be displayed in the size you specify in the height and width attribute. A *false* value will hide the console from viewers. The following list outlines attributes that may be used interchangeably between the two tags:

## AUTOSTART

If the Autostart attribute is set to equal true, the sound file will play after it is downloaded. A good rule of thumb is to set the width and height attributes to 0 and the loop to 1. This way, the sound will play only once and not serve as an annoyance to page viewers that will not have the ability to control playing of the file.

## LOOP

The loop tells the browser how many times to repeat the sound file. It can be set to true or false or to a number. Once again, use good judgment setting this value.

## ALIGNMENT

You can align the placement of your console the same way you align images. This includes the width and height attributes as well as left and right.

Sound files may be linked to from another server or Web page rather than stored on the local server. These files are essentially called, or pulled, from another server. To do this, substitute a full URL to the file.

## PLAYING A SOUND FILE

Sound files may be linked to via a hyperlink in an HTML document. When clicked, the sound file will activate the associated program defined by the MIME type for the particular audio format. Windows Media Player and Real Networks media player are the most common programs used for all media formats, including streaming media, sound files such as WAV and MIDI, and the new MP3 format. The Real Networks product has far broader platform support, including MAC, Windows, and Unix. You don't need to know the format of the audio file, as long as, the installed player is associated with, and supports, the file format.

## INTRODUCING MACROMEDIA SHOCKWAVE

Shockwave is a technology developed by Macromedia, Inc. that enables Web pages to include multimedia objects. To create a shockwave object, you use Macromedia's multimedia authoring tool called *Director,* and then compress the object with a program called

*Afterburner.* Next, you insert a reference to the shocked file in your Web page. To see a Shockwave object, you need the Shockwave plug-in, a program that integrates seamlessly with your Web browser. The plug-in is freely available from Macromedia's Web site as either a Netscape Navigator plug-in or an ActiveX control.

Shockwave supports audio, animation, video, and even processes user actions, such as mouse clicks. It runs on all Windows platforms, as well as, the Macintosh.

## INTRODUCING MACROMEDIA DIRECTOR

Macromedia Director is the standard toolset for creating Internet Shockwave and Flash content, as well as, distributable multimedia on CD-ROMs and DVD-ROMs. Shockwave Player, a plug-in Active-X control necessary for playing Shockwave content, has an incredibly wide distribution base. Shockwave content is considered the de facto standard for Internet multimedia content.

The Director product is actually a suite of products that include tools for creating graphics and sounds and then further assembling these files into movies that display as multimedia presentations for the Web or CD-ROM. The price for this suite is steep, nearly $1,000 U.S., though the product is capable of creating extremely high level and complex multimedia content. For more information on this product and online multimedia examples, visit *www.macromedia.com.*

## ADDING STREAMING MEDIA TO WEB SITES

Streaming media is a technique for transferring data such that it can be processed as a steady and continuous stream. Streaming technologies are becoming increasingly important with the growth of the Internet because most users do not have fast enough access to download large multimedia files quickly. With streaming, the client browser or plug-in can start displaying the data before the entire file has been transmitted.

For streaming to work, the client side receiving the data must be able to collect the data and send it as a steady stream to the application that is processing the data and converting it to sound or pictures. This means that if the streaming client receives the data more quickly than required, it needs to save the excess data in a buffer. If the data doesn't come quickly enough, however, the presentation of the data will not be smooth.

There are a number of competing streaming technologies emerging. For streaming audio and video data on the Internet, the de facto standard is Progressive Network's *RealAudio*. In direct competition is Microsoft's media format, ASX, which provides streaming audio and video like RealAudio RAM format. Other contenders include VivoActive and StreamWorks, though they share considerably less popularity in the market.

To create streaming media for any of these formats, special encoding tools must be used to convert regular media sources, such as voice recordings, Compact Disk, VHS tapes, and so forth. These tools are proprietary to their respective formats and are downloadable from each company's Web site. A video capture card is necessary to input from analog video sources.

## ADDING STREAMING AUDIO

Adding streaming audio to a Web page is accomplished much in the same manner as a hyperlink. A link to a streaming audio file is made via a hyperlink which will launch the streaming media player that is installed on the system, though the file may play inline if the <EMBED> tag is used to display the player as an Active-X control within the Web page.

The following line of HTML code produces a text link labeled Play the Stream Here! that, when clicked, launches the standalone media player. The viewer must click the Play button to hear the *stream.RAM* file. In general, you must have the RealAudio Server software installed and properly configured on a server host before you can use RealAudio content on your Web pages.

```
<A HREF="pnm://audio.realaudio.com/duck.ram">Duck Quacking</A>
```

Streaming audio files must first be processed into a digital format using software provided by a streaming audio player manufacturer (Microsoft ASX and Real Networks formats may be used interchangeably, each format being supported by both players), in addition to, using a sound card. Content that has already been produced by someone else may also be used, though this content is often copyrighted and permission must be granted.

## ADDING STREAMING VIDEO

Streaming video, like streaming audio, may be linked to within an HTML document via the <A> anchor tag or used inline with the <EMBED> tag (see the previous section). The precursor to adding streaming media to a Web page is support from the ISP's Web server that the

pages are hosted on or having a streaming media server available, such as Real Network's Streaming Server or Microsoft's NetShow Theater Server.

## DIFFERENCES IN STREAMING VIDEO IMPLEMENTATIONS

There are definite differences between the two major streaming content software providers, Microsoft and Real Networks. The Real Networks family of products and video production products have been around much longer than their Microsoft counterparts and hence had time to develop and mature.

The Real Networks products offer better error correction and pixelation via their improved codecs which means a better experience for the viewer. In addition to the technology and delivery improvements, the Real Networks server is far easier to implement and configure than the comparable Microsoft product, NetShow Theater Server. This is not to say that the Microsoft product does not deserve merit. Price may also affect the final decision, in which Microsoft ultimately holds the edge in all markets.

## DETERMINING WHETHER YOU NEED A STREAMING VIDEO SERVER

The use of streaming media requires a server that not only supports the MIME format of the streaming files, but also a server that has the ability to serve such content, including support for multicasting (the ability for users to tune in, rather than launch a new instance of the file which takes up resources on the server).

If the intent is to serve up a lot of streaming content and multiple sets of content, then a streaming content server is a must. Examples of this include sites that distribute computer-based training or seminars online. Sites that are based on video media, such as television or video music, are also examples of sites that would need a content server.

## CONSIDERING STREAMING VIDEO COMPRESSION METHODS

Streaming video is produced through the use of a hardware device, a sound card for steaming audio, a video capture card for streaming video, and a software package that translates the

signal (analog or digital) to the acceptable format. This process is referred to as encoding, where the source is converted to the respective digital format.

Part of the encoding process involves setting a compression threshold for the streaming content file which directly affects the quality of the final stream. The major problem with applying too much compression to a streaming file is that the resulting file will display through the media player as chunky or more accurately pixilated.

The use of compression is directly related to two factors: the bandwidth going out to users and the connection that users have to the server. In the case of Internet servers where many users will use analog dial up connections, the compression should be set higher to facilitate these slower links. In the case of an intranet, where users connect at LAN speeds of 10 Mbs to 100 Mbs, compression may be omitted altogether (bear in mind that some compression is added via these types of media, regardless).

## CONSIDERING GRAPHIC IMPLEMENTATIONS ON YOUR WEB SITE

As with any media, the use of visual aids to support text (or audio) content is a powerful way to convey a message. Web images may be used in the background of the page, in the page, as a header to the page, as navigational buttons, and so on. However, there are considerations in using any level of graphics and any of the supported Web image formats. The number of colors, image size (resolution), and image compression are all factors.

The first rule of Web page design is to avoid the use of too many graphics, but if you absolutely have to, use an image type that supports maximum compression while supporting adequate color formatting. The prime candidates for such an implementation are GIF and PNG, which support compression ratios up to 80% and 256 colors.

In many instances, the 256 color barrier must be broken to adequately portray the richness of color found in a photograph or image. To do this, the JPEG format should be used. Caution should be exercised, however, in limiting the size of these images if you are posting them to Web sites on the Internet where bandwidth is an issue.

## UNDERSTANDING THE WEB'S COMMON GRAPHICS FORMATS

Images in use on the Internet today are for the most part, of four varieties: PNG ( Portable Graphics Network), GIF (Graphic Interchange Format), JPEG (Joint Photographers Expert Group). Each has its own distinct advantages, as shown below:

PNG (Portable Network Graphics) is a relatively new file format for portable storage of raster images. PNG is designed to work online with your browser and offers many new options for the Web designer.

GIF supports the most commonly used 256 colors and is a good choice for just about any image in a Web page. It should always be used for scanned text and low-resolution images, such as black and white or line drawings. As an example, you can use the GIF format for navigation buttons.

JPEGs support 16.7 million colors which are useful for photographs, grey scale images, and works of art. Black and white is not served well by the present JPEG format. However, several new compression types are being worked on for these images.

## UNDERSTANDING GIFS

GIF, pronounced *jiff* or *giff* (hard *g*), stands for *graphics interchange format,* a bit-mapped graphics file format used by the World Wide Web, CompuServe, and many BBSs. GIF supports color and various resolutions. It also includes data compression, making it especially effective for scanned photos. GIF images also support transparency (the absence of a background) and animation as well. Because of its compressible abilities, it is the most popular format.

The GIF specification has undergone three revisions, as outlined in the following table:

| Revision | Information |
| --- | --- |
| GIF89a (1/9/95) | This is the latest GIF specification. The specification was modified to add a notice in the Licensing chapter that LZW compression and decompression algorithms are patents owned by Unisys Corporation. The graphical format wasn't modified. |
| GIF89a (7/31/90) | Many extensions were defined, such as Transparent Color, Delay Time for Multiple Image (animation), Comment, and so on. |
| GIF87a (6/15/89) | This was the first GIF specification. |

*GIF specification revision.*

## UNDERSTANDING JPGs

JPG, or JPEG, is short for *Joint Photographic Experts Group,* and pronounced *jay-peg.* JPEG is a *lossy compression* (lossy compression technologies attempt to eliminate redundant or unnecessary information) technique for color images. Although it can reduce file sizes to about 5% of their normal size, some detail is lost in the compression. The JPG format is often used where pictures or graphics require great detail.

## UNDERSTANDING TIFs

TIF (or TIFF) is an acronym for *tagged image file format*, one of the most widely supported file formats for storing bit-mapped images on personal computers (both PCs and Macintosh computers). Other popular formats are BMP and PCX.

TIFF graphics can be any resolution, and they can be black and white, gray-scaled, or color. Files in TIFF format often end with a *.tif* extension.

## UNDERSTANDING PNGs

PNG is short for *Portable Network Graphics,* pronounced *ping,* a new bit-mapped graphics format similar to GIF. In fact, PNG was approved as a standard by the World Wide Web consortium to replace GIF because GIF uses a patented data compression algorithm called LZW. In contrast, PNG is completely patent and license free. The most recent versions of Netscape Navigator and Microsoft Internet Explorer now support PNG.

## UNDERSTANDING TRANSPARENCY

GIF images offer the ability to make transparent the background of an image where the foreground image is displayed with only the frame of the object. From a technical standpoint, a **transparent GIF** is an image that has a certain bit set on one of its color map entries, so that a Web browser's background will show through wherever that color appears in the image. Therefore, every blue bit in a specified range of blue will appear as transparent in a Web page.

## TOOLS YOU CAN USE TO CREATE GRAPHICS

There are literally hundreds of software, shareware, and freeware image creation tools available on the market to create Web-supported graphics. Many of the freeware or shareware programs are adequate though they lack the sophistication of the middle and higher end software packages.

The following is a list of freeware/shareware programs from *www.tucows.com* that are (mostly) freely available:

- Lview Pro
- Ultimate Paint
- Web Painter
- Graphic Workshop

If you are not concerned with high level image productions, these tools should suffice. The manufacturers only charge a nominal fee if you should decide to purchase them. If you are interested in producing complex, multi-layered images and collages, use the middle and upper tier products. These products have the advantage of creating multi-layered images that produce a collage affect and the filters that are used to create or manipulate the image are far more advanced than those found in shareware packages, if they exist at all. The following is a sampling of programs that are considered to be more sophisticated, high end graphics creation manipulation tools:

- Adobe Illustrator
- Adobe Photoshop (image manipulation)
- Paint Shop Pro

- Macromedia Freehand

- Macromedia Fireworks

Of course, the added functionality of these professional grade products comes with a price. Most of these products sell for over $200 U.S. The exception to the rule is Paint Shop Pro which often retails below the $100 U.S. mark. Paint Shop Pro qualifies in the mid to upper range and provides many of the features of its higher priced competitors.

You must also consider the learning curve when buying a graphics program. If you are unfamiliar with graphic tools and graphics creation, you may spend another $50 U.S. on a book to learn how to use the tool. You can try less expensive programs first before sinking big money into a complex program you may never use.

## AVOID 16 MILLION COLOR IMAGES FOR WEB GRAPHICS

One of the factors that contribute to the size of an image, and ultimately the download performance, is the color depth applied to the image at the time of creation. Some image formats, such as GIF, only allow a maximum of 256 colors. Others, such as JPEG, allow up to 24-bit color depth or 24,000,000 colors. Many graphics programs will save this image format by default with a color depth of 16,000,000 colors. While this is advantageous for vivid and realistic color images, such images can take seemingly eons to download over analog connections.

As a rule, try and stay away from this type of color depth, opting for the lower color depth and resolutions to make downloading these images more manageable.

## COMPARING GRAPHICS FORMATS

All of the different image formats have their strengths and weaknesses. On the whole, GIF and PNG images are excellent for rapid graphic loading though they are limited in color depth. TIFF images allow the best of both worlds where color depth and some compression may be utilized. JPEG, on the other hand, allows for a maximum of 5% compression but very rich and realistic color depths.

In all, best judgment should be used when deciding on an image format. When high bandwidth is plentiful, such as on an intranet, JPEGs may work well for all applications though you may end up angering network administrators when bandwidth reports are issued! Web

sites deserve special consideration. For the most part, it must be assumed that the slowest modem speed is the common determining factor, where many times users may be accessing the Internet at 28.8Kbs. GIFs work well in these situations and TIFFs may be acceptable with the proper compression applied.

## USING THE BEST TOOL FOR THE JOB

A recommendation as to which tool is best for the job is really dependent on your comfort level using an array of products. With this disclaimer duly noted, suffice to say you do not need a bulldozer to plant a flowerbed, and often people get in way over their heads when purchasing graphics tools. The more expensive tools tend to come with a serious learning curve in order to master the software's features. The key is to first understand your needs and then decide on the tool for the job. There is nothing wrong with taking on a new and complex product, simply make sure that you are up to the challenge.

Products like Paint Shop Pro offer an intuitive interface and competitive price point that will be attractive to most everyday Web artists. If you need a product with more teeth, the Adobe family of graphics products are the defacto standard for graphic creation, bringing to the table a host of tools that, when used properly, are limited only by imagination.

## USING GIFs WITHIN YOUR WEB PAGES

The most common Web image format is the GIF image and for good reason. The GIF image format is portable and offers a variety of options over other image formats, such as animation and transparency. Using the GIF format in an HTML document provides the author a powerful format where images are rapidly downloaded and loaded into the browser. GIF images also provide a faculty for interlacing where the image is loaded in a series of scan lines. An **interlaced GIF,** instead of being transmitted and displayed top-to-bottom like a normal image, is first displayed at its full size with a very low resolution, then at a higher resolution, until it finally attains a normal appearance. The advantages of the GIF format over JPEG and TIFF are quite evident.

## UNDERSTANDING INTERLACING

GIF graphics files may be tweaked to make it seem as if the images are downloading faster than normal. The .GIF format, in particular, supports a feature called interlacing, which basically keeps track of the odd-numbered and even-numbered scan lines in a picture separately. At download time, all of the odd-numbered scan lines are transmitted first. The result, from the end user's point of view, is that the full image appears on screen in half the time because the image consists of only half the data (every other scan line). However, although it appears faster, it is also blurry. The image will come into focus as the second half (the even-numbered scan lines) of the data is downloaded. In truth, interlacing doesn't shorten the actual time it takes to download the entire .GIF file but because the entire—albeit blurry—image is displayed, the psychological effect is the same as speeding up transmission.

## USING INTERLACED GIFS WITHIN YOUR WEB PAGES

Interlaced GIF images are created using a graphics program that supports this technology and the image is called in the HTML document via the <IMG SRC'"...">  tag. While using interlaced images in a Web page may make the image appear to download faster, this is psychological rather than technical. Interlaced images are used in an HTML document in the following manner:

```
<IMG  SRC="http://www.imagefarm.com/images/cat/business/
ledger.gif>
```

A simple way to increase the apparent speed by which images appear in HTML documents is to use an image more than once. Web browsers cache images after downloading them. When an image is stored on the local hard disk, it is displayed faster on subsequent pages. This is an ideal technique for a company logo, which can (and probably should) appear on every page of a document.

You can also repeat a picture to good advantage by using it as a background pattern or wallpaper motif. You will need to work with the HTML 3.0 specification or later, but given

that requirement, wallpaper is easy to implement. Simply designate a graphics file as part of the <BODY BACKGROUND> HTML tag. Provided that the picture is smaller than the browser's window, the image is automatically tiled. This technique works best when done subtly. The graphic should appear as a lightly tinted watermark, so that it doesn't interfere with the legibility of the text on your page.

## UNDERSTANDING ANIMATED GIFS

While Java, Shockwave, and CGI scripts all let developers add motion to Web pages, animated GIFs have three major advantages over these technologies: they're easy to create, they do not tax the server, and they may be viewed with almost any browser.

Taking several GIF images, known as frames, which differ slightly, marrying them together, and setting a frame rate accomplish the animation effect. Several tools on the market can help you accomplish this task, and most are either freeware or shareware.

Animated GIFs, upon their introduction, were once considered the greatest invention since sliced bread. Because of the numerous Web page creators that give little or no thought to the content or layout of a Web page, that is, those who cannot distinguish between eye candy and eyesore, have severely overused this graphic format, creating virtual three ring circuses on computer screens everywhere.

Animated GIFs work like any other animation where a set of images is placed in sequence to produce motion. Each of the images, or frames, is given a slice of time to give the net result. Animations that are comprised of more frames typically produce more realistic results. The frame rate of these animations is usually higher and the size of the image itself is typically large. Good results may be achieved using fewer images and slower frame rates—this works well for smaller images where the transitions between frames are less noticeable.

## EVALUATING DESIGN ISSUES WITH ANIMATED GIFS

Animated GIFs are relatively easy to create and perhaps in this belies some of the main issues surrounding their overuse. Used strategically, animated GIFs provide a page with motion and excitement. When these animated sprites are used en force, they become overbearing and an eyesore.

Several factors should impact the design of animated GIFs. First, animated GIFs are much larger than single-image GIFs, and therefore, take longer to load. One animated

GIF comprised of five images will take five times longer to load than a single layer of the same image. The same rules of using images and image types in an HTML page apply to animated GIFs as well. That is, size, compression, and so forth. Animated GIFs that are made up of a large number of frames should be scaled down in size for easier loading.

It is important to remember that the same color limits also apply to animated GIFs, the limit being 256 colors. Using images that were originally JPEG format and saved in 16,000,000 colors will not produce the same stunning color effects they once had when converted to GIF format. Using a high level tool, such as Adobe Illustrator or Photoshop, to convert these images first may help produce a better end result.

Finally, as with all animation, the more frames used to produce the animation, the smoother and more realistic the animation looks. Movie quality is 30 frames per second (fps). Try setting out a layout first before creating the animation to determine the number of frames needed, the duration of each frame, and the duration of the animation. This will help to better understand the image sizing and scale and file size.

## CREATING A SIMPLE ANIMATED GIF

While there are a variety of tools available for creating animated GIFs, this book will focus on one of the higher level products, though the concept is pretty much the same across all of the software tools.

Viscosity is a complex and expensive software product made by Jedor, Inc. This tool comes with several embedded utensils and filters that simplify the creation of GIF animations once these tools are mastered. The learning curve is steep with this product, and only the basics are covered in this book. Viscosity goes far beyond a simple GIF animation tool as it offers the ability to edit digitized movie files, as well as, applying affects and transitions to video. Viscosity is available for download through *www.tucows.com* or *www.viscosity.com*.

The following example is provided courtesy of Jedor, Inc.

STEP 1

Click your mouse on File, New to create a new image file. Viscosity, in turn, will display a dialog box. Click your mouse on the Animation icon at the top, type width and height values of 80 and 40 pixels, respectively, and specify the length of the animation to be 8 frames.

STEP 2

Using the Rectangular Selection tool, select a rectangular region on the new image. Before creating the actual selection, you can adjust the roundness of its corners on the Tools Page and anti-alias its edges by enabling the Anti-alias button.

STEP 3

To create the moving light source effect, use the Elliptical Gradient filter and make it appear to move. First, select all the frames on the Animation Reel. Hold down the SHIFT key while clicking to select multiple frames. In the Filter > Render > Elliptical Gradient, configure the gradient to have 3 bands in total, with white, dark green, and black as the colors.

To make the gradient move, enable the Vary Parameters button. This button places the gradient settings on a Start page and an End page. By specifying different start and end states, it will look like the gradient is animated, gradually developing from one state to the other.

On the end page, make the **X Offset 0.65** so that the gradient slides from left to right.

STEP 4

Contract the selection by two pixels by clicking Selection > Modify and using the Contract filter.

STEP 5

Create the inside ring by flipping the contents of the selection (Edit > Flip), then mirroring it (Edit > Mirror).

STEP 6

Repeat steps 4 and 5. Contract the selection another 2 pixels and then flip and mirror it again.

STEP 7

To make the light source reverse directions halfway through the animation, you need to make a copy of the frames, place these copies at the end of the animation, and reverse their order. You can do this by selecting all of the frames, right-dragging them to the end of the Animation Reel, and choosing Copy from the resulting context menu. Then, click Animation > Reverse Frame Order.

STEP 8

Next, add text or a drop shadow to complete the overall effect.

## PLACING THE ANIMATED GIF ON YOUR WEB PAGE

Incorporating animated GIFs in a Web page is accomplished the same way as any other image format. The primary tag is the <IMG> element with the SRC source attribute displaying the path to the file. The following HTML example shows how the HTML is represented in the page:

```
<IMG SRC="/images/ani/myanimation.gif">
```

This example may be used in conjunction with table elements, as well, as list elements to structure the image on the HTML page.

## DESIGN ISSUES RELATING TO GRAPHICS

Graphics are more than just pictures. On the Web, graphics often comprise entire user interfaces much the same as in software packages.

Almost the entire environment consists of graphics framed in a table. The result is a colorful and dynamic experience that draws the eye to the page. The use of balanced colors makes the site fluid and appealing (if you can't see that here, visit the site at *www.eggheadcom*). In fact, this use of colorful images lain out in a table is the most popular format for creating user front ends to Web sites. Balanced color use is a key factor as well. The use of too much color can be unappealing.

The use of graphics to frame the page enhances user navigation while adding allure. In designing a site such as this, it is often helpful to sketch out a diagram of the desired site first and then work from that sketch toward the final result. Decide on the primary colors for the site, usually two colors, and then two to four complementary colors that are used less frequently to enhance the primary colors. While there is browser overhead incurred by creating such graphically intense GUIs, the end result is an attractive site that attracts users and adds navigability. Using small GIFs will help minimize the browser/connection impact.

## EVALUATING THE BENEFITS A GRAPHIC PROVIDES TO YOUR WEB SITE

It has been said that a picture is worth a thousand words. Indeed, you are likely drawn to images on a page before ever reading the text and pictures that sell media in general. Just look at the graphic nature of magazines, the most popular form of print media today.

This idea works just as well in the electronic world. Sites that are comprised primarily of graphics tend to rope a browser in for further exploration.

Even though this book is printed in grayscale, which page is more appealing at first look? Advertisers say that you have approximately three seconds to rope a person in and capture his or her interest. To solidify this theory, think of the times you pick up the remote control to channel surf. A Web page without graphics or a graphical environment will surely be surfed by as well.

## OFFER TEXT-ONLY VERSIONS OF YOUR PAGES FOR USERS WITH SLOW CONNECTIONS

One of the most beneficial services you can offer users to your Web site is a text-only version of the site to rapidly deliver content to their Web browser as an option to heavier graphically laden pages. Text-only versions of a site offer all of the same text content and links that the original version offers, minus the load of graphics.

Text-only versions may be created prior to or after the inclusion of images to the page, though creating the site in a text-only version, and then applying graphics, may be less time consuming. The goal is to offer rapid access to every feature of the site, if possible. Some sites may include many high-level features, such as Active-X controls and Java, that cannot be reproduced via text, this is acceptable. The object is to reduce the graphic content to a level whereby the pages load instantaneously.

The following examples show the same site offered, in a text version and, second, in the original graphics integrated version. Notice how the links between the two sites are the same, retaining navigability for all aspects of the site.

## EVALUATING SIZE CONSIDERATIONS WITH GRAPHICS

Several factors will affect the speed in which graphics on your Web pages download, one of which is the actual size of the file. A well–planned Web site uses graphics formats that download rapidly, as well as, graphics whose size has been optimized for download.

The current trend, in most households and with computer manufacturers, is the acquisition or bundling of image scanners, which lets photos and other images be digitized into a graphics format, such as GIF or JPEG. Another technology that has seen record sales this year is digital cameras which store images digitally rather than using film. One of the main problems with these technologies lies in the size in which pictures are digitized. Scanners usually default to a resolution of 300 dots per inch (dpi) which equates to an image roughly 1280x1040 monitor size. Similarly, digital cameras may store images at a resolution of 1024x768. While many monitors support image displays of these and higher resolutions, in the Web world these images are unsuitable for download over normal dial-up lines.

Keeping image sizes below 72 dpi for scanned images is typically acceptable as is an image resolution of 160x120. Larger image sizes, such as those at 1024x768 stored as a JPEG in 16,000,000 colors, typically carry a file size of approximately 150Kb–175Kb. Over a 56K

dial-up connection, this could take over 5 minutes to download! For sites that are not commercial based, this may be acceptable, but for business sites, this could equate to losing potential users or customers. The best sites carry small portable images or, if larger images are necessary, the image is split into several parts and displayed in a table. The advantage here lies in the fact that most Web servers and browsers today let multiple connections transfer several files at once and thereby decrease download times for the page and graphics on the page.

## EVALUATING NUMBER OF COLORS CONSIDERATIONS WITH GRAPHICS

Another factor that will impact the speed in which graphics download is the number of colors that the image was saved in. For some formats, such as GIF, this is not an issue as the maximum color depth is 256 colors. For other formats, color depth may be as rich as 24,000,000 colors. The problem in saving images to this color depth is directly related to the process involved in creating this color depth. The more color in the image, the more bits it will take to produce the image. More color equals larger file sizes.

Most image programs will let images be saved in a variety of color depths with the exception of those that only support a limited amount of colors. The JPEG format may be saved anywhere from 256 colors up to 16,000,000 (known as true color). The less the number of colors, the less the image renders as realistically colored, though it has a smaller footprint.

## OTHER DESIGN ISSUES ON YOUR WEB PAGE WHICH MAY IMPACT GRAPHICS

The layout of your page may ultimately affect the way that images display. This is particularly true when using tables or frames to frame text and graphics. The screen resolution that was used to develop the page may further impede efforts to create the perfect page.

Graphics may be placed on a page and set in different positions. The ALIGN attribute of the <IMG> tag lets you position graphics on an HTML page or within a frame or table cell in the middle (default), left, right, bottom, or top. Using this attribute will affect the way the image is presented to the browser.

Another set of attributes, VSPACE and HSPACE allow the Web developer the ability to designate a number of pixels as white space or padding around the image so the text is not aligned right next to or on top of the image.

Another factor to consider when placing graphics on the page is using browser supported formats, such as GIF and JPEG. Use of non-supported image types may prompt the user for a supporting program, launch another program, or return an error possibly.

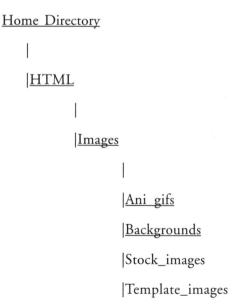

## PLACING GRAPHICS WITHIN YOUR SITE

A Web site should be organized into logical sections, folders, or directories to help the Web developer access or call programs, such as Active X controls, images, and style sheets. A good Web site directory structure accounts for all Web site elements and logically files them away in the appropriate directory or sub-directory.

In the case of images, an images, pictures, or graphics subdirectory under the root directory should be created to hold all of the images contained in the site. Under this directory, you might include subdirectories for animated GIFs, backgrounds, and other specialized graphics that may be grouped together logically. The following is a representative tree structure on a Web server for housing images:

Home Directory

   |

 |HTML

    |

   |Images

      |

     |Ani_gifs

     |Backgrounds

     |Stock_images

     |Template_images

If your ISP will provide support for virtual directories, you may request that the directory be given a virtual name making it easier to call these images. The following is a comparison of calling an image using a straight URL and calling the same image where a virtual directory has been created:

```
<IMG SRC="http://www.myisp.com/~myname/myimages/animatedgifs/
nature/tree.gif>

<IMG SRC="/myimages/animatedgifs/nature/tree.gif">
```

Notice how the image is called directly from the virtual directory "myimages" rather than furnishing the entire URL to the Web server.

## OTHER ISSUES WITH SITE ORGANIZATION

Web sites are much like publications. In print media, a magazine, for example, is divided into logical sections consisting of a table of contents, articles, highlights, features, pictures, and advertisements. Many Web sites consist of the same types of content.

The most important part of the magazine is the structure or framework on which the content lies. The importance is twofold. First, the way that content is laid out throughout the site and on individual pages ropes the reader in and prioritizes what is seen, where, and in what order. This may fluctuate from publication to publication, such as what advertisements are displayed first and in what order.

The other part to organizing media is providing a structure that offers consistency to the overall publication. In print media, this is usually a table of contents. In Web publishing, this is called a Site Map.

Web sites must take a second step in the organization process as physical files make up the body of work. These files must be organized within directories and subdirectories in order to categorize the content into manageable sections.

## ACCESSIBILITY ISSUES WITH GRAPHICS

If you are meticulous about Web development, you will put aside browser biases and testing all work on *at least* the popular 4.0 browsers (and hopefully the 3.0 ones, too). You've probably learned to bend HTML to create a cross-browser site regardless of how complicated the layout may be. Unfortunately, the more you use clever HTML and graphics to control the look of your site, the more inaccessible your pages may be.

Many of the users and agents that visit your site are different from the typical Web surfer. User agents visiting your page, for example, can range from desktop graphical browsers, text browsers, voice browsers, mobile phones, multimedia players, and plug-ins to assisting technologies, such as screen readers and screen magnifiers. Contrary to popular belief, just using <ALT> tags isn't enough for your site to get an A in Accessibility.

As a professional Web builder, you should build a site that transforms effectively regardless of when, where, and how it's viewed. You can still use the latest techniques, but you need to take responsibility for delivering logical and sensible information to as many users as possible. To get started, visit the Web Accessibility Initiative (WAI) so that your site will meet basic accessibility guidelines at *www.wai.org*.

## DETERMINING WHAT SIZE YOU DEVELOP YOUR WEB SITE TO CAN IMPACT CONTENT

A dilemma exists today among Web site creators that will probably not soon be resolved. In monitor resolution, if a Web page or site is developed in one resolution it may not display correctly or as desired in other resolutions.

The use of the horizontal scroll bar is necessary to view all of the page content. Often, in the case of framed pages, this problem is amplified.

## WEB PAGE SIZE WILL IMPACT USERS

In the old days of Web development, it was easy to design a Web page and have it fit into the confines of the average monitor that only supported a maximum resolution of 640x480. Life was indeed good. Then came the bigger and better graphics cards and monitors that supported 800x600, then 1024x768 and so on. One of the biggest problems facing Web developers at the onset of this new technology was the dilemma of creating a homogenous page that would fit into every browser window on every monitor in all resolutions. The temptation has always been to develop for larger resolutions and to develop on systems using higher resolution to take advantage of all of that monitor real estate.

As is the problem with all technology, it is seldom seen where everyone in the word upgrades at the same time and more, so users tend not to upgrade and try and wear out existing technology. In Web pages and screen resolution, developers that had state of the art PCs developed in 800x600 resolution. The net result to the other 70% of the population was a Web page that only displayed 70% of the page in the browser, the remaining 30% to be scrolled from right to left.

This brings up an important concept in Web page design where a page must be developed for the masses, since the Web is made of millions of users, whose technology may vary from browsers to video cards and monitors as well. It is easy to take the approach that if the world cannot keep up, too bad. That's fine if the page is about your pet squirrel Bosco and his trials and tribulations. Chances are you are developing for a finite audience. On a grander scale, where the site may draw hundreds or thousands of visitors, design aspect must be taken into account to accommodate the audience.

For the most part, until it changes, 800x600 has been loosely adopted by Web developers as the standard resolution for a site and the site will not support anything less than that specification. This is acceptable today as most computer systems come standard at this resolution. However, a site devolped on a computer with 1024x768 resolution should be tested on lesser and greater resolutions to find out how the pages might appear to the user community.

## EVALUATING DESIGN ISSUES

It is alleged you never have a second chance to make a first impression, and that the first impression is made within five seconds of meeting. With Web pages, it's faster than that.

What does your first page say about your site? Does it grab your readers and hold them, drawing them deeper into the site? Or does it say and do nothing and drive them away? Does it load quickly, allowing readers to see what's in store immediately? Or does it take several seconds to download, making readers less likely to stay once the page finally arrives? Seven to ten seconds, that's all you have to hook your reader and get them to stay on your site. Even for the faster sites, two to three of those seconds are spent downloading the page. That leaves you four to eight seconds to get your message across and keep readers clicking through your pages.

It is paramount in any media design field to remember that content is king. The same way a builder cannot begin construction of your home until he has the information from an architect, a site designer can't build graphics or Web pages for a site until the content has been clearly defined.

One helpful tip is to map out the site using a flow chart format for organizing content into what is known as a site map. These hierarchical flow charts organize the site's content into groups. This may help when expansion to the site is forthcoming or to determine if the site is optimized for getting to the main part of the site. Suppose, for example, you own a business that sells informational CD-ROMs about bird watching. Your site information might contain the following:

1. Information on relative content
2. An ordering system for buying your CDs

3. Online instructions for using the products
4. Information on sale items
5. A monthly newsletter

From this list, you should determine what information you want your site visitors to find most easily.

First and foremost, since the purpose of being in business is to make money, a quick route to the information about the products being sold must be easy to find. You also want users to visit the site regularly, so a newsletter with a lot of information that changes monthly will help drum up repeat visitors. You also want to cut down on the number of phone calls you get from customers who need to understand how to use your products, so the online instructions for your products should be readily available. These four areas can all be made prominently on your Web site through the use of graphics.

You should also know you users. Knowing who you are writing for is critical to the success of the site. Using pastel colors on a site about the Chicago Bears would probably field some serious spamming from visitors.

Demographic information is also useful. Go out onto the World Wide Web and look through sites that are targeted toward the same audience you are trying to reach. Magazines are another good resource. Notice how print ads are laid out and how colors and fonts are used. Look for the visual cues.

Just as a business plan has a mission statement, so too should a Web page. From this will come all of the design effort. This means not only understanding the message that you are trying to convey, but your audience as well.

Don't downplay the use of white space throughout your Web pages as this can assist the reader in following site concepts. Choosing a proper background color can help set the stage for your information. The addition of graphics can add emphasis or expression to key points. Well-chosen font selection can indicate a change of voice or position.

Spending time on how you present your message not only makes it easier to understand, but indicates to your readers how important the message is to you—and that it might be worth their time to read. All of this helps create a personality for your site.

## DETERMINING HOW MUCH IS TOO MUCH

Maybe you have been to a carnival or circus and felt completely overwhelmed by the amount of activity surrounding you. Flashing lights, abundant noise, stimulation overload is the name of the game. Unless the main goal of your Web site is to confuse, trick, turn-off, or hypnotize the reader, think in terms of Ralph Waldo Emerson, the minimalist, who said "Simplify, simplify, simplify!"

One of the worst design mistakes encountered on the Web, and often the most frequent, is cramming too much information onto a single page or, worse still, the overuse of animations or graphics. The carnival environment may sit well for pre-adolescent teens who like the flash and trash to impress their friends, but in the real world this approach often leads to a quick change of the channel (the site is surfed on by).

The following list suggests a basis for friendly Web pages:

1. Use a color scheme where complimentary colors are used.
2. Use images in moderation.
3. Use animations only sporadically to attract attention.
4. Create pages that are easy to navigate from one to the next.
5. Complimentary images should only be large enough to convey the message, not shout it.
6. Span information across many pages rather than trying to fit it all on a single page.

## CONSIDERING THE COMPOSITION OF THE PAGE AS A WHOLE

A good starting point for Web designers is learning the lay of the land, or the Web page, as the case may be. Layout and design are key elements to creating an appealing site that draws in visitors. The composition of a page may have as much affect on the end user as the color or graphics used.

# WEB SITE CONSTRUCTION TIPS & TRICKS

It is always a good idea to have a plan for your Web page prior to actually creating it. This will ensure not only that the site was well thought out, it will avoid having to redo work if the layout does not come out quite the way you planned.

The two vehicles for dividing up pages into true layouts are frames and tables. For ease of use and better layout functionality, use tables to create your pages.

## DETERMINING HOW MANY DIFFERENT TYPES OF ELEMENTS TO USE WITHIN A PAGE

One major design question you should determine prior to creating a site is what content you consider important to convey your message. Your answer will help tailor the content on the site and help prevent what is known as content overrun. Content overrun can mean simply that too many elements crowd the page, making it difficult for the reader to assimilate the message of the site or navigate around the site. The result of such content usually loses the attention of the reader.

Two main elements are typically standard on any site: HTML and images. There is little that cannot be accomplished using these two building elements. That is not to say that using too much of an item may be obtrusive to the eye as is a poor layout. An effective balance of these two elements encapsulated in an HTML table structure is a sure bet toward attractive page design.

There are also elements that should be used conservatively in order to avoid the carnival effect, predominately animations. Overuse of these elements will draw in visitors for a quick look but ultimately their eye will move on to a page that is less cumbersome to the eye.

A solid balance of images and text used in conjunction with a small number of animations and multimedia effects will serve you well in your endeavor to capture the roaming eye of Web surfers everywhere.

## REUSE ELEMENTS WHERE POSSIBLE

Rapid design and implementation reaps rewards regardless of whether you are a professional Web designer or a weekend warrior. The use of reusable elements, or even generating templates for the site, can cut time to production in half or more. Creating a framework that will be used to create all pages in a site not only provides rapid production, this method also provides a consistent look, and feel throughout the site.

Elements that may be reused in an HTML document include base tag elements and text, graphics, style sheets (discussed later), and programming code such as Java and Visual Basic. These different elements may be saved as plain text and simply interjected where necessary, though some HTML editors provide a provision for creating reusable templates and code snippets.

## NOT ALL BROWSERS ARE CREATED EQUAL

In a utopian society, you would never have to worry about what screwdriver to use as all screws would be of the same type and head design. Until that day, you must tolerate incompatibility issues on a daily basis. From batteries to brakes to browsers, there are always competing forces coming out with a new or better way to invent the wheel. In the case of Web browsers this could not be more true.

There are a myriad of issues that exist in creating Web pages that work across all browsers, particularly in the case of adding Web code such as Java. Formatting issues are as abundant. Typically, a Web developer must return to the days of basic HTML in order for all elements of the page to work across all browsers.

An example of this is found in the way that the two major browsers on the market, Netscape's Navigator and Microsoft's Internet Explorer, display table layouts in the document window. Microsoft's IE 3.0 and later supports a TOP MARGIN attribute of value 0 for Web pages in the HEAD section of the document. The result of using this formatting mechanism is text or graphics which butt up to the top of the document window. The Netscape product also supports this tag, though the end result is different. A small space of about 1-2 pixels is introduced between the edge of the browser window and the beginning of the document. This may seem inconsequential, however, if the need is for a graphic, such as a navigational tool bar, to lay flush with the top margin this 1-2 pixel variation fails to produce the desired result. The figure below shows an example of this in both Netscape and Microsoft's browsers.

## EXAMINING THE IMPORTANCE OF CROSS-BROWSER FUNCTIONALITY

In the World Wide Web today, there is a constant struggle for power to dominate the current and emerging technologies that make up the Internet and the Web. One of the fiercest battles to date involves the battle to be king of the Web browser market. The two major players are Microsoft and Netscape (AOL) of which each owns about 50% of the market today more or less.

These two dominant and competing browsers often make Web development cumbersome as neither one offers 100% support for features of the other. The result is that pages developed and tested in one browser may not work properly or as expected in the competing browser. Other than competing browsers, the version of the browser must also be taken into consideration. Older browsers comprise much of the market and these browsers do not support newer features such as frames (very old versions such as IE and Netscape 2.0) or programming languages such as Java or VBScript. This brings up another point as well, the fact that Java is a Web programming language supported industry-wide whereas VBScript is supported natively only by IE version 3.01 and later. Thus, there are a myriad of considerations when developing in such an unsure environment as the Internet. Often the best approach is to take the least common denominator approach where the content is developed for older versions of browsers and adheres strict HTML version specifications.

Cross-browser development is a critical aspect of Web development unless the site being developed is in a controlled environment where standards are set for browser types and versions (for example, a corporate intranet). By not taking into account the potential use of numerous browser types, you are effectively eliminating potential users of the sites that use older browsers to surf the Internet.

Where to make the cutoff is entirely up to the developer. Many may decide that backward compatibility is not an option where sites that want to embrace all walks of users, such as e-commerce sites, will opt for such compatibility.

## ALL-BROWSER SUPPORT RESULTS IN LOWEST-COMMON DENOMINATOR PRESENTATION

Understanding how to make your Web pages conform to all browser specifications involves understanding what each browser and browser level supports. To keep up with the ever growing myriad of browsers (AOL, Netscape, Internet Explorer, and so on) would be cumbersome. Instead, you might want to take an approach of using the least common denominator where pages are developed using older standards that are sure to work across all browsers. Creating a Web site focused on the Lowest-Common-Denominator (LCD) approach means the site will not use any of the newer HTML developments, such as scripting or frames, or rely on embedded applets. The end result is just information simply presented but well structured. HTML 2.0 is a good starting point, including the use of tables, as well as, part of the LCD.

After you have set up an HTML 2.0 version of your pages, you can start adding some visual features that let newer browsers utilize some of their functionality. This can easily be done in a compatible manner with, for example, the <FONT> element, for affecting the color and typeface of the text, and the <TABLE> element, for helping fine-tune the layout of the page.

And, of course, you can use the <IMG> element, but remember that some surfers still use text-mode browsers, so, if you want to make your pages backward compatible, be careful how you utilize this element.

## UNDERSTANDING HTTP——THE WEB'S NATIVE PROTOCOL

*HTTP* stands for **Hypertext Transfer Protocol**. It is the network protocol used to deliver virtually all files and other data (collectively called *resources*) on the World Wide Web, whether they are HTML files, images, query results, script output, or anything else. Typically, *HTTP* occurs on top of TCP/IP sockets. TCP/IP is the standard protocol used for Internet communication. *HTTP* communication is two-way and follows the client-server model.

*HTTP* communication is stateless, meaning that the communication is not permanent or semi-permanent, rather it is an open-close form of communication where a connection is established, data transferred, and the connection is closed. A Web browser is an *HTTP client* because it sends requests to an *HTTP server* (Web server), which then sends responses back to the client. The standard (and default) port for *HTTP* servers to listen on is 80, though they can use any port.

*HTTP* is used to transmit *resources*, not just files. The most common kind of resource is a file, but a resource may also be a dynamically-generated query result, the output of a CGI script, a document that is available in several languages, and so on.

Like most network protocols, *HTTP* uses the client-server model: An *HTTP client* opens a connection and sends a *request message* to an *HTTP server*; the server then returns a *response message*, usually containing the resource that was requested. After delivering the response, the server closes the connection (making *HTTP* a *stateless* protocol, not maintaining any connection information between transactions).

## UNDERSTANDING MULTI-PURPOSE INTERNET MAIL EXTENSIONS (MIME)

MIME types are found in the header fields of the HTTP transaction and help the client to discern by what type of data is being received. These MIME types are defined in the Internet draft Request for Comments (RFC) 1521 found on the Web at *www.cis.ohio-state.edu/htbin/rfc/rfc1521.html*.

The Content-Type: header of the HTTP message from the Web server is responsible for relaying this information to the client. If the MIME type is supported (natively) by the client

(browser) then the content is displayed in the browser window. MIME types natively supported by most browsers include text and image types and their respective subtypes, such as HTML in the case of text type, and GIF in the case of image type.

In the case of multiple part messages, in which one or more different sets of data are combined in a single body, a multipart Content-Type field must appear in the entity's header. The body must then contain one or more body parts, each preceded by an encapsulation boundary, and the last one followed by a closing boundary. Each part starts with an encapsulation boundary, and then contains a body part consisting of header area, a blank line, and a body area. Thus, a body part is similar to an RFC 822 message in syntax but different in meaning.

A body part is not to be interpreted as actually being an RFC 822 message (that is, part of the header communication). To begin with, no header fields are actually required in body parts. A body part that starts with a blank line, therefore, is allowed and is a body part for which all default values are to be assumed. In such a case, the absence of a Content-Type header field implies that the encapsulation is plain US-ASCII text.

The only header fields that have defined meaning for body parts are those the names of which begin with "Content-". All other header fields are generally to be ignored in body parts. Although they should generally be retained in mail processing, they may be discarded by gateways, if necessary. Such other fields are permitted to appear in body parts but should not be depended on. "X-" fields may be created for experimental or private purposes, with the recognition that the information they contain may be lost at some gateways.

As you have learned, each body part is preceded by an encapsulation boundary. The encapsulation boundary must not appear inside any of the encapsulated parts. Thus, it is crucial that the composing agent be able to choose and specify the unique boundary that will separate the parts.

All present and future subtypes of the multipart type must use an identical syntax. Subtypes may differ in their semantics, and may impose additional restrictions on syntax but must conform to the required syntax for the multipart type. This requirement ensures that all conformant user agents will at least be able to recognize and separate the parts of any multipart entity, even of an unrecognized subtype.

As stated in the definition of the Content-Transfer-Encoding field, no encoding other than 7bit, 8bit, or binary is permitted for entities of type multipart. The multipart delimiters and header fields are always 7-bit ASCII in any case, and data within the body parts can be encoded on a part-by-part basis, with Content-Transfer-Encoding fields for each appropriate body part.

## CONSIDERING MIME TYPES AND SUB-TYPES

There are seven standard initial predefined Content-Types passed in the HTTP header. The following information is excerpted from RFC 1432:

**Text:** Textual information. The primary subtype, plain, indicates plain (unformatted) text. No special software is required to get the full meaning of the text, aside from support for the indicated character set. Subtypes are to be used for enriched text in forms where application software may enhance the appearance of the text, but such software must not be required in order to get the general idea of the content. Possible subtypes thus include any readable word processor format. A simple and portable subtype, richtext, is defined in this document.

**Multipart:** Data consisting of multiple parts of independent data types. Four initial subtypes are defined, including the primary mixed subtype, alternative for representing the same data in multiple formats, parallel for parts intended to be viewed simultaneously, and digest for multipart entities in which each part is of type message.

**Message:** An encapsulated message. A body of Content-Type message is itself a fully formatted RFC 822 conformant message, which may contain its own different Content-Type header field. The primary subtype is rfc822. The partial subtype is defined for partial messages, to permit the fragmented transmission of bodies that are thought to be too large to be passed through mail transport facilities. Another subtype, External-body, is defined for specifying large bodies by reference to an external data source.

**Image:** Image data. Image requires a display device (such as a graphical display, a printer, or a FAX machine) to view the information. Initial subtypes are defined for two widely-used image formats, JPEG and GIF.

**Audio:** Audio data, with initial subtype basic. Audio requires an audio output device (such as a speaker or a telephone) to display the contents.

**Video:** Video data. Video requires the capability to display moving images, typically including specialized hardware and software. The initial subtype is mpeg.

**Application:** Typically some other kind of data than the aforementioned types, usually either uninterpreted binary data or information to be processed by a mail-based application. The primary subtype, octet-stream, is used uninterpreted binary data, in which case the simplest recommended action is to offer to write the information into a file for the user. The most common example of this is found when downloading a binary executable from a site.

Two additional subtypes, ODA and PostScript, are defined for transporting ODA and PostScript documents in bodies while other expected uses for application include spreadsheets, data for mail-based scheduling systems, and languages for active (computational) e-mail.

Default RFC 822 messages are typed by this protocol as plain text in the US-ASCII character set, which can be explicitly specified as **Content-type: text/plain; charset=us-ascii**. If no Content-Type is specified, either by error or by an older user agent, this default is assumed. In the presence of a MIME-Version header field, a receiving User Agent can also assume that plain US-ASCII text was the sender's intent. In the absence of a MIME-Version specification, plain US-ASCII text must still be assumed.

## UNDERSTANDING THE COMMUNICATIONS HTTP PERFORMS

HTTP communication is stateless, where the client makes a request, the server responds, data is transferred, and the connection is closed. The formats of the request and response messages are similar, and English-oriented. Both types of messages consist of:

- an initial line
- zero or more header lines
- a blank line (a CRLF [Carriage Return/Line Feed ] by itself)
- an optional message body (a file, or query data, or query output)

Put another way, the format of an HTTP message is:

```
<initial line, different for request vs. response>

Header1: value1

Header2: value2

Header3: value3

<optional message body goes here, like file contents or query
data; it can be many lines long, or even binary data $&*%@!^$>
```

Initial lines and headers should end in CRLF, though you should gracefully handle lines ending in just LF. (More exactly, CR and LF mean ASCII values 13 and 10, even though some platforms may use different characters.)

**The Initial Request Line**

The initial line is different for the request than for the response. A request line has three parts, separated by spaces: a *method* name, the local path of the requested resource, and the version of HTTP being used. A typical request line is:

```
GET /path/to/file/index.html HTTP/1.0
```

GET is the most common *HTTP* method. It says, give me this resource. Other methods include POST and HEAD, which will be discussed later. Method names are always uppercase.

The path is the part of the URL after the host name, also called the *request URI* (a URI is like a URL, but more general).

The *HTTP* version always takes the form *HTTP*/x.x, uppercase.

**Initial Response Line (Status Line)**

The initial response line, called the *status line*, also has three parts separated by spaces: the HTTP version, a *response status code* that gives the result of the request, and an English *reason phrase* describing the status code. Typical status lines are:

```
HTTP/1.0 200 OK
```

or

```
HTTP/1.0 404 Not Found
```

The following describes the *HTTP* lines:

- The *HTTP* version is in the same format as in the request line, *HTTP/x.x*.

- The status code is meant to be computer-readable. The reason phrase is meant to be human-readable, and may vary.

- The status code is a three-digit integer, and the first digit identifies the general category of response:

- **1xx** indicates an informational message only

- **2xx** indicates success of some kind

- **3xx** redirects the client to another URL

- **4xx** indicates an error on the client's part

- **5xx** indicates an error on the server's part

The most common status codes are:

**200 OK.** The request succeeded, and the resulting resource (file or script output) is returned in the message body.

**404 Not Found .** The requested resource doesn't exist.

**301 Moved Permanently.** Source has moved.

**500 Internal Server Error.** An unexpected server error. The most common cause is a server-side script that has bad syntax, fails, or otherwise can't run correctly.

### Header Lines

Header lines provide information about the request or response, or about the object sent in the message body.

- As noted above, they should end in CRLF, but you should handle LF correctly.

- The header name is not case-sensitive (though the value may be).

- Any number of spaces or tabs may be between the ":" and the value.

- Header lines beginning with a space or tab are actually part of the previous header line, folded into multiple lines for easy reading.

Thus, the following two headers are equivalent:

```
Header1: some-long-value-1a, some-long-value-1b

Header1:    some-long-value-1a,

            some-long-value-1b
```

These headers help Webmasters troubleshoot problems. They also reveal information about the user. When you decide which headers to include, you must balance the Webmasters' logging needs against your users' needs for privacy.

### The Message Body

An HTTP message may have a body of data sent after the header lines. In a response, this is where the requested resource is returned to the client (the most common use of the message body), or perhaps explanatory text if there's an error. In a request, this is where user-entered data or uploaded files are sent to the server.

If an HTTP message includes a body, there are usually header lines in the message that describe the body. In particular,

- The **Content-Type:** header gives the MIME-type of the data in the body, such as **text/html** or **image/gif**.

- The **Content-Length:** header gives the number of bytes in the body.

## HTTP IS STATELESS

HTTP is called a stateless protocol and, such as, *HTTP* does not maintain any information from one transaction to the next, so the next transaction must start all over again from the request phase. The advantage to this form of communication lies in that an HTTP server may serve many more clients in a given period of time since there is no additional overhead for tracking sessions from one connection to the next. The disadvantage is that more elaborate CGI programs, Web languages, and Web applications need to use hidden input fields or external tools, such as Netscape cookies, to maintain information from one transaction to the next.

## BENEFITS OF STATELESS CONNECTIONS

HTTP communication was developed to be optimized for wide area communications, running over TCP/IP, where the communication attaches to a specified port, transfers data, then closes the connection. When the HTTP protocol was developed as a shoot off of the DARPA project, communication between various sites were slow at best. Such a catch and release system frees up traffic over communication lines and also frees up system resources between client and server machines where a connection does not have to be constantly maintained. The net result is more clients may exist on such a network and hence more transactions between clients and servers.

## UNDERSTANDING HOW A CLIENT RETRIEVES INFORMATION

The client part of Web communication is the Web browser and the primary method of communication is via the HTTP protocol running over TCP/IP. Of the four phases of HTTP communication, the client has a hand in three. The four phases are:

- Connection

- Request

- Response

- Close

The connection phase is instigated by the client where a URL to a specified or default document is requested on the server via a given protocol. This takes the form of <protocol>://<server name>.<registered domain name>.<top level domain>/<path to file>/<file name> (file name is optional unless calling a specific document other than the default document defined by the server).

After the connection is established and the request for the file is made, the server responds to the client with a header that defines the content (MIME) type to the browser and begins the transfer of the data. If the data type transferred is supported by the browser, such as ASCII text, HTML, or image files, the contents are displayed in the browser window. If the data type requires a supporting program or control to function, this may be launched or, further, if the data type is a binary download (such as an executable or other file type), the file is transferred to the local hard drive for execution or other handling.

After all of the data has been transferred from the server, the client sends an acknowledgement to the server and closes the connection. This process is repeated over and over as hyperlinks are used or files downloaded from various sites.

## DETAILING THE FOUR STEPS OF THE HTTP TRANSACTION

On the Internet, the communication takes place over a TCP/IP connection. This does not preclude this protocol being implemented over any other protocol on the Internet or other networks. In these cases, the mapping of the HTTP request and response structures onto the transport data units of the protocol in question is outside the scope of this specification. It should not, however, be complicated.

The protocol is basically stateless, a transaction consisting of:

**Connection.** The establishment of a connection by the client to the server—when using TCP/IP, port 80 is the well-known port, but other non-reserved ports may be specified in the URL

**Request.** The sending, by the client, of a request message to the server

**Response.** The sending, by the server, of a response to the client

**Close.** The closing of the connection by either or both parties

The format of the request and response parts is defined in this specification. While the header information defined in this specification is sent in ISO Latin-1 character set in CRLF (Carriage Return/Line Feed) terminated lines, object transmission in binary is possible.

## IMPLICATIONS OF THE FOUR STEP TRANSACTION WITH CLIENT-SIDE SCRIPTS

Web scripts are pieces of code written in an array of programming languages including, but not limited to, PERL, Java, VB, and PYTHON. Scripting may take place on either the Web browser (client) or the Web server (server) at the discretion of the programmer. Scripting is bound by the four-step transaction method of communication of the *HTTP* protocol where it must exist in the confines of the four steps.

The browser itself processes client-side scripts and therefore the browser must have an interpreter for the scripting language in question. This, in part, has attributed to the enormous size of many of today's modern browsers.

Scripting must also work under the four steps of client-server communication native the stateless nature of *HTTP* regardless of whether the scripting is handled by the client or the server. In client-side scripting, the fours steps of the transaction are handled in the following manner:

**Connection.** The browser makes a connection request to the server

**Request.** The browser requests the HTML page. The script may be embedded in the HTML code

**Response.** The page is received by the browser and embedded scripts may be processed

**Close.** The session is closed and the process may be repeated to complete transactions

## IMPLICATIONS OF THE FOUR STEP TRANSACTION WITH SERVER-SIDE SCRIPTS

Server–side script processing takes place on the Web server rather than the browser (see last section), and therefore, may use a variety of languages as long as the server has the corresponding interpreter installed.

As with client side scripting, server-side scripting must adhere to the four step HTTP method of communication. Server side scripting is processed under this process as follows:

**Connection.** The browser makes a connection request to the server

**Request.** The browser requests the HTML page

**Response.** Script processing is generally handled after some event or trigger on the client, such as a form submit

**Close.** The session is closed and the process may be repeated to complete transactions

## UNDERSTANDING THE UNIFORM RESOURCE LOCATOR'S (URL) SIGNIFICANCE

A URL is a Uniform Resource Locator, a standard way developed to specify the location of a resource available electronically. URLs are defined by RFC (Request for Comments) 1738, to which you can look for more definitive, technical information.

URLs make it possible to direct both users and software applications to a variety of information, available from a number of different Internet protocols. Most commonly, you will run into URLs when using a World Wide Web (WWW) client, as that medium uses URLs to link WWW pages together. In your WWW browser's location box, the item that generally starts with *http*: is a URL. Files available over protocols besides HTTP, such as FTP and Gopher, can be referenced by URLs. Even Telnet sessions to remote hosts on the Internet and a user's Internet e-mail address can be referred to by a URL.

A URL is like a complete mailing address: it specifies all the information necessary for a user to address an envelope to you. However, they are much more than that, since URLs can refer to a variety of different types of resources. A more fitting analogy would be a system for specifying your mailing address, your phone number, or the location of the book you just read from the public library, all in the same format.

In short, a URL is a convenient and succinct way to direct users and applications to a file or other electronic resource. Learning how to interpret, use, and construct URLs will greatly assist your exploration of the Internet.

## RELATING URLs, PROTOCOLS, AND FILE TYPES

The entire process of retrieving Web pages and other Web data starts with the URL, the actual address of the electronic data and its location on the server, then, via *HTTP* running over TCP/IP, the connection to the server is established and the data requested. The server

recognizes the file type and sends header information back to the client along with the accompanying data found in the body of the communication. File types are defined, or better, understood via predefined content types known as MIME types. If the browser does not understand the file type natively, an application that does understand the MIME type and is associated with the browser must be launched to display the file. After the data transfer is complete (a process which is helped in the way that the TCP/IP protocol works), the connection between the two entities is closed.

## UNDERSTANDING THE URL'S COMPONENT PIECES

URLs have a specific syntax, as defined by RFC 1738 and 1630. A URL is a Uniform Resource Locator, a standard way developed to specify the location of a resource available electronically. URLs are defined by RFC 1738, to which you can look for more definitive, technical information.

URLs make it possible to direct both users and software applications to a variety of information, available from a number of different Internet protocols. Most commonly, you will run into URLs when using a World Wide Web (WWW) client, as that medium uses URLs to link WWW pages together. In your WWW browser's location box, the item that generally starts with *http*: is a URL. Files available over protocols, besides *HTTP*, such as FTP and Gopher, can be referenced by URLs. Even Telnet sessions to remote hosts on the Internet and a users Internet e-mail address can be referred to by a URL.

A URL is like your complete mailing address: it specifies all the information necessary for someone to address an envelope to you. However, they are much more than that, since URLs can refer to a variety of different types of resources. A more fitting analogy would be a system for specifying your mailing address, your phone number, or the location of the book you just read from the public library, all in the same format.

In short, a URL is a very convenient and succinct way to direct users and applications to a file or other electronic resource. Learning how to interpret, use, and construct URLs will greatly assist your exploration of the Internet.

URLs have a specific syntax as defined by RFCs 1738 and 1630. Every URL follows the format:

```
<scheme>:<scheme-dependent-information>
```

Examples of various *schemes* are *http*, gopher, ftp, and news. These schemes and others are Web-based services and protocols running over the TCP/IP protocol. The scheme tells you or the application using the URL what type of resource you are trying to reach and what mechanism to use to obtain that resource.

*Scheme dependent information* is defined as the actual metadata associated with the scheme type. Most schemes include two different types of information: the Internet machine making the file available and the path to that file. With these types of schemes, you generally see the scheme separated from the Internet address of the machine with two slashes (*//*), and then the Internet address separated from the full path to the file with one slash (*/*). FTP, HTTP, and Gopher URLs generally appear in this fashion:

```
scheme://machine.domain/full-path-of-file
```

As an example, consider this file's URL:

```
http://www.ncsa.uiuc.edu/ncsa.html
```

The protocol for this URL is *http* for the HyperText Transfer Protocol. The Internet address of the machine is *www.ncsa.uiuc.edu,* (www is the name of the actual server in the domain) and the path to the file is ncsa.html. This is the standard format for all URLs listed on the World Wide Web with slight variations occurring with regard to protocol and directory features.

Note that when using FTP, HTTP, and Gopher URLs, the full-path-of-file will sometimes end in a slash. This indicates that the URL is pointing not to a specific file, but a directory. In this case, the server generally returns the default index of that directory. This might be just a listing of the files available within that directory, or a default file that the server automatically looks for in the directory. With HTTP servers, this default index file is generally called index.html, but is frequently seen as default.htm, home.html, or default.html.

## BETTER UNDERSTANDING NAME SERVERS

When you type in a Web address to look for the latest news or stock quote, remembering to point your browser at *www.yahoo.com* is a lot easier than remembering the site's numeric IP address. However, if you examine the packets that pass between your browser and the *Yahoo!* site, you will see that it is 204.71.200.243 in the packet header that guides your requests through the Internet.

Domain Naming Service (DNS), an Internet protocol and distributed database, provides the mapping between these disparate addresses and their friendly names. Having a basic understanding of how DNS works makes for a better understanding of how Web services and protocols work as a whole, taking a layered approach (DNS works over TCP/IP providing name services).

To begin, first take a quick look at the structure of Internet host names. The last portion of a host name, such as .com, is the top-level domain to which the host belongs. In

addition to the .com domain, there are *six* other top-level domains assigned by InterNIC (a/k/a. Network Solutions @ *www.networksolutions.com*), the coordinating body for Internet name services.

If a site is outside the United States, the organization that assigns domain names has its own standards. In most cases, top-level domains for non-U.S. hosts look like .co.uk or .ac.uk, which indicate a company or academic institution in the United Kingdom.

At the top of the DNS database tree are root name servers, which contain pointers to master name servers for each of the top-level domains. For example, to find out the numeric address of *www.yahoo.com*, a DNS server would ask the root name server for the address of the master name server for the .com domain.

In return, the master name servers for each of the top-level domains contain a record and name-server address of each domain name. In trying to find out the numeric address of *www.yahoo.com*, the DNS server asks the .com server for the name of the server that handles the yahoo.com domain.

The individual name servers for each domain name, such as *yahoo.com*, contain detailed address information for the hosts in that domain. In this example, the DNS server then asks the *yahoo.com* server for the name of the server that handles the *yahoo.com* domain.

Finally, this most specific name server supplies the DNS server with the IP address of the machine called *www.yahoo.com*.

Providing DNS to your users is an important part of linking them to the Internet. There are two basic ways to configure DNS. One option is to use your ISP's (Internet service provider's) DNS server. Many ISPs will let you do this. Another option is to set up a DNS server on your own network. For smaller organizations with simpler needs, the best option is to have an ISP provide name services. There are three steps to this process. First, have your ISP inform the InterNIC that it is providing both primary and secondary DNS services for your organization. Second, your ISP will give you the numeric IP addresses of the primary and secondary DNS servers, which you'll need to configure your users' TCP/IP stacks. You can do this by entering the information manually either at the desktop or at your Dynamic Host Configuration Protocol (DHCP) server. Finally, you need to tell your ISP about the DNS records that you wish to publish to let outside users interact with your network.

In addition, if you want to receive e-mail from the Internet, you will need to have a Mail Exchange (MX) record for your domain in your ISP's DNS database. MX refers to a machine that accepts e-mail connections for your domain. An MX record has three parts: your domain name, the name of the machine that will accept mail for the domain, and a preference value. The preference value lets you build some fault tolerance into your mail setup.

Your domain can have multiple MX records, such as the following:

```
Acme.com mail.acme.com 0 ; Acme.com mail2.acme.com 10 ; and
Acme.com mail.isp.net 100.
```

In this case, mail delivery will be attempted to *mail.acme.com* first because it has the lowest preference value. If delivery fails, *mail2.acme.com* will be tried next. If mail2 is also down, mail will be sent to a relay host called *mail.isp.net* which, in this case, is at Acme's ISP.

If you plan to use your ISP's DNS server, you'll also need to have the ISP set up some A records, which associate IP addresses with computer names. Each of the computers mentioned in your MX records needs an A record to associate them with an IP address.

You may also want to set up A records for each of your workstations if your users need to use FTP (File Transfer Protocol) to download software from the Internet because some FTP sites perform a lookup to get the DNS name of the machine from which they receive download requests. If the machine has no name, the sites deny the request.

You will also need A records for any public servers you maintain. For example, if you have a World Wide Web server, you'll need to have the ISP set up an A record linking the name *www.acme.com* to the IP address of your Web server.

If your ISP does not provide name services or if you need to have a DNS server at your site to support internal networking applications, the first thing you need to know is that you must have at least two name servers—a primary and a secondary. The InterNIC (Network Solutions) will not grant you a domain name unless there are at least two DNS servers on the Internet with information about that domain. Another reason for a second server is the need for fault tolerance, which a second name server can provide.

Some sites take a middle-of-the-road approach and use an onsite DNS server as well as their ISP's. Because maintenance of the domain names is done at the primary name server, choosing which one is primary and which is secondary is quite important.

If you choose to administer the primary name server yourself, keep in mind that you'll have to maintain the DNS records.

If you choose to have a secondary name server on site, your ISP will do all of the work, and your secondary name server will simply download the data about your domain from the primary server periodically.

Having a name server on site offers several advantages. First, if you are running IP network-based applications inside your network that require users to connect to internal machines by name, it is not advisable to advertise the names and addresses of these machines. DNS can give hackers a map of your network, so setting up an internal DNS server that does not publish information to the world is a good idea.

Second, a DNS server inside your network lets you be the master of your own domain. You can make changes, additions, and deletions on your own schedule.

## NAME SERVERS AND ALIASES

Suppose you had a single server to work from and that server had to offer Web (HTTP) services, File Transfer Protocol (FTP) services, and mail services, including Simple Mail Transport Protocol (SMTP) and Post Office Protocol 3 (POP3). A registered server on the Internet, that is, a server that has a legal and registered IP address, may only have one registered name on a DNS server for name resolution. So how do you offer multiple meaningful names for these services and continue to host them all on the same server? The answer is found in the DNS specification where canonical names or CNAME records are available to apply multiple names to the same IP address.

The result of the above example is the ability to run all of the services on the same server and each service (or TCP/IP) port has its own name. To the end user or the outside world it may appear that the services are hosted on separate servers, though a simple PING test would confirm otherwise.

Once again, the benefit to adding aliases for specific services is to add meaning to the specified port or service. DNS names are used to provide a friendly method of calling on various TCP/IP services

## LOOKING AT URLs

Files may be called or referenced from within an HTML page using Uniform Resource Locators or URL, for short. Think of a URL as an address to a file on a server located on the Web. More precisely, the URL is an appended version of a call to a file in the file structure of the server. The process is similar to navigating to a file from an MS-DOS or Unix command line. To better understand how a URL works, you must first understand the structure of a URL and how each part functions.

A URL may be separated into the following four parts:

- Protocol type
- Fully Qualified Domain Name (FQDM includes the server name and domain name)
- The directory name (if any)
- The filename

The URL takes the form:

**1.)** <HTTP://> **2.)** <WWW.UBID.COM/> **3.)** <CAT/> **4.)** <1.ASP>

where the beginning of the address, 1.), defines the protocol used to retrieve the file. This may be any Web-based protocol supported by the browser, such as HTTP, FTP, GOPHER, and so on. The second section, 2.), is the FQDN of the server on which the file(s) reside. In this example the server name is www and the domain in which that server resides is *ubid.com*. Following the FQDN is the directory where the file resides. This may or may not be present depending on the directory structure of the site. Many simple sites may only contain the root Web directory and no other supporting structure. In this case, the default page is registered upon entering the URL. The filename, 4.), is the last in the address line and calls a specific file from the server. If the browser supports the file MIME-type, it will be displayed in the browser window, otherwise you are prompted to download the file.

## INTRODUCING ABSOLUTE AND RELATIVE URLs

A URL may take one of two forms, absolute or relative. An absolute URL is a complete address that calls all four of the address components outlined in the last section and looks similar to the following:

```
http://www.yahoo.com/WM/FAQ/index.html
```

It has the protocol (http), the fully qualified domain name (*www.yahoo.com*), and information about where the file is on that machine via a directory and file call (*WM/FAQ/index.html*).

A partial or relative URL leaves out part of the information, letting the machine assume the rest. Among the advantages of using relative URLs are the fact that you don't have to type as much, and portability (if you move your files to another server or a different place on the same server, links within your directories will still work).

## ANALYZING RELATIVE URLs FURTHER

Relative URLs may follow the file directory structure of the Web server to address a file or virtual directories found on the Web server. Both types of relative URLs serve to help to make the process of calling a file from within HTML pages easier.

Relative URLs work by removing the assumed protocol. In the case of most browsers this is HTTP and the FQDN of the server to leave only the directory structure and filename. To use

relative URLs, it is important to understand the directory structure you created for your site. Doing so will help to avoid having to spend time debugging a link that fails to work. Relative URLs use several different formats to call files within the directory structure. The following list outlines the use of relative URLs within an HTML document:

- To link to another file in the same folder:

```
<a href="TheOtherFileName.html">Link Text</a>
```

- To link to a file in a subfolder of the current folder:

```
<a href="SubfolderName/somefile.html">Link Text</a>
```

- To link to the default file (typically the homepage) in another folder, give the folder location followed by a slash:

```
<a href="SubfolderName/">Link Text</a>
```

- To link to a file in a folder one step up in the file structure:

```
<a href="../TheOtherFileName.html">Link Text</a>
```

- To link to a file on this server, but not in your folder(s):

```
<a href="/FolderNameInWWWFolder/OtherFileName.html">Link Text</a>
```

A virtual directory is one that may or may not reside on the server itself and is addressed by a name that it is given. The most common of use of a virtual directory is the creation of an image virtual directory so that all image files may be called from that directory directly in the HTML. Directly means that the image file would be called as `images/image0001.gif` rather than back referencing an image directory where the file exists that is part of the tree (`../images/image001.gif`).

Virtual directories are unique to the server on which they reside, and there can be only a single instance of the virtual address name. Thus, two virtual directories with the same name of image cannot exist.

## DEFINING THE BASIC HTTP METHODS

Client requests are broken up into three sections. The first line of a message always contains an HTTP command called a *method*, a URI that identifies the file or resource the client is querying, and the HTTP version number. The following lines of a client request contain header information, which provides information about the client and the data entity it is

sending the server. The third part of a client request is the entity body, the data being sent to the server.

URI (Uniform Resource Identifier) is a general term for all valid formats of addressing schemes supported on the World Wide Web. The one in common use now is the URL (Uniform Resource Locator) addressing scheme.

A method is an HTTP command that begins the first line of a client request. The method tells the server the purpose of the client request. The three main methods defined for *HTTP* are GET, HEAD, and POST. Other methods are also defined, but are not as widely supported by servers as GET, HEAD, and POST (although the other methods will be used more often in the future). Methods are case sensitive, so a GET is different than a get.

### The GET method

GET is a request for information located at a specified URI on the server. It is the most commonly used method by browsers to retrieve documents for viewing. The result of a GET request can be generated in many different ways. It can be a file accessible by the server, the output of a program or CGI script, the output from a hardware device, and so on.

When a client uses the GET method in its request, the server responds with a status line, headers, and the requested data. If the server cannot process the request due to an error or lack of authorization, the server usually sends a textual explanation in the data portion of the response.

The entity-body portion of a GET request is always empty. GET is basically used to say, "Give me this file." The file or program that the client requests is usually identified by its full path name on the server.

The following example shows a successful GET request to retrieve a file. The client sends:

```
GET /index.html HTTP/1.0

Connection: Keep-Alive

User-Agent: Mozilla/4.07 (WinNT; I)

Host: www.yahoo.com

Accept: image/gif, image/x-xbitmap, image/jpeg, image/pjpeg,
*/*
```

The server responds with:

```
HTTP/1.0 200 Document follows

Date: Fri, 20 Sep 1996 08:17:58 GMT
```

```
Server: NCSA/1.5.2

Last-modified: Mon, 17 Jun 1996 21:53:08 GMT

Content-type: text/html

Content-length: 2482

(body of document here)
```

The GET method is also used to send input to programs like CGI through form tags. Since GET requests have empty entity-bodies, the input data is appended to the URL in the GET line of the request.

### The HEAD method

The HEAD method is functionally like GET except that the server will not send anything in the data portion of the reply. The HEAD method requests only the header information on a file or resource. The header information from a HEAD request should be the same as that from a GET request.

This method is used when the client wants to find out information about the document and not retrieve it. Many applications exist for the HEAD method. For example, the client may desire the following information:

- Modification time of a document, useful for cache-related queries
- The size of a document, useful for page layout, estimating arrival time, or determining whether to request a smaller version of the document
- The type of document, to let the client examine only documents of a certain type
- The type of server, to allow customized server queries

It is important to note that most of the header information provided by a server is optional and may not be given by all servers. A good design for Web clients is to allow flexibility in the server response and take default actions when the server does not give desired header information. The following is an example HTTP transaction using the HEAD request. The client sends:

```
HEAD /index.html HTTP/1.0

Connection: Keep-Alive

User-Agent: Mozilla/4.07 (WinNT; I)

Host: www.cnet.com
```

```
Accept: image/gif, image/x-xbitmap, image/jpeg, image/pjpeg,
*/*
```

The server responds with:

```
HTTP/1.0 200 Document follows

Date: Fri, 20 Sep 1996 08:17:58 GMT

Server: NCSA/1.5.2

Last-modified: Mon, 17 Jun 1996 21:53:08 GMT

Content-type: text/html

Content-length: 2482

(No entity body is sent in response to a HEAD request.)
```

### The POST method

The POST method lets data be sent to the server in a client request. The data is directed to a data handling program that the server has access to (a CGI script). The POST method can be used for many applications. For example, it can be used to provide input for:

- Network services, such as newsgroup postings
- Command-line interface programs
- Annotation of documents on the server
- Database operations

The data sent to the server is in the entity-body section of the client's request. After the server processes the POST request and headers, it passes the entity-body to the program specified by the URI. The encoding scheme most commonly used with POST is URL-encoding, which lets form data be translated into a list of variables and values for CGI processing.

An example of a client request using the POST method to send birthdate data from a form is shown below:

```
POST /cgi-bin/birthday.pl HTTP/1.0

User-Agent: Mozilla/4.07 (WinNT; I)

Accept: image/gif, image/x-xbitmap, image/jpeg, image/pjpeg,
*/*
```

```
Host: www.cnet.com

Content-type: application/x-www-form-urlencoded

Content-length: 20

month=august&date=24
```

## DEFINING THE OTHER HTTP METHODS

The following is a list of methods that are also defined through the HTTP specification, although not as frequently used as the GET, POST, and HEAD types.

**LINK.** Requests that header information is associated with a document on the server.

**UNLINK.** Requests dissociation of header information from a document on the server.

**PUT.** Requests that the entity-body of the request be stored at the specified URI.

**DELETE.** Requests the removal of data at a URI on the server.

**OPTIONS.** Requests information about communications options available on the server. The request URI can be substituted with an asterisk (*) to indicate the server as a whole.

**TRACE.** Requests the request entity body be returned intact. Used for debugging.

The server's response to a client request is grouped into three parts. The first line is the server response line, which contains the HTTP version number, a number indicating the status of the request, and a short phrase describing the status. The response line is followed by the header information and an entity body, if there is one.

## UNDERSTANDING GENERAL-HEADER FIELDS

An HTTP transaction consists of a header followed (optionally) by an empty line and some data. The header will specify (generally) three things:

- The action required of the server
- The type of data being returned
- A status code

The header lines received from the client, if any, are placed by the server into the CGI environment variables with the prefix "*HTTP_*" followed by the header name. Any "-" characters in the header name are typically changed to "_" characters. The server may exclude any headers which it has already processed, such as Authorization, Content-type, and Content-length.

The MIME types which the client will accept, as given by *HTTP* headers:

- **HTTP_ACCEPT**

Other protocols may need to get this information from elsewhere. Each item in this list should be separated by commas per the *HTTP* spec:

- HTTP_USER_AGENT

The server sends back to the client the following:

- A status code that indicates whether the request was successful or not. Typical error codes indicate that the requested file was not found, that the request was malformed, or that authentication is required to access the file.

- The data itself. Since HTTP is liberal about sending documents of any format, it is ideal for transmitting multimedia such as graphics, audio, and video files.

- It also sends back information about the object being returned.

## UNDERSTANDING REQUEST-HEADER FIELDS

The request header fields let the client pass additional information about the request (and about the client itself) to the server. All header fields are optional and conform to the generic *HTTP-header* syntax. The following is excerpted from the W3C Internet Specification draft for the HTTP protocol:

```
Request-Header =       Accept

        |       Accept-Charset

        |       Accept-Encoding
```

| Accept-Language

| Authorization

| From

| If-Modified-Since

| Pragma

| Referer

| User-Agent

| Extension-header

Although additional request header fields may be implemented via the extension mechanism, applications which do not recognize those fields should treat them as *Entity-Header* fields.

**Accept**

The *Accept* header field can be used to indicate a list of media ranges which are acceptable as a response to the request. The asterisk "*" character is used to group media types into ranges, with "*/*" indicating all media types and "type/*" indicating all subtypes of that type. The set of ranges given by the client should represent what types are acceptable given the context of the request. The *Accept* field should only be used when the request is specifically limited to a set of desired types (such as a request for an in-line image), to indicate qualitative preferences for specific media types, or to indicate acceptance of unusual media types.

The field may be folded onto several lines and more than one occurrence of the field is allowed (with the semantics being the same as if all the entries had been in one field value).

Accept =     "Accept" ":" 1#(

            media-range

            [ ";" "q" "=" ( "0" | "1" | float ) ]

            [ ";" "mxb" "=" 1*DIGIT ] )

```
media-range      =          ( "*/*"

        |             ( type "/" "*" )

        |             ( type "/" subtype )

                    ) *( ";" parameter )

float    =        < ANSI-C floating point text representation,

                    where (0.0 < float < 1.0) >
```

The parameter $q$ is used to indicate the quality factor, which represents the user's preference for that range of media types. The parameter *mxb* gives the maximum acceptable size of the *Entity-Body* (in decimal number of octets) for that range of media types. If at least one *Accept* header is present, a quality factor of 0 is equivalent to not sending an *Accept* header field containing that *media-type* or set of *media-types*. The default values are: q=1 and mxb=undefined (i.e. infinity).

The example:

    Accept: audio/*; q=0.2, audio/basic

should verbally be interpreted as "if you have audio/basic, send it; otherwise, send me any audio type."

If no *Accept* header is present, then it is assumed that the client accepts *all* media types with quality factor 1. This is equivalent to the client sending the following accept header field:

Accept: */*; q=1

or

Accept: */*

A more elaborate example is:

Accept: text/plain; q=0.5, text/html,

    text/x-dvi; q=0.8; mxb=100000, text/x-c

Verbally, this would be interpreted as "text/html and text/x-c are the preferred media types, but if they do not exist then send the *Entity-Body* in text/x-dvi if the entity is less than 100,000 bytes, otherwise send text/plain."

*Note:* In earlier versions of this document, the mxs parameter defined the maximum acceptable delay in seconds before the response would arrive. This has been removed as the server has no means of obtaining a useful reference value. However, this does not prevent the client from internally measuring the response time and optimizing the Accept header field accordingly.

It must be emphasized that this field should only be used when it is necessary to restrict the response media types to a subset of those possible, to indicate the acceptance of unusual media types, or when the user has been permitted to specify qualitative values for ranges of media types. If no quality factors have been set by the user, and the context of the request is such that the user agent is capable of saving the entity to a file if the received media type is unknown, then the only appropriate value for *Accept* is "*/*" and the list of unusual types. Whether or not a particular media type is deemed unusual should be a configurable aspect of the user agent.

## Accept-Charset

The Accept-Charset header field can be used to indicate a list of preferred character sets other than the defaults US-ASCII and ISO-8859-1. This field lets clients capable of understanding more comprehensive or special-purpose character sets signal that capability to a server which is capable of representing documents in those character sets.

Accept-Charset =        "Accept-Charset" ":" 1#charset

An example is:

Accept-Charset: iso-8859-5, unicode-1-1

The value of this field should not include US-ASCII or ISO-8859-1, since those values are always assumed by default. If a resource is only available in a character set other than the defaults, and that character set is not listed in the *Accept-Charset* field, it is only acceptable for the server to send the entity if the character set can be identified by an appropriate charset parameter on the media type or within the format of the media type itself.

## Accept-Encoding

The *Accept-Encoding* header field is similar to *Accept*, but lists the *encoding-mechanisms* and *transfer-encoding* values which are acceptable in the response, as shown below:

Accept-Encoding       =       "Accept-Encoding" ":"

                1#( encoding-mechanism | transfer-encoding )

An example of its use is:

Accept-Encoding: compress, base64, gzip, quoted-printable

The field value should never include the identity *transfer-encoding* values (7-bit, 8-bit, and binary) since they actually represent "no encoding." If no *Accept-Encoding* field is present in a request, it must be assumed that the client does not accept any *encoding-mechanism* and only the identity *transfer-encodings*.

## Accept-Language

The *Accept-Language* header field is similar to *Accept*, but lists the set of natural languages that are preferred as a response to the request, as shown below:

Accept-Language     =     "Accept-Language" ":" 1#language-tag

Languages are listed in the order of their preference to the user. For example:

Accept-Language: dk, en-gb

would mean, "Send me a Danish version if you have it; else a British English version."

If the server cannot fulfill the request with one or more of the languages given, or if the languages only represent a subset of a multi-linguistic *Entity-Body*, it is acceptable to serve the request in an unspecified language.

## Authorization

A user agent that wishes to authenticate itself with a server (usually, but not necessarily, after receiving a 401 Unauthorized response) may do so by including an *Authorization* header field with the request. The *Authorization* field value consists of *credentials* containing the authentication information of the user agent for the realm of the resource being requested, as shown below:

Authorization   =     "Authorization" ":" credentials

HTTP access authentication is described in Section 10. If a request is authenticated and a *realm* specified, the same *credentials* should be valid for all other requests within this *realm*.

## From

The *From* header field, if given, should contain an Internet e-mail address for the human user who controls the requesting user agent. The address should be machine-usable, as defined by *addr-spec* in RFC 822:

From   =     "From" ":" addr-spec

An example of its use is:

From: Webmaster@w3.org

This header field may be used for logging purposes and as a means for identifying the source of invalid or unwanted requests. It should not be used as an insecure form of access protection. The interpretation of this field is that the request is being performed on behalf of the user given, who accepts responsibility for the *method* performed. In particular, robot agents should include this header so that the user responsible for running the robot can be contacted if problems occur on the receiving end.

The Internet e-mail address in this field does not have to correspond to the Internet host which issued the request. (For example, when a request is passed through a proxy, then the original issuer's address should be used). The address should, if possible, be a valid Internet e-mail address, whether or not it is in fact an Internet e-mail address or the Internet e-mail representation of an address on some other mail system.

### If-Modified-Since

The *If-Modified-Since* header field is used with the *GET* method to make it conditional: if the requested resource has not been modified since the time specified in this field, a copy of the resource will not be returned from the server. Instead, a 304 Not Modified response will be returned without any *Entity-Body*, as shown below:

If-Modified-Since        =        "If-Modified-Since" ":" HTTP-date

An example of the field is:

If-Modified-Since: Sat, 29 Oct 1994 19:43:31 GMT

The purpose of this feature is to allow efficient updates of local cache information with a minimum amount of transaction overhead. The same functionality can be obtained, though with much greater overhead, if the server indicates that issuing a HEAD request and following it with a GET request have modified the entity.

### Pragma

The *Pragma* header field is used to specify directives that must be applied to all servers along the request chain (where relevant). The directives typically specify behavior that prevents intermediate proxies from changing the nature of the request. Although multiple pragma directives can be listed as part of the request, HTTP/1.0 only defines semantics for the no-cache directive, as shown below:

Pragma          =          "Pragma" ":" 1#pragma-directive

pragma-directive          =          "no-cache" | extension-pragma

extension-pragma          =          token

When the `no-cache` directive is present, a caching proxy must forward the request toward the origin server even if it has a cached copy of what is being requested. This lets a client insist upon receiving an authoritative response to its request. It also lets a client refresh a cached copy, which has become corrupted or is known to be stale.

Pragmas must be passed through by a proxy even when they have significance to that proxy. This is necessary in cases when the request has to go through many proxies, and the pragma may affect all of them. It is not possible to specify a pragma for a specific proxy. However, any *pragma-directive* not relevant to a gateway or proxy should be ignored.

### Referer

The *Referer* field lets the client specify, for the server's benefit, the address (URI) of the document (or element within the document) from which the *Request-URI* was obtained. This lets a server generate lists of back-links to documents, for interest, logging, optimized caching, and so on. It also lets obsolete or mistyped links be traced for maintenance. The format of the field is:

Referer =          "Referer" ":" URI

Example:

Referer: http://info.cern.ch/hypertext/DataSources/Overview.html

If a partial URI is given, it should be interpreted relative to the *Request-URI*.

### User-Agent

The *User-Agent* field contains information about the user agent originating the request. This field is for statistical purposes, the tracing of protocol violations, and automated recognition of user agents for the sake of tailoring responses to avoid particular user agent limitations. Although it is not required, user agents should always include this field with requests. The field can contain multiple tokens specifying the product name, with an optional slash and version designator, and other products which form a significant part of the user agent. By convention, the products are listed in order of their significance for identifying the application.

| User-Agent | = | "User-Agent" ":" 1*( product ) |
|---|---|---|

| product | = | token ["/" product-version] |
|---|---|---|

| product-version | = | token |
|---|---|---|

Example:

User-Agent: CERN-LineMode/2.15 libwww/2.17b3

Product tokens should be short and to the point—use of this field for advertising or other non-essential information is explicitly deprecated and will be considered as non-conformance to the protocol. Although any token character may appear in a *product-version*, this token should only be used for a version identifier (successive versions of the same product should only differ in the *product-version* portion of the *product* value). The *User-Agent* field may include additional information within comments that are not part of the value of the field.

## DEFINING ENTITY-HEADER FIELDS

HTTP body information and content types are defined in the *HTTP Entity Header* field. This section specifies the format and semantics of the *Entity-Header* fields. *Entity-Header* fields define optional meta-information about the *Entity-Body* or, if no body is present, about the resource identified by the request. The following is excerpted from the W3C Internet Specification draft for the HTTP protocol.

Entity header information follows to this format:

Entity-Header  =      Allow

|      Content-Encoding

|      Content-Language

|      Content-Length

|      Content-Transfer-Encoding

|      Content-Type

|      Derived-From

|        | Expires          |
|--------|------------------|
|        | Last-Modified    |
|        | Link             |
|        | Location         |
|        | Title            |
|        | URI-header       |
|        | Version          |
|        | extension-header |

extension-header        =        HTTP-header

Each entity header field is explained in the subsections below. Other header fields are allowed but cannot be assumed to be recognizable by the recipient. Unknown header fields should be ignored by the recipient and forwarded by proxies. It has been proposed that any HTML meta-information element (allowed within the <HEAD> element of a document) be a valid candidate for an HTTP entity header. The above example document defines two header fields, Link and Title, which are both examples of this.

*HTTP* communication takes place in four parts:

- Connection
- Request
- Response
- Close

The response aspect of the communication is by way of the server to the client. Responses may consist of a header with response codes and (usually) an HTML page or server response to an error encountered during the four step process. HTTP response codes are grouped into similar types and represented by a number or number set. The following list defines the common HTTP server response codes and a brief description of each:

200 OK: The request has been fulfilled and an entity corresponding to the requested resource is being sent in the response.

201 Created: The request has been fulfilled and resulted in a new resource being created. The newly created resource can be referenced by the URI(s) returned in the *URI-header* field of the response.

202 Accepted: The request has been accepted for processing, but the processing has not been completed.

203 Provisional Information: The returned meta-information in the *Entity-Header* is not the definitive set as available from the origin server.

204 No Content: The server has fulfilled the request, but there is no new information to send back.

300 Multiple Choices: The requested resource is available at one or more locations and a preferred location could not be determined via content negotiation.

301 Moved Permanently: The requested resource has been assigned a new permanent URI, and any future references to this resource must be done using the returned URI.

302 Moved Temporarily: The requested resource resides temporarily under a different URI. Since the redirection may be altered on occasion, the client should, on future requests from the user, continue to use the original *Request-URI* and not the URI returned in the *URI-header* field and *Location* fields.

304 Not Modified: If the client has performed a conditional GET request and access is allowed, but the document has not been modified since the date and time specified in the *If-Modified-Since* field, the server shall respond with this status code and not send an *Entity-Body* to the client.

400 Bad Request: The request had bad syntax or was inherently impossible to be satisfied.

401 Unauthorized: The request requires user authentication.

402 Payment Required: Not currently in use.

403 Forbidden: The request is forbidden because of some reason that remains unknown to the client.

404 Not Found: The server has not found anything matching the *Request-URI*.

405 Method Not Allowed: The method specified in the *Request-Line* is not allowed for the resource identified by the *Request-URI*.

406 None Acceptable: The server has found a resource matching the *Request-URI*, but not one that satisfies the conditions identified by the *Accept* and *Accept-Encoding* request headers.

407 Proxy Authentication Required: The client must first authenticate itself with the proxy.

408 Request Timeout: The client did not produce a request within the time that the server was prepared to wait.

409 Conflict: The request could not be completed due to a conflict with the current state of the resource.

410 Gone: The requested resource is no longer available at the server and no forwarding address is known.

500 Internal Server Error: The server encountered an unexpected condition, which prevented it from fulfilling the request.

501 Not Implemented: The server does not support the functionality required to fulfill the request.

502 Bad Gateway: The server received an invalid response from the gateway or upstream server it accessed in attempting to complete the request.

503 Service Unavailable: The server is currently unable to handle the request due to a temporary overloading or maintenance of the server.

504 Gateway Timeout: The server did not receive a timely response from the gateway or upstream server it accessed in attempting to complete the request.

## UNDERSTANDING RESPONSE-HEADER FIELDS

The response-header fields let the server pass additional information about the response, which cannot be placed in the *Status Line*. These header fields are not intended to give information about an *Entity-Body* returned in the response, but about the server itself. The following outlines the format of the response header fields:

```
Response-Header      =        Public
        |       Retry-After
        |       Server
        |       WWW-Authenticate
        |       extension-header
```

The following list reprinted from the W3C HTTP specification document further defines the fields found in the response header.

### Public

The *Public* header field lists the set of non-standard methods supported by the server. The purpose of this field is strictly to inform the recipient of the capabilities of the server regarding unusual methods. The methods listed may or may not be applicable to the Request-URI.

The *Allow* header field should be used to indicate methods allowed for a particular URI. This does not prevent a client from trying other methods. The field value should not include the methods predefined for HTTP/1.0 in Section 5.2.

```
Public          =          "Public" ":" 1#method
```

Example of use:

```
Public: OPTIONS, MGET, MHEAD
```

This header field applies only to the current connection. If the response passes through a proxy, the proxy must either remove the *Public* header field or replace it with one applicable to its own capabilities.

### Retry-After

The *Retry-After* header field can be used with 503 Service Unavailable to indicate how long the service is expected to be unavailable to the requesting client. The value of this field can be either a full *HTTP-date* or an integer number of seconds (in decimal) after the time of the response.

```
Retry-After =          "Retry-After" ":"
( HTTP-date | delta-seconds )
```

Two examples of its use are:

```
Retry-After: Wed, 14 Dec 1994 18:22:54 GMT
Retry-After: 120
```

In the latter example, the delay is 2 minutes.

### Server

The *Server* header field contains information about the software being used by the origin server program handling the request. The field is analogous to the *User-Agent* field and has the following format:

```
Server          =          "Server" ":" 1*( product )
```

Example:

```
Server: CERN/3.0 libwww/2.17
```

If the response is being forwarded through a proxy, the proxy application must not add its data to the product list. Instead, it should include a *Forwarded* field.

**WWW-Authenticate**

The *WWW-Authenticate* header field must be included as part of a 401 Unauthorized response. The field value consists of a *challenge* that indicates the authentication scheme and parameters applicable to the *Request-URI*.

```
WWW-Authenticate    =    "WWW-Authenticate" ":" challenge
```

## DEFINING ENTITY BODIES

The entity body (if any) sent with an HTTP request or response is in a format and encoding defined by the Entity-Header fields, as shown below:

```
Entity-Body    = *OCTET
```

An entity body is included with a request message only when the request method calls for one. The presence of an entity body in a request is signaled by the inclusion of a Content-Length header field in the request message headers. HTTP/1.0 requests containing an entity body must include a valid Content-Length header field.

For response messages, whether or not an entity body is included with a message is dependent on both the request method and the response code. All responses to the HEAD request method must not include a body, even though the presence of Entity-/header fields may lead one to believe they do. All 1xx (informational), 204 (no content), and 304 (not modified) responses must not include a body. All other responses must include an entity body or a Content-Length header field defined with a value of zero (0).

When an Entity-Body is included with a message, the data type of that body is determined via the header fields Content-Type, Content-Encoding, and Content-Transfer-Encoding. These define a three-layer, ordered encoding model:

```
entity-body <-  Content-Transfer-Encoding( Content-Encoding
( Content-Type ) )
```

The default for both encodings is none (the identity function). A Content-Type specifies the media type of the underlying data. A Content-Encoding may be used to indicate an additional encoding mechanism applied to the type (usually for the purpose of data compression) that is a property of the resource requested. A Content-Transfer-Encoding may be applied by a transport agent to ensure safe and proper transfer of the message. Note that the Content-Transfer-Encoding is a property of the message, not of the resource.

The Content-Type header field has no default value. If, and only if, the media type is not given by a Content-Type header (as is always the case for Simple-Response messages), the receiver may attempt to guess the media type via inspection of its content or the name extension(s) of the URL used to access the resource. If the media type remains unknown, the receiver should treat it as type application/octet-stream.

When an *Entity-Body* is included with a message, the length of that body may be determined in one of several ways. If a *Content-Length* header field is present, its value in bytes (number of octets) represents the length of the *Entity-Body*. Otherwise, the body length is determined by the *Content-Type*, the *Content-Transfer-Encoding*, or the closing of the connection by the server.

## CONSIDERING THE HTTP TRANSACTION OVERALL

After reviewing the several previous sections it may be hard to surmise how the whole HTTP four-step transaction occurs from beginning to end. Upon first inspection, the approach to HTTP stateless communication seems very simplistic and, for the most part, it is. The layers of complexity have been formed over the years to contend with all of the contingencies that have surfaced between this client/server interface.

From a high level view, an HTTP session between your Web browser might look like this:

The Web browser is started (a connection to the Internet is assumed)

A request is made to the Web server for connection

- The server responds

- The browser requests the URI

- The server responds

- The connection is closed

- You then decide to fill out a survey form on this page, clicking on the "submit" button when done.

- A request is made to the Web server for connection

- The server responds

- The browser requests the URI

- The server responds

- The connection is closed

## BRIEFLY CONSIDERING THE PROTOCOLS THAT HTTP RUNS ON TOP OF

TCP/IP is a layered set of protocols. To understand what this means, it is useful to look at an example. A typical situation is sending mail. First, there is a protocol for mail. This protocol defines a set of commands which one machine sends to another, such as commands to specify who the sender of the message is, who it is being sent to, and the text of the message. However, this protocol assumes that there is a way to communicate reliably between the two computers. Mail, like other application protocols, simply defines a set of commands and messages to be sent. It is designed to be used together with TCP and IP.

TCP is responsible for making sure that the commands get through to the other end. It keeps track of what is sent, and retransmitts anything that did not get through. If any message is too large for one datagram, that is, the text of the mail, TCP will split it up into several datagrams and make sure that they all arrive correctly. Since these functions are needed for many applications, they are put together into a separate protocol, rather than being part of the specifications for sending mail. You can think of TCP as forming a library of routines that applications can use when they need reliable network communications with another computer. Similarly, TCP calls on the services of IP. Although the services that TCP supplies are needed by many applications, there are still some kinds of applications that don't need them. However, there are some services that every application needs, so these services are put together into IP. As with TCP, you can think of IP as a library of routines that TCP calls on, but which is also available to applications that don't use TCP. This strategy of building several levels of protocol is called layering. You can think of the applications programs, such as mail, TCP, and IP, as being separate layers, each of which calls on the services of the layer below it. Generally, TCP/IP applications use four layers:

- An application protocol, such as mail

- A protocol, such as TCP, that provides services need by many applications

- Provides the basic service of getting datagrams to their destination

- The protocols needed to manage a specific physical medium, such as
  Ethernet or a point to point line

TCP/IP is based on the catenet model. This model assumes that there are a large number of independent networks connected together by gateways. The user should be able to access computers or other resources on any of these networks. Datagrams will often pass through

a dozen different networks before getting to their final destination. The routing needed to accomplish this should be completely invisible to the user. As far as the user is concerned, all he needs to know to access another system is an Internet address. This is an address that looks like 128.6.4.194. It is actually a 32-bit number. However, it is normally written as four decimal numbers, each representing 8 bits of the address. (The term octet is used by Internet documentation for such 8-bit chunks. The term byte is not used because TCP/IP is supported by some computers that have byte sizes other than 8 bits.) Generally, the structure of the address gives you some information about how to get to the system. For example, 128.6 is a network number assigned by a central authority to Rutgers University. Rutgers uses the next octet to indicate which of the campus Ethernets is involved. 128.6.4 happens to be an Ethernet used by the Computer Science Department. The last octet allows for up to 254 systems on each Ethernet. (It is 254 because 0 and 255 are not allowed, for reasons that will be discussed later.) Note that 128.6.4.194 and 128.6.5.194 would be different systems. The structure of an Internet address is described later in the book.

Of course, systems are normally referred to by name, rather than by Internet address. When you specify a name, the network software looks it up in a database, and comes up with the corresponding Internet address. Most of the network software deals strictly in terms of the address. (RFC 882 describes the name server technology used to handle this lookup.)

TCP/IP is built on connectionless technology. Information is transfered as a sequence of datagrams. A datagram is a collection of data that is sent as a single message. Each of these datagrams is sent through the network individually. There are provisions to open connections (to start a conversation that will continue for some time). However, at some level, information from those connections is broken up into datagrams, and those datagrams are treated by the network as completely separate. For example, suppose you want to transfer a 15000 octet file. Most networks can't handle a 15000 octet datagram. The protocols will break this up into, for example, thirty 500-octet datagrams. Each of these datagrams will be sent to the other end. At that point, they will be put back together into the 15000-octet file. However, while those datagrams are in transit, the network doesn't know that there is any connection between them. It is possible that datagram 14 will arrive before datagram 13. It is also possible that somewhere in the network, an error will occur, and some datagram won't get through at all. In that case, that datagram has to be sent again.

The terms datagram and packet often seem to be nearly interchangable. Technically, datagram is the right word to use when describing TCP/IP. A datagram is a unit of data, which is what the protocols deal with. A packet is a physical item, appearing on an Ethernet or some wire. In most cases, a packet simply contains a datagram, so there is little difference. However, they can differ. When TCP/IP is used on top of X.25, the X.25 interface breaks the datagrams up into 128-byte packets. This is invisible to IP because the packets are put back together into a single datagram at the other end before being processed by TCP/IP. In this case, one IP

datagram would be carried by several packets. However, with most media, there are efficiency advantages to sending one datagram per packet, and so the distinction tends to vanish.

## The TCP level

Two separate protocols are involved in handling TCP/IP datagrams. TCP (the Transmission Control Protocol) is responsible for breaking up the message into datagrams, reassembling them at the other end, resending anything that gets lost, and putting things back in the right order. IP (the Internet Protocol) is responsible for routing individual datagrams. It may seem like TCP is doing all the work. In small networks that is true. However, in the Internet, simply getting a datagram to its destination can be a complex job. A connection may require the datagram to go through several networks at Rutgers, a serial line to the John von Neuman Supercomputer Center, a couple of Ethernets there, a series of 56Kbaud phone lines to another NSFnet site, and more Ethernets on another campus. Keeping track of the routes to all of the destinations and handling incompatibilities among different transport media turns out to be a complex job. Note that the interface between TCP and IP is fairly simple. TCP simply hands IP a datagram with a destination. IP doesn't know how this datagram relates to any datagram before it or after it.

It may have occurred to you that something is missing. You have learned about Internet addresses but not about how you keep track of multiple connections to a given system. Clearly, it isn't enough to get a datagram to the right destination. TCP has to know which connection this datagram is part of. This task is referred to as demultiplexing. In fact, there are several levels of demultiplexing going on in TCP/IP. The information needed to do this demultiplexing is contained in a series of headers. A header is simply a few extra octets tacked onto the beginning of a datagram by some protocol in order to keep track of it. It's similar to putting a letter into an envelope and putting an address on the outside. Except with modern networks, the process happens several times. For example, you put the letter in a small envelope, your secretary puts it into a larger envelope, the mail center puts that envelope into a larger one, and so on. The following overview demonstrates how headers get stuck on a message that passes through a typical TCP/IP network:

> TCP sends each of these datagrams to IP. It has to tell IP the Internet address of the computer at the other end. Note that this is all IP is concerned about. It doesn't care about what is in the datagram, or even in the TCP header. IP's job is simply to find a route for the datagram and get it to the other end. To allow gateways or other intermediate systems to forward the datagram, it adds its own header. The main items in this header are the source and destination Internet address (32-bit addresses, like 128.6.4.194), the protocol number, and another checksum. The source Internet address is simply the address of your machine. (This is necessary so the other end knows where the datagram came from.) The destination Internet address is the address of the other machine. (This is necessary so any gateways in the middle know where you want the datagram to go.) The protocol number tells IP at the other end

to send the datagram to TCP. Although most IP traffic uses TCP, there are other protocols that can use IP, so you have to tell IP which protocol to send the datagram to. Finally, the checksum lets IP at the other end verify that the header wasn't damaged in transit. Note that TCP and IP have separate checksums. IP needs to be able to verify that the header didn't get damaged in transit, or it could send a message to the wrong place. It is both more efficient and safer to have TCP compute a separate checksum for the TCP header and data.

## UNDERSTANDING THE COMPONENTS OF THE TCP/IP PROTOCOL SUITE

HTTP is a subset of a broader set of protocols that fall under the Transmission Control Protocol/Internet Protocol (TCP/IP) umbrella. TCP/IP is a set of protocols developed to allow cooperating computers share resources across a network. It was developed by a community of researchers centered around the ARPAnet, the best-known TCP/IP network. However, as of June 1987, at least 130 different vendors had products that support TCP/IP, and thousands of networks of all types use it.

The most accurate name for the set of protocols described in this book is the Internet protocol suite. TCP and IP are two of the protocols in this suite. Because TCP and IP are the best known of the protocols, it has become common to use the term TCP/IP. TCP/IP is a family of protocols. A few of these protocols provide low-level functions needed for many applications, such as IP, TCP, and UDP. (These will be described in more detail later.) Others are protocols for doing specific tasks, such as transferring files between computers, sending mail, or finding out who is logged in on another computer. Initially, TCP/IP was used mostly between minicomputers or mainframes. These machines had their own disks, and generally were self-contained. The most important traditional TCP/IP services include:

**File transfer.** The file transfer protocol (FTP) lets a user on any computer get files from another computer or to send files to another computer. Security is handled by requiring the user to specify a user name and password for the other computer. Provisions are made for handling file transfer between machines with different character set, end of line conventions, and so on. This is not the same as more recent network file system or netbios protocols, which will be described below. Rather, FTP is a utility that you run any time you want to access a file on another system. You use it to copy the file to your own system. You then work with the local copy. (See RFC 959 for specifications for FTP.)

**Remote login.** The network terminal protocol (TELNET) lets a user log in on any other computer on the network. You start a remote session by specifying a computer to connect to. From that time until you finish the session, anything you type is sent to the other computer.

Note that you are still talking to your own computer, but the Telnet program effectively makes your computer invisible while it is running. Every character you type is sent directly to the other system. Generally, the connection to the remote computer behaves much like a dial-up connection. That is, the remote system will ask you to log in and give a password, in whatever manner it would normally ask a user who had just dialed it up. When you log off of the other computer, the Telnet program exits, and you will find yourself talking to your own computer. Microcomputer implementations of Telnet generally include a terminal emulator for some common type of terminal. (See RFC's 854 and 855 for specifications for Telnet. The Telnet protocol should not be confused with Telenet, a vendor of commercial network services.)

**Computer mail.** This lets you send messages to users on other computers. Originally, users tended to use only one or two specific computers. They would maintain mail files on those machines. The computer mail system is simply a way for you to add a message to another user's mail file. There are some problems with this in an environment where microcomputers are used. The most serious is that a micro is not well-suited to receive computer mail. When you send mail, the mail software expects to be able to open a connection to the addressee's computer, in order to send the mail. If this is a microcomputer, it may be turned off, or it may be running an application other than the mail system. For this reason, mail is normally handled by a larger system, where it is practical to have a mail server running all the time. Microcomputer mail software then becomes a user interface that retrieves mail from the mail server. (See RFC 821 and 822 for specifications for computer mail. See RFC 937 for a protocol designed for microcomputers to use in reading mail from a mail server.)

It stands to reason that HTTP should now be considered the most widely used protocol of the TCP/IP suite with some half billion people accessing Web resources daily. Second in line would be the mail protocols, SMTP and POP3, with FTP running a close third. Because TCP and IP are the encapsulation and segmenting mechanisms for transporting the other protocols in the suite, the others are said to run on top of them.

## PROTOCOLS RELATIVE TO TCP

TCP is responsible for breaking up messages into datagrams, and reassembling them properly. However, in many applications, you will have messages that always fit in a single datagram. An example is name lookup. When a user attempts to make a connection to another system, he or she will generally specify the system by name, rather than Internet address. The user's system has to translate that name to an address before it can do anything. Generally, only a few systems have the database used to translate names to addresses. So the user's system will want to send a query to one of the systems that has the database. This query is going to be very short. It will fit in one datagram. So will the answer. Thus, it seems silly to use TCP. Of

course, TCP does more than just break things up into datagrams. It also makes sure that the data arrives, resending datagrams where necessary. But for a question that fits in a single datagram, you don't need all the complexity of TCP. If you don't get an answer after a few seconds, you can just ask again. For applications like this, there are alternatives to TCP.

The most common alternative is UDP (user datagram protocol). UDP is designed for applications where you don't need to put sequences of datagrams together. It fits into the system much like TCP. There is a UDP header. The network software puts the UDP header on the front of your data, just as it would put a TCP header on the front of your data. Then UDP sends the data to IP, which adds the IP header, putting UDP's protocol number in the protocol field instead of TCP's protocol number. However, UDP doesn't do as much as TCP does. It doesn't split data into multiple datagrams. It doesn't keep track of what it has sent so it can resend, if necessary. UDP provides port numbers so that several programs can use UDP at once. UDP port numbers are used just like TCP port numbers. There are well-known port numbers for servers that use UDP. Note that even though the UDP header is shorter than a TCP header, it still has source and destination port numbers and a checksum. There is no sequence number, since it is not needed. UDP is used by the protocols that handle name lookups (see IEN 116, RFC 882, and RFC 883), and a number of similar protocols. UDP, while not as connection oriented as TCP, does have advantages in that it is much faster with a smaller footprint. Because of the quick and light nature of this protocol, it is used often in many of today's Web multimedia products, such as streaming audio.

Another alternative protocol is ICMP (Internet control message protocol). ICMP is used for error messages, and other messages intended for the TCP/IP software itself, rather than any particular user program. For example, if you attempt to connect to a host, your system may get back an ICMP message saying host unreachable. ICMP can also be used to find out some information about the network. See RFC 792 for details of ICMP. ICMP is similar to UDP, in that it handles messages that fit in one datagram. However, it is simpler than UDP. It doesn't have port numbers in its header. Since all ICMP messages are interpreted by the network software itself, no port numbers are needed to say where a ICMP message is supposed to go.

## EVALUATING HOW INFORMATION TRANSMITS ACROSS THE WEB'S TCP/IP BACKBONE

Stop and think for a moment how the Web got its name. Imagine thousands of interconnecting strands with connection points throughout the structure much like that of a spider's web. Today, this name still fits the Internet though it is more of a tangled web with millions of connection points and hundreds of millions of users supported.

Like a spider's web or, more accurately, a mesh of fibers, some fiber is invariably larger in diameter than other fibers in the mesh or weave. Think of these larger fibers as the larger

bandwidth lines owned by the world's Internet backbone providers. These companies consist of such names as MCI/Worldcom, Sprint, and UUNET, to name a few. These providers own and operate digital data lines that are capable of transmitting gigabytes of data and are arranged as redundant systems. In the event of a failure, the traffic can be rerouted. Connections to these backbone providers is typically reserved for large Internet Service Providers (ISPs), large hosting facilities, and educational and governmental bodies.

Downstream from these larger providers may be intermediate carriers that provide Internet access to large business, hosting providers and ISPs, dedicated service for businesses, as well as dial up support for home users. Examples include carriers like Verio.

Further downstream from the intermediate carriers are smaller local carriers, usually termed local ISPs, that provide Web hosting for small to medium business and dial up service for home users.

Examining this model of how the Internet is connected lets you determine the quality of service that you are receiving by determining the amount of hops it will take to get from your ISP to a resource.

## CONSIDERING HOPS VERSUS END-TO-END TRANSMISSIONS

While the terms Internet or Web may conjure images of a single unified network of computers, the Internet really consists of many different networks that are interconnected to form a global communications network with hundreds of millions of access points. These networks are interconnected via varying link types and speeds and routing devices that decide where the packets should go.

The path of a TCP/IP packet from your dial-up line to the resource you are accessing on the Web is not a straight end-to-end connection. The TCP/IP packet may take dozens of hops from router to router to reach a particular resource.

To better illustrate this, consider using the TCP/IP tool "TRACEROUTE" (TRACERT in Microsoft-based operating systems). Once you are connected to the Internet, from a command prompt type in the following:

**Traceroute (or tracert) www.yahoo.com**

Each of the returned lines represents a router junction or hop between your internet connection and the resource *www.yahoo.com*.

## SECURITY CONSIDERATIONS OF TCP/IP

Part of the popularity of the TCP/IP protocol suite is due to its ability to be implemented on top of a variety of communications channels and lower-level protocols, such as T1 and X.25, Ethernet, and RS-232-controlled serial lines. Most sites use Ethernet connections at local-area networks to connect hosts and client systems, and then connect that network via a T1 line to a regional network (a regional TCP/IP backbone) that connects to other organizational networks and backbones. Sites customarily have one connection to the Internet, but large sites often have two or more connections. Modem speeds are increasing as new communications standards are being approved, thus versions of TCP/IP that operate over the switched telephone network are becoming more popular. Many sites and individuals use PPP (Point-to-Point Protocol) and SLIP (Serial Line IP) to connect networks and workstations to other networks using the switched telephone network.

TCP/IP is more correctly a *suite* of protocols including TCP and IP, UDP (User Datagram Protocol), ICMP (Internet Control Message Protocol), and several others. The TCP/IP protocol suite does not conform exactly to the Open Systems Interconnection's seven-layer model.

Some of the problems with Internet security are a result of inherent vulnerabilities in the services (and the protocols that the services implement), while others are a result of host configuration and access controls that are poorly implemented or overly complex to administer. Additionally, the role and importance of system management is often short changed in job descriptions, resulting in many administrators being, at best, part-time and poorly prepared. This is further aggravated by the tremendous growth of the Internet and how the Internet is used—businesses and agencies now depend on the Internet (often more than they realize) for communications and research and thus have much more to lose if their sites are attacked. The following list outlines the inherent weaknesses of the TCP/IP protocol:

- Weak authentication
- Protocol tampering
- Specific stack weaknesses
- Ability to hijack sessions
- Ability to spoof identities
- Ability to eavesdrop on connections

From these weaknesses stem the hacks that occur every minute of the day and continually plague the new business Internet.

**181**

## PACKET SNIFFERS, MEN-IN-THE-MIDDLE, AND OTHER SECURITY RISKS

To understand the common hacks found on the Internet today, you must first understand what it is that the hacker is after. For the most part, a hack is a malicious attack on some computer and is not limited to those systems on the Internet. The most commonly found attacks on computer systems are *internal* rather than external.

The hack is equated to a break-in, burglary, and/or vandalism. The majority of attacks are focused on achieving some prize, usually your information. Other times the attack may be a prank, such as changing your company's Web page. Further, the hacker(s) may initiate a denial of service attack where some resource on the Web is shut down.

Because of the innate insecure nature of the TCP/IP protocol, these attacks are quite common. Many times a hacker will institute a rogue machine on the Internet and simply listen in, gathering information via programs called *packet sniffers*, which have the ability to grab packets off of the Internet and read the information within them. This information gathering is the first step. The second step is to actually exploit the information that has been gathered by trying to logon to remote systems using the information gathered. If these logon attempts fail, the hacker will often attempt to fake or spoof the identity of a trusted system by assuming the machine's IP address. All of these man-in-the-middle attacks are common and necessitate the use of secondary protection methods, such as encryption, or newer protocol technology such as IPv6 or IPSEC.

## UNDERSTANDING THE HTTPS PROTOCOL

HTTPS (Secure HyperText Transfer Protocol) is a Web protocol developed by Netscape and supported now by most browsers that encrypt and decrypt user page requests, as well as, the pages that are returned by the Web server. HTTPS is really just the use of Netscape's Secure Socket Layer (SSL) as a sublayer under its regular HTTP application layer. (HTTPS uses port 443 instead of HTTP port 80 in its interactions with the lower layer, TCP/IP.) SSL uses a 40-bit key size for the RC4 stream encryption algorithm, which is considered an adequate degree of encryption for commercial exchange.

Suppose you use a Netscape browser to visit a Web site such as *Amazon.com* (*http://www.amazon.com*), and view their catalog. When you're ready to order, you will be given a Web page order form with a URL that starts with https://. When you click Send to send the page back to the catalog retailer, your browser's HTTPS layer will encrypt it. The

acknowledgement you receive from the server will also travel in encrypted form, arrive with an https:// URL, and be decrypted for you by your browser's HTTPS sublayer.

HTTPS and SSL support the use of X.509 digital certificates from the server so that, if necessary, a user can authenticate the sender. SSL is an open, non-proprietary protocol that Netscape has proposed as a standard to the World Wide Consortium (W3C). HTTPS is not to be confused with SHTTP, a security-enhanced version of HTTP developed and proposed as a standard by EIT.

## UNDERSTANDING ENCRYPTION

Encryption is defined as the translation of data into a secret code. Encryption is the most effective way to achieve data security. To read an encrypted file, you must have access to a secret key or password that enables you to *decrypt* it. Unencrypted data is called *plain text* and encrypted data is referred to as *cipher text*.

There are two main types of encryption: asymmetric encryption (also called public-key encryption) and symmetric encryption.

Public key encryption is a cryptographic system that uses two keys—a *public* key known to everyone and a *private* or *secret* key known only to the recipient of the message. When John wants to send a secure message to Jane, he uses Jane's public key to encrypt the message. Jane then uses her private key to decrypt it.

An important element to the public key system is that the public and private keys are related in such a way that only the public key can be used to encrypt messages and only the corresponding private key can be used to decrypt them. Moreover, it is virtually impossible to deduce the private key if you know the public key.

Public-key systems, such as Pretty Good Privacy (PGP), are becoming popular for transmitting information via the Internet. They are extremely secure and relatively simple to use. The only difficulty with public-key systems is that you need to know the recipient's public key to encrypt a message for him or her. What's needed, therefore, is a global registry of public keys, which is one of the promises of the new LDAP technology.

Public-key cryptography was invented in 1976 by Whitfield Diffie and Martin Hellman. Thus, it is sometimes called *Diffie-Hellman encryption*. It is also called *asymmetric encryption* because it uses two keys instead of one (*symmetric encryption*).

Symmetric encryption is a type of encryption where the same key is used to encrypt and decrypt the message. This differs from asymmetric (or public-key) encryption, which uses one key to encrypt a message and another to decrypt the message.

## OTHER PROTOCOL-INTEGRATED SECURITY METHODS

S-HTTP is an extension to the HTTP protocol to support sending data securely over the World Wide Web. Not all Web browsers and servers support S-HTTP. Another technology for transmitting secure communications over the World Wide Web—Secure Sockets Layer (SSL)—is more prevalent. However, SSL and S-HTTP have very different designs and goals so it is possible to use the two protocols together. Whereas SSL is designed to establish a secure connection between two computers, S-HTTP is designed to send individual messages securely. Both protocols have been submitted to the Internet Engineering Task Force (IETF) for approval as a standard. Used in conjunction with IPv6, which also incorporates security features, it offers the next generation of Web surfers tightly controlled and secure access via multiple layers of security.

## UNDERSTANDING THE NEW IPv6 PROTOCOL

The Internet Protocol was introduced in the ARPANET in the mid-1970s. The version of IP in common use today is IP version 4 (IPv4), described in Request for Comments (RFC) 791 (September, 1981). Although several protocol suites (including Open System Interconnection) have been proposed over the years to replace IPv4, none have succeeded because of IPv4's large, and continually growing, installed base. Nevertheless, IPv4 was never intended for the Internet as it is today, either in terms of the number of hosts, types of applications, or security concerns.

In the early 1990's, the Internet Engineering Task Force (IETF) recognized that the only way to cope with these changes was to design a new version of IP to become the successor to IPv4. The IETF formed the IP next generation (IPng) Working Group to define this transitional protocol to ensure long-term compatibility between the current and new IP versions and support for current and emerging IP-based applications.

Work started on IPng in 1991 and several IPng proposals were subsequently drafted. The result of this effort was IP version 6 (IPv6), described in RFCs 1883-1886. These four RFCs were officially entered into the Internet Standards Track in December 1995.

## NEW FEATURES IN IPV6

IPv6 is designed as an evolution from IPv4 rather than as a radical change. Useful features of IPv4 were carried over in IPv6 and less useful features were dropped. According to the IPv6 specification, the changes from IPv4 to IPv6 fall primarily into the following categories:

- *Expanded Addressing Capabilities:* The IP address size is increased from 32-bits to 128-bits in IPv6, supporting a much greater number of addressable nodes, more levels of addressing hierarchy, and simpler auto-configuration of addresses for remote users. The scalability of multicast routing is improved by adding a *Scope* field to multicast addresses. A new type of address, called *anycast*, is also defined.

- *Header Format Simplification:* Some IPv4 header fields have been dropped or made optional to reduce the necessary amount of packet processing and to limit the bandwidth cost of the IPv6 header.

- *Improved Support for Extensions and Options:* IPv6 header options are encoded in such a way to allow for more efficient forwarding, less stringent limits on the length of options, and greater flexibility for introducing new options in the future. Some fields of an IPv4 header have been made optional in IPv6.

- *Flow Labeling Capability:* A new quality-of-service (QOS) capability has been added to enable the labeling of packets belonging to particular traffic flows for which the sender requests special handling, such as real-time service.

- *Authentication and Privacy Capabilities:* Extensions to support security options, such as authentication, data integrity, and data confidentiality, are built in to IPv6.

IPv6 also introduces and formalizes terminology that, in the IPv4 environment, is loosely defined, ill-defined, or undefined. The new and improved terminology includes:

- *Packet:* An IPv6 protocol data unit (PDU), comprising a header and the associated payload. In IPv4, this would have been termed packet or *datagram*.

- *Node:* A device that implements IPv6.

- *Router:* An IPv6 node that forwards packets, based on the IP address, not explicitly addressed to itself. In former TCP/IP terminology, this device was often referred to as a *gateway*.

- *Host:* Any node that is not a router; these are typically end-user systems.

- *Link:* A medium over which nodes communicate with each other at the Data Link Layer (such as an ATM, frame relay, or SMDS wide-area network, or an Ethernet or token ring LAN).

- *Neighbors:* Nodes attached to the same *link*.

## IMPROVED TRANSMISSION SPEEDS IN IPv6

While the move toward a new IP model was mostly initiated by the need for a larger address space, overall improvements were not overlooked, namely security and protocol efficiency. IPV6 offers improved transmission speeds due to the following, which was excerpted from the proposed IPV6 standard:

### Header Format Simplification

Some IPv4 header fields have been dropped or made optional, to reduce the common-case processing cost of packet handling and to keep the bandwidth cost of the IPng header as low as possible despite the increased size of the addresses. Even though the IPng addresses are four times longer than the IPv4 addresses, the IPng header is only twice the size of the IPv4 header.

### Improved Support for Options

Changes in the way IP header options are encoded and allows for more efficient forwarding, less stringent limits on the length of options, and greater flexibility for introducing new options in the future.

### Quality-of-Service Capabilities

A new capability is added to enable the labeling of packets belonging to particular traffic flows for which the sender requests special handling, such as non-default quality of service or real-time service.

## SECURITY CONCERNS OF IPv6 ADDRESSES

In the early days of TCP/IP, the ARPANET user community was small and close, and security mechanisms were not of primary concern. As the number of TCP/IP hosts grew, and the user community became one of strangers (some nefarious) rather than friends, security became more important. As critical and sensitive data travels on today's Internet, security is of paramount concern.

Although many of today's TCP/IP applications have their own security mechanisms, many would argue that security should be implemented at the lowest possible protocol layer. IPv4 had few, if any, security mechanisms, and authentication and privacy mechanisms at lower protocol layers is largely absent. IPv6 builds two security schemes into the basic protocol.

The first mechanism is the IP Authentication Header (RFC 1826), an extension header that can provide integrity and authentication for IP packets. Although many different authentication techniques will be supported, use of the keyed Message Digest 5 (MD5, described in RFC 1321) algorithm is required to ensure interoperability. Use of this option can eliminate a large number of network attacks, such as IP address spoofing, and it will also be an important addition to overcoming some of the security weaknesses of IP source routing. IPv4 provides no host authentication—all IPv4 can do is to supply the sending host's address *as advertised by the sending host* in the IP datagram. Placing host authentication information at the Internet Layer in IPv6 provides significant protection to higher layer protocols and services that currently lack meaningful authentication processes.

The second mechanism is the IP Encapsulating Security Payload (ESP, described in RFC 1827), an extension header that provides integrity and confidentiality for IP packets. Although the ESP definition is algorithm-independent, the Data Encryption Standard using cipher block chaining mode (DES-CBC) is specified as the standard encryption scheme to ensure interoperability. The ESP mechanism can be used to encrypt an entire IP packet (*tunnel-mode ESP*) or just the higher layer portion of the payload (*transport-mode ESP*).

These features will add to the secure nature of IP traffic while actually reducing the security effort. Authentication performed on an end-to-end basis during session establishment will provide more secure communications even in the absence of firewall routers. Some have suggested that the need for firewalls will be obviated by widespread use of IPv6, although there is no evidence to that effect yet.

## ADVANCED HARDWARE SUPPORT OF IPV6

Until service providers build IPv6 backbones and offer IPv6 services, end-to-end IPv6 will require tunneling through IPv4 networks. This is accomplished by encapsulating an IPv6 packet into the payload of an IPv4 packet. An IPv6 node originates the IPv6 packets, which are encapsulated in IPv4 and forwarded through the IPv4 network. The node at the end of the tunnel uncouples the IPv4 packet, exposing the IPv6 packet for delivery to the destination node.

The type of tunnel will vary depending on who's doing the encapsulating and uncoupling. Router-to-router tunnels can be used to hook up two IPv6-only networks separated by an IPv4-only network (like the Internet). Host-to-router tunnels let isolated dual-IP hosts cut across an IPv4-only network to communicate with IPv6 networks through a dual-IP router. Router-to-host tunnels link isolated IPv6 or IPv4 nodes with IPv6 networks, while host-to-host tunnels let isolated IPv6 or IPv4 nodes communicate with one another through IPv4 networks. (In this last case, the two dual-IP nodes could just as easily use IPv4 to communicate, as the end-to-end route is identical to the tunnel's end points.)

How the end points are determined also can vary. IPv6 tunnels can be configured automatically or by IPv4 multicast tunneling. In a configured tunnel, the end point is determined independently from the IPv6 packet destination; this usually means that someone has to configure the system doing the IPv4 encapsulation to indicate where to send the IPv4 packets. Automatic tunnels are created when the IPv6 packet uses an IPv4-compatible address and ends up at a dual-IP node with either protocol. Automatic tunneling propagates the entire IPv4 routing table within the IPv6 routing infrastructure, and it does nothing about IPv4 address depletion. IPv4 multicast tunneling is possible only within an IPv4 infrastructure that supports multicast. The node encapsulating IPv6 in IPv4 determines the tunnel end point by using IPv4 multicast to do neighbor discovery. That's a mechanism that lets an IPv6 node discover other nodes on the same link, determine their link-layer addresses, find routers, and maintain information about paths to active neighbors. This option eliminates tunnel configuration, as well as the use of IPv4-compatible addresses—but finding an IPv4 infrastructure that supports multicast may be difficult because many ISPs (Internet service providers) don't offer multicast routing yet.

## PROTOCOL-IMPOSED LIMITATIONS ON HTML

The innate nature of the HTTP protocol being stateless provides some interesting problems for Web developers, the biggest of which is trying to maintain a semblance of state to carry over transactions from place to place.

Suppose, for example, a Web developer wants to develop a series of forms of which some data from previous forms (form A to form C) will carry over. Because of the stateless nature of HTTP, the connection and the session are closed. This is in contrast to a program that maintains state throughout, such as a game or business application.

Fortunately for developers, there are several ways to overcome this shortcoming including scripting and cookies.

## HTML ADVANCES TO SIDESTEP OR ELIMINATE LIMITATIONS

After the server has responded to the client's request, the connection between client and server is dropped and forgotten. There is no memory between client connections. The pure HTTP server implementation treats every request as if it was brand-new, without context.

CGI applications get around this by encoding the state or a state identifier in hidden fields, the path information, or URLs in the form being returned to the browser. The first two methods return the state or its ID when the form is submitted back by the user. The method of encoding state into hyperlinks (URLs) in the form only returns the state (or ID) if the user clicks on the link, and the link is back to the originating server.

It's often advisable to not encode the whole state but to save it, for example, in a file, and identify it by means of a unique identifier, such as a sequential integer. Visitor counter programs can be adapted very nicely for this and thereby become useful. You then only have to send the state identifier in the form, which is advisable if the state vector becomes large, thus saving network traffic. However, you then have to take care of housekeeping the state files by periodic clean-up tasks.

## UNDERSTANDING THE DIFFERENCE BETWEEN THE NETSCAPE AND MICROSOFT IMPLEMENTATIONS OF DHTML

Dynamic HTML supports richer multimedia Web content through a collection of new technologies in the 4.0 browsers. Some of these technologies are common to both browsers, while others are unique to either Microsoft or Netscape.

The three DHTML concepts shown below are common to both the Netscape and Microsoft 4.0 browsers, though some of their specific support differs in the details:

- Cascading Style Sheets

- Document Object Model
- JavaScript

Cascading Style Sheets are used to define the appearance of content on Web pages. Much of the expressive nature of Dynamic HTML is based on these new settings, and fortunately they are defined in the same way in both Microsoft and Netscape's browsers.

The Document Object Model is a common concept in both browsers, providing scripting access to Web page elements. The actual Microsoft and Netscape object models are different, making it challenging to write JavaScript which works in both, as described below.

### Microsoft model

Scripting access to all HTML page elements is supported in Internet Explorer, including style sheet properties. Page elements are reflected as objects contained in a *document.all* collection, and elements can be accessed by index, name, or ID.

### Netscape model

Scripting access to specific collections of HTML page elements is supported, such as layers on the page. The layer collection in Navigator includes areas bounded by a <layer> tag and areas positioned using CSS attributes. Elements can be accessed by index, name, or ID within those collections.

The JavaScript language is largely common to both 4.0 and greater browsers, though a final agreement on it is being reached through the ECMA standards body. Unfortunately, their event handling models are different, in fact, they are reversed.

## UNDERSTANDING THE ADVANCEMENTS OF HTML 4.0

There have been a number of advancements in the HTML version 4.0 specification from the previously adopted 3.2 version. While some elements have been added or removed, many of the advancements are semantic and help to further integrate dynamic HTML into the existing tag base. The following is a summary of these changes and have been reprinted from the w3c.org for accuracy:

This section describes how the 18 December 1997 specification of HTML 4.0 differs from HTML 3.2.

## Changes to elements

### New elements

The new elements in HTML 4.0 are: ABBR, ACRONYM, BDO, BUTTON, COL, COLGROUP, DEL, FIELDSET, FRAME, FRAMESET, IFRAME, INS, LABEL, LEGEND, NOFRAMES, NOSCRIPT, OBJECT, OPTGROUP, PARAM, S (deprecated), SPAN, TBODY, TFOOT, THEAD, and Q.

### Deprecated elements

The following elements are deprecated: APPLET, BASEFONT, CENTER, DIR, FONT, ISINDEX, MENU, S, STRIKE, and U.

### Obsolete elements

The following elements are obsolete: LISTING, PLAINTEXT, and XMP. For all of them, authors should use the PRE element instead.

## Changes to attributes

Almost all attributes that specify the presentation of an HTML document (e.g., colors, alignment, fonts, graphics, etc.) have been deprecated in favor of style sheets. The list of attributes in the appendix indicates which attributes have been deprecated.

The ID and CLASS attribute allow authors to assign name and class information to elements for style sheets, as anchors, for scripting, for object declarations, general purpose document processing, etc.

## Changes for accessibility

HTML 4.0 features many changes to promote accessibility, including:

The TITLE attribute may now be set on virtually every element.

Authors may provide long descriptions of tables (see the SUMMARY attribute), images and frames (see the LONG DESC attribute).

## Changes for meta data

Authors may now specify profiles that provide explanations about meta data specified with the META or LINK elements.

### Changes for text

New features for internationalization allow authors to specify text direction and language.

The INS and DEL elements allow authors to mark up changes in their documents.

The ABBR and ACRONYM elements allow authors to mark up abbreviations and acronyms in their documents.

### Changes for links

The ID attribute makes any element the destination anchor of a link.

### Changes for tables

The HTML 4.0 table model has grown out of early work on HTML+ and the initial draft of HTML 3.0. The earlier model has been extended in response to requests from information providers as follows:

- Authors may specify tables that may be incrementally displayed as the user agent receives data.

- Authors may specify tables that are more accessible to users with non-visual user agents.

- Authors may specify tables with fixed headers and footers. User agents may take advantage of these when scrolling large tables or rendering tables to paged media.

The HTML 4.0 table model also satisfies requests for optional column-based defaults for alignment properties, more flexibility in specifying table frames and rules, and the ability to align on designated characters. It is expected, however, that style sheets will take over the task of rendering tables in the near future.

In addition, a major goal has been to provide backwards compatibility with the widely deployed Netscape implementation of tables. Another goal has been to simplify importing tables conforming to the SGML CALS model. The latest draft makes the align attribute compatible with the latest versions of the most popular browsers. Some clarifications have been made to the role of the dir attribute and recommended behavior when absolute and relative column widths are mixed.

A new element, COLGROUP, has been introduced to allow sets of columns to be grouped with different width and alignment properties specified by one or more COL elements. The semantics of COLGROUP have been clarified over previous drafts, and rules="basic" has been replaced by rules="groups".

The style attribute is included as a means for extending the properties associated with edges and interiors of groups of cells. For instance, the line style: dotted, double, thin/thick etc; the

color/pattern fill for the interior; cell margins and font information. This will be the subject for a companion specification on style sheets.

The frame and rules attributes have been modified to avoid SGML name clashes with each other, and to avoid clashes with the ALIGN and VALIGN attributes. These changes were additionally motivated by the desire to avoid future problems if this specification is extended to allow frame and rules attributes with other table elements.

### Changes for images, objects, and image maps

- The OBJECT element allows generic inclusion of objects.

- The IFRAME and OBJECT elements allow authors to create embedded documents.

- The alt attribute is required on the IMG and AREA elements.

- The mechanism for creating image maps now allows authors to create more accessible image maps. The content model of the MAP element has changed for this reason.

### Changes for forms

This specification introduces several new attributes and elements that affect forms:

- The ACCESSKEY attribute allows authors to specify direct keyboard access to form controls.

- The DISABLED attribute allows authors to make a form control initially insensitive.

- The READONLY attribute, allows authors to prohibit changes to a form control.

- The LABEL element associates a label with a particular form control.

- The FIELDSET element groups related fields together and, in association with the LEGEND element, can be used to name the group. Both of these new elements allow better rendering and better interactivity. Speech-based browsers can better describe the form and graphic browsers can make labels sensitive.

- A new set of attributes, in combination with scripts, allow form providers to verify user-entered data.

- The BUTTON element and INPUT with TYPE set to "button" can be used in combination with scripts to create richer forms.

- The OPTGROUP element allows authors to group menu options together in a SELECT, which is particularly important for form accessibility.

Additional changes for internationalization.

### Changes for style sheets

HTML 4.0 supports a larger set of media descriptors so that authors may write device-sensitive style sheets.

### Changes for frames

HTML 4.0 supports frame documents and inline frames.

### Changes for scripting

Many elements now feature event attributes that may be coupled with scripts; the script is executed when the event occurs (e.g., when a document is loaded, when the mouse is clicked, etc.).

### Changes for internationalization

HTML 4.0 integrates the recommendations of [RFC2070] for the internationalization of HTML.

However, this specification and [RFC2070] differ as follows:

- The ACCEPT-CHARSET attribute has been specified for the FORM element rather than the TEXTAREA and INPUT elements.

- The HTML 4.0 specification makes additional clarifications with respect to the bidirectional algorithm.

- The use of CDATA to define the SCRIPT and STYLE elements does not preserve the ability to transcode documents, as described in section 2.1 of [RFC2070].

## INTRODUCING THE NEW <ACRONYM> ELEMENT

The <acronym> element specifies that the enclosed text is an acronym (WWW). It is one of the new HTML 4.0 elements (technically a roll-over from HTML version 3.0) and is currently only supported by **Internet Explorer** 4.0.

```
<ACRONYM TITLE="HyperText Markup Language">HTML</ACRONYM>
```

The <acronym> element is ideally targeted at speech synthesis and other non-visual Web browsers, so it may not render visually on all browsers. The <acronym> tag supports the following attributes:

- TITLE="informational ToolTip"

  The **Internet Explorer** 4.0 (and above) specific TITLE attribute is used for informational purposes. For the <ACRONYM> element, the TITLE attribute should be used to provide the extended definition of the acronym. If present, the value of the TITLE attribute is presented as a ToolTip when the user's mouse hovers over the <ACRONYM> section.

- LANG="language setting"

  The LANG attribute can be used to specify what language the <ACRONYM> element is using. It accepts any valid ISO standard language abbreviation (for example, en for English, de for German, and so on.) For more details, see the Document Localization section for more details.

- LANGUAGE="Scripting language"

  The LANGUAGE attribute can be used to expressly specify which scripting language **Internet Explorer** 4.0 uses to interpret any scripting information used in the <acronym> element. It can accept values of VBScript, VBS, JAVA or JSCRIPT. The first two specify the scripting language as Visual Basic Script, the latter two specify it as using Javascript (the default scripting language used if no LANGUAGE attribute is set.

- CLASS="Style Sheet class name"

  The CLASS attribute is used to specify the <ACRONYM> element as using a particular style sheet class. See the Style Sheets topic for details.

- STYLE="In line style setting"

  As well as using previously defined style sheet settings, the <acronym> element can have in-line styling attached to it. See the Style Sheets topic for details.

## INTRODUCING THE NEW <Q> ELEMENT

The <Quote> or <Q> element is a welcome update to the HTML markup language for users that still use a text editor to generate their Web pages. While the change may seem trivial, the <Q> element takes the place of the <BLOCKQUOTE> element and is used to section text in an indented, blocked paragraph.

Usage of the <Quote> element is as follows:

```
<HTML>

<HEAD>

<TITLE></TITLE>

</HEAD>

<BODY>
```

The following quotation is cited from Joseph Roux:

**<Q>** "We call that person who has lost his father, an orphan; and a widower that man who has lost his wife. But that man who has known the immense unhappiness of losing a friend, by what name do we call him? Here every language is silent and holds its peace in impotence."

```
</Q>

</BODY>

</HTML>
```

## USING THE <INS> AND <DEL> TAGS TO HIGHLIGHT DOCUMENT CHANGES

The idea behind many of the advancements of the HTML specification is to offer the same features found in many of today's popular word processor programs. One of the most important features used by groups of users working on the same document is the ability to track document changes throughout the written work. Tracking is used heavily in the publishing industry to monitor the changes of a book.

The <INS> element specifies that the enclosed text has been inserted, since the document was originally written. Along with <DEL>, the two HTML 4.0 elements are used to mark document revisions. Typically, it renders underlined, but any style can be used with the <INS> element. For example:

```
<INS CITE="http://www.company.com/docs/marketing01.html"
DATETIME="1999-09-02T18:41:00+0:00">New Marketing Procedures</
INS>
```

The above code listing would render as:

New Marketing Procedures

The <INS> tag supports the following attributes:

**CITE**="citation"

The CITE attribute should contain a URL, defining a document that specifies the details of the newly inserted text. For example, an author who inserts some text in a document, based on a new company procedure, could use the CITE attribute to specify the URL of a document that defines the new procedure.

**DATETIME**="Date/time of insertion"

The DATETIME attribute can be used to specify the date and time that the insertion was made. The DATETIME attribute value is of a specific format, being YYYY-MM-DDThh:mm:ssTZD to specify the year, month, date, hours (using 24-hour clock notation), minutes, seconds, and a Time Zone identifier. In the above example, the DATETIME attribute is set to 1999-09-02T18:41:00+0:00, which would mark the new procedure information as being inserted as 5.53:12pm on the 6th January 1997, Greenwich Mean Time, also referencing the source of the new procedure information.

**TITLE**="informational ToolTip"

The **Internet Explorer** 4.0 (and above) specific TITLE attribute is used for informational purposes. If present, the value of the TITLE attribute is presented as a ToolTip when the user's mouse hovers over the <INS> section.

**LANG**="language setting"

The LANG attribute can be used to specify what language the <INS> element is using. It accepts any valid ISO standard language abbreviation (for example, en for English, de for German, and so on.)

**LANGUAGE**="Scripting language"

The LANGUAGE attribute can be used to expressly specify which scripting language **Internet Explorer** 4.0 uses to interpret any scripting information used in the <INS> element. It can

accept values of VB, VBScript, Java, or JavaScript. The first two specify the scripting language as Visual Basic Script, the latter two specify it as using JavaScript (the default scripting language used if no LANGUAGE attribute is set).

**CLASS**="Style Sheet class name"

The CLASS attribute is used to specify the <INS> element as using a particular style sheet class. See the Style Sheets topic for details.

**STYLE**="In-line style setting"

As well as using previously defined style sheet settings, the <INS> element can have in-line stylings attached to it. See the Style Sheets topic for details.

**ID**="Unique element identifier"

The ID attribute can be used to either reference a unique style sheet identifier, or to provide a unique name for the <INS> element for scripting purposes. Any <INS> element with an ID attribute can be directly manipulated in script by referencing its ID attribute, rather than working through the All collection to determine the element. See the Scripting introduction topic for more information.

## USING THE <FIELDSET> AND <LEGEND> TAGS TO GROUP ELEMENTS

The <FIELDSET> element can be used to provide a framed container around any other HTML elements. Visual Basic developers should be familiar with the <FIELDSET> frame concept—it being similar to the Frame control in Visual Basic. The <FIELDSET> tag *requires* that the first element it contains to be the <LEGEND> tag, to provide the legend for the field set. The <LEGEND> element provides a label for the <FIELDSET> element. For the <LEGEND> element to be used as the <FIELDSET> label, it *must* be the first element contained in the <FIELDSET> block. The <FIELDSET> element can be nested to contain discrete groups of HTML elements, inside a larger fieldset container group.

*Note:* The <FIELDSET> element is a new element introduced in HTML 4.0 draft specifications and is only supported by **Internet Explorer** 4.0 and above.

## UNDERSTANDING THE DIFFERENCE BETWEEN THE HTML 3.2 AND HTML 4.0 <BUTTON> TAGS

The <BUTTON> tag element has been extended to add greater functionality in the HTML 4.0 specification. With the new features, authors have the choice of creating three types of buttons:

- **Submit buttons (carries over):** When activated, a Submit button submits a form. A form may contain more than one Submit button.

- **Reset button (carries over):** When activated, a reset button resets all controls to their initial values.

- **Push buttons (new):** Push buttons have no default behavior. Each push button may have client-side scripts associated with the element's event attributes. When an event occurs (e.g., the user presses the button, releases it, and so on.), the associated script is triggered.

Authors should specify the scripting language of a push button script through a default script declaration (with the <META> element).

Authors create buttons with the <BUTTON> element or the <INPUT> element. You can consult the definitions of these elements for details about specifying different button types.

*Note:* *Authors should note that the* <BUTTON> *element offers richer rendering capabilities than the* <INPUT> *element.*

## USING THE <COLGROUP> TAG TO GROUP COLUMNS IN A TABLE

There has been a large push in the past to make the formatting of tables easier. The new HTML 4.0 tag <COLGROUP> makes this process easier than ever. This command lets an entire column of data in tables be affected by one command rather than using a separate command for each cell. The following is an example of the usage:

```
<COLGROUP WIDTH="30%"></COLGROUP>
```

The columns of the resulting table are each proportioned to 30% of the table width.

## UNDERSTANDING THE DEPRECATED ELEMENTS IN HTML 4.0

Several elements have been dropped from the new HTML 4.0 specification for various reasons. The following elements are considered deprecated by the W3C:

```
APPLET

BASEFONT

CENTER

DIR

FONT

ISINDEX

MENU

S

STRIKE

U
```

Most of these elements are replaced by new elements that consolidate or function the same.

## INTRODUCING STYLE SHEETS

You may find it frustrating not being able to control how HTML content appears on Web pages.  Now that Web sites encompass hundreds or thousands of pages, consistency is key. Tables have proven awkward and frames are far worse to handle in any Web site, but in the past if you wanted your pages to work in Netscape Navigator and Microsoft Internet Explorer, frames and tables were the common denominator.

Fortunately, those days have passed with the advent of Cascading Style Sheets (CSS). Both Netscape and Internet Explorer support Cascading Style Sheets (CSS), which give Web developers more control over style and layout. (Style sheets made a limited appearance in Internet Explorer 3.0, but not in Navigator 3.0.)

Best of all, the CSS specification is a recommended industry standard by the World Wide Web Consortium (W3C). Style sheets work like templates—you define the style for a particular HTML element once, and then use it over and over on any number of Web pages. If you want to change how an element looks, you just change the style: the element automatically changes wherever it appears. (Before CSS, you had to change the element individually, each time it appeared.) Style sheets let Web designers quickly create more consistent pages—and more consistent sites.

CSS is only part of the 4.0 browser story. *CSS positioning* is an extension to CSS1 that lets you control an object's precise position on the page. You can also specify whether an object is visible or hidden, and even layer objects on the page. Although not yet a W3C-recommended standard, CSS positioning is a working draft, stable enough for public discussion, although it may still change before it's final. More importantly, both Communicator and Internet Explorer 4.0 already support it.

## UNDERSTANDING THE IMPORTANCE OF STYLE SHEETS

In the past, the look of your Web pages depended on the browser they were viewed in. It was up to the browser to decide where to place your content, roughly based on the HTML. With the introduction of *CSS*, or Cascading Style Sheets, and *CSS-P*, or Cascading Style Sheets Positioning, you have strict control over the look of your pages. They also allow you to separate your pages' content and design elements. This simplifies page modifications and redesigns.

CSS is supported by Microsoft Internet Explorer browser, version 4 and up, and Netscape Navigator, version 4 and up. There are, however, a few differences in the CSS supported by each. There are three different types of Cascading Style Sheets; embedded style sheets, inline style sheets, and linked style sheets.

## USING INLINE STYLE SHEETS

Inline style sheets let you to fine tune your Web pages. These style sheets are placed right inside the tags they are to effect, hence the name inline, though this method is not truly a style sheet, per se.

An inline style sheet can be placed inside any HTML tag. If one were placed inside an <IMG> tag, it would have control over that image. If the style sheet were to be placed inside a <SPAN> tag, it would control all encompassed inside that tag.

Inline style sheets are easy to create and use, and all have the same basic format:

```
<TAG STYLE="property: value; property-2: value-2;">
```

For a real-life inline style sheet example, look at the following:

```
<DIV STYLE="background-color: aqua; font-size: 9pt; font-weight:
bold;">Look ma! I can swim!</DIV>
```

Inline style sheets have precedence over embedded and linked style sheets. Hence, the above DIV will contain 9-point text even if an embedded style sheet said it should contain 12 point text. All CSS properties used in embedded and linked style sheets apply here. For a complete list of CSS properties, see the CSS Reference table.

## USING EMBEDDED STYLE SHEETS

To embed a style sheet, you add a <STYLE> </STYLE> block at the top of your document, between the <HTML> and <BODY> tags. This lets you change the appearance of a single Web page. The <STYLE> tag has one parameter, TYPE, which specifies the MIME type as text/css which lets browsers that do not support this to ignore the style sheet. The <STYLE> tag is followed by any number of style definitions and terminated with the </STYLE> tag.

The following example specifies styles for the <BODY>, <H1>, <H2>, and <P> tags:

```
<HTML>

<STYLE TYPE="text/css">

<!–

   BODY {font: 12pt "Verdana"}

   H1 {font: 15pt/17pt "Verdana";

      font-weight: bold;

      color: maroon}

   H2 {font: 13pt/15pt "Verdana";

      font-weight: bold;

      color: blue}
```

```
    P   {font: 10pt/12pt "Verdana";

        color: black}

 ->

 </STYLE>

 <BODY>

 . . .

 </BODY>

 </HTML>
```

## USING LINKED STYLE SHEETS

If you've every created an embedded style sheet, you will have no trouble creating a linked style sheet. The only big difference is how they are implemented.

The process is simple. First, create an embedded style sheet use Notepad or a similar text editing program (SimpleText is a Mac equivalent). Save the file in text format (or ASCII) with a ".css" suffix. Let's say you name your style sheet "style". Its name would become "style.css". The file must be placed where it can be read when called so somewhere in the root of your Website or in a subdirectory labeled "style" will suffice.

We now need to link the style sheet to the Web pages. Doing so requires that you place the following HTML inside the <HEAD> section of your pages:

```
<LINK REL="stylesheet" HREF="http://www.yourpage.com/style.css"
TYPE="text/css">
```

A breakdown of each part of the above statement is shown below:

**LINK.** Tells the browser something must be linked to the page.

**REL "stylesheet".** Tells the browser that this linked item is relative to this page as a style sheet.

**HREF** -"—". Denotes where the browser will find the style sheet.

**TYPE** - "text/css". Tells the browser that what it is reading is text that will act as a Cascading Style Sheet.

The one style sheet you created and placed in your directory will affect every page that contains this command. This is a one-to-many approach to formatting all of your content pages that makes site makeovers simple. When you change the .css document, all pages that include the reference are updated.

## UNDERSTANDING CASCADING STYLE SHEETS

Style sheets let the HTML author separate presentation definitions from content in HTML documents. HTML was designed primarily as content-based mark up language, and the introduction of various text level formatting elements and attributes only served to confuse the issue. Microsoft has led the way by implementing style sheet support in **Internet Explorer** 3.0.

Anyone who does a lot of work using a word processor should be familiar with the concept of style sheets. Basically, styles are defined and then applied to blocks of text (or even single characters) by referring to the definition in the available style range.

The simplest form of style sheet could be:

```
P {color : #800000}
```

This would cause any text that is classified as a paragraph (uses a <P> element) to be rendered using a dark red color.

### Applying a style sheet to a document

Style definitions can be applied to documents and their elements in one of four ways:

- Using the LINK attribute to point to an external style sheet. (See <LINK> for details.)

- Using the <STYLE> element within the HEAD of a document. (See <STYLE> for details.)

- Using the @import mechanism (similar to the <LINK> method above, this allows the importing of external style sheets).

- Using the STYLE attribute in an element. This is allowed for any elements within the BODY of a HTML document.

The fourth option, while allowed, is not recommended as it mixes style definitions with content, which goes against the style sheet concept. An example would be:

```
<H1 STYLE="color : #FF0000">Heading 1</H1>
```

If multiple style sheet declaration methods are used (a stylesheet is <LINK>ed in and a <STYLE> block is also used), then multiple element style settings will be used in the order they are read. For example, if both the <LINK>ed style sheet and the <STYLE> block have settings for the <H*x*> element, then the setting in the <STYLE> block will take precedence. Settings using different properties on the same element will all be applied together for the element. For example, if the <LINK>ed style sheet contains A { color:red } and the <STYLE> block contains A:link { color:blue } then all <A> elements will be red, with links (i.e. <A HREF="...">) being blue. Likewise, style settings set in the STYLE attribute of an element will override any settings in a <STYLE> block or a linked style sheet.

## USING THE NEW <OBJECT> TAG INSTEAD OF THE <APPLET> TAG

The <APPLET> tag has been deprecated and the preferred replacement is the <OBJECT> tag. Do not misconstrue that this tag is a 1:1 replacement for the <APPLET> tag; rather the <OBJECT> tag is a multifunctional element that may be used in a variety of situations.

For this discussion, however, the new <OBJECT> tag may be used as a replacement and functionality is retained from the deprecated element. The <OBJECT> element provides a way for the ActiveX controls and other media to be embedded directly into HTML documents. It also works in the role of the <IMG> element as well, providing a mechanism to employ media other than static pictures. Internet Explorer alone uses the <OBJECT> element for the inclusion of ActiveX controls.

## USING THE NEW <OBJECT> TAG INSTEAD OF THE <IMG> TAG

As you learned in the previous section, the <OBJECT> tag may be used in place of the <IMG> tag and produce the same results. This addition to the HTML family provides a way to incorporate many different forms of media, code, or controls into a Web page using a single markup tag.

## UNDERSTANDING THE NEW <MEDIA> ATTRIBUTE

Recent HTML 4.0 draft specifications have included a MEDIA attribute for the <STYLE> element, which specifies an output device such as a Braille printer or other device. Defaulting to the SCREEN attribute, the MEDIA attribute can have the following properties:

| Value | Meaning |
| --- | --- |
| screen | The style sheet settings given are those that will be used for computer display screen purposes |
| print | The style sheet settings are suitable for printed output (typically, they would contain hard-coded page breaks, for example) |
| projection | The settings are suitable for display on projectors |
| Braille | The settings are to be used for Braille machine output |
| speech | The document is styled to be suitable for speech synthesizer output |
| all | The style sheet settings are to be used for all output devices |

*Properties of MEDIA attributes.*

Using the MEDIA attribute, different style sheets can be set up to be used when the document is used in different display environments.

*Note:* **Netscape** and **Internet Explorer** both purport to support use of the <MEDIA> element, but at the time of writing, no such support exists. As they are by nature, screen output devices, it's likely that support may not get implemented. This attribute is detailed here for completeness.

## CLARIFYING THE DEFINITION OF DHTML

DHTML requires the use of one of the latest and greatest Web browsers—Microsoft Internet Explorer 4+ or Netscape Communicator 4+. Without using one of these browsers, your HTML will still be the standard HTML. That said, you can develop your Dynamic HTML pages using any standard text or HTML editor. As time goes on, there will be more WYSIWYG DHTML editors, but at the moment they are still rather limited in their usefulness.

Standard HTML is a combination of different elements, or tags, which are designed to hold data in a certain fashion. Dynamic HTML extends these tags by making objects of them and

letting you alter the way the data is presented by altering those tag objects. JavaScript does much the same thing and is, itself, used in DHTML to control these tags. Examples of JavaScript objects include window, frame, history, navigator, document, and so on. Examples of DHTML objects include head, title, bgcolor, forecolor, src, and so on.

Using JavaScript, a developer is able to use standard HTML and change the color of, for example, the page's header data but only by re-drawing the entire page. Using DHTML, the developer may change the color on the fly. Other objects, such as image objects, may also be dynamically changed on the fly using DHTML. They may be moved up or down the page at will, in response to mouse movements or simply as the page initially loads up. Form data may be applied to other forms on the same page, and elements may be positioned according to X/Y coordinates across the page. To get a good idea of what can be done with DHTML, take a look at the following sections. Remember that you must be using a 4.0 Web browser.

## UNDERSTANDING THE RELEVANCE OF SCRIPTING LANGUAGES TO DHTML

It is important to note that the Dynamic HTML Object Model is entirely language- and paradigm-neutral, which means that a Web page can be controlled via scripting, controls, or Java applets. The Dynamic HTML Object Model has been designed so that you can add Dynamic HTML functionality to pages, and they will still display well in older browsers that don't support that functionality. The current Object Model is described and standardized by the W3C.

Dynamic HTML provides what is known as an *element model*. This means that every element on the page is accessible, and all of its properties, methods, and events are available. You can handle events, for example, button clicks or mouse-overs, for each HTML tag on a page. Once you trap these events, you can provide certain reactions to each event via scripting. The most common example today is found in many Web pages where the mouse-over event for a tag is added by changing its font to a larger font when the user hovers over the object, and dynamically changing the text of the object when the user clicks it. Using the Dynamic HTML Object Model, you can do things that you couldn't easily do before. The advantage of this approach is twofold: you get simpler coding, and you get code reuse.

## UNDERSTANDING THE DOCUMENT OBJECT MODEL AND ITS IMPORTANCE TO DHTML

Dynamic HTML is a group of technologies designed to create and display more interactive Web pages. It includes Dynamic Styles, Dynamic Content, 2-D Layout, Data Binding, and

Multimedia Effects. The Dynamic HTML Object Model makes all of these features programmable. With Dynamic HTML, you can create Web pages that have all the power of a Microsoft® Windows®-based application.

When you add all of this together, you get better performance for the client and the server. In addition, fewer round trips to the server (because attributes for elements can be updated on the fly on the client side), Web pages that are easier to author, and a truly interactive experience for the user will also be attained.

The Dynamic HTML Object Model doesn't define a whole new set of tags or attributes—it makes the tags, attributes, and CSS attributes that you know totally programmable. Existing JavaScript Object Models provide access to a small set of elements on the page. Further, only a small subset of their attributes can be modified, and only a small subset of events can be fired from them. Dynamic HTML provides access to all HTML elements and full access to every attribute. Additionally, the set of events that can be accessed for each object is much more complete than that of JavaScript Object Models.

The Dynamic HTML Object Model makes it easier to write code due to *event bubbling*. Event bubbling is a process by which objects can either handle events or let events bubble up to the parent object. This capability enables you to write less code to handle events. You can let the parent object handle generic events, so that each object doesn't have to, or provide default actions.

## BENEFITS OF DHTML

Dynamic HTML is an innovative technology that enables new classes of interactive Web pages. With Dynamic HTML, Web applications can take on consumer appeal rivaling that of CD-ROM titles, and developers can create intranet applications with functional front-end interfaces for data entry or reporting.

Dynamic HTML is an open, language-independent object model for standard HTML. It enables scripts or programs to change the style, content, and structure of a Web page, even after the page has loaded, without requesting a new page from the server. Dynamic HTML features include the following:

- **Document Object Model (DOM)** - Dynamic HTML provides a comprehensive object model for HTML. This model exposes all page elements as objects. These objects can easily be manipulated by changing their attributes or applying methods to them at any time. Dynamic HTML also provides full support for keyboard and mouse events

on all page elements. Support for the Document Object Model enables dynamic content, style, and positioning effects as well as data binding and scriptlets.

- **Dynamic styles** – Style sheets are part of the DOM allowing for greater control over text and object formatting and event handling across multiple pages.

- **Dynamic content** - Data binding - Data-driven application front ends can be built that present, manipulate (for example, sort or filter), and update data on the client without numerous round-trips to the server.

- **Scriptlets** - A scriptlet is a Web page, authored with Dynamic HTML, that content providers can use as a component in their Web applications. With scriptlets, content providers can author content once, and easily reuse the content in other Web pages or applications.

## USING DHTML's DRAG-AND-DROP SUPPORT

Several DHTML events will let the browser and cursor act much like an operating system with drag- and-drop functionality. This works by way of three specific events: *ondrag*, *ondrop*, and *ondragleave*. The following represents the mechanics of each of these events:

- **Ondrag.** Fires on the source object continuously during a drag operation. This event fires on the source object after the *ondragstart* event. The *ondrag* event fires throughout the drag operation, whether the selection being dragged is over the drag source, a valid target, or an invalid target.

- **Ondrop.** Fires on the target object when the mouse button is released during a drag-and-drop operation. The *ondrop* event fires before the *ondragleave* and *ondragend* events. When scripting custom functionality, use the returnvalue property to disable the default action.

- **Ondragleave.** Fires on the target object when the user moves the mouse out of a valid drop target during a drag operation.

The following HTML attributes (objects) apply to the above tags:

```
A, ACRONYM, ADDRESS, AREA, B, BDO, BIG, BLOCKQUOTE, BODY, BUT-
TON, CAPTION, CENTER, CITE, CODE, custom, DD, DEL, DFN, DIR,
DIV, DL, document, DT, EM, FIELDSET, FONT, FORM, Hn, HR, I, IMG,
INPUT type=button, INPUT type=checkbox, INPUT type=file, INPUT
```

```
type=image, INPUT type=password, INPUT type=radio, INPUT
type=reset, INPUT type=submit, INPUT type=text, KBD, LABEL, LI,
LISTING, MAP, MARQUEE, MENU, NOBR, OBJECT, OL, P, PLAINTEXT,
PRE, Q, S, SAMP, SELECT, SMALL, SPAN, STRIKE, STRONG, SUB, SUP,
TABLE, TBODY, TD, TEXTAREA, TR, TT, U, UL, VAR, XMP
```

## UNDERSTANDING THE DHTML EVENT MODEL

If you already understand the concept of event handling, you will be at home in the world of
DHTML. Within Windows programming, it is common practice for a programmer to trap
events and call a function in response. For example, when you click a button in a dialog box,
the code that is written to handle the dialog box includes code that is called when a button is
pressed. The button press is the *event* and the function that is subsequently called is the
*action*. Events are not new to Internet Explorer 4.0—you were able to trap events on a small
subset of HTML elements in Internet Explorer 3.*x* as well as Navigator. With Internet Ex-
plorer 4.0 and Dynamic HTML (DHTML), all elements are the source of events and prop-
erties. Before you go on, review the following terms and events:

### How Events Work

A step-by-step description of the flow of events is shown below:

- The user performs a function on his machine, such as press a key or
  click with the mouse (there are also some non-user-initiated events,
  such as the page load, that can be handled).

- An event is fired. When an event is fired, the element affected by the
  event gets to handle it first via its event handler.

- Next, the event will be passed up to successive parent elements until
  it gets to the document or until one of the event handlers cancels
  passing up the event further (known as event bubbling).

- Finally, a default action occurs. The default is independent of event
  bubbling. You must cancel the default in your script if you want to
  stop the default action from occurring.

Currently, you can handle a button-click event using older browsers, but if you want to
define a default behavior based on a button click, you have to copy and paste that code to
script each object. Dynamic HTML provides a container hierarchy for its HTML docu-
ments. Using Internet Explorer 4.0, you write the code once and direct the parent object, via
scripting, to handle the event. This is known as event bubbling. In more HTML-like terms,
this means that you can have a scenario as follows:

- The user clicks an image.

- The <IMG> tag receives the event.

- The <IMG> tag does not want to handle the event.

- The <IMG> tag is inside the <A> tag, and the <A> tag receives the click event.

- If you want the <IMG> tag to handle the event, cancel the bubble.

Event bubbling lets you write more compact code (because you are writing the code only once) for common events.

## USING FORM-OBJECT EVENTS

Every <FORM> element in a document is an object that can be manipulated through scripting. Both **Netscape** and **Internet Explorer** support scripting of the <FORM> object—**Netscape** supports it through the Forms collectionforms array, but **Internet Explorer's** Dynamic HTML support is more varied.

## USING IMAGE-OBJECT EVENTS

The Image object may be manipulated via scripting and the DHTML DOM. The <IMG> element/object supports *all* of the standard Dynamic HTML events such as onclick, ondblclick, ondragstart, onfilterchange, onhelp, onkeydown, onkeypress, onkeyup, onmousedown, onmousemove, onmouseout, onmouseover, onmouseup and onselectstart. In addition, the <IMG> element supports the following events:

- **Onabort**. If the user stops the download of your HTML document before any images defined in <IMG> elements have finished downloading, then (if present) this event handler will execute whatever script function it is set to activate. For example, if you use large graphics and the user cancels the download because they are accessed slowly, perhaps they would prefer to be transferred to a low-graphics version of your site.

- **Onblur**. The *onblur* event executes any script functions attached to it when the user's focus moves away from the image (either by clicking another part of the document, by tabbing away from the image, or by a script using the blur method).

- **Onerror**. This event handler can be used to execute script functions if there is an error while the image is downloading (perhaps caused by an incorrect SRC="…" declaration in the <IMG> element, or a network error).

- **Onfocus**. *Onfocus* is used to execute script functions when the user focuses on the image, either by clicking it (it then fires after the respective *onmouse* events), tabbing to it, or by another script function using the focus method.

- **Onload**. The *OnLoad* event handler can execute script functions when the browser has successfully displayed the image specified in the <IMG> element. For example, as **Netscape** supports the image object in its Object Model, using this event handler (in conjunction with the *OnError* event) can be useful for tracking whether the images have been successfully displayed or not.

- **Onresize**. The *onresize* event is fired whenever the <IMG> element is resized through scripting.

## USING KEYBOARD-RELATED EVENTS

Keyboard events occur in a DHTML application when the user presses or releases a keyboard key. The *onkeydown* and *onkeyup* events fire when a key changes state as it is pressed or released, respectively. These events fire for all keys on the keyboard, including shift state keys such as **SHIFT**, **CTRL**, and **ALT**.

The *onkeypress* event fires when the user's keyboard input is translated to a character. These occur, for example, when the user presses letter or number keys, or a combination of shift keys and letters and numbers.

When a keyboard event occurs, the keyCode property of the **event** object contains the Unicode keycode of the corresponding key. The altKey, ctrlKey, and shiftKey properties specify the state of the **ALT**, **CTRL**, and **SHIFT** keys.

You can change which key is associated with the event by either changing the value of the keyCode property or returning an integer value. You can cancel the event by returning zero or false.

The onhelp event is a special keyboard event that occurs when the user presses the **HELP** key (F1).

## USING MARQUEE-RELATED EVENTS

The <MARQUEE> tag in an HTML document is available for scripting, though, as of the writing of this book, this only applies to Internet Explorer 4.0 and higher. The <MARQUEE> element supports all of the common events in DHTML and also supports the following events:

- Onblur — Fires when the <MARQUEE> element loses focus.

- Onbounce — This event fires when the marquee text hits the side of the marquee boundary.

- Onfinish — Fires when the marquee finishes scrolling.

- Onfocus — This event fires when the focus is passed the <MARQUEE> object.

- Onresize — The onresize event is triggered when the marquee object is resized.

- Onscroll — This event fires when the marquee scrolls.

Since this element is specific to IE 4.0 and greater, it should be used with discretion.

## USING MOUSE-SPECIFIC EVENTS

DHTML scripting allows for the use of mouse-triggered events. Mouse events occur when a user moves the mouse or clicks the left button. The **onmousemove** event fires when the user *moves* the mouse, and **onmouseover** and **onmouseout** fire when the mouse moves *in and out* of an element.

Provisions are also made for the use of the multi-button mouse with the inclusion of the **onmousedown** and **onmouseup** events, which fire when the left mouse button changes state as it is pressed or released, respectively. The **onclick** and **ondblclick** events fire when the user single-clicks and double-clicks the button. To facilitate use across all platforms, it is best to assume a single mouse button when scripting mouse events.

When a mouse event occurs, the **button** property of the **event** object identifies which mouse button, if any, is pressed. The **x** and **y** properties specify the location of the mouse pointer at the time of the event. For the **onmouseover** and **onmouseout** events, the *toElement* and *fromElement* properties specify the objects the mouse is moving to and from.

To understand mouse click events, it is important to note that these events are intermingled with **onmousedown** and **onmouseup** events. For example, the **onclick** event follows an **onmouseup** event. An **onclick** event can also occur when the user presses the ENTER key on a focusable element, such as a <BUTTON> element. In this case, the event fires without a preceding **onmouseup** event. You can cancel a mouse click by returning false or setting the **returnValue** property to false.

## USING OTHER OBJECT-SPECIFIC EVENTS

The list of supported objects in the latest HTML 4.0 specification is quite extensive. For the most part, these events share a common set of events along with their specific events. While this list of specific events is beyond the scope of this book, you can visit *www.w3c.org* for more information on the full DHTM specification. The first table shown below lists the objects defined by Dynamic HTML, and the second table lists common events.

| | | | |
|---|---|---|---|
| !DOCTYPE | DFN | location | STRIKE |
| A | DIR | MAP | STRONG |
| ACRONYM | DIV | MARQUEE | style |
| ADDRESS | DL | MENU | STYLE |
| APPLET | document | META | styleSheet |
| AREA | DT | namespace | SUB |
| Attribute | EM | navigator | SUP |
| B | EMBED | NEXTID | TABLE |
| BASE | event | NOBR | TBODY |
| BASEFONT | external | NOFRAMES | TD |
| BDO | FIELDSET | NOSCRIPT | TEXTAREA |
| BGSOUND | FONT | OBJECT | TextNode |
| BIG | FORM | OL | TextRange |
| BLOCKQUOTE | FRAME | OPTION | TextRectangle |
| BODY | FRAMESET | P | TFOOT |
| BR | HEAD | PARAM | TH |
| BUTTON | history | PLAINTEXT | THEAD |
| CAPTION | Hn | popup | TITLE |
| CENTER | HR | PRE | TR |
| CITE | HTML | Q | TT |
| clientInformation | I | RT | U |
| clipboardData | IFRAME | RUBY | UL |
| CODE | IMG | rule | userProfile |
| COL | INPUT | runtimeStyle | VAR |
| COLGROUP | INS | S | WBR |

*Elements that my be Scripted (continued on next page).*

| | | | |
|---|---|---|---|
| COMMENT | ISINDEX | SAMP | window |
| currentStyle | KBD | screen | XML |
| custom | LABEL | SCRIPT | XMP |
| dataTransfer | LEGEND | SELECT | |
| DD | LI | selection | |
| defaults | LINK | SrMALL | |
| | LISTING | SPAN | |

*Elements that my be Scripted (continued from previous page).*

| | | |
|---|---|---|
| onabort | ondblclick | onmouseleave |
| onafterprint | ondrag | onmousemove |
| onafterupdate | ondragend | onmouseout |
| onbeforecopy | ondragenter | onmouseover |
| onbeforecut | ondragleave | onmouseup |
| onbeforeeditfocus | ondragover | onpaste |
| onbeforefocusenter | ondragstart | onpropertychange |
| onbeforefocusleave | ondrop | onreadystatechange |
| onbeforepaste | onerror | onreset |
| onbeforeprint | onerrorupdate | onresize |
| onbeforeunload | onfilterchange | onresizeend |
| onbeforeupdate | onfinish | onresizestart |
| onblur | onfocus | onrowsinserted |
| onbounce | onfocusenter | onscroll |
| oncellchange | onfocusleave | onselect |
| onchange | onhelp | onselectiontypechange |
| onclick | onkeydown | onselectstart |
| oncontextmenu | onkeypress | onstart |
| oncontrolselect | onkeyup | onstop |
| oncopy | onlayoutcomplete | onsubmit |
| oncut | onload | onunload |
| ondataavailable | onlosecapture | |
| ondatasetchanged | onmousedown | |
| ondatasetcomplete | onmouseenter | |

*Common Events*

## USING STYLE SHEETS FOR IMPROVED APPEARANCE

In earlier versions of the HTML markup language, it was necessary to apply style to text via individual tags or series of tags, encumbering the development process and adding weight to HTML pages.

A style sheet language offers a powerful and manageable way for authors, artists, and typographers to create the visual effects they want, as shown below:

- margins and indents
- line spacing and length
- background images and colors
- fonts, font sizes, and font colors

You can embed a style sheet inside an HTML document, or insert a link to an external style sheet that can influence any number of documents. CSS is implemented in several browsers, including Microsoft Internet Explorer 3/4, and Netscape Navigator 4.

Style sheets contain *rules* to determine how the styles shall be applied. Rules comprise *selectors*. HTML elements are known as *selectors* in CSS. The selector is the link between the HTML document and the style, and all HTML tags are possible selectors. There are two kinds of selectors:

- Type
- Attribute (Class or ID)

The declaration has two parts:

- property (color)
- value (blue)

CSS supports 35 different properties that can be applied to selectors to determine the presentation of an HTML document. Properties include background (color or graphic), font size, font weight, line height (leading or interlinear spacing), font family, letter spacing and word spacing.

Style may be applied at almost every level of the HTML document, including tables, backgrounds, images, and so forth. Because of this level of granularity, it is possible to enhance almost every aspect of a Web page.

## USING THE <STYLE> TAG

The <STYLE> tag is used to embed style sheet information within the individual page, unlike calling a style sheet externally. The <STYLE> element should reside within the <HEAD> element and is used to delimit Style Sheet information.

The TYPE and TITLE attributes can be used within the <STYLE> element. TYPE is used to specify the internet media (MIME) type of the style sheet definition (which is text/css) and TITLE can be used to provide a title for the style sheet definitions. This may be used by browsers when a choice of style sheets are available.

For example:

```
<HTML>

<HEAD>

<TITLE>The Style Tag</TITLE>

<STYLE TYPE="text/css" TITLE="My Color Defintions"

BODY {color : grey}

P {color : black

font size : 14pt;

font family : Arial}

</STYLE>
```

This defines the styles that are specified within the <STYLE>…</STYLE> elements to be a style sheet, having the title Bright Colors. For more information about Style Sheets, see the Style Sheets topic.

*Note:* Use of the <STYLE> element and Style Sheet use is only supported by **Internet Explorer** (from v3.0) and **Netscape** (from v4.0).

## USING THE CLASS ATTRIBUTE

The CLASS attribute was first proposed in the now expired HTML 3 specification. All elements that can reside within the <BODY> section of an HTML document can be addressed using a CLASS attribute. Within the style sheet definition, the style class is set using the following syntax:

```
A.red { color : #FF0000}
```

Any anchors denoted by a <A Class="red";>some text</A> HTML class defined element would be rendered using red text. If the style class is defined with no major element, as shown below:

```
.red { color : #FF0000}
```

then all elements that use CLASS="red" would be rendered in red. The CLASS attribute is used to specify the style class to which the element belongs. For example, the style sheet may have created the funky and caution classes as in the following:

```
.funky      { color: lime; background: #ff80c0 }

P.caution { font-weight: bolder; color: red; background: white
}
```

These classes could be referenced in HTML with the **CLASS** attribute:

```
<H1 CLASS=funky>Warning</H1>
<P CLASS=caution>The use of inappropriate language on this chat
site will result in immediate disbarral by the mediator!</P>
```

In this example, the **punk** class may be applied to any <BODY> element since it does not have an HTML element associated with it in the style sheet. Using the example's style sheet, the **warning** class may only be applied to the **P** element.

A good practice is to name classes according to their *function* rather than their *appearance*. The **warning** class in the previous example could have been named **red**, but this name would become meaningless if you decided to change the style of the class to a different color, or if the author wished to define an audible style for users using speech synthesizers.

Classes can be an effective method of applying different styles to identical sections of an HTML document.

## INTRODUCING STYLE SHEET SYNTAX

Both linked and embedded style sheets include one or more style definitions (the inline style syntax is somewhat different, and will be discussed later.) A style definition consists of an HTML tag (*any* tag), followed by a listing of properties for that tag within curly braces. Each property is identified by the property name, followed by a colon and the property value. Multiple properties are separated by semicolons. For example, the following style definition assigns the <H1> tag a specific font size (15 points) and font weight (boldface):

```
H1 {font-size: 15pt;

     font-weight: bold}
```

You can then create style definitions for any number of HTML tags and either place them in a separate file or embed them directly within your Web pages. The following table shows the current W3C adopted syntax standards for Style Sheets:

| Type | Element | Description |
| --- | --- | --- |
| Font and text properties | font | This is a composite property that specifies up to six font values (e.g. font style, font-size, etc.) |
| | font-face | This feature allows you to use specific fonts that might not be available on your local system (e.g. Arial) |
| | font-family | The value is a prioritized list of font family names and/or generic family names (e.g.Arial) |
| | font-size | Sets or retrieves the size of the font used for text in the object |
| | font-style | Sets or retrieves the font style of the object as italic, normal, or oblique |
| | font-variant | Sets or retrieves whether the text of the object is in small capital letters |
| | font-weight | Sets or retrieves the weight of the font of the object |
| | letter-spacing | Sets or retrieves the amount of additional space between letters in the object |
| | Line-height | Sets or retrieves the distance between lines in the object |
| | Text-align | Sets or retrieves whether the text in the object is left-aligned, right-aligned, centered, or justified |
| | Text-decoration | Sets or retrieves whether the text in the object has blink, line-through, overline, or underline decorations |
| | Text-indent | Sets or retrieves the indentation of the text in the object |

*Current W3C adopted syntax standards for Style Sheets (continued on next page).*

| Type | Element | Description |
|------|---------|-------------|
| Font and text properties | Test-transform | Sets or retrieves the rendering of the text in the object |
| | Unicode-bidi | Sets or retrieves the level of embedding with respect to the bi-directional algorithm |
| | Vertical-align | Sets or retrieves the vertical positioning of the object |
| | WHITESPACE | Defines the document white space characteristics |
| Color and background properties | Background | Sets or retrieves up to five separate background properties of the object (e.g. background-color, background-image, etc.) |
| | Background-attachment | Sets or retrieves how the background image is attached to the object within the document (e.g. scroll or fixed) |
| | Background-color | Sets or retrieves the color behind the content of the object |
| | Background-image | Sets or retrieves the background image of the object |
| | Background-position | Sets or retrieves the position of the background of the element |
| | Background-repeat | Sets or retrieves how the **backgroundImage** property of the object is tiled (e.g. repeat or no-repeat) |
| | Color | Sets or retrieves the color of the text of the object (e.g. red, blue, green) |
| Layout properties | Border | Sets or retrieves the properties to be drawn around the object (e.g. width, style, color) |
| | Border-bottom | Sets or retrieves the properties of the bottom border of the object (e.g. width, style, color) |
| | Border-bottom-color | Sets or retrieves the color of the bottom border of the object (e.g. RGB value) |

*Current W3C adopted syntax standards for Style Sheets (continued on next page).*

| Type | Element | Description |
|---|---|---|
| Layout properties | Border-bottom-style | Sets or retrieves the style of the bottom border of the object (e.g. dotted, dashed, etc.) |
| | Border-bottom-width | Sets or retrieves the width of the bottom border of the object (e.g. medium, thick, thin, width value) |
| | Border-color | Sets or retrieves the color of the bottom border of the object (e.g. RGB value) |
| | Border-left | Sets or retrieves the properties of the left border of the object (e.g. width, style, color) |
| | Border-left-color | Sets or retrieves the color of the left border of the object (e.g. RGB value) |
| | Border-left-style | Sets or retrieves the style of the left border of the object (e.g. dotted, dashed, etc.) |
| | Border-left-width | Sets or retrieves the width of the left border of the object (e.g. medium, thick, thin, width value) |
| | Border-right | Sets or retrieves the properties of the right border of the object (e.g. width, style, color) |
| | Border-right-color | Sets or retrieves the color of the right border of the object (e.g. RGB value) |
| | Border-right-style | Sets or retrieves the style of the bottom border of the object (e.g. dotted, dashed, etc.) |
| | Border-right-width | Sets or retrieves the width of the right border of the object (e.g. medium, thick, thin, width value) |
| | Border-style | Sets or retrieves the style of the border of the object (e.g. dotted, dashed, etc.) |
| | Border-top | Sets or retrieves the properties of the top border of the object (e.g. width, style, color) |
| | Border-top-color | Sets or retrieves the color of the top border of the object (e.g. RGB value) |

*Current W3C adopted syntax standards for Style Sheets (continued on next page).*

| Type | Element | Description |
|---|---|---|
| Layout properties | Border-top-style | Sets or retrieves the style of the top border of the object (e.g. dotted, dashed, etc.) |
| | Border-top-width | Sets or retrieves the width of the top border of the object (e.g. medium, thick, thin, width value) |
| | Border-width | Sets or retrieves the width of the border of the object (e.g. medium, thick, thin, width value) |
| | Clear | Sets or retrieves whether the object allows floating objects on its left and/or right sides, so that the next text displays past the floating objects (e.g. none, left, right, both) |
| | Float | Sets or retrieves on which side of the object the text will flow (e.g. none, left, right) |
| | Margin | Sets or retrieves the width of the left, right, bottom, and top margins of the object (e.g. auto, width, %) |
| | Margin-bottom | Sets or retrieves the height of the bottom margin of the object (e.g. auto, height, %) |
| | Margin-left | Sets or retrieves the width of the left margin of the object (e.g. auto, width, %) |
| | Margin-right | Sets or retrieves the width of the right margin of the object (e.g. auto, width, %) |
| | Margin-top | Sets or retrieves the width of the top margin of the object (e.g. auto, width, %) |
| | Padding | Sets or retrieves the amount of space to insert between the object and its margin or, if there is a border, between the object and its border (e.g. length, %) |

*Current W3C adopted syntax standards for Style Sheets (continued from previous page).*

## SPECIFYING HTML ELEMENTS BY CLASS

Using the CLASS attribute, it is possible to define multiple variations of style elements for the same HTML tag. For example, if you'd like to use three colors for your H2 headings, depending on context, you would define three classes in your STYLE tag:

```
<STYLE>

   H2.gray {font: 17pt/19pt;

           color: gray}

   H2.blue {font: 17pt/19pt;

           color: blue}

   H2.yellow {font: 17pt/19pt;

           color: yellow}

</STYLE>
```

and use them as follows on your Web page:

```
<H2 CLASS=gray>This is the gray heading 1</H1>

...

<H2 CLASS=blue>This is the blue heading 1</H1>

...

<H2 CLASS=yellow>This is the yellow heading 1</H1>
```

## COMBINING THE STYLE SHEET WITH THE HTML DOCUMENT

You can use style sheets in three ways, depending on the relative needs of the page, object, or section:

- By **linking** to a style sheet from your HTML file. This method lets you change the appearance of multiple Web pages by tweaking a single file.

- By **embedding** a style sheet in your HTML file. This method lets you change the appearance of a single Web page by tweaking a few lines.

- By adding **inline** styles to your HTML file. This gives you a quick way to change the appearance of a single tag, a group of tags, or a block of information on your page.

It is also possible to use a combination of the above mentioned style types. Following is a breakdown of the usage for combining style sheets with HTML documents, which involves the **linking** and **embedding** types.

### Linking to a Style Sheet

To link to an external style sheet, you simply create a file with your style definitions (as explained below for embedded styles), save it with a .css file extension, and link to it from your Web page. This way, you can use the same style sheet for any number of pages on your site.

For example, if your style sheet is called MYSTYLES.CSS and is located at the address *http://internet-name/mystyles.css*, you would add the following to your Web page, within the <HEAD> tag:

```
<HEAD>

<TITLE>Title of article</TITLE>

<LINK REL=STYLESHEET

HREF="http://internet-name/mystyles.css"

TYPE="text/css">

</HEAD>
```

### Embedding a STYLE Block

To embed a style sheet, you add a <STYLE> </STYLE> block at the top of your document, between the <HTML> and <BODY> tags. This lets you change the appearance of a single Web page. The <STYLE> tag has one parameter, TYPE, which specifies the Internet Media type as text/css (letting browsers that do not support this type to ignore style sheets). The <STYLE> tag is followed by any number of style definitions and terminated with the </STYLE> tag.

The following example specifies styles for the <BODY>, <H1>, <H2>, and <P> tags:

```
<HTML>

<STYLE TYPE="text/css">

<!—

  BODY {font: 10pt "Arial"}

  H1 {font: 15pt/17pt "Arial";

      font-weight: bold;

      color: maroon}

  H2 {font: 13pt/15pt "Arial";

      font-weight: bold;

      color: blue}

  P  {font: 10pt/12pt "Arial";

      color: black}

—>

</STYLE>

<BODY>

. . .

</BODY>

</HTML>
```

## USING THE STYLE SHEET'S BACKGROUND PROPERTIES

You can use the BACKGROUND attribute to highlight sections of your page by setting a background color or background image. To set a color, you specify a named color or use an RGB color value, as shown in the following example:

```
{background: red}

{background: #6633FF}
```

To place an image, you specify the URL in parentheses:

```
{background:

URL(http://www.somesite.com/bg/boxes.gif)}
```

In Internet Explorer 3.0 and up, you can use backgrounds on any element, such as table cells. You can also use the *repeat*, *scroll*, and *position* parameters to create special effects with background images, as outlined in the following definitions:

- **Position:** You can specify the position of the background image with respect to the element by specifying horizontal and vertical offsets. You can either use the keywords left/center/right and top/middle/ bottom, percentage values, or distances in points, centimeters, inches, or pixels.

- **Repetitions:** The values *repeat-x, repeat-y, repeat*, and *no-repeat* determine whether the background image is repeated horizontally, vertically, in both directions (default), or not at all.

- **Scrolling:** The values *fixed* and *scroll* (default) determine whether the image is fixed on the page or scrolls with content. A fixed value lets text scroll in the browser window while the background is stationary, giving the page the effect of stationary or printed paper.

For example:

```
{background:

URL(http://www.somesite.com/bg/boxes.gif) 0% 100%}
```

or

```
{background: URL(http://www.somesite.com/bg/boxes.gif) left

bottom}
```

places the image at the lower left.

## USING THE STYLE SHEET'S BOX PROPERTIES

The BOX property of the CSS specification applies to elements that are defined as or contain properties that are considered borders. This includes tables and margins. The following table outlines examples of each element:

| Element | Example |
|---------|---------|
| margin-top | Sets the size of the top margin of an element. Negative values are permitted, but exercise caution. UL {margin-top: 0.5in;} |
| margin-right | Sets the size of the right margin of an element. Negative values are permitted, but exercise caution. IMG {margin-right: 30px;} |
| margin-bottom | Sets the size of the bottom margin of an element. Negative values are permitted, but exercise caution. UL {margin-bottom: 0.5in;} |
| margin-left | Sets the size of the left margin of an element. Negative values are permitted, but exercise caution. P {margin-left: 3em;} |
| margin | Sets the size of the overall margin of an element. Negative values are permitted, but exercise caution. H1 {margin: 2ex;} |
| padding-top | Sets the size of the top padding of an element, which will inherit the element's background. Negative values are not permitted. UL {padding-top: 0.5in;} |
| padding-right | Sets the size of the right padding of an element, which will inherit the element's background. Negative values are not permitted. IMG {padding-right: 30px;} |

*Examples of style sheet's box properties (continued on next page).*

| Element | Example |
|---|---|
| padding-bottom | Sets the size of the bottom padding of an element, which will inherit the element's background. Negative values are not permitted. UL {padding-bottom: 0.5in;} |
| padding-left | Sets the size of the left padding of an element, which will inherit the element's background. Negative values are not permitted. P {padding-left: 3em;} |
| padding | Sets the size of the overall padding of an element, which will inherit the element's background. Negative values are not permitted. H1 {padding: 2ex;} |
| border-top-width | Sets the width of the top border of an element, which will inherit the element's background, and may have a foreground of its own (see border-style). Negative values are not permitted. UL {border-top-width: 0.5in;} |
| border-right-width | Sets the width of the right border of an element, which will inherit the element's background, and may have a foreground of its own (see border-style). Negative values are not permitted. IMG {border-right-width: 30px;} |
| border-bottom-width | Sets the width of the bottom border of an element, which will inherit the element's background, and may have a foreground of its own (see border-style). Negative values are not permitted. UL {border-bottom-width: 0.5in;} |
| border-left-width | Sets the width of the left border of an element, which will inherit the element's background, and may have a foreground of its own (see border-style). Negative values are not permitted. P {border-left-width: 3em;} |
| border-width | Sets the width of the overall border of an element, which will inherit the element's background, and may have a foreground of its own (see border-style). Negative values are not permitted. H1 {border-width: 2ex;} |
| border-color | Sets the color of the foreground of the overall border of an element (see border-style), which will inherit the element's background. H1 {border-color: purple; border-style: solid;} |
| border-style | Sets the style of the overall border of an element, using the color set by border-color. H1 {border-style: solid; border-color: purple;} |

*Examples of style sheet's box properties (continued on next page).*

| Element | Example |
| --- | --- |
| border-top | Shorthand property which defines the width, color, and style of the top border of an element. UL {border-top: 0.5in solid black;} |
| border-right | Shorthand property which defines the width, color, and style of the right border of an element. IMG {border-right: 30px dotted blue;} |
| border-bottom | Shorthand property which defines the width, color, and style of the bottom border of an element. UL {border-bottom: 0.5in grooved green;} |
| border-left | Shorthand property which defines the width, color, and style of the left border of an element. P {border-left: 3em solid gray;} |
| border | Shorthand property which defines the width, color, and style of the overall border of an element. H1 {border: 2px dashed tan;} |
| width | Used to set the width of an element. Most oftern applied to images, but can be used on any block-level or re-placed element. Negative values are not permitted. TABLE {width: 80%;} |
| height | Used to set the height of an element. Most oftern applied to images, but can be used on any block-level or replaced element, within limits. Negative values are not permitted. IMG.icon {height: 50px;} |
| float | Sets the float for an element. Generally applied to images to allow text to flow around them, but any element may be floated. IMG {float: left;} |
| clear | Defines which floating elements (if any) are allowed to exist to either side of the element. H1 {clear: both;} |

## USING THE STYLE SHEET'S CLASSIFICATION PROPERTIES

These properties classify elements into categories rather than setting visual display styles. The following constitute the most used Classification Properties:

- Display
- White-space

## Display

This property describes how and if an element is displayed on the canvas (which may be on a printed page, a computer display, and so on).

An element with a display value of block opens a new box. The box is positioned relative to adjacent boxes according to the CSS formatting model. Typically, elements like <H1> and <P> are of type block. A value of 'list-item' is similar to block except that a list-item marker is added. In HTML, <LI> usually has this value.

An element with a display value of inline results in a new inline box on the same line as the previous content. The box is dimensioned according to the formatted size of the content. If the content is text, it may span several lines, and there will be a box on each line. The margin, border and padding properties apply to 'inline' elements but will not have any effect at the line breaks.

A value of none turns off the display of the element, including children elements and the surrounding box. The following values are valid for display:

- Values: block | inline | list-item | none
- Initial value: block
- Applies to: all elements

Usage is as follows:

```
P { display: block }

EM { display: inline }

LI { display: list-item }

IMG { display: none }
```

## White-space

The white-space classification property allows for the declaration of how white space inside the element should be handled, for example, the normal way where white space is collapsed or as the <PRE> element in HTML, or as nowrap, which is essentially the same as using the <NOBR> element, forcing line breaks with <BR>. The following values are acceptable for use with the white-space classification property:

- Value: normal | pre | nowrap
- Initial values: normal
- Applies to: block-level elements

## OTHER CLASSIFICATION PROPERTIES

The following additional classification properties also apply to custom element formatting within an HTML document via Style sheets:

- list-style-type
- list-style-image
- list-style-position
- list-style

## COMBINING HTML IN A DOCUMENT WITH A CASCADING STYLE SHEET

You can use style sheets in three ways, depending on the relative needs of the page, object, or section:

- By linking to a style sheet from your HTML file. This method lets you change the appearance of multiple Web pages by tweaking a single file.
- By embedding a style sheet in your HTML file. This method lets you change the appearance of a single Web page by tweaking a few lines.
- By adding inline styles to your HTML file. This gives you a quick way to change the appearance of a single tag, a group of tags, or a block of information on your page.

It is also possible to use a combination of the above mentioned style types. Following is a breakdown of the usage for combining style sheets with HTML documents, which involves the inline method.

## Using Inline Styles

If you want to take advantage of point sizes, indentation, or other styles in only a few sections of your Web page, you can use inline styles.

Inline style definitions affect individual occurrences of a tag. These are embedded within the tag itself using the STYLE parameter. The following HTML code indents a specific <P> tag:

```
<P STYLE="margin-left: 0.5in; margin-right:

0.5in">

This line will be indented on the left and right.

<P>

This line will receive no indentation.
```

The resulting HTML formatting would appear like this:

```
    This line will be indented on the left and right.

This line will receive no indentation.
```

If the inline style conflicts with an embedded or linked style, the inline style overrides for that particular occurrence. For example, if the line above appears on a Web page that defines <P> with 1-inch margins through a linked style sheet, all paragraphs on the Web page will get 1-inch margins except for the <P> above, which will get 0.5-inch margins.

If you want to change the appearance of an entire section, you can use the <DIV> tag to define styles globally for that section. The following example changes the color and point size of a block of text by using the <DIV> tag (this has the same effect as assigning these styles separately for the <P>, <UL>, and <LI> tags):

```
<DIV

STYLE="font-size: 20pt; color: red">

<P>

The style specification affects everything on this page until
the

DIV close tag.

<UL>
```

```
<LI>This is red and 20 pt.

<LI>So is this.

</UL>

</DIV>
```

## ADDING EVENT CODE TO THE STYLED DOCUMENT

With the advent of Cascading Style Sheets (CSS) in Internet Explorer 3.0, Web authors received unprecedented control over the look of all the HTML elements on a page. Internet Explorer 4.0 brings this technology a step further, providing the ability to dynamically change any attribute, at any time, on any element. All other HTML attributes (such as *src* on an *img*) can be changed dynamically as well.

Scripting events may be interjected inline to affect an element as in the following example (IE 4 or better):

```
<H1 onmouseover="this.style.color = 'red';">Make me red</H1>
```

In Netscape, the syntax is:

```
<H1 onmouseover="this.color = 'red';">Make me red</H1>
```

Regular HTML attributes are accessed as properties on each element. CSS attributes can be set from the style sub-object. Using this same principle in a style sheet will produce the same results in either scenario, and the event may be reproduced across multiple pages.

## USING GRAPHICS WITH DYNAMIC HTML

The dynamic nature of DHTML extends to objects other than just text. Images may also be manipulated via trigger events. In the following example, as the mouse moves over the image, its source changes from before.gif to after.gif:

```
<IMG src="before.gif" onmouseover="this.src = 'after.gif';">
```

The ramifications here are endless. Client side scripting can be used to display dynamic advertising banners or slideshows of company products when the page loads to name some simple examples. Using DHTML, the Web programmer also has the ability to write code for applications or games as well. You can find examples at *http://madgames.com/*, as well as, *http://members.xoom.com/ultrafluid/*.

## DIFFERENCES BETWEEN STYLE-SHEET APPEARANCES IN DIFFERENT BROWSERS

One reason HTML has been so successful is that it provides a consistent way to present a document on the Web. You mark up a page once, and, with a few exceptions, it basically works everywhere. The same is true with JavaScript. Even with the multitude of versions, a consistent syntax and a core level of functionality will work with all browsers that support JavaScript. CSS is also consistent, at least as far as syntax goes. There's one way to declare things, and, barring compliance issues, you get a consistent result across browsers. Thus, everything seems poised to enable you to create cross-platform, consistently rendered dynamic pages.

However, in 1997, when Netscape and Microsoft were creating their dynamic HTML browsers, there wasn't a specification for how a scripting language should interact with elements on a Web page. There was, however, a precedent for how JavaScript should interact with collections of images, links, and form-elements. Unfortunately, each company had a different idea about how to control elements on a page.

Netscape added collections of objects to JavaScript with the introduction of its <LAYER> tag. This went along with its DHTML rendering:

> A layer of content—either with the depreciated <LAYER> tag or with a <DIV> tag that's been positioned with CSS—could be accessed as a JavaScript object, and then its properties (left, top, visibility, and background color) could be manipulated.

Microsoft, however, went a few steps further. With a completely new rendering engine, it could position not only any element, but also could alter any of the CSS selectors assigned to any element. (For example, you could change the font-family or your EM tag.) Furthermore, it implemented a Document Object Model that could be accessed through any programming or scripting language that happened to run on Internet Explorer.

The observable difference between the two is the syntax. Netscape supports a treelike syntax, as shown below:

```
document.layers['topLayer'].document.layers['subLayer']
.document.layers['bottom'].left
```

On the other hand, Internet Explorer exposes all HTML objects as a *flat* collection and lets you modify the style object directly:

```
bottom.style.left
```

If you try to use either method on the wrong browser, you will get an error message. There are, however, many techniques to be used that work around this inconsistency. After you learn these techniques, you should be able to code whatever you want.

One of the best tricks is to remember that almost everything in DHTML may be handled using the <DIV> tag as a container. (In the specification for cascading stylesheets and the CSS positioning draft, it states that *any* object may be positioned, but Netscape browsers don't support this yet.) To provide greater cross-browser functionality, you should get used to using the <DIV> tag as a generic container. For an excellent reference as to what is supported across browsers, see the table located at the following URL:

*http://Webreview.com/wr/pub/guides/style/mastergrid.html*

## FAST ANIMATION WITH STYLE SHEETS

Although it is still only a working draft, CSS positioning is supported in both Microsoft's Internet Explorer 4.0 and Netscape's Communicator. Positioning opens up a whole new level of control over Web pages. Instead of building awkward tables to hold objects, you can place each object exactly where you want it on the page.

It works like this: when a browser renders an object on the page with CSS positioning, it places it into an invisible rectangle, called a *bounding box*. You can set the box's exact distance from the top and/or left edges of the browser window (known as *absolute positioning*), or you can offset the box from other elements on the page (known as relative positioning). You can also specify the height and width of the box. You can even layer objects on top of one another. And since objects can overlap, CSS positioning includes clipping features that let you cut off an area of an element—for example, to have a top object reveal another one beneath it. Finally, you can make entire objects visible or invisible.

The CSS positioning clip, overflow, and visibility features make it easy to add special effects to pages. The clip property lets you reveal overlapped objects, and the overflow property lets

you specify what happens to objects that don't fit into a boundary box with a set height and width. The visibility property lets you make objects invisible—it's a great way to have an object flow around something that's seemingly not there.

In the example below, a span element is created that calls the "hidden" class and goes on to use the "visibility" property to hide the text. The text is invisible in the browser window, but you'll notice the line that follows it makes room for it on the screen.

The next class element calls the overflow class, which, naturally, employs the overflow property. The tag's bounding box is smaller than its text, so the text is cut off. The last two elements demonstrate clipping. The last object is placed directly on top of the one before it, but it's clipped to a smaller size; thus, the previous one shows through. The figure below shows the result.

Here is the code:

```
<HTML>

<HEAD>

<STYLE type="text/css">

<!—

.hidden   { position: relative;

   visibility: hidden

   }

.overflow { position: absolute;

   top: 210px;

   left: 60px;

   width: 40px;

   height: 40px;

   background-color: yellow;

   overflow: hidden

   }
```

```
.plain { position: absolute;

    top: 200px;

    left: 200px;

    width: 150px;

    height: 150px;

    background-color: #eeeeee;

    }

.clip    { position: absolute;

    top: 200px;

    left: 200px;

    width: 150px;

    height: 150px;

    color: yellow;

    background-color: blue;

    clip: rect(25px 125px 125px 25px);

    }

-->

</STYLE>

</HEAD>

<BODY>

<SPAN class="hidden">This text is invisible on the page,</SPAN>
but this text is affected by the invisible item's flow.
```

```
<DIV class="overflow">This is way too much text for the little
box that we've designated. The overflow property hides the
excess.</DIV>

<DIV class="plain">This text is partially covered by the blue
square in the 'clip' class example that follows, but since the
square is clipped, some of this text shows through.</DIV>

<DIV class="clip">This text is yellow on a blue square, but it's
getting cut off by clipping.</DIV>

</BODY>

</HTML>
```

Imagine this code being used with DHTML events, such as onLoad, to move the positions of the objects dynamically in sequence across the screen. CSS positioning coupled with scripting allows for this kind of manipulation of HTML objects, resulting in animation.

One of the goals of the latest style sheet specification is to define style elements that can be applied to structured documents of many different types, including HTML (HyperText Markup Language) and XML (Extensible Markup Language) pages. HTML, the markup language for traditional Web pages, is used to format text and multimedia to be viewed in browsers, such as Microsoft Internet Explorer and Netscape Navigator. XML is designed to structure data so that it can be transferred over a network. The latest CSS specification seeks to define style elements that can work with formatted text and multimedia, as well as, data structures.

## USING STYLE SHEETS TO CREATE ANIMATED MENUS

Because style sheets are so versatile and fit within the Document Object Module, it is possible to pull a sort of smoke and mirrors with CSS and a couple of DHTML events to create an animated menu for your site. With a little bit of DHTML mixed in with a style sheet you can create the same sort of effects that are often found only by calling Java applets or extensive scripts. The principle is simple. Using the mouseover event and a style sheet class definition, you can create active menus that respond to a mouseover.

Using the onmouseover and onmouseout events, coupled with calling style sheet custom classes to alter the style of the target object, you can create any number of variations for an animated menu system on your pages that will help aid users in navigating your site.

## CREATING A SIMPLE ANIMATED MENU WITH A STYLE SHEET FOR INTERNET EXPLORER

To begin creating a simple animated menu in Microsoft's Internet Explorer 4.0 or higher, open a text editor or HTML editor in HTML edit mode. Start by adding an embedded style sheet that resembles the following:

```
<Style>

<!–

TD.Nav            {        background: #0000cc;

                  color:            #ff9900;

                  }

</Style>

–>
```

This creates a class for the table row element. Next, create a table with a single column and several rows that will house the navigation items. These should be text that is encapsulated with anchors to form an active link, as shown in the following example code:

```
<table border="0" cellpadding="0" cellspacing="0" width="70">

  <tr>

    <td align="center "onmouseover="this.className='Nav'"

                onmouseout    ="this.className=""><A
HREF="www.mysite.com">Home</A></td>

  </tr>

  <tr>

    <td align="center" onmouseover="this.className='Nav'"

        onmouseout ="this.className=""><A HREF="/links/
index.html">Links</A></td>

  </tr>
```

```
    <tr>

      <td align="center" onmouseover="this.className='Nav'"

            onmouseout ="this.className=""><A HREF="/pics/
index.html">Pictures</A></td>

      </tr>

      <tr>

      <td align="center" onmouseover="this.className='Nav'"

            onmouseout ="this.className=""><A HREF="/friends/
index.html">Friends</td>

      </tr>

      <tr>

      <td align="center" onmouseover="this.className='Nav'"

            onmouseout ="this.className=""><A HREF="/contact/
form.html">Contact</A></td>

      </tr>

</table>
```

## THE FUTURE OF STYLE - XSL

Extensible Style Sheet Language (XSL) is a fairly simple language, based on level 0 of the ISO/IEC 10179 Document Style Semantics and Specification Language (DSSSL). It is, itself, based on XML, which means that the language is defined using TAGS, or NAMED RULES, delimited by angle brackets. XSL is also based on the concept of PATTERNS, which are syntactic rules that determine which XSL presentation is applied to what XML elements.

To demonstrate XSL, consider the following block of XML:

```
:document>

<title>What is XML</title>
```

```
<sidebar>

  <title>What is XML?</title>

  <body>

  XML is a custom markup language that contains

  Customized markup tags that determine how content is

  processed.

  </body>

 </sidebar>

 <content>

<title>What is XSL?</title>

  <body>

Extensible Style Sheet Language (XSL) is a fairly simple lan-
guage, based on level 0 of the ISO/IEC 10179 Document Style
Semantics and Specification Language (DSSSL).

  </body>

  </content>

</document>
```

The above XML defines a document that has a main title and regular document content with a sidebar included and with its own title. The XML document described the elements of the document, but nothing about how the elements are presented. XSL is described in the next sections, beginning with the XSL rule.

XSL styles are defined as elements with an element name of rule and contain patterns used to match a style with a specific XML element. For example, the following defines an XSL rule for an element with the label of title, and applies a presentation equivalent to an H1 header, with a red font and using the font-family of Arial:

```
<xsl>

 <rule>
```

```
    <target-element type="title"/>

    <H1 color="red" font-family="Arial">

    <children/>

    </H1>

    </rule>

</xsl>
```

## EXPANSIONS TO THE SIMPLE ANIMATED MENU

After you have created a simple animated menu, you may now add additional code to provide greater functionality to your navigational system. Using richer DHTML along side style sheets provides several options. Consider the following code and the resulting page shown in the figure below:

```
<HTML>

<HEAD>

<TITLE>DHTML Expanding Menus</TITLE>

</HEAD>

<BODY>

<SCRIPT LANGUAGE="JavaScript">

<!-

    NS4 = (document.layers);

    IE4 = (document.all);

   ver4 = (NS4 || IE4);

    isMac = (navigator.appVersion.indexOf("Mac") != -1);

  isMenu = (NS4 || (IE4 && !isMac));
```

```
    function popUp(){return};

    function popDown(){return};

    function startIt(){return};

    if (!ver4) event = null;

    if (isMenu) {
menuVersion = 3;

menuWidth = 120;

borWid = 2;

borSty = "solid";

borCol = "black";

separator = 1;

separatorCol = "red";

fntFam = "sans-serif";

fntBold = false;

fntItal = false;

fntSiz = 10;

fntCol = "blue";

overFnt = "purple";

itemPad = 3;

backCol = "#DDDDDD";

overCol = "#FFCCCC";

imgSrc = "tri.gif";
```

```
    imgSiz = 10;

    childOffset = 5;

    childOverlap = 50;

    perCentOver = null;

    clickStart = false;

    clickKill = false;

    secondsVisible = 0.5;

    keepHilite = false;

    NSfontOver = false;

    isFrames = false;

    navFrLoc = "left";

    mainFrName = "main";

    }
//-->

</SCRIPT>

<SCRIPT LANGUAGE="JavaScript1.2">

<!--

  if (isMenu) {

    document.write("<SCRIPT LANGUAGE='JavaScript1.2'
SRC='hierArrays.js'><\/SCRIPT>");
```

```
     document.write("<SCRIPT  LANGUAGE='JavaScript1.2'
SRC='hierMenus.js'><\/SCRIPT>");

   }

//-->

</SCRIPT>

<P><A HREF="defaultLinkForOldBrowsers.html"

onMouseOver="popUp('elMenu1',event)"

onMouseOut="popDown('elMenu1')">

Appropriate Text for this Link/Menu</A></P>

<P><A HREF="defaultLinkForOldBrowsers.html"

onMouseOver="popUp('elMenu2',event)"

onMouseOut="popDown('elMenu2')">

Appropriate Text for this Link/Menu</A></P>

<P><A HREF="defaultLinkForOldBrowsers.html"

onMouseOver="popUp('elMenu3',event)"

onMouseOut="popDown('elMenu3')">

Appropriate Text for this Link/Menu</A></P>

<P><A HREF="defaultLinkForOldBrowsers.html"

onMouseOver="popUp('elMenu4',event)"

onMouseOut="popDown('elMenu4')">

Appropriate Text for this Link/Menu</A></P>
```

```
<P><A HREF="defaultLinkForOldBrowsers.html"

onMouseOver="popUp('elMenu5',event)"

onMouseOut="popDown('elMenu5')">

Appropriate Text for this Link/Menu</A></P>

</BODY>

</HTML>
```

The following external array is called (as a file named hierarray.js) to define menu items:

```
arMenu1 = new Array(

"",

"","",

"","",

"","",

"","",

"Link 1","Link URL for Item 1",1

);

arMenu1_1 = new Array(

"Sub-Link1","Link URL for Item 1",0,

"Sub-Link2","Link URL for Item 2",0,

"Sub-Link3","Link URL for Item 3",0

);

arMenu2 = new Array(

"",
```

```
"","",

"","",

"","",

"","",

"Link 2","Link URL for Item 1",1

);

arMenu2_1 = new Array(

"Sub-Link1","Link URL for Item 1",0,

"Sub-Link2","Link URL for Item 2",0

);

arMenu3 = new Array(

"",

"","",

"","",

"","",

"","",

"Link 3","Link URL for Item 1",0

);
```

## CONSIDERING OTHER SOLUTIONS POSSIBLE WITH DYNAMIC HTML

Because DHTML gives the Web programmer the ability to offer interactive content based on a rich object model, the possibilities are only limited to the imagination of the user. Indeed,

entire applications, including games and productivity types, have been deployed via the Web using this technology. Once again, this is due in part to the fact that the DOM and scripting technologies allow such rich interaction with the user through peripheral devices, such as the mouse and keyboard. For examples of the power of DHTML in creating applications, visit the Web site:

*http://www.ruleWeb.com/dhtml/ie4.html*

You can also visit *http://www.terrarium.nu/terrarium/* to see exuberant displays of DHTML and CSS.

For a comparison of DHTML and XML features, visit:

*http://www.npac.syr.edu/users/gcf/cps616advancedhtmlapril98/*

## LIMITATIONS OF DYNAMIC HTML

Dynamic HTML today is (unfortunately) a browser specific Object Model that enables programmers to create Web pages that are dynamic and interactive. You can create Dynamic HTML with any of the following programming languages:

- JavaScript
- JScript
- VBScript
- C++
- Java

VBScript support is not native to Netscape browsers and requires a plug-in for interpretation of the language. Dynamic HTML removes programmer limitations on access to the Web document. Dynamic HTML, in Microsoft Internet Explorer 4.0, empowers developers with the following features:

- HTML 4.0 and advanced cascading style sheets
- Full access to the document's structure
- Dynamic style
- Dynamic contents
- Instant user response

- Client/server Web pages

- Multimedia and animation effects

Limitations are based on the lack of adoption of standards between the major Web browser producers, Netscape and Microsoft. Do not confuse this with a lack of standards on the whole as DHTML and the DOM are widely standardized via the W3C consortium. The following list outlines the limitations of the current DHTML implementation:

- Only works with versions 4.x of Netscape and Microsoft browsers

- Both browsers' implementations are slightly different

- Language support

## BENEFITS OF SCRIPTING OVER DYNAMIC HTML

The line between virgin scripting and DHTML may not always be obvious. DHTML provides a rich object-oriented model combined with speed. However, your code may not work across all platforms or browsers where using pure JavaScript may give you broader functionality.

Straight scripting using languages such as Java, JavaScript, VB, or VBScript allow for greater flexibility though there may be a sacrifice in performance. A significant aspect of the Object Model includes the use of scripting languages that let programmers write actions between the various HTML elements. Still, this may not provide enough teeth for true Web-based applications which would certainly benefit more from using straight Java.

## DETERMINING WHEN TO USE SCRIPTING AND WHEN TO USE DHTML

The purpose of Dynamic HTML is to make Web content more compelling, productive, and interactive, though DHTML won't replace more advanced technologies (like CGI) anytime soon. But think about the kinds of advantages DHTML (especially Microsoft's flavor) offers: instant interaction with common data types, interfaces that are easier to configure and build, multimedia, built-in mathematics (via JavaScript and VBScript), excellent database connectivity, and the ability to take advantage of plug-ins and components already on the system. And, of course, scriptlets add a dimension to lightweight object-oriented programming on the Web.

**249**

Variations in Dynamic HTML implementation present an immediate obstacle for Web developers and designers in that pages built using Microsoft's Dynamic HTML will not display properly on Netscape's Navigator and those built with Netscape's extensions will not be viewed correctly with Microsoft's Internet Explorer.

Straight scripting using languages such as Java, JavaScript, VB, or VBScript, allow for greater flexibility though there may be a sacrifice in performance. A significant aspect of the object model includes the use of scripting languages that let designers write the actions between the various elements.

Aside from politics, there's a good chance that part of the reason many companies have put Java to the wayside is solely so they can deliver more excitement with fewer resources.

## INTRODUCING ACTIVEX CONTROLS

To better understand ActiveX Controls, it might be useful to review some basic principles and language associated with Object Oriented Programming (OOP). Visit *http://msdn.Microsoft.com* for a good primer. ActiveX controls, known in the past as OCX controls, are components you can insert into a Web page or other application to reuse packaged functionality another user programmed. For example, the ActiveX controls that are included with Microsoft® Internet Explorer version 3.0 or higher let you enhance your Web pages with sophisticated formatting features and animation.

A key advantage of ActiveX controls over Java applets and Netscape plug-ins is that ActiveX controls can also be used in applications written in many programming languages, including all of the Microsoft programming and database languages.

You can add ActiveX controls to your Web pages by using the standard HTML <OBJECT> tag. The <OBJECT> tag includes a set of parameters that you use to specify which data the control should use and to control the appearance and behavior of the control.

The basic definition of an ActiveX control is simply an OLE object that supports the *IUnknown* interface according to Microsoft. An ActiveX control supports many more interfaces in order to offer greater functionality, though additional interfaces are optional. By not specifying additional interfaces that a control must support, a control can efficiently target a particular area of functionality without having to support particular interfaces to qualify as a control.

As always with OLE (see next section for a description of OLE), whether in a control or a container, it should never be assumed that an interface is available, and standard return-checking

conventions should always be followed. It is important for a control or container to degrade gracefully and offer alternative functionality if a required interface is not available.

It is important for controls that require optional feature, or features specifics to a certain container, be clearly packaged and marketed with those requirements. Similarly, containers that offer certain features or component categories must be marketed and packaged as offering those levels of support when hosting ActiveX Controls.

An ActiveX control is simply another term for OLE Object or, more specifically, under the new realm of Microsoft programming, a COM Object. In other words, a control, at the very least, is a COM object that supports the *IUnknown* interface and is also self-registering. Through *IUnknown::QueryInterface,* a container can manage the lifetime of the control, as well as dynamically discover the full extent of a control's functionality based on the available interfaces. This lets a control implement as little functionality as it needs to, instead of supporting a large number of interfaces that actually don't do anything. In short, this minimal requirement for nothing more than *IUnknown* lets any control be as lightweight as it can.

Other than *IUnknown* and self-registration, there are no other requirements for a control. There are, however, conventions that should be followed about what the support of an interface means in terms of functionality provided to the container by the control. The next section describes what it means for a control to actually support an interface, as well as methods, properties, and events that a control should provide as a baseline if it has occasion to support methods, properties, and events.

## UNDERSTANDING OLE TECHNOLOGY

In the computer industry today, applications exist for almost every conceivable user need. However, if a user wanted to use parts of one application in another (such as a graph created in a spreadsheet in a word processing package), this could not be done. Around mid-1992, Microsoft created the Object Linking and Embedding (OLE) stream of programming functions that let programmers create applications for users that let one large document consist of a variety of smaller documents, each created in a different application.

Pronounced as separate letters, O-L-E, or as *oh-leh,* OLE is a compound document standard developed by Microsoft Corporation. It enables you to create objects with one application and then link or embed them in another application. Embedded objects retain their original format and links to the application that created them. Support for OLE is built into the Windows and Macintosh operating systems. A competing compound document standard developed jointly by IBM, Apple Computer, and other computer firms is called *OpenDoc.*

## UNDERSTANDING THE PRECURSORS OF OLE

There are important precursors to understanding and implementing OLE, up to and including basic programming design method and theory. You cannot implement OLE code without having at least a fully designed application. This means that the program must be well thought out, designed, and preferably flowcharted. Additionally and preferably, a nearly deployed application is a better candidate for OLE implementation. Also, you can't add OLE to just any application. The application has to deal with displaying objects of some sort or other for it to make any sense to add OLE. This isn't quite true, because OLE provides a structured storage system that can be used as a standalone feature, and it also provides an automation feature. Nonetheless, the main purpose of OLE is linking and embedding objects, but you have to provide an application to link them to or embed objects in.

This holds true even for the Microsoft browser itself, which is an OLE container and utilizes ActiveX controls as part of the navigational UI. ActiveX controls work within the Internet Explorer environment (not just the navigational controls but within the browser window as well) because the application itself is prepared to utilize ActiveX controls through OLE.

## EXPANDING THE CONCEPTS OF OLE TO ACTIVEX

You can think of ActiveX controls as miniature Web-based applications, though this is somewhat of a misnomer as Microsoft has extended and implemented the ability to use ActiveX controls in almost every product they develop. The reason is simple. The controls are lightweight and extensible and allow greater flexibility through almost any user interface.

## ACTIVEX CONTROL DELIVERY OVERVIEW

Delivery of ActiveX controls takes a distinct path to ensure safety and reliability to the user. The following is the Microsoft standard recommendation for ActiveX control delivery taken from *http://msdn.microsoft.com*. There are four steps to take in preparing your ActiveX control for use on Web pages:

- Package the component for Internet component download.

- Digitally sign the software to be distributed.

- Ensure that the component is safe for scripting and initialization, and mark it as such.

- Arrange to provide for licensing of components that require it.

### Internet Component Downloading

Internet Component Downloading is a capability of the Internet browser. The browser is responsible for copying all of the needed files to users' hard disks—and for not copying those they already have copied. Before the browser can copy the files, however, you must package them and place them on your Internet server. Additionally, browsers have configurable security settings that protect your PC from potentially harmful files by allowing or disallowing downloading of certain files. In fact, the browser's security settings must be set correctly or the end user will not get your control.

The Setup Wizard packages your control for Internet component download. It creates a Cabinet (.cab) file for your ActiveX control. This .cab file is a compressed file, containing all of the information necessary to download, install, and register your control and any other dependent components necessary to run in the HTML page. The benefits of this architecture include:

- File compression for faster download.

- A single file for your .ocx and .inf that describe other files required.

- Dependency files, such as Msvbvm50.cab, that will be downloaded only as necessary—thus minimizing download time.

- Easier updating when new versions of your component are created.

- Automatic installation when the control component is downloaded.

### Digital Signing

Code received via the Internet lacks shrink-wrapped packaging to vouch for its reliability, and users are understandably skeptical when they're asked to download it. A *digital signature* provides an opportunity for you to reassure them by effectively creating your stamp of approval that states that you created the component and that it will not damage their computer. It creates a path from the user to you, should your software harm their system. (Note that this does not ensure that a control is hazard-free, but it puts your name to your code. Thus, any hazardous software can be traced back to the author.) As a developer of professional Web sites, you want to provide that security to your users.

When you develop software for distribution over the Internet, you work with a third party known as a *Certificate Authority* (CA) to obtain a *digital certificate,* which will give users information about you. The CA provides and renews your certificate, authenticates your identity, and handles legal and liability issues for broken security. In addition, the CA typically provides the tools you need to digitally sign your components. Your digital certificate is included with all code you digitally sign and distribute over the Internet.

The default setting of Internet Explorer doesn't allow software that is not digitally signed to be downloaded to the end user's machine. Thus, it is important that you obtain a digital signature for software components you intend to distribute over the Internet.

## Safety

Downloaded components are initialized when they first load, and they can also be scripted. It is also possible for a user other than yourself to script your component. Thus, you must ensure that the component you create doesn't have any potentially harmful capabilities. Your script might not do any harm, but another user's script might. In other words, you need to design your component so that it is guaranteed to interact safely with script and data passed to it during initialization. A malicious script or data can have harmful results on users' computers—and users will come looking for you when that happens. By default, Internet Explorer will display a warning and will not download a component that has not been marked safe for scripting and initializing.

You set your component Safe for Scripting and Safe for Initialization in the Setup Wizard of the development environment that you are using. On an HTML page, your component's functionality is accessed through scripting, such as when events are handled through Visual Basic Scripting Edition (VBScript). For ActiveX controls, scripting is the only way to fully utilize the control's features in a browser. While your control may be a trusted component from a reputable source (you), a malicious script may be able to use its methods to delete files on the user's machine, install macro viruses, and worse. A component is safe for scripting when it can't be scripted to harm the user's computer. In other words, your control doesn't have any interface properties or methods that, when called, do something malicious.

Another potential security hazard is initializing your control's state using untrusted data. On an HTML page, your control's initial state is set from the PARAM attributes that accompany the OBJECT tag in the HTML embedding the control. A component is safe for initializing when its properties can't be passed data that in some way harms the user's computer.

## Licensing

If you wish to make a business of creating ActiveX content for the Internet, you can create controls that require a license for use in an HTML page. A Visual Basic application supplies the run-time license to a control automatically, but this process does not happen with an HTML page. This functionality is built in to Microsoft Developer Products using the Setup Wizard.

## INTRODUCING SOME OF THE MOST COMMON ACTIVEX CONTROLS

A standard set of ActiveX controls comes with the Web browser as well as many other Microsoft Windows-based applications. You use controls to get user input and to display output. Some

of the controls you can use in your applications include text boxes, command buttons, and list boxes. Other controls let you access other applications and process data as if the remote application was part of your code. Each control has its own set of properties, methods, and events.

The following list outlines additional common controls in use today and their descriptions:

- **Animation Control:** Basic operation covers opening, playing, stopping, and closing silent *.avi* files

- **Communications Control:** The Communications control is used with a modem to dial a phone number, interact with another modem, or add advanced communications functionality to your applications.

- **CoolBar Control:** The CoolBar control lets you create user-configurable toolbars similar to those found in Microsoft Internet Explorer.

- **DateTimePicker Control:** The DateTimePicker control provides a drop-down calendar to users, useful for date or time input.

- **FlatScrollBar Control:** The FlatScrollBar control is an alternative to the original VScrollBar and HScrollBar controls and features hot tracking—the scrollbar changes appearance as the cursor hovers over it.

- **ImageCombo Control:** Similar to the standard ComboBox control, the ImageCombo control additionally provides an image to rapidly distinguish items in a list.

- **Transfer Control:** Transfer files to and from a remote computer using the HTTP or FTP protocol. Basic operation includes specifying a proxy server, invoking the OpenURL or Execute operation, and using the GetChunk method to retrieve data.

- **ListView Control:** Organize and view your data in any of four different views using the ListView property. Add items to be ListImages collection using the Add method, and customize the view by specifying images to be associated with the viewed items.

- **MaskedEdit Control:** Used to create mask patterns that prompt users for date, time, currency, or customized data input.

- **MonthView Control:** The MonthView control presents a graphical representation of a calendar for easy input of dates into any application.

- **Multimedia Control:** Used to manage the recording and playback of a variety of multimedia using a simple push-button interface.

- **ProgressBar Control:** Gives the user feedback about a lengthy operation by associating the Value property with a metric of the operation. Set the Min and Max properties to actual values used in the operation.

- **Slider Control:** Lets users set values using the Slider control. Basic operation includes setting Min and Max values, and letting the user select a range of data.

- **StatusBar Control:** Add Panel objects to the Panels collection, and program text and images to be displayed in the StatusBar control. Set the Style property to automatically view keyboard status, time, and date.

- **SysInfo Control:** The SysInfo control is used to determine the current operating system and version, and how to monitor and respond to system and plug-and-play events or changes in AC and battery power status.

- **TabStrip Control:** Create tabs by adding Tab objects to the Tabs collection.

- **ToolBar Control:** Use a Toolbar to give users quick access to frequently used operations. Allows for the addition of Button objects to the control, and associate images, text, and ToolTips with each button.

- **TreeView Control:** Displays a navigational, hierarchical tree of Node objects and how they relate to each other.

- **WinSock Control:** Send data to remote computers using either the TCP or UDP protocol. Simple scenarios include building a chat application.

## SECURITY ISSUES SURROUNDING ACTIVEX FOR THE CONSUMER

As is the case with any scripting or Web application, the consumer should always be weary. So-called hostile applications can do damage to many systems up to and including erasing data from a hard drive or sending local information stored on your hard drive to a remote location. Many times the application or script is not intentionally written as hostile but rather is poorly coded and crashes a system every time the code runs.

Whether you are a home user or behind the corporate firewall, dangerous applications can affect you just the same. It is important to realize the potential for danger and what can be done about it.

First and foremost, the ultimate protection is abstinence. If program code is forbidden to run on your machine, then you are protected from these rogue elements. This will, however, significantly limit your Web experiences to static content. The top browsers offer safety levels as an option. Setting a security level that you are comfortable with will help, in part, to protect your system while allowing the continued enjoyment of dynamic content. Most browsers will ask for a confirmation prior to installing ActiveX controls.

All controls should be signed and the certificate should be dated appropriately. Never accept the installation of an ActiveX control that is out of date or from an entity that is unfamiliar. Limiting your Web surfing to known sites will also curtail the chances of picking up a hostile application.

## SECURITY ISSUES SURROUNDING ACTIVEX FOR THE SITE DEVELOPER

As a developer of ActiveX controls, you bear a certain responsibility in offering such applications to the general public. It is important to note that downloaded components are initialized when they first load or they may be scripted to load upon an event. Controls may be harvested and used maliciously as it is possible for another user to script your component.

Therefore, to provide safe code to the masses, you must ensure that the component you create doesn't have any potentially harmful capabilities. Testing components with scripts is a sure way to guarantee that a component cannot be used maliciously. Design components so that they may interact safely with scripts or data passed to them during initialization. Users will come looking for you, should this happen, through the digital signature on the control.

A *digital signature* provides an opportunity for you to reassure users by effectively creating your stamp of approval that states you created the component and that it will not damage their computer. It creates a path from the user to you, should your software harm their system. (Note that this does not ensure that a control is hazard-free, but it puts your name to your code. Thus, any hazardous software can be traced back to the author.)

## VISUALIZING THE ACTIVEX SECURITY MODEL

Much is the security model for ActiveX is left to the discretion of the end user which, in the security world, has a great potential for failure or danger because users often know little or nothing regarding security issues surrounding much of today's technology. The inclination for most users is to click Yes to install.

The ActiveX security model is distributed and is based on three primary elements:

- Digital signatures
- User response
- Web browser technology

Digital signatures only provide a mechanism for tracking down the author of the control rather than providing actual protection. Still, an audit trail is good to have in a pinch.

User response is controlled by the user operating the computer. The safety of this situation depends largely on the experience level of the user and is truly a flaw in the grand design of the ActiveX security model.

Microsoft came to understand the security implications involved in letting such a beast loose on the general public and integrated some failsafe technology into their browser technology to better server the public. Options under Internet Explorer let the user have the ability to set security levels whereby downloaded content is implemented in a discretionary manner.

Overall, the security model is weak. Therefore, the user should be aware of everything that is downloaded through the browser and take steps to familiarize his or herself with the potential threats and the workarounds.

## DESIGN CONSIDERATIONS FOR ACTIVEX CONTROLS

An ActiveX control is an object that supports a customizable, programmatic interface. Using the methods, events, and properties exposed by a control, Web authors can integrate applications into their HTML pages. If you are familiar with any windowed environment, be it in Unix, MACOS, or Microsoft Windows, you should also be familiar with the components of these environments such as radio buttons or text boxes. Examples of ActiveX Controls also include text boxes, command buttons, audio players, video players, stock tickers, and so on.

You can develop ActiveX Controls using Microsoft Visual Basic 5.0 and later, Microsoft Visual C++, and Java. Advancements in VB technology compilation make it a platform of choice for many when designing and packaging ActiveX controls for the Web or other interfaces.

When developing ActiveX controls, or anything for use on the Web, it is important to remember the Lowest Common Denominator, in this case, modem speed. Controls should be lightweight and downloadable without encumbering the user's connection to the Internet.

Testing and debugging controls for proper functionality is critical to the success of the product. Always perform rigorous testing with differing browser levels on a test machine to circumvent the possibility of destroying user's machines.

## INCLUDING ACTIVEX CONTROLS ON YOUR WEB SITE

When Internet Explorer 3.0 encounters a Web page with an ActiveX control (or multiple controls), it first checks the user's local system registry to find out if that component is available on their machine. If it is, Internet Explorer 3.0 displays the Web page and activates the control. If the control is not already installed on the user's computer, Internet Explorer 3.0 automatically finds and installs the component over the Web, based on a location specified by the developer creating the page.

The Web page developer provides this information by setting the CODEBASE property for the control. When using the ActiveX Control Pad, you can easily set this property using the visual property table in the Object Editor. Specify a URL location or set of locations where the control can be found and downloaded on the Internet. Internet Explorer 3.0 will then use this information to locate the control and download the component automatically. After the download, the Web page will be displayed. See the *Safe Web Surfing with the Internet Component Download Service* article in the July 1996 edition of the *Microsoft Systems Journal* for detailed information on how this works. Note that for many Microsoft-supplied controls, no CODEBASE is necessary since there is an ActiveX Object Index that will automatically find the control based on the CLSID (a unique identifier for a control).

## USING OTHER COMPANIES' ACTIVEX CONTROLS

ActiveX controls include a mechanism to prevent the unlicensed use of controls in Web pages. Today, this mechanism is supported in development tools, such as Visual Basic and Microsoft Access, and is also supported in the beta 2 release of Internet Explorer 3.0. The licensing mechanism works by letting controls be distributed with either a *developer license*, or with a *runtime license*. With a developer license, a user can use the control for development purposes in developer tools, such as Visual Basic, the ActiveX Control Pad, and similar tools. With a runtime license, the user can only view the control within an existing application or Web page, but cannot insert the control into a tool for further development purposes. Supporting the licensing mechanism is up to the individual control vendor. Some control vendors choose not to implement the licensing mechanism, so their controls can be used for

development purposes by anyone once they are installed on the computer. Other control vendors permit royalty-free redistribution of the runtime version of the control only, while charging for the developer license. Users should read the license agreement provided with the control to understand how they can distribute a control on the Web.

## ENABLING NAVIGATOR AND COMMUNICATOR FOR ACTIVEX CONTROL SUPPORT

Netscape Navigator can display ActiveX controls using the ActiveX plug-in for Netscape. This plug-in is available in a beta version from Ncompass Labs. Also, Internet Explorer 3.0 and the Mosaic Web browser can display ActiveX controls.

## ACTIVEX CONTROLS REQUIRE SCRIPTING LANGUAGES

Knowledge of a scripting language such as Visual Basic Scripting Edition (VBScript) or JavaScript™ is helpful, but not required. Some controls require some amount of scripting to be fully integrated into a Web page, but many others do not. The ActiveX Control Pad lets even non-programmers insert many controls by simply pointing and clicking.

## USING THE HTML 4.0 <OBJECT> TAG TO REFER TO ACTIVEX CONTROLS

The <OBJECT> element provides a way for the ActiveX controls and other media to be embedded directly into HTML documents. It has taken over the role of the previous <IMG> tag and provides a technique for inserting a variety of media types. Microsoft's Internet Explorer version 3.0 and later, the <OBJECT> element can be used for the inclusion of ActiveX OLE controls. The following is an example of how the code would look in an HTML page:

```
<OBJECT

CLASSID="clsid:89A56140-6FC5-22CF-A6C7-00AA00A45DE1"

ID=10a0

WIDTH=40

HEIGHT=250
```

```
>

<PARAM NAME="angle" VALUE="90">

<PARAM NAME="alignment" VALUE="2">

<PARAM NAME="BackStyle" VALUE="0">

<PARAM NAME="caption" VALUE="Hello there">

<PARAM NAME="FontName" VALUE="Arial">

<PARAM NAME="FontSize" VALUE="30">

<PARAM NAME="FontBold" VALUE="1">

<PARAM NAME="frcolor" VALUE="8388608">

</OBJECT>
```

The above example inserts the label ActiveX control into the page and subsequent parameters allow for a custom look. Netscape will not display the label control by default.

The TYPE attribute specifies the MIME type for the object and for ActiveX controls this should be "application/x-ole-object".

## USING THE CODEBASE ATTRIBUTE

When the CODEBASE where the ActiveX control that is to be inserted is not be present on the user's system, the automatic download mechanism of ActiveX controls (using the CODEBASE attribute) can be employed. This attribute can be used to provide a location from which the control will be downloaded.

For example, this could be:

```
<OBJECT CLASSID="clsid:99B42120-6EC7-11CF-A6C7-00AA00A47DD2"

CODEBASE=http://www.mysite.com/controls/mycontrol.ocx

ID=lbl1

WIDTH=90
```

which would look within the system registry to see if the control with the given CLASSID is present on the system and, if not, the control will be retrieved from the URL given by the CODEBASE attribute. Full version checking can also be employed using this mechanism.

For example :

```
<OBJECT  CLASSID="clsid:99B42120-6EC7-11CF-A6C7-00AA00A47DD2"

CODEBASE=http://www.mysite.com/controls/
mycontrol.ocx#ver=4,10,0,1"

ID=lbl1

WIDTH=90
```

would only download the control to the user's system if the version present on the system is older than that given by the #ver setting of the CODEBASE attribute, or, in this example, if it is older than version 4.10.0.1.

## USING THE ID ATTRIBUTE

The ID attribute identifies the specific label with a unique name which all objects must have within an OOP setting to allow interaction with other programmatic objects via active OLE scripting (such as JavaScript or VBScript). Such unique identifiers are common to all OOP languages and are similar to the name-value pair used in the Visual Basic language to identify objects on a form, or similarly, in ASP.

## USING THE CLASSID ATTRIBUTE

The object being inserted into the HTML document in this case is referred to by its CLASSID, which is a unique identifier for this control. This is defined according to the Component Object Model (COM) class id URL format. Every control must have a unique identifier to distinguish it from all other controls on the system. The ClassID attribute also holds information about the controls creator. For more information on ClassID enumeration, visit *http://msdn.microsoft.com*.

## TESTING COMPONENT DOWNLOAD

Testing your download file is more complex than testing a conventional setup program because the software installs only if it's missing from the PC or if an older version exists. Also, when there are files listed in the Confirm Dependencies dialog box when you run Setup Wizard in programs like Visual Basic 6, you should test the download on Windows 9x, Windows NT, and Windows 2000 to detect any operating system–specific problems.

At the most elementary level to check the installation (download) of the control, remove the software registration from the registry first. You can do this by running the Regsvr32 command line tool, as shown in the following example:

```
regsvr32 /u controlname.ocx
```

Thereafter, loading the HTML page generated by the wizard should cause the software to be downloaded and re-installed.

*Note:* Remember to select Binary Compatibility in your Visual Basic Project settings to prevent multiple different CLSIDs for your software.

If you have left the DestDir= line in the *.inf* file blank (the default), you should see the file appear in your Occache directory. You may also find other copies of your component in subdirectories (called conflict directories), such as Occache\Conflict.2 and Occache\Conflict.5. The date/time of each file will be different, indicating different builds of the control (and different CLSIDs).

If, on the other hand, you specify the System directory in the DestDir= line in the *.inf* file, only the latest version will save. Care must be taken to ensure that the CLSID remains the same between the builds.

If you want to do heavy-duty testing to ensure that all of the support files also install and register, you can un-register everything in your system directory and your Occache directories. This may be done by the following command lines in each directory:

```
for %f in (*.ocx *.dll) do regsvr32 /u /s %f
```

When you are finished testing, the following restores the entries:

```
for %f in (*.ocx *.dll) do regsvr32 /s %f
```

## EMBEDDING A SIMPLE ACTIVEX CONTROL WITHIN A WEB PAGE

The <EMBED> element lets authors embed objects directly into an HTML page.

The basic syntax is:

```
<EMBED SRC="">

<NOEMBED>Insert alternative content for non-supporting brows-
ers here!</NOEMBED>

</EMBED>
```

where URL represents the URL of the object that is to be embedded. The <EMBED> element will let you embed documents, or objects of any type, including ActiveX controls or Netscape plug-ins. Users only need to have an application that can view the data installed correctly on their machine, or have a plug-in that is associated with the embedded file format. In the case of Internet Explorer, the local registry is checked for the application and the version is checked. If it is not present, then the URL will define where to obtain the source.

Netscape plug-ins make use of the <EMBED> element. Essentially, plug-ins are dynamic code modules which are associated with a MIME data type for which the Netscape client has no native support.

ActiveX controls may be embedded in HTML pages as well using the <EMBED> tag set. Examples of use include installing a MIDI player or movie control inline to the page. When the page is displayed, the object is loaded within the page instead of as a separate entity outside of the browser window.

## REVIEWING WHAT HAPPENS WHEN A USER DOWNLOADS A CONTROL

The overall process of downloading a control is a bit more complex than what appears on the surface. The process begins with the author calling the control from within a Web page. After the page is accessed, the browser will first check the local Windows Registry to see if the control already exists. The ClassID called from the page is checked against the Registry. Absence of the control will then turn focus to the download location of the control, defined by the CODEBASE attribute of the <OBJECT> tag set. After the application and supporting files have been downloaded, the user is presented

with a dialog box that displays information regarding the source and author of the control, as well as, an option as to whether or not to proceed with the install of the control. Once accepted, the control is installed on the local system in the *<system_root>\Windows\occache* subdirectory and registered in the Registry. The only part of the process the user sees or interacts with is the presentation of the control and the certificate.

## DISPLAYING A CONTROL'S DIGITAL CERTIFICATE

After a new control is presented for installation on your system, you have the option of viewing the control's digital signature, an information source about the control and its author. Upon presentation of the control, the resulting dialog box gives the user the option to view certificate.

The digital signature should be complete and informative in order to have a high level of trust in the application. Digital certificates should have the following information included at all times:

- Name of issuing company
- Address of issuing company
- Contact information
- Versioning

Additionally, the certificate should be issued from a well-known certificate authority, such as Verisign. This means that the user who signed the certificate registered with such an authority as a means of proving that user's/companies' existence and credentials.

## UNDERSTANDING HOW A WEB BROWSER KNOWS A CONTROL IS SAFE

When using Internet Explorer and ActiveX controls, and you run across an unsigned or unmarked ActiveX control, you may have encountered a dialog box or boxes informing you that the control is not signed, the control is not safe for initializing, or the control is not safe for scripting. Control for seeing such dialog boxes for ActiveX controls that may have security issues is set through the browser's security settings. If you set your security level to high rather than medium, the control will not load or display at all. If you enjoy reinstalling applications or operating systems, the low setting will install all controls by default without notice or interaction.

These behaviors happen because of Internet Explorer's security mechanisms for ActiveX controls. The ActiveX controls you can automatically download over the Internet can do anything—including things that can damage your system. Java attempts to solve this problem by severely limiting what a Java applet can do. It can't, for instance, access the client's computer file system.

ActiveX controls take a different approach: they demand positive identification of the author of the control, verify that the control hasn't been modified since it was signed, and they identify safe controls—similar to shrink-wrapping a control for download over the Internet. Because of this approach, in theory, ActiveX controls can use the full power of the client's system safely.

If a user attempts to load a Web page that uses a control not registered on the user's system (via a check of the registry), Internet Explorer will download the control. Before this action occurs, the browser first checks to see if the control has been digitally signed. If not, and security is set at high, a dialog box appears.

To eliminate the dialog box, you must perform two steps during control creation: sign the control, and mark it as safe for scripting and for initializing.

## UNDERSTANDING THE SAFE-FOR-INITIALIZATION ATTRIBUTE

Controls must be marked as safe for initialization in order to avoid possible security warnings on the user's system during the pre-installation process. To be safe for initialization, the control should comply with the following basic principles:

- The control does not manipulate the file system

- The control does not manipulate the registry (except to register and unregister)

- The control does not manipulate memory incorrectly

- The control was tested in a variety of circumstances

- The control does not misuse data about the user

This list is the short list and is by no means inclusive as to all testing that should occur prior to giving a control the safe-for-initializing attribute. It is very important never to mark a control safe that isn't actually safe. Once marked safe, the control will be considered safe by all Web pages.

The following is Microsoft's recommendation for rendering a control as safe. The full text of this may be found in the help file of the respective development platform you are using to develop controls or on the MSDN Web site.

You can mark a control as safe in two basic ways:

- Add the necessary entries to the registry key for the control to mark it as safe. You can do this either by manipulating the registry yourself, perhaps when you install the control, or, better yet, by calling certain functions when the control registers itself.

- Implement the IObjectSafety OLE interface, which lets the container query the control's current safety state and to request that it change to safe mode.

Each method has advantages and disadvantages.

Implementing IObjectSafety lets a control have a safe mode and an unsafe mode. A chart control, for instance, could both read and write files when it's in unsafe mode, but only read from files when it is in safe mode. This would let the control be used in powerful ways when safety wasn't important but still be safe for use in a Web page.

Using IObjectSafety also lets a container determine whether an already-created control is safe without accessing the registry, which can make your control come up faster. Finally, controls that implement IObjectSafety can be safe on some interfaces and unsafe on others, since safety is on an interface-by-interface basis.

Adding the entries to the registry has the theoretical advantage that a container could check the registry to see if a control is safe before instantiating it. (Checking the registry is expensive, but instantiating controls is even more expensive.) For example, when an authoring environment, such as the ActiveX Control Pad or Visual Basic, shows you a list of controls you can insert, it can also indicate which controls are safe and which are not. (This is a theoretical advantage because neither environment currently does this.) If the entries aren't in the registry, the authoring environment would have to instantiate the control in order to use IObjectSafety.

Because ActiveX controls must be able to register and unregister themselves using DllRegisterServer and DllUnregisterServer, you'll want to do the registry manipulation in your control's code rather than in a setup program.

One situation in which you might want to add the entries to the registry using a setup program or .REG file is when you know the control is safe, but you can't modify the control itself. As you have learned, this is not recommended unless you're sure the control is actually

safe. (You can always create a new control that safely subclasses the unsafe control.) If you use this method to mark controls that are automatically installed by Internet Explorer 3.0, you'll need to install your control using an .INF file rather than just supplying the control's executable file.

The added code necessary to implement IObjectSafety is about the same size as the code to implement self-registration—less than 1K. Thus, from a size perspective, it doesn't matter which you use.

If your control is always safe, it is possible to use both methods. Using both methods gives you the best performance, both in secure containers and in authoring environments that check for safety (although no such authoring environments exist as of this writing) but makes your control grow roughly an additional 1K.

If your control has both safe and unsafe modes, or is only safe on some of its interfaces, you should only implement IObjectSafety—do not add the registry keys, because they imply that your control is always safe on all interfaces. Also, remember that implementing IObjectSafety will give better runtime performance.

## WHAT YOU PROMISE WHEN YOU MARK A CONTROL SAFE-FOR-INITIALIZATION

The Safe for Initialization attribute on a control is only half of the equation. The control must also be signed as Safe for Scripting, lest the browser return a dialog box marking the control as unsafe. The marking of a control is embedded within and stays *with the control,* not the HTML page. Therefore, controls marked as safe must be safe in every scenario possible. A control marked as safe for initialization has to be written to protect the control itself from any manipulation that might occur during the initialization of the control.

Remember, it is simple to verify that a control is safe when used with a particular Web page. The real challenge comes from cross-checking every scenario that may render the control a possible renegade. It is from this notion that the digital signature came about as a method of notification should a user discover a bug.

If you mark your control as safe for initialization, you are declaring that no matter what values are used to initialize your control, it won't do anything that would damage a user's system or compromise the user's security.

## UNDERSTANDING THE SAFE-FOR-SCRIPTING ATTRIBUTE

Code signing using a digital certificate may provide a guarantee to a user that code is trusted, however, letting ActiveX Controls be accessed from scripts can be a secondary risk that is little known to many end users. Even if a control is known to be safe in the hands of a user, it is not necessarily safe when automated by an untrusted script. For example, Microsoft Word is a trusted tool from a reputable source, but a malicious script can use its automation model to delete files on the user's computer, install macro viruses, and worse.

There are two methods for indicating that your control is safe for scripting. The first method uses the Component Categories Manager to create the appropriate entries in the system registry (when your control is loaded). Internet Explorer 3.0 examines the registry prior to loading your control to determine whether these entries appear. The second method implements the IObjectSafety interface on the control. If Internet Explorer determines that your control supports IObjectSafety, it calls the IObjectSafety::SetInterfaceSafetyOptions method prior to loading your control to determine whether your control is safe for scripting.

## WHAT YOU PROMISE WHEN YOU MARK A CONTROL SAFE-FOR-SCRIPTING

The marking of a control is embedded within and stays with the control, not the HTML page. Therefore, controls marked as safe must be safe in every scenario possible. A control marked as safe for scripting has to be written to protect the control itself from any manipulation that might occur by a page author via scripting of the control. It is simple to verify that a singular control is safe when used with a particular Web page but remember that multiple page secenarios should always be checked and rechecked.

If you mark your control as safe for scripting, you are emphasizing that your control won't do anything to damage a user's system or compromise the user's security regardless of how your control's methods and properties are manipulated by the Web page's script. In other words, it has to accept any method calls (with any parameters) and property manipulations in any order without doing anything harmful to the system.

## HOW THE USER'S BROWSER RESPONDS WHEN YOU UPDATE A CONTROL (VERSIONING)

It is important to remember that an ActiveX control is a program that runs in physical memory on a computer. And, like many programs, it is common to write newer versions of a program that enhances functionality, fixes bugs, and so forth. When an ActiveX control is developed, it is stamped with a version number just like any program. That version number is used to determine whether or not the user's browser needs to download and install a newer version.

When a user loads the page where the control lives, the browser checks to see if the versions of the controls match by checking the current version number of the control on the page against the version number of the control installed on the local system (if the control has been downloaded in the past). This process involves scanning the registry for the version number. If the version number of the control on the page is newer, then the new control is presented for installation. Once installed, the new version number is applied to the system registry.

## USING THE MICROSOFT CHART CONTROL TO CREATE A SIMPLE CHARTING PAGE

The Microsoft Chart control may be used to provide data from some source, such as a database or flat file, in chart form. The Chart control may be customized to provide an intricate user interface within a Web page. For example, see *http://investor.msn.com*.

The Chart control is usually associated with some data source and is, therefore, a data bound control as well. The data source may be as simple as a text file or comma-delimited file, to a Microsoft Excel spreadsheet or Access Database, on up to a large scale database, such as Microsoft's SQL server, or an Oracle database. The code that is used to access the information files or database is built into the chart control at the time of creation.

Use of the Chart control that comes standard with the Internet Explorer or the Visual Basic libraries within an Web page is easy. The <OBJECT> tag is used to call the control, as shown in the following code example:

```
<OBJECT ID="chrtctl"

type="application/x-oleobject"

classid="clsid:9276B91C-E780-11d2-8A8D-00C04FA31D93"
```

```
codebase="http://fdl.msn.com/public/investor/v7/
investor.cab#version=7,1999,1104,1"

width=100%

height=65%

align="texttop"

>

<param name="ServerRoot" value="http://moneycentral.msn.com">

<param name="AppRoot" value="/investor">

<param name="InitTickers" value="dell">

<param name="InvType" value="1">

</OBJECT>
```

Within the <OBJECT> tag set are the ClassID of the OLE object and the CODEBASE attribute that tells the browser where the code lives on the Internet as well as where to check for a newer version of the control.

## ACCESSING THE ACTIVEX SDK

The Microsoft ActiveX Designer Software Development Kit (SDK) provides all of the requirements for creating custom controls. To download the SDK and supporting components, go to the following URL:

*http://msdn.microsoft.com/downloads/sdks/ActiveXSDK/axsdk.asp*

Additionally, you may also download the ActiveX Control Pad, a free tool for creating ActiveX controls. The ActiveX Control Pad is an authoring tool that lets you add ActiveX controls and ActiveX scripting (VBScript or JScript) to your HTML pages. Using the ActiveX Control Pad, you can easily author pages that include advanced layout and multimedia features, such as exact object placement, object layering, and transparency effects. The ActiveX Control Pad can be found on the Microsoft Website at the following address:

*http://msdn.microsoft.com/workshop/misc/cpad/default.asp*

*Note*: URL's often change on Microsoft's site. If these URL's are not accurate, refer to the Microsoft Developer Network at *http://msdn.microsoft.com*

## USING VISUAL BASIC TO CREATE A SIMPLE CUSTOM CONTROL

One of the most powerful tools that you can use to create custom ActiveX controls is Visual Basic. The latest version of Visual Basic from Microsoft offers wizards that help along the process of creating custom controls with the simplicity of the VB language.

Microsoft has included many sample controls with the Visual Basic product to help you speed development of custom controls via example. To open these controls from the Visual Basic **File** menu, choose **Open Project** and select one of the .vbp files (usually a *samp.vbp file, such as chartsamp.vbp), which is listed in the **Samples** directory. Press F5 or choose **Start** from the **Run** menu to run the application.

## CREATING A SIMPLE CUSTOM CONTROL

The easiest method of creating a custom control involves using the VB environment to create an ActiveX control. Begin by opening the Visual Basic environment and select **ActiveX Control** from the new projects window.

Once selected, VB will create a blank page on which you can create your control. Begin by first drawing the control objects, then add any code that may be necessary. For the sake of demonstration, simply add another control to this page for demonstration purposes.

Begin by adding the Calendar control to the toolbox. To do this, right-click on the toolbar and select components. From the list of components, choose the Microsoft Calendar Control and click Apply.

The control is now displayed in the toolbox for use.

## UNDERSTANDING THE IMPORTANCE OF VERSIONING INFORMATION

Versioning provides a user's system the ability to differentiate between newer and older controls and, upon finding a newer version, will initiate the download and update process.

According to Microsoft, when you create a new version of a control, there are several areas of backward compatibility you must address:

- Your control's interface, that is, its properties, methods, and events.

- UserControl properties that affect control behavior.

- Whether property values are saved and retrieved.

- Procedure attribute settings.

### Interface Compatibility

You can add new properties, methods, and events without breaking applications compiled by using earlier versions of your control component. However, you cannot remove members from the interface, or change the arguments of members.

You can use Visual Basic's Version Compatibility feature to avoid creating incompatible interfaces. On the Component tab of the Project Properties dialog box, click your mouse on Binary Compatibility in the Version Compatibility box. This enables a text box in which you can enter the path and filename of the previous version of your component.

The default value in this text box is the last location where you built the component. If you are going to continue using that location to build the new version of your control component, it's a good idea to place a copy of your previous version in another location, and then enter that location in the text box.

### UserControl Properties

Be careful when changing properties of the **UserControl** object, such as **ControlContainer**. If a previous version of your control had this property set to True, so that developers could use the control to contain other controls, and you change the property to False in a subsequent version, existing applications may no longer work correctly if the new version is installed on the same computer.

### Saving and Retrieving Property Values

You may retain a property for backward compatibility, but stop mentioning it in your Help file, and mark it as Hidden using the Procedure Attributes dialog box.

You can stop saving the value of such obsolete properties in the **WriteProperties** event, but you should continue to load their values in the **ReadProperties** event. If you stop loading a property value, you will break any previously compiled application that used the property.

### Procedure Attribute Settings

Changing attributes of a procedure may break applications that were compiled using previous versions of your control. For example, if you use the Procedure Attributes dialog to change the default property or method of a control, the code that relied on the default will no longer work.

By maintaining these aspects of a control, you, as an Active X programmer, can maintain a high standard of control delivery by updating controls often to address bugs or to add additional functionality.

## MAKING SURE THAT YOUR SYSTEM UPDATES VERSIONING INFORMATION ON THE CONTROL

For a client to update a control, there must be some method of distinguishing between newer and older versions of the control. This is accomplished through the use of versioning, a common practice in writing software.

Versioning information is written into the control itself, but versioning information may also be written into the Web page as well. Examine the following code sample:

```
<OBJECT ID="ctlFind"

type="application/x-oleobject"

CLASSID="clsid:9276B91D-E780-11d2-8A8D-00C04FA31D93"

codebase="http://fd1.msn.com/public/investor/v7/
investor.cab#version=7,1999,1104,1"

</OBJECT>
```

Versioning information is stored as an option within the <OBJECT> tag set under the CODEBASE attribute. This ensures that the latest version of the control is advertised and will be installed on a user's system. It is important to note that the Web page must be updated when later versions of the control are introduced for download.

## DIGITAL SIGNATURES AND ACTIVEX CONTROLS

To sign your control, you'll need to obtain a certificate from a Certificate Authority, such as VeriSign. Find directions from VeriSign at *http://digitalid.verisign.com/codesign.htm*.

There are two classes of digital IDs for Authenticode™ technology. Class 2 certificates, for individuals who publish software, cost U.S.$20 per year and require that you provide your name, address, e-mail address, date of birth, and Social Security number. After VeriSign verifies this information, you will be issued a certificate. Class 3 certificates, for commercial

software publishers, cost U.S.$400 per year and require a Dun and Bradstreet rating in addition to company name, location, and contacts.

After you obtain the certificate, use the SIGNCODE program provided with the ActiveX SDK to sign your code. Note that you'll have to re-sign code if you modify it (such as to mark it safe for initializing and scripting). Note also that signatures are only checked when the control is first installed. The signature is not checked every time Internet Explorer uses the control.

After your code is signed, even users whose security setting is high will be able to download, install, and register your controls. But they will only be able to use pages that initialize and script these signed controls if you mark them as safe for initializing and safe for scripting.

## CONSIDERING ACTIVEX DATA BOUND CONTROLS

Many of the same tools that are available within the Visual Basic design environment may be used within Active X Controls much in the same way that they are used within any normal application. For example, you decide that you are going to create an ActiveX control that accesses data from a SQL Database. You decide to use ActiveX over a straight HTML or ASP page because the compiled control offers the ability to maintain state with the database and data. This may allow for quicker handling of customer data.

Using Visual Basic, you can design a control that loads upon page load and provides all of the same functionality of the old database system with the same look and feel and retains speed and state features. Additionally, the new control may be used across hardware platforms and often across browsers with the appropriate plug-in.

Designing such controls, as with any GUI that accesses data from a database, requires knowledge of the query language used to access data. The most common form of database query languages is called Structured Query Language, or SQL, and is found in products such as Microsoft's SQL Server, Oracle, and Sybase.

## ACTIVEX CONTROLS CAN WRAP OTHER CONTROLS

As you have learned, ActiveX controls may be used interchangeably in many containers as well as wrap other controls in a nested manner. For example, Internet Explorer is a container which can host ActiveX controls, which may further have ActiveX controls embedded within for navigation and functionality. The form element of a control is considered a control once it is compiled and the form may host other controls, such as drop-down lists or Winsock functionality.

## ACTIVEX DOCUMENTS VERSUS ACTIVEX CONTROLS

The term ActiveX document is often misused and misunderstood. The word document in ActiveX document is somewhat misleading, though contributing to this confusion. While the origin of an ActiveX document reveals that a Microsoft Visual Basic ActiveX document is similar to a Word document in nature, when you create a Visual Basic ActiveX document, the difference between a document and an application becomes somewhat non-descript. While a traditional document (such as a Word document) is static, ActiveX documents are not providing rich interactivity. In other words, you have the functionality of the application, but the flexibility of a document's behavior. When a user opens an ActiveX document, that user will not only have the full functionality of an application, but the ability to persist and distribute copies of the data intrinsic to the application. Thus, the document is truly active.

ActiveX documents are not an entirely new concept. You are probably already familiar with Word documents. Microsoft describes the differentiation as such: "As you know, a Word document is not the same as a Word application—the Word document (with the extension *.doc*) contains the actual content, whereas the Word application (Winword.exe) is used to create the document."

You may also know that a Word document can be viewed in other containers. In that case, the Word application supplies the objects (such as the control bar) that enable another ActiveX container (such as Internet Explorer) to view and activate the document. The stipulation lies in that the controls must be available to the system, in other words, the Word application must be installed for this interoperability to work. This same mechanism works for ActiveX documents created with Visual Basic.

When you create an ActiveX document-based project, you are creating a Visual Basic document that can be contained in an ActiveX container, such as Internet Explorer. Compiling the ActiveX document creates both a Visual Basic Document file with the extension .vbd and its corresponding server, which can be an ActiveX .dll, or ActiveX .exe file. In other words, the .vbd file is to the .exe or .dll file what the .doc file is to the Winword.exe file.

## RETURNING A VALUE FROM THE CONTROL TO THE HTML PAGE

ActiveX controls run as programs. Each control uses system resources such as RAM and processor time. What this translates to for the Web programmer is the ability to overcome the stateless nature of typical HTTP communication between the client and the server.

ActiveX components have the ability to interact with the HTML page as well, providing, for example, animation or output. An example of this might be a control that is not visible on the page but is used to perform complex mathematical functions though the interface itself is HTML.

## ActiveX Controls Provide Persistence

One of the major problems or limitations with using straight HTML or even ASP pages to generate dynamic content lies in that the underlying communication protocol is HTTP, a stateless protocol. What this absence of state means to the programmer is that in order for content or data to remain consistent across each interaction of the client server process, the system must store data somewhere and then be able to access it. Usually this transpires on the client machine, meaning the application has direct access to the file system.

ActiveX Controls, on the other hand, are applications that run within their own memory space and can handle large amounts of variable data on their own without having to store it locally. Rather the data is stored within RAM until the data is passed to a database or vice versa. This persistence allows for greater flexibility, particularly with Web-based applications.

## Applications for Persistence

ActiveX Controls are applications that run in their own memory space just like a program, such as Microsoft Word, the difference being that the control is usually housed within a container of some sort (such as Internet Explorer or Word) and is dependent on the container for certain functions.

The use of ActiveX controls, which are running applications, provides greater security, application persistence, and flexibility. Persistence is the one factor that may prove the most useful to many Web programmers, overcoming this limitation in regular Web-based applications. Gaining persistence through the use of applications provides a vehicle for programmers to flex their coding muscles and fully utilize the power of a given language, such as C++, Java, or VB, where scripting languages may fall short.

## EVALUATING A CONTROL VERSUS AN ACTIVE SERVER PAGE FOR PERSISTENCE FEATURES

The distinction between Active Server Page (ASP) applications and ActiveX Controls may seem arbitrary if each is not clearly understood. Clearly the difference in the two technologies is opposite from a working standpoint.

ASP technology uses scripting built into Web pages, which is processed by the server rather than the client (browser). This means that the processing takes place on the server rather than the client. More often than not, ASP pages are used in conjunction with a database to provide the persistence necessary for a given application. Such is not always the case with ActiveX.

ActiveX Controls are applications that run within the memory space or physical memory of the computer. They load upon the page load and may run as individual applications or as application front ends to back end servers.

Thus, persistence with an ASP page is dependent on the server providing some sort of cache or data store for that application. ActiveX data may be stored within the application space itself, and therefore within physical memory providing persistence across boundaries and with greater flexibility.

## ACTIVEX VERSUS COOKIES

A cookie is a message passed to a Web browser by a Web server. The browser stores the message in a text file called *cookie.txt*. The message is then sent back to the server each time the browser requests a page from the server.

The main purpose of cookies is to identify users and possibly prepare customized Web pages for them. When you enter a Web site using cookies, you may be asked to fill out a form providing information such as your name and interests. This information is packaged into a cookie and sent to your Web browser which stores it for later use. The next time you go to the same Web site, your browser will send the cookie to the Web server. The server can use this information to present you with custom Web pages. For example, instead of seeing just a generic welcome page, you might see a welcome page with your name on it.

The name *cookie* derives from Unix objects called *magic cookies*. These are tokens that are attached to a user or program and change depending on the areas entered by the user or program. Cookies are also sometimes called *persistent cookies* because they typically stay in the browser for long periods of time.

This mock persistence of state is a way to overcome the lack of persistence provided by the HTTP protocol upon which HTML pages are passed. ActiveX, on the other hand, does not necessarily depend on such smoke and mirrors to provide state, rather the programmer can build this into the application itself and actually provide persistence across transactions.

## USING THE SETUP WIZARD TO CREATE AN INTERNET DISTRIBUTION

The Visual Basic Package and Deployment Wizard makes it easy for you to create the necessary .cab files and set up programs for your applications. Like other wizards, the Package and Deployment Wizard prompts you for information so that it can create the exact configuration you want.

There are three ways you can start the Package and Deployment Wizard:

- You can run it from within Visual Basic as an add-in. If you run the wizard as an add-in, you must first set the necessary references in the Add-In Manager to load the wizard. When you use the wizard as an add-in, Visual Basic assumes that you want to work with the project you currently have open. If you want to work with another project, you must either open that project before starting the add-in, or use the wizard as a standalone component.

- You can run it as a standalone component from outside the development environment. When you run the wizard as a standalone component, you are prompted to choose the project on which you want to work.

- You can start it in silent mode by launching it from a command prompt. See Running the Wizard in Silent Mode in this topic for more information.

After you start the wizard, a series of screens prompt you for information about your project and let you choose options for the package. Each screen explains how it is to be used, including which information is optional, and what information must be entered before you can move to the next screen. If you find that you need more information on any screen, press F1 or click the Help button.

*Note*: You should save and compile your project before running the Package and Deployment Wizard.

In most cases, the Package and Deployment Wizard is all you need to create a package that is ready for deployment. However, if you want to customize your packaging process further or

provide functionality not supported by the Package and Deployment Wizard, you can modify the Setup Toolkit Project. To use the Package and Deployment Wizard, perform the following steps:

1. Open the project you want to package or deploy using the wizard.

2. Use the Add-In Manager to load the Package and Deployment Wizard, if necessary: (Select **Add-In Manager** from the **Add-Ins** menu, select **Package and Deployment Wizard** from the list, then click **OK**.)

3. Select **Package and Deployment Wizard** from the **Add-Ins** menu to launch the wizard.

4. On the main screen, select one of the following options:

   • If you want to create a standard package, Internet package, or dependency file for the project, click **Package**.

   • If you want to deploy the project, click **Deploy**.

   • If you want to view, edit, or delete scripts, click **Manage Scripts**.

5. Proceed through the wizard screens.

To start the Package and Deployment Wizard as a stand alone component, perform the following steps:

1. If the project you want to package is open, save it and close Visual Basic.

2. Click the **Start** button, and then click **Package and Deployment Wizard** from the Visual Basic submenu.

3. In the **Project** list on the initial screen, choose the project you want to package.

4. On the main screen, select one of the following options:

   • If you want to create a standard package, Internet package, or dependency file for the project, click **Package**.

   • If you want to deploy the project, click **Deploy**.

   • If you want to view, edit, or delete scripts, click **Manage Scripts**.

5. Proceed through the wizard screens.

## REVIEWING THE FILES THE SETUP WIZARD CREATES

Application packaging is the act of creating a package that can install your application onto the user's computer. A *package* consists of the .cab file or files that contain your compressed project files and any other necessary files the user needs to install and run your application. These files may include setup programs, secondary .cab files, or other needed files. The additional files vary based on the type of package you create.

You can create two kinds of packages—standard packages or Internet packages. If you plan to distribute on disk, floppy, or via a network share, you should create a *standard package* for your application. If you plan to distribute via an intranet or Internet site, you should create an *Internet package*.

In most cases, you will package your applications using the Package and Deployment Wizard, which is provided with Visual Basic. You can package applications manually, but the wizard provides valuable shortcuts and automates some of the tasks you would have to perform yourself in a manual packaging session.

The wizard must determine the project files and dependent files for your application before it can create the package. Project files are the files included in the project itself — for example, the .vbp file and its contents. Dependent files are run-time files or components your application requires to run. Dependency file information is stored in the vb6dep.ini file, or in various .dep files corresponding to the components in your project. These may include data files, Dynamic Link Library files, and so forth.

## UNDERSTANDING CAB FILES

Use of CAB files is not limited to ActiveX or Internet distributions. In fact, they were first seen with the distribution of Windows 95. CAB files or Cabinet files (like file cabinets) provide a method by which programs may be distributed in a complete and compressed manner. In regard to ActiveX Internet distributions, CAB files may be easily and quickly distributed over the Web because of their small footprint and single source. The .cab format bundles all of the necessary files needed for an ActiveX application to run packages them together for distribution and compresses them for easy download.

## USING CAB FILES WITH ACTIVEX DISTRIBUTIONS

To use CAB files for Internet distributions you must own a copy of Visual Basic 5.0 or later and understand how to use the Setup Wizard to package your files for distribution. The process for doing this is outlined on the previous page.

## COMMON CAB FILE COMPONENTS

CAB files are made up of several distinct subcomponents. Several files that are always included as part of an Internet package are shown below:

- **The primary *.cab* file for your application.** The primary *.cab* file for Internet packages is used as the setup program for your application. The primary *.cab* file includes project components, such as the executable or DLL for your application or your *.ocx* file for controls, an *.inf* file referencing secondary cabs and containing safety and registry information, and all required dependency files that are not in secondary *.cabs*.

- **All required support files.** Support files for an Internet application may include HTML files, Active Server Pages (*.asp*) files, graphics files in a variety of formats, or other files your application must access to run.

- **Any secondary *.cab* files for your application.** In addition to project files, applications often reference several run-time components, such as the Visual Basic run-time DLL, individual ActiveX controls, and data access objects. If these components are available online in pre-packaged .cab files, you can reference those *.cab* files in your primary *.cab*, rather than shipping the files yourself.

## OTHER USES FOR CAB FILES

The use of the Cabinet format is not new. It is transmutable across Microsoft development platforms and seen widely in many software distributions. The use of CAB files may be

extended to almost any Microsoft-based development system, including C++, J++, and Visual Basic.

The main idea behind the Cabinet packaging format is to provide an effective means for distributing your product to users. It is used in much the same way that zipped or tarred files might be used to distribute code.

## UNDERSTANDING HOW THE PAGE KNOWS WHERE TO LOOK FOR THE CONTROL

The download and use of a control can be set to a primary site, known as the controls home. Within the <OBJECT> tag is an attribute called CODEBASE that lets developers advertise the home and versioning information of an ActiveX control. Consider the following example:

```
<OBJECT ID="ctlFind"

type="application/x-oleobject"

CLASSID="clsid:9276B91D-E780-11d2-8A8D-00C04FA31D93"

codebase="http://fd1.msn.com/public/investor/v7/
investor.cab#version=7,1999,1104,1"

</OBJECT>
```

The CODEBASE attribute points the browser to the location on the Web where the control is housed.

## CONSIDERING THE PROCESS THAT THE USER'S BROWSER PERFORMS WHEN IT ENCOUNTERS A CONTROL

The installation of an ActiveX control happens in a procedural order and is an exchange between the local system and the control itself, much like the installation of any software program.

## UNDERSTANDING WHAT HAPPENS IF THE PROVIDER MOVES THE CONTROL OR RELEASES A NEW VERSION

The CODEBASE attribute of the <APPLET> tag, set along with some coding that takes place during the time of packaging the ActiveX control using the Setup Wizard, tells the

browser where to find a control for download and keeps the control safe from being used illegally on other sites.

In the event either the versioning information or the home of the control changes, these changes must be reflected within the code itself through recompilation and on the Web page that hosts the control. Failure to carry out either of these tasks will bring certain errors on user's systems, including failure to download and install the control.

## CARE AND SAFETY WITH CONTROL VERSIONS

Versioning is a tool by which developer's track changes in their programs and applications caused by bug fixes or added functionality. Control versions should be well thought out and each new version of a control should have a list of fixes or additions included as a text file, or on a Web page in the case of a control. Proper use of tracking changes is critical to the success of any program, just as adding remarks to code is a good practice. Newer versions should always address reported problems or those found after the release of an application.

## PERIODIC CHECKING OF CERTIFICATE VALIDITY AND VERSION VALIDITY IS YOUR RESPONSIBILITY

It cannot be stressed enough that ActiveX controls do have the ability to squash an entire system. Unfortunately, the weakest link in the change is the user. While it may seem harmless to accept a control that is presented to you over the Internet or to set your browser security settings to low or none (suicide), these acts can destroy all of the data on your system or, worse, let a hacker penetrate your sensitive data via a Trojan Horse (hacking program that sits behind the scenes). You should always make it a practice to view the certificate of a control, to verify the validity of the control developer.

If a control does not have a certificate or the certificate is questionable or outdated, it is recommended that you do not install the control.

## COMPARING ACTIVEX AND JAVA

It is both difficult and simple to compare ActiveX and Java. You can find similarities in that they may both run as applications and require container or interpreter to work. To contrast,

ActiveX applications may be developed in many different languages while Java applications are written only in the Java language. Java has a greater exposure than ActiveX, as proven by browser support levels for ActiveX controls compared to Java application support. If you program only in VB, ActiveX may seem like a no-brainer, but to miss out on the possibilities of an application development environment that produces Web-based applications across any and all platforms is tough to grasp. In the end, it seems that Java will win the battle and the war. Much advancement has been made within the language, and it has a strong foothold within the developer community.

## INTRODUCING JAVA

Java is a high-level programming language developed by Sun Microsystems and is dubbed the preferred Internet programming language. Java was originally called *OAK* and was designed for handheld devices and set-top boxes. *OAK* was unsuccessful so, in 1995, Sun changed the name to Java and modified the language to take advantage of the burgeoning World Wide Web.

Java is an object-oriented language similar to C++, but simplified to eliminate language features that cause common programming errors. Java source code files (files with a *.java* extension) are compiled into a format called *bytecode* (files with a *.class* extension), which can then be executed by a Java interpreter. Compiled Java code can run on most computers because Java interpreters and runtime environments, known as *Java Virtual Machines (VMs),* exist for most operating systems, including Unix, the Macintosh OS, and Windows. Bytecode can also be converted directly into machine language instructions by a just-in-time compiler (JIT).

Java is a general purpose programming language with a number of features that make the language well-suited for use on the World Wide Web. Small Java applications are called Java applets and can be downloaded from a Web server and run on your computer by a Java-compatible Web browser, such as Netscape Navigator or Microsoft Internet Explorer.

The Java language also comes with a wide-range collection of libraries (also known as packages) that extend the language, such as user interface objects called AWT, an I/O library, a network library, and so on. You can use Java to create both applets that are loaded over the Web and executed inside a browser, as well as standalone applications.

## JAVA AS A PLATFORM-INDEPENDENT LANGUAGE

You will be hard pressed to find a modern browser that does not include support for the Java language in today's Web world. The logic is simple. Programmers easily understand the

language and concepts and the VM support is easily bundled into Web browsers across all platforms. This simplicity has made the Java language the preferred Internet development language/environment. Because an application written in Java on a PC using Symantec's Visual Café works the same on a Web browser on a Mac or Unix-based browser, the language is considered fully platform- independent, although a different VM must be written for every platform.

## JAVA IS AN INTERPRETED LANGUAGE AND A COMPILED LANGUAGE

Java is an interpreted language, meaning that some supporting effort or interpreter must be present to actually run the compiled code modules. Java source code files are first compiled into a format called *bytecode*, which can then be executed by a Java interpreter. Compiled Java code can run on most computers because Java interpreters and runtime environments, known as *Java Virtual Machines (VMs),* exist for most operating systems. If you are familiar with Adobe System's popular Portable Document Format (PDF), then this system should sound familiar. As is the case with the Adobe product, there are many platform versions of the program making it a (implied) standard.

## UNDERSTANDING BYTECODE

Bytecode is defined as the compiled format for Java programs. Once a Java program has been converted (compiled) to bytecode, it can be transferred across a network and executed by Java Virtual Machine (VM). Bytecode files generally have a *.class* extension. Bytecode is not compiled down to the point of machine code or machine language, and therefore, needs an interpreter, the VM, to run.

## UNDERSTANDING VIRTUAL MACHINES AND THEIR ROLE WITH JAVA

For the Java language and resulting compiled code to be interpreted, the system or Web browser must have a Java Virtual Machine in place to interpret the Java bytecode. This is mainly because the bytecode is not compiled down to a very low level called machine code or

machine language. The Virtual Machine takes the compiled Java bytecode and makes its final transformation down to the machine level.

## UNDERSTANDING THE BENEFITS OF JAVA PROGRAMMING

The biggest strength that the Java language has is wide acceptance across any and all hardware and software platforms. Secondary to that, it has been embraced by many programmers for its similarity to the C and C++ languages and its Object Oriented nature. It has been said that the Java language never would have made it had it not been for the fact that it is based on Internet technologies. Indeed, this may be true for many other recent hybrid languages seem to have gone the way of the dinosaur (such as Python and PERL).

Java's ability to commute across platforms, be they hardware or software, makes it an attractive development platform for any Web designer or Web design house. The language itself can be tricky to pick up at first if you are unfamiliar with the C language and OO programming. You should start slow and use repetition to reinforce programming techniques already learned.

## UNDERSTANDING PERSISTENT JAVA AND ITS EFFECTS

The use of the term persistent, when discussing development languages, means, in simple terms, trying to achieve a harmony of standards across all development languages and systems where these languages adhere to a set of standards above the actual language definitions themselves.

The appeal of persistent class-oriented programming languages is strong, particularly with the advent of the Java programming language and the rush for programmers, old and new, to embrace the platform. Allowing class definitions to be persistent within any development environment, in addition to instance data, greatly increases the ease of maintaining consistency among type definitions and their instances.

Persistent class definitions become a serious impediment if they cannot evolve, however, as software systems are constantly evolving. Much work has been done to include such standards across the Java development environment that does not require a modified Java Virtual Machine and allows for persistent class definitions and evolution of persistent classes in the JDE.

## SECURITY ISSUES WITH JAVA APPLETS

As is the case with any program you may install and run, a certain security risk is associated with running a Java application or applet on your computer. Renegade applications can shut down your browser, system, or if it had rights to the file system, wipe out your data. Unlike ActiveX controls, Java applets or applications do not require or display a certificate to authenticate the developing party. This means that if the security settings on your browser are weak, you may enter a site that loads a renegade application without you knowing it. Use great care to know what sites you are entering and verify that browser security settings are generous.

## JAVA CAN BE BOTH CLIENT AND SERVER

The Java language can be compiled to run as an independent program with the aid of a VM. Thus, it is logical to assume that these compiled programs can run as both a client piece and as a server. The ramifications of this capability are immense in that entire client/server systems can be written entirely in Java as well as regular applications, such as Word Processors.

With the introduction of the Java Network Libraries and Java ODBC (JDBC), the Java development environment has become a formidable opponent to RAD programs, such as Borland C++ and Microsoft's Visual C++.

## LEARNING WHAT JAVA CAN DO FOR A WEB SITE

Java opens up the doors to a rich interactive experience within the Web browser and on the server as well. Java may run as an independent application (much like ActiveX) or as an applet that interacts on the various objects within a Web page.

If you look at the Java applets being used on the Web today, you will find that a Web developer uses Java for four primary tasks:

- Creating animated graphics, including bitmap-loops, moving bitmaps, and animated drawings. For example, the White House site has waving flags that are created using Java applets.

- Creating graphical objects (bar charts, graphs, diagrams, and so on.) that you do not want to download from the server through a CGI

script. Typically, a graph is created by having a CGI script look at a database, producing a GIF, and then sending it back to the browser. You might not want to do this because it would take too long to download a large GIF or because you do not want to have to manufacture a GIF on the server.

- Creating new controls. If you want to create a push button control with special properties, or a more complicated control that looks like a graphics equalizer, you can create it with Java. Since you can draw and get events, you can create any kind of control you like.

- Creating applications made up of collections of controls such as edit areas, buttons, check boxes, and so on. This is similar to what you can do with JavaScript, but the program is completely self-contained and compiled so that you do not reveal the source code.

Java is often used today in the form of DHTML and alongside XML to provide feature rich, interactive sites for Web users, surfers, and customers alike.

## UNDERSTANDING THE DIFFERENCES BETWEEN JAVA VERSIONS

Before the interaction of the U.S. Government, there were competing versions of the Java language. It is important to note that if you are using older Microsoft development tools for Java, your applications may fail to run cross platform today. Microsoft lost the right to change any of the Sun source code, which under patents, and consequently had to update their version of the Java Virtual Machine to be compliant with the Sun specification.

As long as you are using the Sun Java SDK, found at *http://java.sun.com*, as a guide to develop Java applications you should be OK. Again, you may run into problems using versions of Microsoft's J++. See the product documentation or the product Web site for further compliance statements.

## OBTAINING THE JAVA DEVELOPER'S KIT

The Java development platform was developed by Sun Microsystems several years ago to bridge the gap between server processed scripting and a true Internet-based development environment and language. The result was Java.

Today, almost anyone can pick up the Java language with the help of the Java Developer's Kit or JDK. The most current specification from Sun, as of the printing of this book, is the Java 2 SDK, in beta 1.3. For more information on the Java language, and to learn how to download the latest Java software development kit, refer to *http://java.sun.com*.

## CONSIDERING ALTERNATIVE JAVA DEVELOPMENT ENVIRONMENTS

A myriad of choices are available for when it comes to choosing the right Java development environment. If you have little or no experience, you should look at What You See is What You Get (WYSIWIG) environments to get a jump-start. These are the most popular design tools for Java as they can speed production of an application ten fold. Experienced user's may choose simply to write their code in a text editor and save is as a *.java* extension for later compilation using Sun's Java compiler. Regardless, the following list is by no means comprehensive, but a good starting point:

- JdesignerPro (Excellent for beginners and available for multiple platforms)

- Microsoft's J++ (Advanced)

- Java Studio (Sun Microsystems)

- IBM Visual Age

- Symantec Visual Café

## REVISITING THE HTML <APPLET> TAG

The <APPLET> tag set may be used with Java to insert code either directly into the page or by calling a class module(s) from some location on a network. To add an applet to an HTML page, you need to use the <APPLET> element in the following manner.

```
<APPLET CODE="Applet.class" WIDTH=200 HEIGHT=150>

</APPLET>
```

This tells the viewer or browser to load the applet whose compiled code is in *Applet.class* (in the same directory as the current HTML document), and to set the initial size of the applet to 200 pixels wide and 150 pixels high. (The <APPLET> element supports standard image type attributes, as shown below.)

Below is a more complex example of an <APPLET> element:

```
<APPLET CODEBASE="http://java.sun.com/JDK/applets/ NervousText"
CODE="NervousText.class"

width=400 height=75 align=center>

</APPLET>
```

This tells the viewer or browser to load the applet whose compiled code is at the URL *http://java.sun.com/JDK/applets/NervousText/NervousText.class* to set the initial size of the applet to 400x75 pixels, and to align the applet in the center of the line.

## USING ATTRIBUTES WITH THE <APPLET> TAG

Many attributes are associated with the <APPLET> tag set that allow for the manipulation of the applet itself. The following list represents the most common attributes of the <APPLET> element:

### ALIGN=alignment

This required attribute specifies the alignment of the applet. The possible values of this attribute are the same as those for the <IMG> element: left, right, top, texttop, middle, absmiddle, baseline, bottom, absbottom.

### ALT=alternateText

This optional attribute specifies any text that should be displayed if the browser understands the <APPLET> element but cannot run applets written in the Java Programming Language.

### ARCHIVE=compressed file

This optional attribute specifies the location (relative to the CODEBASE of the main class file) of a compressed file (consisting of all the necessary class files, support images/sounds, and so on.) that may be downloaded to a user's Hard Disk, to save download time should he or she return to the page at a later date. Any files not contained in this archive that are needed will be searched for by the browser in the normal way.

*Note:* The ARCHIVE attribute is Netscape specific.

### CLASS=Style Sheet class

The CLASS attribute is used to specify the <APPLET> element as using a particular style sheet class. See the Style Sheets topic for details.

### CODE=appletFile

This required attribute gives the name of the file that contains the applet's compiled Applet subclass. This file is relative to the base URL of the applet. It cannot be absolute.

### CODEBASE=URL

This optional attribute specifies the base URL of the applet—the directory that contains the applet's code. If this attribute is not specified, then the document's URL is used.

### DATAFLD=Column Name

The DATAFLD attribute can be used to specify a data column name from the Data source (see DATASRC) that the <APPLET> is bound to. For more information on the DATAFLD attribute, see the Data Binding topic.

### DATASRC=Data Source

The DATASRC attribute can be used to specify a data source that the <APPLET> is bound to. For more information on the DATASRC attribute, see the Data Binding topic.

### HEIGHT=pixels WIDTH=pixels

These required attributes give the initial width and height (in pixels) of the applet display area, not counting any windows or dialogs that the applet brings up.

### HSPACE=pixels VSPACE=pixels

These option attributes specify the number of pixels above and below the applet (VSPACE) and on each side of the applet (HSPACE). They are treated the same way as the <IMG> element's VSPACE and HSPACE attributes.

### ID=Unique Identifier

The ID attribute can be used to either reference a unique style sheet identifier, or to provide a unique name for the <APPLET> element for scripting purposes. Any <APPLET> element with an ID attribute can be directly manipulated in script by referencing its ID attribute, rather than working through the All collection to determine the element. See the Scripting introduction topic for more information.

### NAME=appletInstanceName

This optional attribute specifies a name for the applet instance, which makes it possible for applets on the same page to find (and communicate with) each other.

### SRC=URL

The SRC attribute specifies a URL associated with the applet. Such a URL may point to the support site, with development information.

### STYLE=Styling

As well as using previously defined style sheet settings, the <APPLET> element can have in-line stylings attached to it. See the Style Sheets topic for details.

### TITLE=ToolTip

The Internet Explorer 4.0 (and above) specific TITLE attribute is used for informational purposes. If present, the value of the TITLE attribute is presented as a ToolTip when a user's mouse hovers over the <APPLET> section.

### <PARAM NAME=appletAttribute1 VALUE=value>

This element is the only way to specify an applet-specific attribute. Applets access their attributes with the getParameter() method.

## SETTING THE APPLET'S ALIGNMENT

An applet may be placed within the browser window using the ALIGN attribute of the <APPLET> tag set. The following example demonstrates the use of this attribute:

```
<APPLET CODEBASE="http://java.sun.com/JDK-prebeta1/applets/
NervousText" CODE="NervousText.class" align=center>

<PARAM NAME="text" VALUE="This is the Applet Viewer.">

</APPLET>
```

The ALIGN attribute may carry one of the following definitions for the placement of the applet in the browser window:

- Left
- Right
- Top
- Texttop
- Middle
- Absmiddle
- Baseline
- Bottom
- Absbottom

## LETTING THE USER KNOW IF HIS OR HER BROWSER SUPPORTS JAVA

There are a number of ways to inform a user as to whether or not his or her browser carries support for Java. Consider the following lines of code:

```
<APPLET CODEBASE="http://java.sun.com/JDK/applets/ NervousText"
CODE="NervousText.class"

width=400 height=75 align=center>

<PARAM NAME="text" VALUE="This is the Applet Viewer.">

<BLOCKQUOTE>

<HR>

If you were using a Java-enabled browser, you would see dancing
text instead of this paragraph.

<HR>

</BLOCKQUOTE>

</APPLET>
```

## USING CODEBASE TO SPECIFY AN APPLET'S LOCATION

Adding a compiled Java applet to a Web page is accomplished much the same way an ActiveX control is embedded in a page. To add an applet to an HTML page at a basic level, you need to use the <APPLET> HTML element, as shown in the following example.

```
<APPLET CODE="Applet.class">

</APPLET>
```

This tells the viewer or browser to load the applet whose compiled code is in Applet.class in the *same directory* as the current HTML document.

Below is a more complex example of an <APPLET> element showing use of the CODEBASE attribute:

```
<APPLET  CODEBASE="http://java.sun.com/JDK1.2.2/applets/
NervousText" CODE="NervousText.class"

</APPLET>
```

This tells the viewer or browser to load the applet whose compiled code is at the URL *http://java.sun.com/JDK1.2.2/applets/NervousText/NervousText.class.*

## WHERE YOU CAN GET JAVA DOCUMENTATION

While there may be a host of sites to scour for information on Java development, the definitive and most accurate site is found at *http://java.sun.com/docs/.* At this site, will find information from the source, Sun Microsystems, the creator of the Java language and the party responsible for creating and maintaining the standard.

## UNDERSTANDING JAVA FILE TYPES

Java files may take one of two forms and are differentiated on the surface by differing file extensions. Java code, called source, is the actual program in its written form created by a programmer and carries a .java extension, for example program.java.

After the source code is compiled into the bytecode using a Java compiler, the program extension is changed to a .class extension.

Java source code files created by programmers have visible lines of code and are not executable. Java .class files on the other hand are executables through a Java Virtual Machine. Once in this compiled format, the source code is no longer viewable unless the program is first decompiled.

## CREATING YOUR FIRST JAVA SOURCE FILE

Java source files carry a .java extension and may be created with a simple text editor. Java uses a C/C++ type syntax. Blocks of code are opened using a left curly bracket and closed using a right curly bracket. Statement terminators are semicolons. Beyond this, Java resembles many

languages. There is no way to create structures or enumerators. Everything is an object except for the basic types, such as int, char, and long. It is not possible in Java to create objects with operator overloading—performing arithmetic operations on class objects, for example. Unlike C++, a pointer-based language where you can add any two objects together without regard for type (or results), Java enforces some restrictions that let the developer focus on building objects and the interactions between them. Consider the following code excerpt, the classic Hello World in Java:

```java
//SampleClass.java

public class SampleClass

{

        public static void  main( String arg[]) {

                System.out.println( "Hello World");

        }

}
```

The elements in underlined text are reserved Java keywords (do not underline the text in a text editor!). Keeping within object-oriented programming principles, the class declaration must be made first. In the preceding code sample, the file name is SampleClass.java and the class name is SampleClass.

## CREATING AN HTML SOURCE FILE FOR THE JAVA FILE

Your Java applet would do you little good without a place to house it. Compiled Java files that carry the .class extension are called from within an HTML page using the HTML tag set <APPLET>.

Consider the following HTML page:

```html
<HTML>

<HEAD>

<TITLE> An HTML page with an embedded Java applet </TITLE>

</HEAD>
```

```
<BODY>

<applet  codebase="java.sun.com/openstudio/applets/classes"
code="JavaClock.class"

        width="150" height="150">

<param  name="delay"   value="100">

<param  name="border"  value="5">

<param  name="nradius" value="80">

<param  name="cfont"    value="TimesRoman|BOLD|18">

</APPLET>

<HR>

</BODY>

</HTML>
```

The compiled source code is called from across a network using the CODEBASE attribute of the <APPLET> tag set. Applets may occur anywhere within the body of the HTML document. This is similar to the way that ActiveX objects are embedded in a page.

## COMPILING YOUR JAVA FILES

You have a number of options when it comes to creating and compiling Java source files. Process of compiling these files depends largely on the development environment being used. For the sake of simplicity, you will use the compiler available from the Sun Microsystems Web site, which is included as part of the Java SDK (the assumption being that you have downloaded and installed the latest Java SDK).

Take a Java source file that you have created or use the following:

```
//SampleClass.java

 public class SampleClass

 {
```

```
        public static void  main( String arg[]) {

                System.out.println( "Hello World");

        }

   }
```

Save the above file as HelloWorld.java.

From the Start menu, select the MS-DOS Prompt application (Windows 95 or 98) or the Command Prompt application (Windows NT). To compile your source code file, change your current directory to the directory where your file is located. For example, if your source directory is Java on the C drive, you would type the following command at the prompt and press ENTER:

```
C:\java
```

*Note*: Make sure that your source file is in the above directory for the sake of simplicity. For extended usage of the command line compiler, consult the Java SDK.

Now type the following:

```
C:\javac HelloWorld.java
```

The javac command is the command-line Java compiler. Compilation should be quick for such a small program. Once complete, the finished product HelloWorld.class should be in the same directory.

## UNDERSTANDING THE DIFFERENCES BETWEEN APPLETS AND APPLICATIONS

Two possibilities exist when programming with Java. First, you might build a Java *application, for example, a standalone* program, the way you would with C or C++. On the other hand, you might build a Java *applet*, a term used to define a Java mini-application (or mini-version of an application) designed to run expressly inside *a Web page*.

An *applet* does not run standalone, rather it adheres to a set of conventions that lets it *run within a Web page* (HTML file). Java code may be embedded right in to the Web page though this is limited to the JavaScript specification and language.

When it comes to code execution, applications also differ from applets in that:

- To run (or execute) a Java application, you must have a Java interpreter.

- To run a Java *applet,* you need only an *applet viewer,* or a *Java-compatible Web browser.*

That is the layman's contrast of the two from a developer stand point consider the following more technical differentiation:

An application in Java is simply a class with a static main method that accepts an array of arguments. The main method is a class (static) method, so it always exists. When the main method is called, it must create an instance of the class. (The args parameter contains the command-line arguments—if applicable.) When the class is instantiated, its instance variables are created and its constructor is called. The main method will then do whatever the application is supposed to do.

An applet is a subclass of the AWT's Applet class. Applets are panels, so they can contain GUI elements. An applet is instantiated by the browser. The browser then calls the init method. There are methods to be called when the browser leaves the page, comes back to it, or quits.

## STRUCTURING A SIMPLE JAVA APPLET

The following is the Hello World application, as written in Java, which you will now dismantle into many pieces to better understand the structure of a Java applet.

```
class HelloWorld {

   public static void main (String args[]) {

      System.out.println("Hello World!");

   }

}
```

*Hello World* is close to the simplest program imaginable. Nonetheless, there's a lot going on in it. The initial class  statement may be thought of as defining the program name, in this case HelloWorld. The compiler actually got the name for the class file from the class HelloWorld statement in the source code, not from the name of the source code file.

Note that if there is more than one class in a file, then the Java compiler will store each one in a separate .class file. For reasons that will be discussed later, it's advisable to give the source code file the same name as the main class in the file plus the .java extension.

The initial class statement is more than that since this program can be called not just from the command line but also by other parts of the same or different programs.

The HelloWorld class contains one *method*, the main method. As in C programming, the main method is where an application begins executing. The method can be declared *public*, meaning that the method can be called from anywhere. It is declared *static*, meaning that all instances of this class share this one method. It is declared *void*, which means, as in C, this method does not return a value. Finally, you pass any command line arguments to the method in an array of Strings called ARGS or arguments. However, this simple program, there aren't any command line arguments.

In Java, a source code file is broken up into parts separated by opening and closing braces, the { and } characters. Everything between { and } is a *block* and exists more or less independently of everything outside of the braces.

Blocks are important both syntactically and logically. Without the braces the code wouldn't compile. The compiler would have trouble figuring out where one method or class ended and the next one began. Similarly, it would be difficult for another user reading your code to understand what was going on. For that matter, it would be difficult for you to understand what was going on. The braces are used to group related statements together. In the broadest sense, everything between matching braces is executed as one statement (though, depending, not necessarily everything inside the braces is executed every time).

Blocks can be hierarchical. One block can contain one or more subsidiary blocks. In this case, one outer block defines the HelloWorld class. Within the HelloWorld block is a method block called main.

In this section, different blocks are identified with indentation. Every time a new block is entered, you will indent your source code by two spaces. When you leave a block, indent by two spaces. This is a common convention in many programming languages. However, it is not part of the language. The code would produce identical output if you didn't indent it. Indentation makes the code easier to read and understand, but it does not change its meaning.

Comments can appear anywhere in a source file. Comments are identical to those in C and C++. Everything between /* and */ is ignored by the compiler and everything on a line after two consecutive slashes is also thrown away. Therefore, the following program is, as far as the compiler is concerned, identical to the first one:

```
// This is the Hello World program in Java

class HelloWorld {

    public static void main (String args[]) {
```

```
        /* Now let's print the line Hello World */

        System.out.println("Hello World");

    }

}
```

Methods are only half of a Java class. The other half is data. Consider the following generalization of the HelloWorld program:

```
// This is the Hello You program in Java

class HelloYou {

    public static void main (String args[]) {

        // You may feel free to replace "You" with your own name

        String name = "You";

        /* Now let's say hello */

        System.out.print("Hello ");

        System.out.println(name);

    }

}
```

In this example, rather than saying hello to a rather generic world, Java says hello to a specific individual. This is done by creating a *String variable* called name and storing the value You in it. Next, you print out "Hello ". Notice the switch from the System.out.println method to the similar System.out.print method. System.out.print is just like System.out.println except that it doesn't break the line after it's finished. Therefore, when you reach the next line of code, the cursor is still located on the same line as the word "Hello" and you are ready to print out the name.

This Hello program isn't general. You can't change the name you say hello to without editing and recompiling the source code. This may be fine for the programmers, but if secretaries want their computers to say Hello to them? You need a way to change the name at *runtime* rather than at compile time. Runtime is when you type:

```
c:\java HelloWorld
```

Compile time is when you type:

```
c:\javac HelloWorld.java
```

To do this, you make use of *command-line arguments*. They let us type the following:

```
c:\java hello John
```

and have the program respond with "Hello John". The code is shown below:

```
// This is the Hello program in Java

class Hello {

    public static void main (String args[]) {

        /* Now let's say hello */

        System.out.print("Hello ");

        System.out.println(args[0]);

    }

}
```

## WRITING A BASIC JAVA APPLET

The Applet class, defined in the package `java.applet` is only useful as a basis for making subclasses. An object of type Applet has certain basic behaviors, but doesn't do anything

useful. To create a useful applet, a programmer must define a subclass of the Applet class. A number of methods in Applet are defined to do nothing at all. The programmer must override at least some of these methods and give them something to do.

An applet is inherently part of a graphical user interface. It is a type of graphical component that can be displayed in a window (whether belonging to a Web browser or to some other program). When shown in a window, an applet is a rectangular area that can contain other components, such as buttons and text boxes. It can display graphical elements such as images, rectangles, and lines. It can also respond to certain events, such as when a user clicks on the applet with a mouse. All of the applet's behaviors—what components it contains, what graphics it displays, how it responds to various events—are determined by methods. These methods are included in the Applet class, but the programmer must override these methods in a subclass of Applet in order to make a genuinely useful applet that has interesting behaviors.

The **main()** routine of a program is there to be called by the system when it wants to execute the program. The programmer writes the main routine to say what happens when the system runs the program. An applet needs no **main()** routine, since it is not a program. However, many of the methods in the Applet class are similar to **main()** in that they are meant to be called by the system, and the job of the programmer is to say what happens in response to the system's calls.

One of the important applet methods is **paint()**. The job of this method is to draw the graphical elements displayed in the applet — which is, remember, just a rectangular area in a window. The **paint()** method in the Applet class doesn't draw anything at all, so **paint()** is a method that the programmer can override in a subclass. The definition of this method must have the following form:

```
public void paint(Graphics g) {

    // draw some stuff

}
```

The method must be public because it will be called by the system from outside the class. The parameter g of type Graphics is provided by the system when it calls the paint() method. In Java, all drawing to the screen must be done using methods provided by a Graphics object. For example, the following applet displays the string "Hello World!" using We'll use the paint() method:

```
import java.awt.*;

import java.applet.*;
```

```
        public class HelloWorldApplet extends Applet {

        // An applet that simply displays the string Hello
World!

        public void paint(Graphics g) {

        g.drawString("Hello World!", 10, 30);

        }

        }   // end of class HelloWorldApplet
```

The **drawstring()** method, defined in the Graphics class, actually does the drawing. The parameters of this method specify the string to be drawn and the point in the applet where the string is to be placed. Note the following packages have been imported: **java.applet**, which includes the Applet class, and **java.awt**, which includes the Graphics class and many other classes related to the graphical user interface. Almost every applet uses these two packages.

By definition, an applet is an object, not a class. You can create an applet object, as shown in the following example:

```
Applet hw = new HelloWorldApplet();
```

This example might be useful if you are writing a program and would like to add an applet to a window you've created. Most often, however, applet objects are created by the system. For example, when an applet appears on a page in a Web browser, it is up to the browser program to create the applet object. For this reason, subclasses of Applet are almost always declared to be public. Otherwise, the system wouldn't be able to access the class, and there would be no way for it to create an applet based on that class.

## UNDERSTANDING THE KEY APPLET FUNCTIONS

Just as important as the Java programming language is the Java platform, which is the set of predefined classes that programs written in the Java language rely on. These predefined classes are the building blocks of all Java applications, applets, servlets, and components.

Java classes are grouped into related groups known as *packages*. The Java platform defines packages for functions such as input/output, networking, graphics, user interface creation, security, and much more. These functions are the core working processes that provide functionality through using the Java platform.

## UNDERSTANDING THE JAVA INTERPRETER

The Java virtual machine is a quasi-computing machine. Like a real computing machine, it has an instruction set and manipulates various memory areas at runtime. It is reasonably common to implement a programming language using a virtual machine such as the P-Code machine of UCSD Pascal.

The first prototype implementation of the Java virtual machine, created at Sun Microsystems, emulated the Java virtual machine instruction set in software hosted by a handheld device that resembled a contemporary PDA like 3 Com's Palm Pilot. Sun's current Java virtual machine implementations, components of its Java 2 SDK and Java 2 Runtime Environment products, emulate the Java virtual machine on Win32 and Solaris hosts in much more sophisticated ways. However, the Java virtual machine does not assume any particular implementation technology, host hardware, or host operating system. It is not inherently interpreted, but can just as well be implemented by compiling its instruction set to that of a silicon CPU. It may also be implemented in microcode or directly in silicon.

The Java virtual machine knows nothing of the Java programming language, only of a particular binary format, the class file format. A class file contains Java virtual machine instructions or *bytecode* and a symbol table, as well as other ancillary information.

For the sake of security, the Java virtual machine imposes strong format and structural constraints on the code in a class file. However, any language with functionality that can be expressed in terms of a valid class file can be hosted by the Java virtual machine. Attracted by a generally available, machine-independent platform, implementors of other languages are turning to the Java virtual machine as a delivery vehicle for their languages.

## FUNDAMENTALS OF JAVA PROGRAM STRUCTURE

There are a few fundamentals when learning to program in Java, mostly in the semantics and rules as they apply to coding. There are several elements that are indigenous to almost any Java program:

- Beginning comments

- Package Statements and Import Statements

- Class and Interface Statements

- Indentation

- Comments

- Indentation

- Declarations

- Statements

- White Space

Beginning comments should always precede the rest of the code, providing an introduction to the program itself and some description. While not necessary, this is just good coding practice.

Next, the first non-comment line of most Java source files is a *package* statement. After that, *import* statements can follow. For example:

```
package java.awt;

import java.awt.peer.CanvasPeer;
```

A package is a collection of related classes and interfaces that provides access protection and namespace management and is called from this statement. The import statement then calls the specific package element.

Class statements are used to define aspects of the program, such as whether the class is publicly accessible or whether the class can be sub-classed. The class line declares the name of the application and class for the file as well. An interface is defined as a Java programming language keyword used to define a collection of method definitions and constant values. It can later be implemented by classes that define this interface with the implements keyword. The interface statement declares the interface keywords.

In Java, a source code file is broken up into parts separated by opening and closing braces, the { and } characters. Everything between { and } is a *block* and exists more or less independently of everything outside of the braces.

Blocks are important both syntactically and logically. Without the braces the code wouldn't compile. The compiler would have trouble figuring out where one method or class ended and the next one began. Similarly, it would be difficult for another user reading your code to understand what was going on. For that matter, it would be difficult for you to understand what was going on. The braces are used to group related statements together. In the broadest

sense, everything between matching braces is executed as one statement (though, depending, not necessarily everything inside the braces is executed every time).

Blocks can be hierarchical. One block can contain one or more subsidiary blocks. In this case, one outer block defines the HelloWorld class. Within the HelloWorld block is a method block called main.

Every time a new block is entered, you will indent your source code by two spaces. When you leave a block, indent by two spaces. This is a common convention in many programming languages. However, it is not part of the language. The code would produce identical output if you didn't indent it. Indentation makes the code easier to read and understand, but it does not change its meaning.

Comments can appear anywhere in a source file. Comments are identical to those in C and C++. Everything between /* and */ is ignored by the compiler and everything on a line after two consecutive slashes is also thrown away.

## UNDERSTANDING THE IMPORTANCE OF CODING STYLE

Coding standards are every bit as important in Java as they have been in C/C++ or any other coding language. This section will discuss six common Java pitfalls and coding standards you can use prevent them.

Code should be as easy to read and understand as possible because it is merely a language that represents real-life functions and processes. Anyone who looks at the code, even months after it's been written, should be able to determine its function at a glance.

Another important reason to produce clearly-written code is that later in the development process, when it is time to check code for errors, you should be able to debug the algorithm and easily determine whether the logic is correct. Therefore, when you choose names for your variables, you should be trying to connect the variables to real life.

You should use standard naming conventions to connect code to its real-life function. By using naming conventions, you free your mind to focus on one problem at a time, which is the key to successful error prevention. The human brain is far more accurate when it compartmentalizes tasks, and accuracy is of utmost importance in preventing errors. With clearly written code, you can check the logic of the code and focus on real problems. Another advantage to using standard naming conventions is that you can apply real-life experience and intuition to code checking. Intuition is important in checking code for the same reason that it is important in understanding mathematics. Students who have trouble with algebra in high school often lack the ability to connect equations to real life. To them,

algebra is a meaningless jumble of numbers and letters, and the process of solving a problem remains a mystery. However, when students learn to connect the problems to real life, they often show a marked improvement in their ability to reach a correct answer by using intuition and applying life experience to problems. Applying intuition is also essential to testing the logic of an algorithm. Additionally, it is important to understand the proper use of code blocks. While not necessary in Java programming, using code blocking helps the readability of the code.

## UNDERSTANDING CASE-SENSITIVITY

Java, like many programming languages, is not forgiving when it comes to type case, hence the language is termed case sensitive. What this means to the programmer is simple. Suppose your name is Karen. You can spell out the name Karen in many ways using case alternatives, as shown in the following list:

- Karen
- karen
- KaReN
- KAREN

Each of these is compiled differently once it changes into bytecode. Therefore, it is imperative that you type with great care your programs and recheck your code throughout the process to avoid searching for that proverbial needle in a haystack because of a single mistyped character.

## UNDERSTANDING LOGIC ERRORS

If there is only one certainty in regard to any programming, it is this: errors occur in software programs. However, what really matters is what happens *after* the error occurs.

Program errors are called exceptions. An *exception* is an event that occurs during the execution of a program (runtime) that disrupts the normal flow of instructions. Many kinds of errors can cause exceptions—problems ranging from serious hardware errors, such as a hard disk crash, to simple programming errors, such as mistyped code. When these errors occur within a Java method, the method creates an exception object and hands it off to the runtime system. The exception object contains information about the exception, including its type and the state of the program when the error occurred. The runtime system is then responsible for

finding some code to handle the error. In Java terminology, creating an exception object and handing it to the runtime system is called *throwing an exception*.

After a method throws an exception, the runtime system leaps into action to find someone to handle the exception. The possible handlers of the exception are the set of methods in the *call stack* of the method where the error occurred. The runtime system searches backward through the call stack, beginning with the method in which the error occurred, until it finds a method that contains an appropriate *exception handler*.

All exceptions should be dealt with by an exception handler. An exception handler is considered appropriate if the type of the exception thrown is the same as the type of exception handled by the handler. Programmers may build their own exeption handlers or the default handler may be used by the system. So the exception bubbles up through the call stack until an appropriate handler is found and one of the calling methods handles the exception. The exception handler chosen is said to *catch the exception*. Once caught, the program will pass an error to the user display and either pass control back to the program or kill the program.

## UNDERSTANDING THE IMPORT STATEMENT

The import statement makes Java classes available to the current class under an abbreviated name. Public Java classes are always available by their fully qualified names, assuming that the appropriate class file can be found (and is readable) relative to the CLASSPATH environment variable. Import doesn't actually make the class available or read it in; it simply saves you typing and makes your code more legible.

Any number of import statements may appear in a Java program. They must appear, however, after the optional `package` statement at the top of the file, and before the first class or interface definition in the file.

There are three forms of the import statement:

```
import        package ;

import        package.class ;

import        package.* ;
```

The first form lets the specified package be known by the name of its last component. For example, the following import statement allows **java.awt.image.ImageFilter** to be called:

```
image.imagefilter

Import java.awt.image;
```

The second form lets the specified class in the specified package be known by its class name alone.

Finally, the third form of the import statement makes all classes in a package available by their class name. For example, the following import statement is implicit (you need not specify it yourself) in every Java program:

```
Import java.lang.*;
```

It makes the core classes of the language available by their unqualified class names. If two packages imported with this form of the statement contain classes with the same name, it is an error to use either of those ambiguous classes without using its fully qualified name.

## UNDERSTANDING JAVA'S KEYWORDS

Java keywords are programming language constructs or words reserved as operators in the Java language. The following list shows the most current Java keywords used in a Java program:

Primitive Data Types

byte
short
int
long

float
double

char
boolean

Looping Keywords

do
while
for

break
continue

Branching Keywords

if
else
switch case default
break

Method, Variable and Class Modifiers

private
public
protected
final
static
abstract
synchronized

Literal Constants

false
true
null

Method Related

return
void

Package Related

package
import

Exception Handling

try
catch
finally
throw
throws

General Objected Related Keywords

new

extends
implements
class
instanceof
this
super

## UNDERSTANDING NON-QUALIFIED VERSUS QUALIFIED NAMES

Names are used to refer to entities declared in a Java program. A declared entity is a package, class type, interface type, member (field or method) of a reference type, parameter (to a method, constructor, or exception handler), or local variable.

Names in Java programs are either simple (non-qualified), consisting of a single identifier, or qualified, consisting of a sequence of identifiers separated by "." tokens. Packages and reference types (that is, class types, interface types, and array types) have members. A member can be referred to using a qualified name $N.x$, where $N$ is a simple or qualified name and $x$ is an identifier. If $N$ names a package, then $x$ is a member of that package, which is either a class or interface type or a subpackage. If $N$ names a reference type or a variable of a reference type, then $x$ names a member of that type, which is either a field or a method.

In Java, every variable and method is declared within a class and forms part of that class. Also, every class is part of a *package*. Thus, every Java variable or method may be referred to by its fully qualified name, which consists of the package name, the class name, and the field name (the variable or the method name), all separated by periods. Package names are usually composed of multiple period-separated components. Thus, the fully qualified name for a method might be:

The following are examples of non-qualified and qualified names:

Non-qualified

    Date

    Time

    lang

Qualified

```
java.util.Date

java.lang

java.math

java.lang.System
```

## ADDING COMMENTS TO JAVA PROGRAMS

There are literally thousands of ways that a single program may be coded and all will produce the same result. The one habit that should remain consistent throughout your program code and programs in general is good coding practices. One of the most important coding practices is the effective use of program comments throughout.

Like most programming languages, Java makes a provision for adding comments to lines or sections of code. Normally, comments are added to the preceding line above the program line or code block. Program comments are denoted by two hash marks, as shown in the following example:

```
// An applet that simply displays the string Hello World!
```

Adding comments throughout the program simplifies debugging later and if more than one user is coding the program or the source is for public distribution, comments help others to understand the program's constructs. This code is not interpreted by the compiler as executable code.

## UNDERSTANDING JAVA VARIABLES

A program would serve little good if it could not hold user data to further manipulate and then spout out a useful response. As a language that is designed to support dynamic loading of modules over the entire Internet, Java takes special care to avoid name space conflicts.

Global variables are simply not part of the language. Neither are global functions or procedures, for that matter.

In Java, every variable and method is declared within a class and forms part of that class. Also, every class is part of a *package*. Thus, every Java variable or method may be referred to by its fully qualified name, which consists of the package name, the class name, and the field name (the variable or the method name), all separated by periods. Package names are usually composed of multiple period-separated components. Thus, the fully qualified name for a method might be:

```
games.asteroids.SoundEffects.play()
```

The name space rules described in this book apply to packages, classes, and the fields within classes. Java also supports local variables, declared within method definitions. These local variables behave just like local variables in C—they do not have globally unique hierarchical names, nor do they have access modifiers like *public* and *private*.

In any programming language, variables provide the foundation upon which all else is built. You can think of a variable as a placeholder, or a name that represents one or more values. In essence, a variable is a data structure that is provided by the language itself.

The generic syntax for defining variables is as follows:

```
variableName = value;
```

Thus, for example, you might assign the value of 50 to the variable named age with the syntax:

```
age = 50;
```

From then on, unless you change the value of age, the script will translate it to 50, acting as a placeholder for the value.

To display the value of the variable, use this code:

```
System.out.println(age);
```

The Java Console will display the value 50.

In Java, you can name your variables anything you like so long as they are not a Java Keyword and contain only characters within the set of Unicode characters. However, a good practice is to use characters within the ranges of A-Z, a-z, 0-9, or _. Of course, variable names should help you understand what is happening in your program. Thus, it is useful to name your variables intelligently, such as firstName. Notice the variable

firstName in which the first word is lower case, the second word begins with an uppercase letter, and there are no spaces. This is standard practice in Java and naming your variables like this is a good habit to get into.

## UNDERSTANDING JAVA'S PRIMITIVE DATA TYPES

Primitive data types are core code components that define logic or mathematic functions. Java adds byte and Boolean primitive types to the standard set of C types (remember that Java is modeled after the C language). In addition, it strictly defines the size and signed-ness of its types. In C, an *int* type may be 16-, 32-, or 64-bits, and a *char* may act signed or unsigned, depending on the platform. This is not true in Java. In C, an uninitialized local variable usually has garbage as its value. In Java, all variables have guaranteed default values, though the compiler may warn you in places where you rely, accidentally or not, on these default values. The following table is a list of Java's primitive data types.

| Type Value | Contains | Default | Size | Min Val | Max Val |
|---|---|---|---|---|---|
| Boolean | True or false | False | 1 bit | N/A | N/A |
| Char | Unicode character | \u0000 | 16bits | \u0000 | \uffff |
| Byte | Signed integer | 0 | 8bits | -128 | 127 |
| Short | Signed integer | 0 | 16bits | -32768 | 32767 |
| Int | Signed integer | 0 | 32bits | -2147483648 | 2147483647 |
| Long | Signed integer | 0 | 64bits | -9223372036854775808 | 9223372036854775807 |
| Float | IEEE 754 floating point | 0.0 | 32bits | +-3.40282347E+38 | +-1.40239846E-45 |
| Double | IEEE 754 | 0.0 | 64bits | +-1.79769313486231570E+308 | +-4.94065645841246544E-324 |

*Java Primitive Data Types*

## USING JAVA OPERATORS

Java supports almost all of the standard C operators. These standard operators have the same precedence and associative nature in Java as they do in C. The following table outlines these common operators:

| Operator | Type | Operation Performed |
|----------|------|---------------------|
| ++ | Arithmetic | Increment |
| — | Arithmetic | Decrement |
| +, - | Arithmetic | Plus / minus |
| ~ | Integral | Bitwise complement |
| ! | boolean | Logical compliment |
| *, / ,% | Arithmetic | Multiply / divide / percentage |
| << | Integral | Left shift |
| >> | Integral | Right shift |
| < , <= | Arithmetic | Less than / less than or equal to |
| > , >= | Arithmetic | Greater than / greater than or equal to |
| = | Arithmetic | Equal to |
| & | Integral / Boolean | AND |
| ^ | Arithmetic | Raise int to a power |

*Common Java Operators.*

Java also adds some new operators, as discussed below.

"**+**," the + operator applied to **String** values, concatenates them. To C++ programmers, this looks like operator overloading. In fact, Java does not support operator overloading—the language designers decided that overloaded operators were a good idea, but that code that relied on them was hard to read and understand.

If only one operand of + is a String, the other one is converted to a string. The conversion is done automatically for primitive types, and by calling the `toString()` method of non-primitive types. This **String +** operator has the same precedence as the arithmetic + operator. The += operator works as you would expect for String values.

The **instanceof** operator returns true if the object on its left-hand side is an instance of the class (or implements the interface) specified on its right-hand side. **instanceof** returns false if the object is not an instance of the specified class or does not implement the specified interface. It also returns false if the specified object is `null`. The **instanceof** operator has the same precedence as the <, <=, >, and >= operators.

Because all integral types in Java are signed values, the Java >> operator is defined to do a right shift with sign extension. The >>> operator treats the value to be shifted as an unsigned number and shifts the bits right with zero extension. The >>>= operator works as you would expect.

When & and | (pipe) are applied to integral types in Java, they perform bitwise AND and OR operations. Java makes a strong distinction between integral types and the boolean type, however. Thus, if these operators are applied to Boolean types, they perform logical AND and logical OR operations. These logical AND and logical OR operators always evaluate both of their operands, even when the result of the operation is determined after evaluating only the left operand. This is useful when the operands are expressions with side effects (such as method calls), and you always want the side effects to occur.

## USING CONDITIONAL STATEMENTS

Conditional statements add logic to a program and are event driven in nature. Event driven means that the program language allows keywords that specifiy **if** something happens, **then** do this. This involves adding the logic of making decisions, and doing different things based on those decisions. Consider the following example:

Simple:

"**IF** cheeseburgers are 59 cents, **THEN** buy six."

Compound:

"**IF** cheeseburgers are 59 cents, **AND** I'm that hungry, **THEN** buy six."

In regard to the Java language, the following conditional statements are valid (all conditional statements in Java require a Boolean value.)

```
// Nested If else statements

if (i>5){ //in C if(i) may be 0, and trigger a false; not so in
Java
```

```
//do something

} else if (i<5) {

//do something else

} else {

//what ever you do, i == 5

}
```

The switch statement works on CHAR, INT BYTE data types:

```
public void paint(Graphics g){

ch = test( ); //Method test performs an evaluation

switch (ch) {

case 'p':

g.drawString("ch is p", 5, 25);

break;

case '\u0000':

g.drawString("ch is empty", 5, 25);

break;

default:

g.drawString("who knows what ch is", 5, 25);

        }

    }
```

## USING LOOPING CONSTRUCTS

In programming, a loop is a series of instructions that is repeated until a certain condition is met. Each pass through the loop is called an *iteration*. Loops constitute one of the most basic and powerful programming concepts. Using loops in programming helps to avoid the tedium of repeated lines of code to produce the same result or to aid in incremental functions.

The most complex of the loop statements is for. The for loop is often used in cases where you want to repeat a section of a program for a fixed number of times. It also can be used if the number of times the loop should be repeated is variable.

This for loop displays every number from 0 to 999 that is evenly divisible by 12. Every for loop has a variable that is used to determine when the loop should begin and end. The variable, often called a counter, in this loop is number. Consider the following:

```
for (int number = 0; number < 1000; number++) {

    if (number % 12 == 0)

        System.out.println("#: " + number);
```

There are three parts to for statement:

- **The initialization section**: In the first part, the number variable is initialized with a value of 0.

- **The conditional section**: In the second part, there is a conditional test like one you might use in an if statement. The test is number < 1000.

- **The change section**: The third part is a statement that changes the value of the number variable by using the increment operator.

In the initialization section, you can set up the counter variable that you want to use in the for statement. You can create the variable inside the for statement, as the number variable shown here, or you can create the variable elsewhere in the program. In either case, the variable should be given a starting value in this section of the for statement. The variable will have this starting value when the loop starts.

The conditional section contains a test that must remain true for the loop to continue looping. Once the test is false, the loop will end. In this example, the loop will end when the number variable is no longer smaller than 1,000.

The last section of the for statement contains a Java statement that changes the value of the counter variable in some way. This statement is handled each time the loop goes around. The counter variable has to change in some way, or the loop will never end. In this case, number is incremented by 1 using the increment operator ++ in the change section. If number were not changed, it would stay at its original value, 0, and the conditional number < 1000 would always be true.

## USING THE FOR LOOP

The for loop has identical syntax to C's for loop, **for (initialization; test; increment)**. The initialization is the setting of the variable which occurs the first time the loop is entered, then the first time and every time after that when the control reaches the top of the loop, as shown in the following example:

```
//Count to ten

class CountToTen  {

  public static void main (String args[]) {

      int i;

    for (i=1; i <=10; i = i + 1) {

      System.out.println(i);

    }

    System.out.println("All done!");

  }

}
```

This program prints out the numbers from 1 to 10. It begins by setting the variable i to 1. Then it checks to see if 1 is in fact less than or equal to 10. Since 1 is less than 10, the program prints it. Finally it adds 1 to i and starts over. *i* is now 2. The program checks to see if 2 is less than 10. It is, so the program prints 2 and adds 1 to "i" again. "i" is now 3. Once again the code checks to see that 3 is less than or equal to 10. The computer continues this

process until i is 10. The computer prints 10 and adds 1 to 10. Now "i" is 11. 11 is not less than or equal to 10 so the computer does not print it. Rather, it moves to the next statement after the end of the for loop, `system.out.println("All done!");`. The computer will print All Done! and the program will end.

## UNDERSTANDING SWING (AND JFC)

JFC is short for Java Foundation Classes, which encompass a group of features to help users build graphical user interfaces (GUIs). The JFC was first announced at the 1997 JavaOne developer conference and is defined by Sun Microsystems as containing the following features:

**Swing Components:** Include everything from buttons to split panes to tables. You can see mugshots of all the components in A Visual Index to the Swing Components.

**Pluggable Look and Feel Support:** Gives any program that uses Swing components a choice of looks and feels. For example, the same program can use either the JavaTM look and feel or the Windows look and feel. Many more look-and-feel packages—including some that use sound instead of visual, are expected to be available from various sources.

**Accessibility API:** Enables assistive technologies, such as screen readers and Braille displays, to get information from the user interface.

**Java 2DTM API (Java 2 Platform only):** Enables developers to easily incorporate high-quality 2D graphics, text, and images in applications and in applets.

**Drag and Drop Support (Java 2 Platform only):** Provides the ability to drag-and-drop between a Java application and a native application.

The first three JFC features were implemented without any native code, relying only on the API defined in JDK 1.1. As a result, they could and did become available as an extension to JDK 1.1. This extension was released as JFC 1.1, which is sometimes called the Swing release. The API in JFC 1.1 is often called the Swing API.

The Swing API is available in two forms:

- As a core part of the Java 2 Platform (standard edition of either v 1.2 or v 1.3)

- JFC 1.1 (for use with JDK 1.1)

The Swing API is powerful, flexible, and immense. For example, the 1.1 version of the API has 15 public packages:

```
javax.accessibility, javax.swing, javax.swing.border,
javax.swing.colorchooser, javax.swing.event,
javax.swing.filechooser, javax.swing.plaf,
javax.swing.plaf.basic, javax.swing.plaf.metal,
javax.swing.plaf.multi, javax.swing.table, javax.swing.text,
javax.swing.text.html, javax.swing.tree, and
javax.swing.undo.
```

Fortunately, most programs use only a small subset of the API.

The biggest difference between the Abstract Window Toolkit (AWT) components and Swing components is that the Swing components are implemented with no native code. Since Swing components aren't restricted to the least common denominator—the features that are present on every platform—they can have more functionality than AWT components.

Because Swing components have no native code, they can be shipped as an add-on to JDK 1.1, in addition to being part of the Java 2 Platform.

The following list is a contrast of AWT and Swing components:

- Swing buttons and labels can display images instead of, or in addition to, text.

- You can easily add or change the borders drawn around most Swing components. For example, it's easy to put a box around the outside of a container or label.

- You can easily change the behavior or appearance of a Swing component by either invoking methods on it or creating a subclass of it.

- Swing components don't have to be rectangular. Buttons, for example, can be round.

- Technologies such as screen readers can easily get information from Swing components. For example, a tool can easily get the text that's displayed on a button or label.

Swing lets you specify which look and feel your program's GUI uses, mimicking GUI components such as those from MOTIF or Microsoft Windows. By contrast, AWT components always have the look and feel of the native Java platform.

To use the Swing components, they must be imported into the program. The following line imports the main Swing package:

```
import javax.swing.*;
```

Most Swing programs also need to import the two main AWT packages:

```
import java.awt.*;

import java.awt.event.*;
```

Every program that presents a Swing GUI contains at least one top-level Swing container. For most programs, the top-level Swing containers are instances of JFrame, JDialog, or (for applets) JApplet. Each Jframe object implements a single main window, and each Jdialog implements a secondary window. Each JApplet object implements an applet's display area within a browser window. A top-level Swing container provides the support that Swing components need to perform their painting and event handling.

While Swing is gaining in popularity with Java programmers, the Abstract Windows Toolkit (AWT) is used more widely to date. For that reason, this book will focus on AWT as the primary provider of GUI interfaces to the Java language though it may be prudent to learn more about Swing in the coming months if you are serious about Java programming for its ease of use.

## CREATING JAVA GUI COMPONENTS WITH THE ABSTRACT WINDOWS TOOLKIT

Without the inclusion of a graphical representation system to create GUI components, the Java language would probably now be extinct. The world depends on point and click access to programmatic code in order to avoid the endless command line input that was once so common in DOS and Unix. The following sections will discuss the most common of these components that come bundled as the AWT (Abstract Windows Toolkit). The following list describes the most common objects found in the AWT toolkit and, consequently, in a Java application or applet:

- Command Button
- TextField
- TextArea
- Choice
- List

- CheckboxGroup
- Scrollbar
- Label

## CREATING A COMMAND BUTTON IN JAVA

One of the most common GUI items found on Web page forms is the command button to which some event might be tied in order to process form input or another defined event. The following Java code creates a command button:

```java
import java.applet.*;

import java.awt.*;

public class zzz extends Applet

{  public void init()

        {       add(new Button ("Enter"));

        }

}
```

In the init(), you add a button called Enter. When you run this program, you will see a button with the name (or the label ) Enter on the screen. You just wrote your first Java AWT program!

## CREATING CHECKBOXES IN JAVA

Using the example in the command button tip, add the following code to add a checkbox to the form:

```java
add(new Checkbox());
```

Checkboxes are used to provide multiple choice answers in a form rather than a simple yes or no or true or false selection like the choice provided by a CheckboxGroup (a/k/a. radio buttons in the Windows O/S/).

## CREATING CHOICE OPTIONS IN JAVA

Suppose you want to add a choice from a long list, such as what country a person resides in. Only a single choice is valid here so the solution is to add a drop-down list box, which is accomplished by adding the following code to the form:

```
add(new Choice());
```

Choice is a word from the old days of programming and in programming GUIs, it could also be accomplished using radio buttons where the choice was true or false.

## USING A SIMPLE TEXT FIELD

Text fields take typed input from a user, such as first or last name. Consider the following code:

```
import java.applet.*;

import java.awt.*;

public class zzz extends Applet

{  public void init()

        {       add(new TextField());

        }

}
```

Running the earlier program presented you with a command button, and this one will give you a text field, which is simply a single line edit box on the screen. Often, such GUI objects are helpful in updating databases with customer or other business information.

## CREATING A TEXTAREA FOR HANDLING MULTI-LINE INPUT

Over and above the simple text field is the multiple line text field called a TextArea, which might be used to take in customer comments. Consider the following addition to a form:

```
add(new TextArea());
```

This is similar to a huge text field, that is, it covers a larger area than the Textfield. While trying the text area, you may want to maximize the applet window because it appears like a multiple line edit box on the screen.

## CREATING A SCROLL BAR IN JAVA

Just as in your typical Unix or Windows environment, the inclusion of a window scrolling element provides greater functionality and usability in the creation of a GUI. To add a scrollbar to your application, add the following line of code:

```
add(new Scrollbar());
```

The addition of this code produces a scroll bar that lets the form move from left to right or top to bottom.

## ADDING LABELS TO FORM ITEMS

Labels provide a convenient way of spelling out specific regions on your form, giving a clue as to what the group of objects do on a specified form. To add labels to a Java form, use the following code:

```
add(new Label("my label"));
```

## CREATING MENUS IN JAVA

Java's Abstract Windowing Toolkit (AWT) includes four concrete menu classes: menu bars representing a group of menus that appears across the top of the window or the screen (class MenuBar); pull-down menus that pull from menu bars or from other menus (class Menu); menu items that represent menu selections (class MenuItem); and menu items that the user can turn on and off (class CheckBoxMenuItem).

These classes are all subclasses of MenuComponent, not subclasses of Component. Because they aren't components, they can't be placed in any container—the way you would place buttons and lists in a container. In a graphical user interface (GUI), the only way to use these menu classes is to place a menu bar (which can contain additional menus) in a frame using the frame's setMenuBar method. Since the applet class is not a subclass of Frame, it does not inherit the setMenuBar method. This means you cannot simply place a menu bar in an applet.

Still, there are several ways to create applets with menus:

1. An applet can open a new frame that contains an AWT menu bar with pull-down menus—perhaps in response to the user clicking on a button.

2. An applet can use a custom pop-up-menu class, either one that you implement yourself or one that comes from a third-party widget library. (The AWT itself does not include pop-up menus.).

3. An applet can also use an AWT menu bar with pull-down menus embedded in its enclosing rectangle in a Web page. You can accomplish this action using the simple technique described in this section.

While each of the three approaches has advantages, the last one has the most advantages. The main advantages of this approach over a design in which the applet opens a new frame with a menu bar are:

• An applet that does not open a new frame integrates better with Web pages and is less distracting to users than an applet that requires the user to click a button to open a frame. This is especially true in windowing environments that require the user to manually place the new frame—like many X window managers.

• Using AWT menus within an applet rather than opening a new frame lets you embed an exact working copy of the GUI of a standalone application within a Web page—or you can even embed the entire application. This capability can be valuable for user guides and tutorials, as well as for distributing applications to users who do not have a standalone Java interpreter installed on their machines. These users can use the application with a Java-enabled Web browser instead of launching the standalone application.

The main advantages of using AWT menus in applets rather than using a custom pop-up-menu class are:

- Using a custom pop-up-menu class requires you to develop the class, purchase it, or at least find a suitable free one, whereas the AWT menus are built into every Java runtime environment.

- The AWT menus always have the look and feel of the native windowing environment, whereas a custom pop-up-menu widget might not.

- An applet that uses the AWT menus loads faster because it does not need to load the menu class from across the network.

### Placing a Menu Bar and Menus in an Applet

Although an applet is not a subclass of Frame and therefore cannot contain a menu bar, it is always contained within some frame. You can find the frame that contains your applet using the following code:

```
Object f = getParent ();

  while (! (f instanceof Frame))

    f = ((Component) f).getParent ();

  Frame frame = (Frame) f;
```

This code finds the applet's parent, the parent's parent, and so on, until it finds a container that is an instance of class Frame.

The following applet shows how to place menus in an applet. It creates, in its init method, a menu bar that contains two menus—one with three menu items and the other with two. It then finds its enclosing frame and adds the menu bar to that frame. It attempts to handle, in its *action* method, the events that are generated when a menu item is selected but, as you will see, if you try to make a menu selection, it fails. The next section analyzes the problem and demonstrates how to solve it.

```
import java.applet.*;

import java.awt.*

import java.lang.*;

import java.util.*;

public class MenubarApplet extends Applet {   private Frame
frame;

  private MenuBar  mb;
```

```java
    private Menu   fm, hm;

    private MenuItem ol, of, pr, hi, hc;

    private Label message = new Label("Select an option from a
menu (nothing will happen)");

    public void init() {

setLayout(new BorderLayout());

    add("Center",message);

    Object f = getParent ();

    while (! (f instanceof Frame))

      f = ((Component) f).getParent ();

    frame = (Frame) f;

    mb = new MenuBar();

    mb.add(fm = new Menu("File"));

    mb.add(hm = new Menu("Help"));    mb.setHelpMenu(hm);

    fm.add(ol = new MenuItem("Open Location"));

    fm.add(of = new MenuItem("Open File"));

    fm.addSeparator();

    fm.add(pr = new MenuItem("Print"));

    hm.add(hi = new MenuItem("Index"));

    hm.add(hc = new MenuItem("Content"));

  frame.setMenuBar(mb);

    frame.pack();

  }
```

```
    public boolean action(Event e, Object arg) {    if (e.target
== ol || e.target == of || e.target == pr || e.target == hi ||
e.target == hc)

{  message.setText((String) arg);

  return true;        }

  return super.action(e,arg);

  }

}
```

## TRACKING MENU ITEM EVENTS

To further understand how events are handled, this section will examine why the previous applet fails to handle menu selection events. The code that creates the menus and places them in the frame is the same code you would use in a subclass of Frame that uses menus. The following is an excerpt that creates a menu bar, a menu, and a menu item, and then places the menu bar in the containing frame:

```
mb = new MenuBar();

  mb.add(fm = new Menu("File"));

  fm.add(ol = new MenuItem("Open Location"));

  frame.setMenuBar(mb);

The event-handling code is also typical:

  public  boolean  action(Event  e,  Object  arg)  {
    if        (e.target        ==         ol)        {
     /*       Handle       the       event        */
      return                                      true;
                                                    }
    return                  super.action(e,arg);
  }
```

The problem is that the menu-item selection events are never passed to the applet's action method. A selection event is first passed to the menu item itself. The menu item does not handle the event, so it is passed from one object to its parent. Eventually, the event reaches the frame, which also does not handle it. The applet is a descendant of the frame, not its parent or ancestor, so the event is never passed to the applet.

You should replace the standard menu items with custom menu items that intercept the selection event and pass it explicitly to the applet rather than rely on the AWT's default event-handling strategy. Custom menu items are an almost trivial derivation from MenuItem as shown below:

```
public class RedirectingMenuItem extends MenuItem {

  private Component event_handler;

   public RedirectingMenuItem(Component event_handler, String
label) {

    super(label);

    this.event_handler = event_handler;

  }

  public boolean postEvent(Event e) {

            if   (event_handler.isValid())    return
event_handler.postEvent(e);

    else return false;

  }

}
```

The RedirectingMenuItem constructor expects an event-handling component, which it simply saves, and a label that it passes to the MenuItem constructor. In this class, you need to intercept events by overriding the postEvent method and posting the event to the event-handling component. The event is only posted to the event-handling component if it is already valid (that is, its peer has been constructed by the AWT).

Using the RedirectingMenuItem class is easy. You simply replace the standard menu items by the redirecting menu items, and pass the this pointer as the reference to the event-handling component:

```
fm.add(ol = new RedirectingMenuItem(this,"Open Location"));
```

## CHECKBOXGROUPS MORE IN DEPTH

The CheckboxGroup is, in effect, a collection of two checkboxes. But, more accurately, the CheckboxGroup looks like typical radio buttons. Consider the following CheckboxGroup code:

```
import java.applet.*;

import java.awt.*;

public class zzz extends Applet

{   CheckboxGroup g;

    Checkbox a, b, c;

    public void init()

    {       g = new CheckboxGroup();

            add(a = new Checkbox("Good", g, false);

            add(b = new Checkbox("Bad", g, false);

            add(c = new Checkbox(null , g, true);

    }

    public boolean mouseUp(Event e, int x, int y)

    {       showStatus("state of a..." + a.getState() + "

            state of c..." +c.getState());

            return true;
```

```
        }

    }
```

The object g that looks like a CheckboxGroup is initialized in the *init* function, then added to three Checkboxes, named "Good", "Bad", and null, respectively (null is not a name, it means that no name has been given). You also have to tell that the checkbox belongs to which CheckboxGroup, in this case, g. The third parameter tells which checkbox will be currently active. In other words, when you run the program, the third one will be active. After that, if you click in, for example, the Checkbox a, and then click inside the window, the showStatus() will show you that the state of a... is true and that of c is false.

## MORE ON COMMAND BUTTONS

In previous Java examples, you learned about command buttons and simple examples of their use. This section will discuss some button customization techniques. Consider the following code:

```java
import java.applet.*;

import java.awt.*;

public class zzz extends Applet

{   Button b;

        public void init()

        {       b = new Button("Enter");

                add(b);

        }

    }
```

Button *b* has been added, similar to the first AWT program, but with one difference. This object *b* looks like a *Button*. Therefore, you can also use the functions of the class *Button*. With this in mind, consider the next example:

```
setLabel()

import java.applet.*;

import java.awt.*;

public class zzz extends Applet

{   Button b;

        int i=0;

        public void init()

        {       b=new Button("i..." + i);

                add(b);

        }

        public boolean mouseUp(Event e, int x, int y)

        {       i++;

                b.setLabel("i..." + i);

                return true;

        }

}
```

Button *b* has been added with the name of i...0(because *i* is 0 in the beginning). The mouseUp()
is included to change the label or the name of the button with the setLabel(). The variable *i*
is incremented every time the user clicks with the mouse. The increased value of *i* is displayed
as the name of the button. To reshape an AWT object, consider the following program:

```
reshape()

import java.applet.*;

import java.awt.*;

public class zzz extends Applet

{   Button b;
```

```
       int i = 0;

public void init()

{       b = new Button("hell");

        add(b);

}

public boolean mouseUp(Event e, int x, int y)

{       b.reshape(x, y, 30, 40);

        return true;

}

}
```

This program demonstrates how the button or any other feature in the AWT, like the text field, list box, and so on, can be moved to any coordinate and resized. In this example the reshape() method was used for button *b*, which means we want to change the shape and the position of our button. The reshape() consumes four parameters: the coordinates of the position where you want the button to be and its width and height.

As you see, there are many ways to manipulate a command button using the AWT, as well as all of the objects in the AWT. For a complete guide to AWT resources, visit *http://java.sun.com*.

## MORE ON CHOICES (DROP-DOWN LIST BOXES)

In the following code is a List *l* and a list box (or a Choice, as it is called). Using add Item, three items are added to the Choice: *xxx, yyy,* and *zzz.* Likewise, *a1, a3,* and *a* are added to the List. It is important to note that when adding items to the drop-down list, the items do not get added in a sorted order. After adding the items to the List and Choice, we add them to the Applet window with the *add()* function.

```
import java.applet.*;

import java.awt.*;

public class zzz extends Applet
```

```
{  List 1;

    Choice c;

    public void init()

    {       c=new Choice();

            c.addItem("xxx");

            c.addItem("yyy");

            c.addItem("zzz");

            1 = new List();

            l.addItem("a1");

            l.addItem("a3");

            l.addItem("a2");

            add(1);

            add(c);

    }

}
```

In this next example, a list of 5 members is created (though only 3 will be visible, as specified) and they are added to the applet window. A button called remove is created. When the user clicks on this button, item number 1 is deleted from the list using the *delItem()* function. Note that when you specify 1, the second item gets the scissors because the items start from 0 onward. Also, false as specified in the statement new List() (or for C++ users, in the constructor) means that multiple selection will not be allowed from the list. If you want to allow multiple selection of the items in a list, you have to specify it as true. Consider the following code:

```
delItem()

import java.applet.*;
```

```java
import java.awt.*;

public class zzz extends Applet

{   List l;

    Button b;

    public void init()

    {       b = new Button("Remove");

            l = new List(3, false);

            l.addItem("aaa");

            l.addItem("bbb");

            l.addItem("ccc");

            l.addItem("ddd");

            l.addItem("eee");

            add(l);

            add(b);

    }

    public boolean action (Event e, Object o)

    {       if("Remove".equals(o))

            {    l.delItem(1);

            }

            return true;

    }

}
```

## MORE ON TEXTFIELD ELEMENTS

In the next example, a TextField 60 characters long and a button is created. When you click your mouse on the button, the text already present in the TextField will be shown in the status bar. Then, its text is set to Hello how are you.

```java
import java.applet.*;

import java.awt.*;

public class zzz extends Applet

{   Button b;

    TextField t;

    public void init()

    {       b = new Button("click");

            t = new  TextField(60);

            add(b);

            add(t);

    }

    public boolean action (Event e, Object o)

    {       if ("click".equals(o))

            {   showStatus(t.getText());

                    t.setText("Hello how are you");

            }

            return true;

    }

}
```

These programs can be difficult for users not really conversant with programming. To simplify the matter further, refer to the following code:

```
public boolean action (Event e, Object o)

        {       String s;   boolean  b;

    s = "click";

    b = s.equals(o);

    if (b)

            {       showStatus(t.getText());

                    t.setText("Hello how are you");

            }

            return true;

        }
```

## UNDERSTANDING DIFFERENCES BETWEEN PURE JAVA AND MICROSOFT'S J++

Visual J++ 6.0 combines effective support for Internet standards with productive but Windows-only enhancements, offering developers an innovative upgrade to Microsoft's Java-based development environment.

Proponents of 100% Pure Java have noted with alarm and fury the emergence in Visual J++ 6.0 of Microsoft extensions to Sun Microsystems, Inc.'s Java language. The Microsoft extensions include conditional compilation flags, the J/Direct syntax for access to low-level Windows APIs, and mechanisms resembling function pointers (with documentation urging developers to use an alternative approach whenever possible).

A compiler-options dialog box lets developers disable support for Microsoft's departures from the multi-vendor Java standard, which is managed by Sun with input from other companies.

The main issue, not only in the eyes of developers but also in the eyes of the Justice Department, is the lack of standards within the product where Java code written in J++ is not portable across all systems, rather only Windows systems. While the development environment is solid and easy to use, this fact may be a reason to refrain from using this product to develop true Java applications or applets.

## USING JAVA WITH DATABASES

If you develop business applications, you know that no matter how great a programming language may be, if it doesn't let you get business data stored in a database, it's useless to you. Java includes a technology called Java Database Connectivity (JDBC) that lets Java programs access data stored in relational databases.

The network-oriented nature of Java makes it an ideal candidate for client/server computing, especially now that the ability to integrate it with popular commercial Database Management Systems (DBMS) is in the making. Many users are confused as to the nature of Java and adhere to the notion that it is useful only for making simple animation and small applets for the Web.

Top commercial database product vendors like Oracle, IBM, Sybase, SAS, and Borland have been taking a careful look at the Java-DBMS integration methodology. hese companies see a new opportunity that programmers everywhere will be taking advantage of in the near future. Starting now gives them a head start in this revolutionary market. Database and connectivity vendors can get a jump on what will be the next, truly distributed processing system.

The first standardized work on Java-DBMS connectivity appears in a draft specification known as the Java Database Connectivity (JDBC) Application Programming Interface (API) specification. Created with the help of the aforementioned database and database-tool vendors, it is intended to fill the current vacancy in this level of connectivity that has prompted companies like Weblogic to develop proprietary interfaces.

JDBC creates a programming-level interface for communicating with databases in a uniform manner similar in concept to Microsoft's Open Database Connectivity (ODBC) component which has become the standard for personal computers and LANs. The JDBC standard itself is based on the X/Open SQL Call Level Interface, the same basis as that of ODBC. This is one of the reasons why the initial development of JDBC is progressing so fast.

Object classes for opening transactions with these databases are written completely in Java to allow much closer interaction than you would get by embedding C language function calls in Java programs, as you would have to do with ODBC. This way, you can still maintain the security, the robustness, and the portability that make Java so exciting. However, to promote its use and maintain some level of backward compatibility, JDBC can be implemented on top of ODBC and other common SQL APIs from vendors.

JDBC consists of two main layers: the JDBC API supports application-to-JDBC Manager communications and the JDBC Driver API supports JDBC manager-to-driver implementation communications. The manager handles communications with multiple drivers of

different types from direct-interface implementations in Java to network drivers and ODBC-based drivers.

In terms of Java classes, the JDBC Driver API consists of:

- *java.sql.Environment:* allows the creation of new database connections
- *java.sql.Connection:* connection-specific data structures
- *java.sql.Statement:* container class for embedded SQL statements
- *java.sql.ResultSet:* access control to results of a statement

The JDBC Driver API is contained in *java.sql.Driver.* Each driver must provide class implementations of the following virtual classes: *java.sql.Connection, java.sql.Statement, java.sql.PreparedStatement, java.sql.CallableStatement,* and *java.sql.ResultSet.* These virtual classes describe the API but are specific to how each database functions. The JDBC-ODBC bridge performs translations of JDBC calls to that which can be understood by ODBC clients at a C language level. This bridge is quite small due to the similarities of the specifications. The bridge is needed to isolate native C language calls to a controlled area while maintaining compatibility with non-JDBC databases.

***Note:*** *To truly use JDBC you need to understand how to use the DriverManager, Connection, Statement, and ResultSet. If you do advanced DBMS work with Java, you will also need to use DatabaseMetaData and ResultSetMetaData, which are outside the scope of this book, but are covered in books on JDBC.*

## UNDERSTANDING SQL

SQL (pronounced ess-que-el) stands for Structured Query Language. SQL is used to communicate with a database. According to ANSI (American National Standards Institute), it is the standard language for relational database management systems. SQL statements are used to perform tasks such as updating data on a database, or retrieving data from a database. Some common relational database management systems that use SQL are Oracle, Sybase, Microsoft SQL Server, Access, and so on. Although most database systems use SQL, most of them also have their own additional proprietary extensions that are usually only used on their system. However, the standard SQL commands such as Select, Insert, Update, Delete, Create, and Drop, can be used to accomplish almost everything that you need to do with a database. This tutorial will provide you with the instruction on the basics of each of these commands as well as let you put them to practice using the SQL Interpreter.

## UNDERSTANDING JDBC

JDBC is a set of Java classes and interfaces that let a Java program connect to Relational Database Management Systems (RDBMS). Like Microsoft, based on the X/Open CLI definition.

JDBC and ODBC are call-level APIs. A Java program uses JDBC by making API calls into the JDBC class library. (An alternate technique to link a programming language to a database is to extend the syntax of the language to include DBMS constructs).

Although ODBC and JDBC are similar, JavaSoft did not use ODBC directly because the ODBC API makes extensive use of C pointers. Java does not support pointers for safety reasons—linking Java to ODBC would have been difficult and would have reduced Java's robustness. JavaSoft developed JDBC as a pure Java implementation and included it in JDK 1.1.

JDBC is represented in layers. The top layer represents a Java application that uses JDBC. Directly under it is the JDBC DriverManager. This code is responsible for managing the set of registered JDBC drivers. Underneath the DriverManager are the actual JDBC drivers. Their job is to present a uniform database access API and map it to the specific native methods of the supported database. As with ODBC, the underlying data store does not have to be a relational DBMS. If it isn't, it is up to the driver to make it look like an RDBMS.

The advent of the JDBC-ODBC bridge driver lets a Java program use existing ODBC drivers. The use of the ODBC bridge will be helpful in the case where ODBC has already been installed and a JDBC driver does not yet exist for a particular database. All major database companies are working on JDBC drivers, so the use of ODBC and the JDBC-ODBC bridge will soon not be critical to an installation.

## CONNECTING TO A DATABASE USING JDBC

To establish a connection with the DBMS you want to use involves two steps: loading the driver and making the connection.

Loading the driver or drivers you want to use is simple and uses one line of code. If, for example, you want to use the JDBC-ODBC Bridge driver, the following code will load it:

```
Class.forName("sun.jdbc.odbc.JdbcOdbcDriver");
```

Your driver documentation will give you the class name to use. For example, if the class name is:

```
jdbc.DriverXYZ
```

you would load the driver with the following line of code:

```
Class.forName("jdbc.DriverXYZ");
```

You do not need to create an instance of a driver and register it with the DriverManager because calling Classfor.Name will do that for you automatically. If you were to create your own instance, you would be creating an unnecessary duplicate, but it would do no harm. When you have loaded a driver, it is available for making a connection with a DBMS.

The second step in establishing a connection is to have the appropriate driver connect to the DBMS, as shown in the following line of code:

```
Connection con = DriverManager.getConnection(url,"myLogin",
"myPassword");

jdbc.DriverXYZ
```

This step is also simple, the most difficult being what to supply for url. If you are using the JDBC-ODBC Bridge driver, the JDBC URL will start with jdbc:odbc:. The rest of the URL is generally your data source name or database system. Thus, if you are using ODBC to access an ODBC data source called mydatasource, for example, your JDBC URL could be jdbc:odbc:mydatasource. In place of mylogin, you put the name you use to log in to the DBMS; in place of mypassword, you put your password for the DBMS. If you log in to your DBMS with a login name of sa and a password of Jumpy, the following two lines of code will establish a connection:

```
String url = "jdbc:odbc:mydatasource";

Connection con = DriverManager.getConnection(url, "sa", "Jumpy");
```

If you are using a JDBC driver developed by a third party, the documentation will tell you what sub-protocol to use, that is, what to put after jdbc: in the JDBC URL. For example, if the driver developer has registered the name *acme* as the sub-protocol, the first and second parts of the JDBC URL will be  jdbc:acme:. The driver documentation will also give you guidelines for the rest of the JDBC URL. This last part of the JDBC URL supplies information for identifying the data source.

If one of the drivers you load recognizes the JDBC URL supplied to the method DriverManager.getConnection, that driver will establish a connection to the DBMS specified in the JDBC URL. The DriverManager class, true to its name, manages all of the details of establishing the connection for you behind the scenes. Unless you are writing a driver, you will probably never use any of the methods in the interface Driver, and the only DriverManager method you really need to know is DriverManager.getConnection.

The connection returned by the method DriverManager.getConnection is an open connection you can use to create JDBC statements that pass your SQL statements to the DBMS. In the previous example, con is an open connection, and you will use it in the examples that follow.

## USING THE SQL SELECT STATEMENT TO ACCESS DATABASES

You use the SQL SELECT statement in Structured Query Language (SQL) to *select* data from the tables located in a database. Immediately, you will notice two keywords: you need to SELECT information FROM a table. These two SQL keywords are crucial to understanding how to retrieve data from a SQL database table. The most basic SQL retrieve structure is as follows:

SELECT "column_name" FROM "table_name"

For example, consider the following table:

**Table Store Information**

| store_name | Sales | Date |
| --- | --- | --- |
| Los Angeles | $1500 | Jan-05-1999 |
| San Diego | $250 | Jan-07-1999 |
| Los Angeles | $300 | Jan-08-1999 |
| Boston | $700 | Jan-08-1999 |

To select all the stores in this table, you use the following SQL statement:

```
SELECT store_name FROM Store_Information
```

**The result of the SQL statement is:**

store_name

Los Angeles

San Diego

Los Angeles

Boston

Multiple column names can be selected, as well as multiple table names. When using SQL select statements, remember:

- SELECT statements don't change data in the database.

- SELECT is usually the first word in an SQL statement. Most SQL statements are either SELECT or SELECT...INTO statements.

- The minimum syntax for a SELECT statement is:

```
SELECT fields FROM table
```

- You can use an asterisk (*) to select all fields in a table. The following example selects all of the fields in the Employees table:

```
SELECT * FROM Employees;
```

The syntax is as follows:

- **SELECT:** Specify what columns or aggregate functions to display

- **FROM [tablename(s)]:** Specify the tables used

- **WHERE:** Specify conditions you want met

- **GROUP BY:** Column_name. Groups data with the same value for column_name

- **ORDER BY:** Column_name. Sorts the data based on the value in column_name

The SELECT and FROM sections are necessary. The other sections are optional. The SELECT section can contain column names or math operations in the columns or aggregate functions.

## J++ AND WFC

WFC is an object-oriented framework that provides a rich encapsulation of the Win32 API, letting developers take advantage of the power and functionality of the Windows platform. Built on the J/Direct™ API, WFC provides an architecture and set of pre-built components that make it possible to rapidly write professional, full-featured applications for Windows. WFC offers more than 100 reusable Java classes and components, simplifying construction of user interfaces, database applications, server-side components, and complex business logic. WFC also lets developers build thin-client Web applications using client- or server-based Java classes that generate Dynamic HTML on the fly.

Visual J++ and WFC let you create controls that you can use in your Java applications, as well as in Visual Basic, Web pages, and any other host application that supports standard ActiveX

controls. WFC provides classes that incorporate most of the functionality of your control, including facilities for designing and implementing properties, handling and invoking events, and so on.

Visual J++ also includes visual tools for creating composite controls — controls made up of multiple visual elements, such as checkboxes and list boxes. The visual tools let you design the layout of your control and generate the appropriate code that you can amend, as required, to implement the full functionality of your control.

## JAVA AND ACTIVEX ARE NOT MUTUALLY EXCLUSIVE

There have been some common misconceptions in the past about ActiveX controls and Microsoft's position on the Java language. First, ActiveX is an Internet standard and was not developed exclusively by Microsoft. Second, ActiveX controls may be written in a variety of languages, including Java, C++, PERL, and Visual Basic.

Java is an excellent language to use in control creation, though you should be careful to make sure that the development environment used to create such controls lets the control work cross platform, if that indeed is the intent. Use of J++ to create such controls will result in the control's usability being limited to the Windows platform.

## USING J++ TO CREATE AN ACTIVEX CONTROL

Visual J++ makes it easy for developers to build their own reusable ActiveX controls so that their Java components can be reused within any COM-aware application, such as Visual Basic, Visual C++, Microsoft Word, and more.

To build an ActiveX control, you need to first build a WFC control. One way to do this is to drag- and-drop components onto a WFC Control form (select the Control template from the Add Project dialog). For example, a simple WFC control can be built using a vertical Scrollbar and an Edit control. All the logic behind the components can also be created so that moving the Scrollbar up or down changes the value in the Edit control. This is a common spin control that most developers have built at one time or another.

After the WFC control is completed, you must convert it into an ActiveX control that can be called by any COM-aware application. To build a COM server, developers must simply create a Java class and then select the COM Enabled checkbox in the Class Properties dialog box.

The same procedure is followed for visual controls. Once a WFC control is assembled and completed, developers can simply tag the class for the Control as COM Enabled.

After the project is compiled, all of the necessary information is generated so that the ActiveX control can be reused from any COM-aware application. Simply launch Visual Basic, import the ActiveX control onto the Toolbar, and drag-and-drop it onto the Visual Basic Form. All of the logic and functionality found in the WFC control is now available as an ActiveX control.

In addition, the original WFC control is still intact as a WFC control. This means that developers using the original control in Visual J++ will not have to use the COM marshalling layer of the Microsoft Java Virtual Machine when using the control. Rather, the control will run in Visual J++ as if it were nothing but a WFC control when, in reality, it is both an ActiveX control usable from any Windows application as well as a WFC control.

In letting developers build ActiveX controls, Visual J++ makes sure that any application or component developed in Java can be used from any other Windows application. In the past, Java developers were forced to not only rewrite their existing business logic, but also had to make a conscious decision to forgo other development options for Java alone. With Visual J++, developers have the utmost in flexibility between a Java-only solution, to a well-integrated Windows solution.

## CALLING THE ACTIVEX CONTROL FROM A VBSCRIPT PAGE

Whether you use an ActiveX control or a Java object, Microsoft Visual Basic Scripting Edition and Microsoft Internet Explorer handle it the same way. You include an object using the <OBJECT> tags and set its initial property values using <PARAM> tags. If you are a Visual Basic programmer, you will recognize that using the <PARAM> tags is just like setting initial properties for a control on a form. For example, the following set of <OBJECT> and <PARAM> tags adds the ActiveX Label control to a page:

```
<OBJECT

classid="clsid:99B42120-6EC7-11CF-A6C7-00AA00A47DD2"

    id=lblActiveLbl

    width=250

    height=250

    align=left
```

```
    hspace=20

    vspace=0

>

<PARAM NAME="Angle" VALUE="90">

<PARAM NAME="Alignment" VALUE="4">

<PARAM NAME="BackStyle" VALUE="0">

<PARAM NAME="Caption" VALUE="A Simple Desultory Label">

<PARAM NAME="FontName" VALUE="Verdana, Arial, Helvetica">

<PARAM NAME="FontSize" VALUE="20">

<PARAM NAME="FontBold" VALUE="1">

<PARAM NAME="FrColor" VALUE="0">

</OBJECT>
```

## DIFFERENCES IN SECURITY BETWEEN A J++ ACTIVEX CONTROL AND A JAVA APPLET

Distributable applets are one of Java's most exciting uses, yet they add security risk. Because applets are downloaded and run locally, they may potentially steal or damage local files. The Java Security API is cryptography-based, letting developers incorporate low- and high-level security functionality in applets and standalone applications. The set of APIs include support for digital signatures, key management, and ACLs. JDK1.1 provides the Javakey utility for managing keys and certificates, and for digitally signing files. It also provides facilities for signing and verifying Java ARchive (JAR) files.

The class signer's identity will be used (by the security manager, for example) to make access decisions. For example, if you trust Alice, and don't mind if she creates files on your machine, then you need to verify that a class or an applet is coming from her. That is, you want to verify Alice's identity. If Alice can sign a class with her private key, then you should be able to verify (using Alice's public key) that the signature is actually Alice's. However, one limitation of public-key encryption is the inability to verify that a public key belongs to the individual you believe it does. The solution to fix this limitation is called a *Certification Authority*.

All of this is similar to the way that an ActiveX control is signed for authenticity though the differences lie in the way that the two are programmed. For the most part, any application that is run locally on your machine of which you have no prior knowledge or familiarity with presents a risk. Java, and particularly JavaScript, have had some security problems. Remember that Java was designed to run untrusted applications on trusted machines. Considerable security has been built in, but some ingenious people have discovered some minor holes. Check the sites that are keeping up with JavaScript Security Problems, Java Security Problems, Safe Internet Programming, and Sun's Applet Security FAQ, and set your browser capabilities accordingly.

## THE ULTIMATE WEB BUILDER TOOLKIT

Web building would be time consuming if all you had to use was a text editor and a command line (the Internet was once built on such archaic tools!)

Fortunately, software companies have not overlooked the need for Web creation tools and have developed sophisticated environments by which almost anyone can create a Web page or site without programming a single line of HTML.

Tools are also available that will help you visually build ActiveX controls, Java applets and programs, and dynamic content. The following sections will discuss what tools might best suit you and your current situation in order to build the ultimate Web toolkit. Your toolkit will need an HTML editor, a scripting or development environment, and graphics utility for the creation of Web-based graphics.

## HTML EDITORS

Perhaps the most important tool in your tool bag when it comes to building a Web presence is the HTML editor. Choosing the right tool for the job can save you time and money when building your site. When considering an HTML editor first, you need to first determine the purpose for which you are creating a Web page. You might, for example want to create a simple site for your family, or build an e-commerce site with anticipation of supporting active content and five hundred separate products." If you choose the latter, then a simple HTML editor should suffice for the job. It would be hard to justify the expense of a $150 editor when you could by a shareware program for $20 to create five pages. Everyone works under a budget, whether for personal or business use, so shop around for price and features before making a decision. Many software companies will let you download the product first and try

it for thirty days on an evaluation basis. This is highly recommended as some editors on the market are quite high level and difficult to master.

On the other hand, if you do intend to add DHTML, XML, and so forth to your five pages, you will want to buy an editor that will help you in this endeavor. In the case of the e-commerce site, a souped up rapid development product will help you to design and implement your product much quicker than a low level editor. The key here is once again to try before you buy.

If you are just starting out in Web development with a limited budget, products such as HotDog Pro and WebSite Complete will work fine as will the myriad of shareware and freeware programs available from sites like *download.com*. Microsoft's FrontPage 2000, Macromedia's Dreamweaver, and Adobe's PageMill are excellent products, all considered high-end and available for both Windows and Mac platforms. Of course, there are feature trade offs between them so make sure to feature shop first before committing.

## DEVELOPMENT TOOLS FOR INTERNET-BASED LANGUAGES

After you have an HTML editor, you will want to delve into the world of Internet development using Java, Javascript, or VBScript. A myriad of tools are available for many different platforms though several have proven to be consistently favored.

By determining your level of experience and what platform you are developing on, you can make educated choices in the realm of development environments. Whether you are an ace or a neophyte, a good product to start with is CodeWarrior for Java by Metrowerks. Another popular program that is available for both the Mac and Windows platforms is Symantec's Café, which continues to sell well over the years. Windows Microsoft's Visual Studio is the number one selling development product for real code slingers, containing development environments for C++, J++, VB, and a myriad of other programs. Microsoft's J++ may be purchased separately as well and is an excellent What You See Is What You Get (WYSIWYG) alternative to the command line alternatives of Sun's JDK, though pricier (Sun's JDK is free and is available for almost any platform).

## GRAPHICS TOOLS

Your choice of graphics tools may be one of the toughest decisions you make to round out your toolkit. If you thought that learning to use HTML or Internet scripting tools was

difficult, you may be in for a surprise when it comes to using graphics tools. Depending on the level of need, graphics tools can be some of the most difficult to learn and use, particularly the high-end tools. Another consideration lies in your artistic abilities.

On the lower end of the spectrum, you may be able to incorporate graphics into your pages via stock clip art without the use of a graphics program. Many Internet sites and CD-ROMs are suitable for this task. Simply do a search on one of the major search engines for clip art for a list of Internet sites. The CD-ROMS are available from online and retail software stores everywhere.

If stock graphics don't work for you, entry level graphics programs are available which are reasonably priced and offer helpful tools that speed the creation of custom graphics, such as buttons. Download a copy of Graphics Workshop from Alchemy Mindworks at *www.mindworkshop.com*. The price to purchase is between $40 U.S. and $80 U.S. There are also a number of shareware programs available. Try *www.download.com* for a list or, alternatively, *www.tucows.com*.

On the higher end are a host of applications that require some technical expertise to create even the simplest of graphics. Products from vendors such as Macromedia (*www.macromedia.com*) and Adobe (*www.adobe.com*) are in the top of their product market and are used by high-level Web designers to create rich and compelling Web graphics and animations. These products are available for both Mac and Windows platforms. Expect to pay a premium for these products, in the $300 U.S. to $700 U.S range.

## UNDERSTANDING MICROSOFT FRONTPAGE 2000

The Windows platform has by far the widest install base in both the home and business market. Therefore, it is warranted that you spend time looking at one of the most popular and user friendly WYSIWYG HTML editors on the market, Microsoft's FrontPage 2000.

As a member of the Microsoft Office family of products, FrontPage 2000 enjoys a large install base and rightly so. The product is easy to use with its WYSIWYG editor, almost as easy as using a word processor. Also built into the product is support for posting to servers that support FrontPage Server Extensions, a product available for not only Windows-based Web servers but also the Unix variety. Many ISP's have chosen the use of these server extensions to ease the posting of content rather than the old way of having to FTP to a file system on the server.

FrontPage 2000 is a multifunctional tool that not only creates HTML pages on the fly, it also incorporates DHTML effects using easy-to-use inserts and acts as a set of site management tools for keeping up with the chores associated with your site, all in one interface. FrontPage

2000 is a complete Web site creation and management tool. If you are already familiar with the tools within other Office products, you will have a jump on the learning curve.

## GETTING STARTED WITH FRONTPAGE 2000

With FrontPage 2000, you can be up and running with a simple site within an hour.

First, check to see if your ISP supports FrontPage server extensions and, if so, what version of the extensions are supported, and if there is an additional charge for adding the use to your account. You will need the IP address or legal DNS name of the server as well. After that has been established and you have the program installed, you are ready to begin. Start by opening the program. You should see something similar to the figure below.

*Opening the FrontPage Environment.*

Next, you will cerate a new FrontPage "Web," which is short for Website, as in the figure below.

The resulting window lets you select a type of Web to create. For our purposes the "Personal Web" will do as shown in the figure below.

*Creating a new "Web".*

*Choosing a "Personal" Web.*

Before Double clicking this choice however you must select a server on which to create the Web as furnished by your ISP and as shown in the figure below.

*Entering the server IP address or name.*

The interface will display an informational window that shows the Web being created on the server (see figure below).

*FrontPage creates the new Web on the server.*

Now before getting ahead of ourselves, let's take a look at the interface to better understand the how to use the tools in FrontPage. Look at the diagram in the figure below. The interface is split into several sections that offer tools and information.

The interface should look familiar if you have used Microsoft products in the past, particularly the menu bar and the toolbar. The split frame workspace on the left is similar to the Windows Explorer (file manager) program. On the right is the actual page that you are working on. At the bottom of the screen is the connection information and connection activity indicator that shows an actual transfer to or from the server (connections are made as needed and not constant).

In choosing the Personal option for your Web site, five default pages are created. The page in the editor presently is a new page to which you might add content and later link. For now, you will  close this page by choosing the menu bar options File. Then, select Close (alternatively, you may click on the x at the top corner of the editor frame—not the one at the very top right of the FrontPage program as this will close the program!) Double-click your mouse

on the file Default.htm in the files and folder list in the left frame. Default.htm or Index.html are often the Home Page of your Web site, that is the default or first page that you see when accessing *www.yoursite.com*.

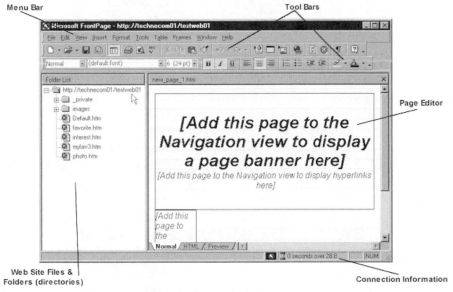

*The different areas of the FrontPage Interface.*

FrontPage has taken the liberty of doing some design work for you via templates, as in the figure below.

*FrontPage designs the Web for you.*

From this point you may add content to the skeletal page, including text and pictures. You may change the Home Page banner at the top to reflect a suitable title by right-clicking on the banner and selecting properties, then changing the text (see figure below).

*Changing the banner text.*

Almost every object on the page can be manipulated. Notice right under the banner at the top of the page there is text that says ""[Edit the properties for this Navigation Bar to display hyperlinks here]". Click on this text and do a right-click and then "Navigation Bar Properties" (see figure below). From here you may add graphical or textual navigational links to the entire site.

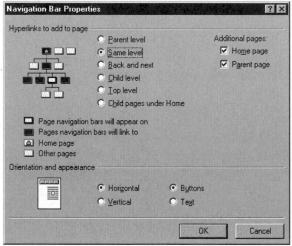

*Changing Navigation bar properties.*

After you have finished adding all of the necessary content to each of the pages, you should use the File Save As option to save your files to the Web server. You may view your pages one of several ways, though the best way is to actually visit the URL to your Web server and make sure that everything was properly stored. You may also look at each page within the FrontPage environment by switching to the Preview tab of the Editor frame.

You have officially created a Web site! For further information, the Help file for FrontPage is very informative, as is the Microsoft Office Web site at *officeupdate.microsoft.com*.

## USING FRONTPAGE SERVER EXTENSIONS

When you use FrontPage to create or maintain a Web site, some of the features in FrontPage require processing on the Web server. Additionally, when someone visits your FrontPage-based Web, they may want to use features on your Web site that also rely on server-side processing. The FrontPage Server Extensions are programs that run on the Web server to do this processing. Features enabled by the FrontPage Server Extensions let you include sophisticated technology on your Web pages without having to learn or understand the programming behind them.

You can use FrontPage to create Web content on any Web server, but you need to avoid using the relatively few features that require the FrontPage Server Extensions.

If you use FrontPage to create or maintain a Web site, certain features require the FrontPage Server Extensions on the Web server. The most obvious of these features is the ability to edit your Web directly from the Web server by using the site's URL. If you can edit your Web by typing http://*Webname* to open it in FrontPage (provided you have proper permissions), then the Web server you're using already has the FrontPage Server Extensions installed.

If you don't edit your Web directly on a Web server, then you probably open your Web from a disk-based location, such as your hard disk (for example, C:\My Documents\My Webs) or a local-area network (for example, \\Network Share\My Workgroup). When editing from a disk-based location, you publish your Web to the Web server to make it available to site visitors.

To reiterate, it is immediately apparent whether the Web server to which you're publishing has the FrontPage Server Extensions installed: if you can publish your Web using the Hypertext Transfer Protocol (HTTP), the Web server has the FrontPage Server Extensions. Otherwise, you can publish your pages using the File Transfer Protocol (FTP) by typing **ftp://***servername* instead of **http://***Webname* as the location for publishing your Web.

Other features that the FrontPage Server Extensions make possible for Web authors and administrators include:

- Setting permissions on a Web.
- Locking files so that only one author at a time can modify a page.
- Creating, deleting, and renaming Webs and subWebs.
- Automatically updating hyperlinks when you rename files.

- Automatically generating a list of hyperlinks.

- Applying a theme to all the pages in a Web.

- Incorporating database access in a Web.

- Enabling other Microsoft Office 2000 applications to save directly to a Web server.

The FrontPage Server Extension's functionality is built into the FrontPage application to make these features work when you create a disk-based Web (a Web on your hard disk rather than on a Web server). When you work with a Web that's on a Web server, however, FrontPage communicates with the FrontPage Server Extensions installed on the Web server to make these features work. Some of these features are available only if the Web is on a Web server, rather than your hard disk. For example, you can set permissions on a Web only when you open the Web on a Web server. When a site visitor browses to a FrontPage-based Web site, certain features on the site may require that the FrontPage Server Extensions be installed on the Web server where the site is published. Without the FrontPage Server Extensions, the following features don't work:

- Search form

- Hit counter

- Discussions

- Form handler and confirmation fields

These features also don't work on a disk-based Web. Therefore, if you create your Web on your hard disk or your local-area network, you must publish it to a Web server that has the FrontPage Server Extensions installed in order to run these features. Database access in your Web also requires that your Web be published on a Web server.

If you know that the Web server on which you publish your Web does not have the FrontPage Server Extensions installed, you can prevent authors from placing components there that require the server extensions. That way, visitors to your site won't be frustrated by trying to use components that don't work.

To restrict the component list to components that don't require FrontPage Server Extensions

- On the Tools menu, click Page Options.

- On the Compatibility tab, clear the Enabled with Microsoft FrontPage Server Extensions checkbox.

- When editing a page in Page view, go to the Insert menu and click Component. (Note that you can no longer select components that rely on the FrontPage Server Extensions.)

Making extensions-dependent components unavailable prevents you from adding those components to pages, but nothing prevents you from creating forms or discussion Webs. If your Web server doesn't have the FrontPage Server Extensions installed, remember to refrain from adding these features to your Web.

## ADVANCED FEATURES OF FRONTPAGE 2000

Beyond the ordinary features of an HTML editor, FrontPage 2000 offers the Web creator dozens of other useful tools that allow for the creation of forms and results pages, page counters, DHTML effects, database connections, and dynamic database results. This section will discuss a few of these options here.

When visitors to your FrontPage-based Web fill out a form, FrontPage stores the results according to your specification. The visitor's input may be:

- Sent to you as an e-mail message.
- Stored as plain text in a text file in your Web.
- Stored as formatted HTML on a page in your Web.
- Stored in a database in your Web.

If you choose to send the form results to a text file or HTML page, you specify a .txt or .htm file to store the form results. FrontPage adds to this file every time a site visitor fills out the form. You can use this file in many ways. For example, you can make it visible in your Web by linking to it from another page, you can keep it hidden from site visitors and use it for your own reference, or you can use Microsoft Excel to view the information in the file.

Two options are available for output when using FrontPage forms: text or HTML. Whether to use text or HTML for your results file depends on how you want to use the file. If you want to read it easily, or link to it so that site visitors can see it, use HTML. If you want to view the file easily in a spreadsheet, use text. You can even specify both, and FrontPage will save the results to both a text file (for easy viewing in a spreadsheet) and an HTML file (for easy viewing as a Web page).

Generally, saving to a text file is faster than saving to an HTML file. When you choose either text or HTML, you can further specify how the text or HTML is formatted in the file.

To set the format of a text or HTML file, perform the following steps:

- In Page view, open a page that contains a form.

- Right-click your mouse on the form, and then click **Form Properties** on the shortcut menu.

- In the **Form Properties** dialog box, click **Options**, and then click the **File Results** tab.

- In the **File name** box, you can tell whether the file is text or HTML by the file extension: .txt is a text file, and .htm is an HTML file.

- If you want to change the file to text or to HTML, change the file extension to .txt or to .htm in the **File name** box.

- In the **File format** list, select a format.

If you are saving form results to a text file (.txt), use one of these formats:

- **Text database using comma, tab, or space as a separator.** These formats are easy to view in a spreadsheet, but the text file is difficult to read.

- **Formatted text.** Text is formatted into columns that are easier to read than the text database formats, but this text is not practical for viewing in a spreadsheet.

- **Text formatted within HTML.** This format saves quickly, yet is easy to convert to a Web page (by changing the file extension to .htm).

If you are saving form results to a Web page (.htm), use one of these formats:

- **HTML.** This format presents a list of fields with the field name in boldface, and a colon separates the field name from the data.

- **HTML definition list.** Data for each field is indented under the field name.

- **HTML bullet list.** This format is like HTML format, except that each field is bulleted.

You can name a file to store the results of a form by editing the form properties. If you are using the Form Page Wizard, you can name the results file in the Output Options pane of the wizard.

If you use the Form Page Wizard to create more than one form page in your Web, be sure to enter a unique name for the results file every time. Otherwise, results from all the forms are stored in the same file (Formrslt.txt or Formrslt.htm, by default). By default, each new post is appended to the end of the file.

If you want to, you can create new results files for existing forms.

To specify a results file for an existing form, perform the following steps:

- In Page view, open a page that contains a form.

- Right-click your mouse on the form, and then click **Form Properties** on the shortcut menu.

- A file name, an e-mail address, or both are displayed in the boxes under the **Send to** option, unless the form is a custom form or a database form.

- Click **Options**, and then click the **File Results** tab.

- In the **File name** box, enter a name with a .txt extension for a text file or an .htm extension for a Web page.

- In the **File format** list, select the format you want.

- Select other options as desired; specify a second file in another format if you want.

- On the **Saved fields** tab, in the **Form fields to save** box, delete any fields that you don't want to appear in the results file (if you make a mistake, click **Save All** and start over). You can also specify date and time formats and other information to save.

- When you're finished, click **OK** to close the dialog box, and click **OK** again to close the **Form Properties** dialog box.

DHTML effects are commonplace today in many sites and they add a creative and interactive flair to a site. One of the most used DHTML effects is the mouseover event which will either manipulate text or a graphic where, when the mouse pointer passes over the object, the object responds with some event.

FrontPage 2000 Dynamic HTML (DHTML) animation effects bring movement and interest to your pages and work seamlessly with Netscape Navigator 4.0 and later, and Microsoft Internet Explorer 4.0 and later.

To add a DHTML effect to your page, perform the following steps:

- If the DHTML toolbar is not present, right-click your mouse on the toolbar area and choose to add the DHTML toolbar (the figure below).

*Adding the DHTML toolbar.*

- Choose the object on the page that you wish to manipulate, such as text or a graphic.

- From the DHTML toolbar On option, choose the Page Load option.

- In the Apply field, choose the effect you want to add.

Data driven Web sites are becoming increasingly more popular. Data driven means that the content of the Web pages may be derived all or in part from some data source, usually a database server. Database connections in the Windows world are accomplished through a number of means. In FrontPage 2000, you define a FrontPage Database Connection to connect to a database. A FrontPage Database Connection is a series of properties that the FrontPage-based database features use to make a connection to ODBC-compliant databases, to read information from them, and to add information to them. Because of this new feature, a System DSN is no longer required for database access in FrontPage 2000. However, you can use a System DSN as one of the four types of FrontPage Database Connections.

Perform the following steps to define a database connection:

- On the Tools menu, click Web Settings, and then click the Database tab.

- Click Add, and supply the necessary information.

One of the most common uses for data driven sites is displaying the results of a database query report in a table. Being able to sort these results by column can provide the user of the site the ability to easily read these results. Using the new database integration features in Microsoft FrontPage 2000, you can have this functionality on a Web page without the need to know Structured Query Language (SQL) or other custom programming.

To follow the first procedure shown below, you need to have already set up a database connection, or you can use the Northwind sample database that has been modified and included in FrontPage 2000. A database connection must be made on a server that supports the Active Server Page (ASP) because FrontPage generates ASP script that needs to reside in an ASP document.

The second procedure describes how to create the hyperlinks that let columns be sorted when a site visitor clicks a column heading. The following steps are reprinted from the Microsoft FrontPage 2000 Web site.

To create a sort-by-column query, perform the following steps:

- Create a new page, and then save it as Sort.asp. The page is saved as an Active Server Page (ASP) because FrontPage generates ASP script that needs to reside in an ASP document.

- On the **Insert** menu in Page view, click **Database**, and then point to **Results** to insert a database results region. This opens the Database Results Wizard, which is one of the database interfaces in FrontPage.

- In Step 1 of the wizard, click **Use a sample database connection** or **Use an existing database connection**, and then click **Next**.

- In Step 2 of the wizard, in the **Record source** list, choose a source, and then click **Next**.

- In Step 3 of the wizard, click **More Options**, and then click **Ordering**.

- Select a field in the **Available fields** list, click **Add** to add it to the **Sort Order** list, and then click **OK**. The results of the query will be sorted according to the values in this column.

- Click **OK** to exit the **More Options** dialog box, and then click **Back** to return to Step 2 of the wizard.

You may be wondering why you've gone back to Step 2 of the wizard after specifying some options. When you specify options, FrontPage writes the SQL that the database uses to retrieve results. For example, in step 6 of the procedure you specified a sort order. FrontPage created a SQL query that tells the database how to sort the results. Going back to Step 2 of the wizard lets you use the SQL FrontPage creates instead of having to write it yourself. The rest of the steps in the procedure show you how to make minor changes to the SQL so that a site visitor can easily sort the results by clicking a column heading.

- Click **Custom Query**, and then click **Edit**. The SQL required to implement your query is in the SQL field.

- Select the name of the field you chose (the name follows the words ORDER BY), and then click **Insert Parameter**.

- In **Form field name**, enter SortColumn, and then click **OK**. You don't have to use the name SortColumn, however, it is a good description of the action that will occur. The name that is used in this field will be used when creating the hyperlinks for each column name.

- Click **OK** to return to Step 2 of the wizard, and then click **Next**.

- In Step 3 of the wizard, click **More Options**, and then click **Defaults**.

- Click **Edit**, add the name of the first column in your table, and then click **OK** until you close all dialog boxes.

- In Step 4 of the wizard, select **Table-one record per row**, and then click **Next**.

- In Step 5 of the wizard, click **Display all Records Together**, and clear the **Add search form** check box.

- Click **Finish**.

After the database region has been generated and displayed on the page, you need to create hyperlinks for all the column headings. Perform the following steps to create hyperlinks for column headings:

- Select the column heading, and then click **Hyperlink**.

- Select **sort.asp** from the **Name** field. Sort.asp is added to the **URL** field.

- Click **Parameters**.

- Click **Add**.

- In the **Name** field, enter the form field name you chose. SortColumn was the suggested name in the procedure above.

- In the **Value** field, enter the name of the column for which you want the hyperlink, and then click **OK**.

- Click **OK** until you close all dialog boxes.

- Repeat steps 1 through 6 for all column names.

When you've finished creating all the hyperlinks, click the Preview in Browser button. The query results are formatted in a table, and each column heading is a hyperlink. When you click a column heading, the query results will be refreshed and sorted according to the values in the column that you selected.

## UNDERSTANDING CGI

CGI is an abbreviation for *Common Gateway Interface*, a specification for transferring information between a World Wide Web server and a CGI program, and is a mechanism through which a browser is allowed to communicate with programs running on a server. If you examine each word in turn, it makes more sense:

- **Common.** Something that is available to many people, regardless of what software they are using.

- **Gateway.** A portal through which two things communicate. In this case, the browser communicates to the server.

- **Interface.** This implies that you are providing a front end for the application running on the server, which is exactly what it is. You enter information in the form, for example, and this is submitted to the program, just like a windows-style program.

A CGI program is any program designed to accept and return data that conforms to the CGI specification. The program could be written in any programming language, including C, Perl, Java, or Visual Basic.

CGI programs are the most common way for Web servers to interact dynamically with users. Many HTML pages that contain forms, for example, use a CGI program to process the form's data once it is submitted. Another increasingly common way to provide dynamic feedback for Web users is to include scripts or programs that run on the user's machine rather than the Web server. These programs can be Java applets, Java scripts, or ActiveX controls. These technologies are known collectively as *client-side* solutions, while the use of CGI is a *server-side* solution because the processing occurs on the Web server.

One problem with CGI is that each time a CGI script is executed, a new process is started. For busy Web sites, this can slow down the server noticeably. A more efficient solution, but one that it is also more difficult to implement, is to use the server's API, such as ISAPI or NSAPI. Another increasingly popular solution is to use Java servlets.

## UNDERSTANDING CGI SCRIPTS

CGI scripts are server-side interpreted shell programs that are processed by the server and generally developed in languages such as C, Perl, TCL/AK, and Java. These scripts provide the processing power behind Web page input or are used to provide dynamic updates to pages, such as advertising banner rotation. These scripts are called from the page via the <FORM ACTION> tag and attribute from a specified directory on the Web server that has rights to run executable code (typically, the CGI-BIN directory). Two methods can be used to access your scripts. These methods are GET and POST. Depending on which method you use, you will receive the encoded results of the form in a different way. If your form has METHOD="GET" in its FORM tag, your CGI program will receive the encoded form input in the environment variable QUERY_STRING. If your form has METHOD="POST" in its FORM tag, your CGI program will receive the encoded form input on stdin. The server

will NOT send you an EOF on the end of the data; instead, you should use the environment variable CONTENT_LENGTH to determine how much data you should read from stdin. Processing such scripts is CPU intensive as the script must be run through an interpreter to generate the form output.

CGI scripting was the most common method of providing dynamic content to Web users, but is now used much less as products that provide a more streamlined approach to delivering such content have replaced scripting. This involves using the Web servers' API to provide the interactivity between client and server.

## UNDERSTANDING WHY WEB SITES USE CGI

The lure of using CGI early on lay in the fact that it was the only vehicle for providing rich content to the Web world. Static pages are pretty and informative but they lack the interaction necessary to provide real world and business application. The use of scripting languages to process Web page input opened new doors to developers, letting the user truly interact with the page.

Another plus for CGI is its cross-server, cross-browser functionality. CGI scripts and programs run on almost every Web server made and require nothing from a compatibility standpoint from browsers as CGI processing is done on the server end.

## UNDERSTANDING WHERE CGI FITS IN

Web-based computing is based on the client/server model, even at the protocol (HTTP) level. Since even the earliest and most archaic browser/Web server computing followed this model, it is important to understand where CGI fits into that model. For the most part, CGI is used on Unix-based systems rather than Windows-based servers, and it is crucial that you understand some sort of scripting language, such as Perl or C, in order to use the power of CGI.

If you're going to create Web pages, at some point you'll want to add a counter, a form to let visitors send you mail or place an order, or something similar. CGI enables you to do that and much more. From mail forms and counter programs, to the most complex database scripts that generate entire Websites on-the-fly, CGI programs deliver a broad spectrum of content on the Web today. If you've ever looked at a site such as *Amazon.com*, *DejaNews*, or *Yahoo*, and wondered how they did it... the answer is CGI. Because CGI experience is also in high

demand from employers now, you could substantially improve your salary and job prospects by learning CGI.

## CGI PROGRAMS ARE SERVER-SIDE PROGRAMS

All processing of CGI programs take place via interpreters on the Web server. This is true whether the script is written in C, Perl, or Java. To a Web programmer, the most tangible benefit lies in that all processing of the CGI takes place on the server rather than the client, so CGI is cross-browser functional regardless of the client or operating system. However, some disadvantages exist which will be discussed later. For now, simply know that your scripts need only be compatible with the server rather than the client browser which means greater flexibility to your potential audience in an ever changing Internet landscape.

## LOOKING AT THE BIG PICTURE WITH CGI

The CGI process begins with the inclusion of a call to the script from within the Web page. There are two methods that may be used to access your forms using CGI and HTTP. These methods are **GET** and **POST**. Depending on which method you use, you will receive the encoded results of the form in a different way. If your form has METHOD="GET" in its FORM tag, your CGI program will receive the encoded form input in the environment variable QUERY_STRING.

If your form has METHOD="POST" in its FORM tag, your CGI program will receive the encoded form input on stdin. The server will NOT send you an EOF on the end of the data; instead, you should use the environment variable CONTENT_LENGTH to determine how much data you should read from stdin.

The script is set into motion by some user interaction, usually a form submit, which passes variables from fields on the page to the script which, in turn, is processed by the interpreter to produce some action defined by the script. In this example, the script writes the data to an e-mail message and forwards the request to an SMTP mail server and then returns a confirmation page back to the user's browser.

As you can see, CGI programming gives the Web programmer flexibility in handling information from users and creates an interactive experience for the user. This example is simple, but there are complete applications that run with many series of scripts to interact with users or to generate dynamic Web pages.

# WEB SITE CONSTRUCTION TIPS & TRICKS

## UNDERSTANDING THE SERVER/CGI SCRIPT RELATIONSHIP

CGI stands for *Common Gateway Interface*. That's a fancy term for something we all know as Application Programming Interface. Thus, CGI is the API for the Web server.

Essentially, a server waits for a client to ask for a file. The file can be an HTML document, or a graphic, or just about any kind of file. Once the server receives the request, it does three things:

- It sends a line of plain text which explains what kind of file is being sent, such as HTML or GIF.

- It sends out a blank line.

- It sends out the contents of the file.

## SECURITY ISSUES WITH CGI SCRIPT PROGRAMMING

Because running CGI scripts requires hosting the script in an open directory that allows read and execute permissions, the possibility exists for malicious intent. Such an attack would affect the Web server rather than the client, though scripts could be rewritten to post sensitive client data to other locations on the Web. The key to security is to start at the bottom and work your way up, beginning with your user name and password. Always use strong multi-character user names and passwords. Also remember to check permissions on all files and directories that are executable that may have public exposure.

## REVIEWING SOME UNIX SECURITY ISSUES WITH SCRIPTS

CGI scripting, like all technologies that may potentially cause harm by malicious use, may open a security risk on systems that are not adequately protected. For a script to run on a Unix system you will need to run the script from a directory (usually CGI-BIN) that has read, write, and execute permissions and you must change the permissions on the file so that it is executable (or runnable) by the system. In Unix, this command is:

```
chmod 755 filename
```

368

This command sets the file permissions so that you can read, write, and execute the file, and all other users (including the Web server) can read and execute it.

However, security is only as strong as the weakest link in the chain. Assuming only your account (and the administrator) have access to change the file, suppose that your account name is your first initial and last name and you have set up your password to mimic this. Further, suppose that your first and last name are all over your site or embedded within the script. A clever hacker could potentially gain access to your scripts by logging on with your account information. Therefore, it is imperative to protect your account identity first and foremost. Directory and file permissions are also extremely important. Always know what the permissions are on both your files and directories. It may also pay off to refrain from using the known CGI-bin directory and using an unknown directory that you have created. Set the file and directory permissions as you would on the CGI-bin directory.

## LOOKING AT CGI AND DATABASES

The saying that any software problem can be solved by adding a layer of indirection is demonstrated in Perl's DBI (Database Interface) module, written by Tim Bunce.

DBI is designed to protect you from the details of the vendor libraries. It has a simple interface for saying what SQL queries you want to make, and for getting the results back. DBI is unable to talk to any particular database, but it does know how to locate and load in DBD (Database Driver) modules. The DBD modules contain the vendor libraries and know how to talk to the real databases. There is one DBD module for every different database.

When you ask DBI to make a query for you, it sends the query to the appropriate DBD module, which spins around three times, or drinks out of its sneaker, or whatever is necessary to communicate with the real database. When it gets the results back, it passes them to DBI. Then DBI gives you the results. Since your program only has to deal with DBI, and not with the real database, you don't have to worry.

To understand how your program would talk to the DBI library. Suppose you are using an Oracle database server on some other machine. Your program sends a query to DBI, which forwards it to the appropriate DBD module, for example DBD::ORACLE. DBD::ORACLE knows how to translate what it gets from DBI into the format demanded by the Oracle library, which is built into it. The library forwards the request across the network, gets the results back, and returns them to DBD::ORACLE. DBD::ORACLE, in turn, returns the results to DBI as a Perl data structure. Finally, your program can get the results from DBI.

Two big wins result from this organization. First, you don't have to hunt around the network to talk to the Oracle server or deal with Oracle's library. You just have to know how to talk to

DBI. Second, if you build your program to use Oracle, and then the following week the company decides to use Sybase, it's easy to convert your code to use Sybase instead of Oracle. You change exactly one line in your program, the line that tells DBI to talk to DBD::Oracle, and have it use DBD::Sybase instead. Or you might build your program to talk to a database like MS Access, and then next year when the application is doing well and getting more use than you expected, you can upgrade to a better database without changing any of your code.

DBD modules are available for talking to nearly every type of SQL database on the market. DBD::Oracle will talk to Oracle, and DBD::Sybase will talk to Sybase. DBD::ODBC will talk to any ODBC database, including Microsoft Acesss. (ODBC is a Microsoft invention that is analogous to DBI itself. There is no DBD module for talking to Access directly.) DBD::CSV allows SQL queries on plain text files.

## UNDERSTANDING WHERE SCRIPTS RESIDE

CGI scripts reside in a directory called CGI-BIN on the Web server, though any directory may be used for this purpose if the proper permissions are set. Scripting files and the directories in which they reside require special permissions in order to run as an executable file. These permissions are read, write, and execute. Regardless of where your CGI scripts will reside, they must have these permissions to run and process input / output.

## DETERMINING THE CGI SCRIPT'S COST AND BENEFITS

When using CGI scripting over other technologies, it is paramount to weigh the cost versus benefits. While CGI has been the vehicle of choice for many over the last decade (mostly due to the dominance of Unix Web servers), using CGI for dynamic content has some downside.

CGI programs must run via some language, such as Perl or C, which means that the script is first run through an interpreter and therefore the system takes a performance hit. In recent years, this has been avoided by running homegrown, multithreaded C++ applications as the command interpreter with great success.

Another issue lies in that CGI is not typically part of the operating system and therefore may lack multithreading capabilities. This too can overload a system if too many requests are attempted against the system, resulting in a system overload.

Another important consideration is the use of C-based languages for writing scripts. Perl, Python, C, C++, and Java are all based on or around the C language, and you must have a

resource either internally or externally in order to write the CGI scripts for you. Most smaller organizations will not have this resource available.

On a more positive note, CGI technology is overcoming these hurdles and there are literally thousands of scripts available for free or a nominal charge that allow the use of shopping carts and e-commerce systems up to database access. As long as you understand how the technology works, you should be able to tune any script to your existing system.

## A Word on UNIX File Permissions

DOS has a limited utility for setting permissions on files: *ATTRIB*. Unix (being that it is a *true* multi-user, multitasking operating system) has a more sophisticated method of setting permissions: the *chmod* command. To understand it, consider the following small directory listing made with the *ls -l* command:

```
drwxrwxr-x    1 files      myserver    1018 Apr 30 23:45 mydir

 -rw-rw-r—    1 file       myserver   18755 Apr 30 23:37
mypic.gif

  -rwxrwxr-x  1 command    myserver   18525 May  4 02:48
mycommand
```

The permissions are indicated by a series of rwx's on the left side of the listing. The first position indicates the type of file. For the purposes of this book, it is always a - for a file, or a d for a directory.

The remaining nine characters indicate the permissions given to the owner, group, and others. Since owner and others both start with the letter O, think of owner as the *user*.

- *X* means execute permission—except for directories, where it means *search* permission.

- The first three permission characters are for the user (owner), the middle three are for the group, and the last three are for all other users on the system.

- *chmod 775 dirname* is the normal permission for a directory. drwxrwxr-x.

- *chmod 664 filename* is the normal permission for a non-executable file, such as an HTML or image file.

- *chmod 775 filename* is the normal permission for an executable file, such as a shell script. Usually these are not in your Web directory.

If you do not have telnet access that uses an FTP program such as Cute-FTP or WS-FTP, you will have to use the Unix command function of your program. Check the Help file with your FTP program for the exact instructions.

## GETTING READY TO USE CGI

The use of CGI in this book assumes that you are using a Unix-based system for hosting CGI scripts which will work with Linux, SCO, and so on. Therefore, you must understand the following things about Unix systems and CGI before beginning to use CGI scripting:

- Your main URL for CGI should be similar to *http://www.yourdomain.com/c/s.dll/*. If it is not, then you will need to find out from your administrator what it is and make the minor corrections to the script where needed.

- You need to know the Unix PATH to your CGI-bin directory, in other words, where to either *cd* or *FTP* to, to do your work. For example: */usr/dom/cgi-bin/*.

- PERL should be on your system since it is the primary scripting language for its ease of use and supportability. You will also need to know what directory it is in. To find out quickly, issue the following command at a command prompt:

```
Type Perl
```

The result on your system should be c:\*perl*. This is where it is on most systems. If it is different, make a note so you can change the first line of your script.

- Determine if your script should end with *.cgi*. If you are using a Web server at an ISP, clarify this with an administrator or support representative. If this is your own server, see the documentation for the server.

*Note*: If you are using FTP to transfer the program from your PC to a Unix server, make sure you use ASCII mode and NOT BINARY. DOS uses an extra character (CR/LF) to indicate end of line, where Unix only uses (LF). Using ASCII removes the extra character. If this is not done, your script most likely will fail to run.

After this checklist is completed, you should be ready to create CGI (Perl) scripts for your site.

## UNDERSTANDING THE CGI ENVIRONMENT VARIABLES

One method that the Web server uses to pass information to a CGI script is through environmental variables. These are created and assigned appropriate values within the environment that the server spawns for the CGI script. They can be accessed as any other environmental variable, such as with getenv() (in C) or %ENV{'VARIABLE_NAME'} (in Perl). Many of them contain important information that most CGI programs need to take into account.

Environment variables are a series of hidden values that the Web server sends to every CGI you run. Your CGI can parse them and use the data they send. Environment variables are stored in a hash called %ENV.

Some servers set other environment variables as well—check your server documentation for more information. Notice that some environment variables give information about your server, and will never change from CGI to CGI (such as SERVER_NAME and SERVER_ADMIN), while others give information about the visitor, and will be different every time someone accesses the script.

Not all environment variables get set for every CGI. REMOTE_USER is only set for pages in a directory or subdirectory that's password-protected via a *.htaccess* file. Even then, REMOTE_USER will be the username as it appears in the *.htaccess* file; it's not the user's e-mail address. There is no reliable way to get a user's e-mail address, short of asking him or her outright for it (with a form).

The %ENV hash is automatically set for every CGI, and you can use any or all of it as needed. For example, if you want to print out the URL of the page that called your CGI, you would type:

```
print "Caller = $ENV{'HTTP_REFERER'}\n";
```

## UNDERSTANDING THE AUTH_TYPE VARIABLE

The AUTH_TYPE variable is the string that identifies the type of user authentication being used by the browser for a request. If the AUTH_TYPE is set, the HTTP_AUTHORIZATION environment variable should also be set. This has the form auth_type: auth_data. The *auth_type* is the same as the AUTH_TYPE environment variable. The *auth_data* is the authorization type specific data.

## UNDERSTANDING THE CONTENT_LENGTH VARIABLE

The CONTENT_LENGTH variable holds the length, in bytes, of the input stream that is being passed through standard input.

This is needed when a script is processing input with the POST method in order to read the correct number of bytes from the standard input. Some servers end the input string with EOF, but this is not guaranteed behavior, so, to be sure that you read the correct input length, you can do something like:

```
read(STDIN,$input,$ENV{CONTENT_LENGTH})
```

## UNDERSTANDING THE CONTENT_TYPE VARIABLE

The CONTENT_TYPE variable is used to pass information about the MIME type of the document itself for queries, which have attached information, such as HTTP POST and PUT. This is the content type of the data.

## UNDERSTANDING THE GATEWAY_INTERFACE VARIABLE

The GATEWAY_INTERFACE variable returns the revision of the CGI specification to which this server complies. The format of the returned data is Format: CGI/revision.

## UNDERSTANDING THE PATH_INFO VARIABLE

The PATH_INFO variable is integral in providing extra path information following the script's path in the URL.

A URL that refers to a script may contain additional information, commonly called extra path information. This is appended to the URL and marked by a leading slash. The server

puts this information in the PATH_INFO variable, which can be used as a method to pass arguments to the script.

## UNDERSTANDING THE PATH_TRANSLATED VARIABLE

The PATH_TRANSLATED variable returns the PATH_INFO mapped onto DOCUMENT_ROOT.

Usually the PATH_INFO variable is used to pass a path argument to the script. For example, a counter might be passed on to the path the file where counts should be stored. The server also makes a mapping of the PATH_INFO variable onto the document root path and the store is in PATH_TRANSLATED which can be used directly as an absolute path/file.

## UNDERSTANDING THE QUERY_STRING VARIABLE

The QUERY_STRING variable contains query information passed via the calling URL, following a question mark after the script location.

QUERY_STRING is the equivalent of content passed through STDIN in POST, but for script called with the GET method. Query arguments are written in this variable in their URL-encoded form, just like they appear on the calling URL. You can process this string to extract useful parameters for the script.

## UNDERSTANDING THE REMOTE_ADDR VARIABLE

The REMOTE_ADDR variable holds the IP address from which the client is issuing the request. This can be useful either for logging accesses to the script (for example, a voting script might want to log voters in a file by their IP in order to prevent them from voting more than once) or to block/behave differently for particular IP addresses (this might be a requirement in a script that has to be restricted to your local network, and maybe perform different tasks for each known host).

## UNDERSTANDING THE REMOTE_HOST VARIABLE

The REMOTE_HOST variable carries the name of the host from which the client issues the request. This variable works just like the REMOTE_ADDR variable, only this is the host name of the remote machine if it is known or can be found via reverse DNS lookup.

## UNDERSTANDING THE REMOTE_IDENT VARIABLE

If the HTTP server supports RFC 931 identification, then the REMOTE_IDENT variable will be set to the remote user name retrieved from the server. Usage of this variable should be limited to logging only.

## UNDERSTANDING THE REQUEST_METHOD VARIABLE

The REQUEST_METHOD variable holds the method used for the request to the server which is usually one of three types: GET, POST, or HEAD.

It is wise to have your script check this variable before doing anything. You can determine where the input will be (STDIN for POST, QUERY_STRING for GET) or choose to permit operation only under one of the two methods. Also, it is a good idea to exit with an explanatory error message if the script is called from the command line accidentally, in which case the variable is not defined.

## UNDERSTANDING THE SCRIPT_NAME VARIABLE

The SCRIPT_NAME variable holds the virtual path from which the script is executed. Virtual paths are those defined by the Web server as a Web share and take the form / images/richard/....

Use of this variable is helpful if your script will output HTML code that contains calls to itself. Having the script determine its virtual path (and hence, along with DOCUMENT_ROOT, its full URL) is much more portable than hard coding it in a configuration variable (such as http://...). Also, if you prefer to keep a log of all script accesses in a file, and want to have each script report its name along with the calling parameters or time, it is portable to use SCRIPT_NAME to print the path of the script.

## UNDERSTANDING THE *SERVER_NAME* VARIABLE

The SERVER_NAME variable holds the Web server's host name or IP address, that is, the server that is hosting the CGI.

Like SCRIPT_NAME, this value can be used to create more portable scripts in case they need to assemble URLs on the local machine. In scripts that are made publicly accessible on a system with many virtual hosts, this can provide the ability to have different behaviors, depending on the virtual server that's calling the script.

## UNDERSTANDING THE *SERVER_PORT* VARIABLE

The SERVER_PORT variable returns the Web server's listening port, typically port 80, for WWW services, but can be almost any number between 0-65,000.

This variable complements SERVER_NAME, in forming URLs to the local system. A commonly overlooked aspect, but it will make your script portable if you keep in mind that not all servers run on the default port and thus need explicit port reference in the server address part of the URL.

## UNDERSTANDING THE *HTTP_ACCEPT* VARIABLE

The MIME types which the client will accept, as given by HTTP headers. Other protocols may need to get this information elsewhere. Each item in this list should be separated by commas, per the HTTP spec.

## UNDERSTANDING THE HTTP_USER_AGENT VARIABLE

The HTTP_USER_AGENT variable is used quite extensively and returns the name/version of the client issuing the request to the script, in the case of Web communication, typically a Web browser.

As with referrers, you might need to implement behaviors that vary with the client software used to call the script. A redirection script could make use of this information to point the client to a page optimized for a specific browser, or you may want to have it block requests from specific clients, like robots or clients that are known not to support appropriate features used by what the script would normally output.

## USING PERL FOR CGI SCRIPTING

If you have read through this book or skipped ahead you probably are already familiar with HTML, thus you know that certain things are necessary in the structure of an HTML document, such as the <HEAD> and <BODY> tags, and that other tags like links and images have a certain allowed syntax. Perl is very similar. It has a clearly defined syntax, and if you follow its syntax rules, you can write Perl as easily as you do HTML.

If you're creating scripts on Unix, you'll need one statement as the first line of every script, telling the server that this is a Perl script, and where to find the Perl interpreter. In most scripts, the statement will look like this:

```
#!/usr/bin/perl
```

For now, there should generally not be anything else on the same line with this statement. (There are some flags you can use there, which will be discussed later.) If you aren't sure where Perl lives on your system, try typing these commands:

```
which perl     OR     whereis perl
```

If the system can find it, it will tell you the path name to Perl. That path is what you should put in the above statement.

Next, you will write your Perl code. Most lines of Perl code must end in a semicolon (;), except the opening and closing lines of loops and conditional blocks.

Let's write a simple first program. Enter the following lines into a new file, and name it "test.pl".

```
#!/usr/bin/perl

print "Hello, world!\n";
```

## YOUR FIRST CGI PROGRAM

Many CGI programs are written in Perl, a programming language suited to manipulating text and files. Let's look at a very simple Perl CGI program line-by-line to get a little feel of perl, CGI, and so forth. First take a look at the figure below. This program will read input from an HTML form and look something like this:

This program will return what you typed in each field to an HTML output page. Now to begin.

This is the first line of the Perl program:

```
#!/usr/bin/perl
```

It tells the computer where the Perl interpreter is located. Every instruction that follows will be shoved into the interpreter, causing it to perform accordingly.

```
print "Content-type: text/html\n\n";
```

This tells whatever Web browser is accessing this program to get ready for some HTML, so it can display something instead of acting like a blank screen saver. (Note: I prefer Netscape's blank screen to Explorer's blank screen.)

```
read(STDIN,$input,$ENV{'CONTENT_LENGTH'})
```

"STDIN" is short for "standard input". Just like you have a mouth as standard input for food, as opposed to your nose or something more imaginative, programs have a standard input to shove in information. So, the Web server shoves information from an HTML form into this standard input, the program reads the amount of info (stored in a special variable called $ENV{'CONTENT_TYPE'}) and copies it to "$input". All simple variables in Perl start with a dollar sign.

```
foreach (split(/&/, $input))

{
```

```
    ($NAME, $VALUE) = split(/=/, $_);

    $NAME =~ s/\+/ /g;

    $NAME =~ s/%([0-9|A-F]{2})/pack(C,hex($1))/eg;

    $VALUE =~ s/\+/ /g;

    $VALUE =~ s/%([0-9|A-F]{2})/pack(C,hex($1))/eg;

    print "$NAME : $VALUE <BR>\n";

}
```

This section digests the information from an HTML form. Each input field in the form has a NAME. For example, the HTML for the input field above is:

```
<INPUT NAME="yourinput">
```

This assigns a particular name to the field in order to call that field data later. Thus, if you type Repeat my words! into the input box, the Web server will package it up, according to the rules of CGI, into a single continuous line containing the name and value you typed:

```
yourinput=Repeat+my+words%3F
```

The name of the input field comes first, followed by an equal sign and its value. Also, notice how the spaces have been replaced by plus signs, and the question mark has been replaced by %3F. This is not some obscure code—it's the world-famous ASCII code. Non-alphanumeric characters are replaced by a percent sign followed by their ASCII value. The question mark is number 63 on the ASCII table. In hexadecimal numbers, that's 3F.

If there were two input fields, they would be packaged up into one gigantic line separated by an ampersand. For example:

```
yourinput=How+do+you+pronounce+meep%3F&yourinput2=
who+put+all+those+things+in+your+head
```

Here is the code:

```
foreach (split(/&/, $input))

{
```

```
        ($NAME, $VALUE) = split(/=/, $_);

        $NAME =~ s/\+/ /g;

        $NAME =~ s/%([0-9|A-F]{2})/pack(C,hex($1))/eg;

        $VALUE =~ s/\+/ /g;

        $VALUE =~ s/%([0-9|A-F]{2})/pack(C,hex($1))/eg;

        print "$NAME : $VALUE <BR>\n";

    }
```

splits the input along the ampersands. Then, you end up with separate name=value elements. For each element, you split again, this time along the equal signs. During the second split, the text before the equal sign is assigned to the variable $NAME, and the data after is assigned to $VALUE.

For both "$NAME" and "$VALUE", you will use text manipulation—all plus signs are substitued with spaces, and anything that matches the pattern %xx is replaced by the character whose ASCII value is xx.

Finally, it prints out the name stored in $NAME, and the value stored in $VALUE:

## USING CGI TO PROCESS FORMS

Most forms you create will send their data using the POST method. POST is more secure than GET, since the data isn't sent as part of the URL, and you can send more data with POST. Also, your browser, Web server, or proxy server may cache GET queries, but posted data is sent each time. However, since data posted via most forms is often more complex than a single word or two, decoding posted data requires more work.

Your Web server, when sending form data to your CGI, encodes the data being sent. Alphanumeric characters are sent as themselves. Spaces are converted to plus signs (+). Other characters—like tabs, quotes, and so on—are converted to %HH (a percent sign and two hexadecimal digits representing the ASCII code of the character). This is called URL encoding. The following table lists some commonly encoded characters:

| Normal Character | URL Encoded String |
|---|---|
| \t (tab) | %09 |
| \n (return) | %0A |
| / | %2F |
| ~ | %7E |
| : | %3A |
| ; | %3B |
| @ | %40 |
| & | %26 |

To do anything useful with the data, your CGI must decode these. Fortunately, this is easy to do in Perl, using the *substitute* and *translate* commands. Perl has powerful pattern matching and replacement capabilities; it can match the most complex patterns in a string, using regular expressions but it's also capable of the simplest replacements. The basic syntax for substitutions is:

```
$mystring =~ s/pattern/replacement/;
```

This command substitutes pattern for replacement in the scalar variable $mystring. Notice the operator is a =~ (an equal sign followed by a tilde)—this is a special operator for Perl, telling it that it's about to do a pattern match or replacement. The following example shows how the demonstrator works:

```
$greetings = "Hello. My name is xnamex.\n";

$greetings =~ s/xnamex/Bob/;

print $greetings;
```

The above code will print out Hello. My name is Bob. Notice the substitution has replaced xnamex with Bob in the $greetings string.

A similar but slightly different command is the translate command:

```
$mystring =~ tr/searchlist/replacementlist/;
```

This command translates every character in searchlist to its corresponding character in replacementlist, for the entire value of $mystring. One common use of this is to change the case of all characters in a string:

```
$lowerc =~ tr/[A-Z]/[a-z]/;
```

This results in $lowerc being translated to all lowercase letters. The brackets around [A-Z] denote a class of characters to match.

With the POST method, form data is sent in an input stream from the server to your CGI. To get this data, store it, and decode it, you will use the following block of code:

```
read(STDIN, $buffer, $ENV{'CONTENT_LENGTH'});

@pairs = split(/&/, $buffer);

foreach $pair (@pairs) {

    ($name, $value) = split(/=/, $pair);

    $value =~ tr/+/ /;

    $value =~ s/%([a-fA-F0-9][a-fA-F0-9])/pack("C", hex($1))/eg;

    $FORM{$name} = $value;

}
```

You will read the input stream using this line:

```
read(STDIN, $buffer, $ENV{'CONTENT_LENGTH'});
```

The input stream is coming in over STDIN (standard input), and you are using Perl's read function to store the data into the scalar variable $buffer. You'll also notice the third argument to the read function, which specifies the length of data to be read; you want to read to the end of the CONTENT_LENGTH, which is set as an environment variable by the server.

To split the buffer into an array of pairs, enter the following code:

```
@pairs = split(/&/, $buffer);
```

As with the GET method, form data pairs are separated by & signs when they are transmitted, such as fname=joe&lname=smith. Next, you will use a foreach loop to further splits each pair on the equal signs:

```
foreach $pair (@pairs) {

    ($name, $value) = split(/=/, $pair);
```

The next line translates every "+" sign back to a space:

```
$value =~ tr/+/ /;
```

Next is a complicated regular expression that substitutes every %HH hex pair back to its equivalent ASCII character, using the pack() function. You will learn how this works later, but for now, you will use it to parse the form data:

```
$value =~ s/%([a-fA-F0-9][a-fA-F0-9])/pack("C", hex($1))
/eg;
```

Finally, you will store the values into a hash called %FORM:

```
$FORM{$name} = $value;

}
```

The keys of %FORM are the form input names themselves. For example, if you have three text fields in the form—called name, e-mail-address, and age—you could refer to them in your script by using $FORM{'name'}, $FORM{'email-address'}, and $FORM{'age'}.

Start a new CGI, and name it post.cgi. Enter the following code, save it, and *chmod* it:

```
#!/usr/bin/perl

print "Content-type:text/html\n\n";

read(STDIN, $buffer, $ENV{'CONTENT_LENGTH'});

@pairs = split(/&/, $buffer);

foreach $pair (@pairs) {

    ($name, $value) = split(/=/, $pair);

    $value =~ tr/+/ /;

    $value =~ s/%([a-fA-F0-9][a-fA-F0-9])/pack("C", hex($1))/
eg;
```

```
        $FORM{$name} = $value;

}

print "<html><head><title>Form Output</title></head><body>";

print "<h2>Results from FORM post</h2>\n";

foreach $key (keys(%FORM)) {

    print "$key = $FORM{$key}<br>";

}

print "</body></html>";
```

## Using Command Lines with CGI

A CGI program can receive input through its command line. You can send it in a similar way the GET method sends data, that is, you append a question mark (?) followed by whatever text you want to send. A URL with a command line may look like:

```
http://www.myWeb.com/cgi-bin/c?Hello
```

You can pass as many command line parameters as will fit on the URL. It works exactly like the GET method. You will probably notice that CGI passed the parameter not only on the command line, but also in the QUERY_STRING environment variable. Just as before, your data should be URL-encoded. That is, you need to convert the spaces into plusses, and the non-alphanumeric ASCII codes into %xx, as shown in the following example:

```
http://www.myWeb.com/cgi-bin/c?Hello+World%21
```

Using plusses, will split the command line into separate *argv* arguments. To keep several words together as one argument, replace the plusses with %20, as shown in the following example:

```
http://www.myWeb.com/cgi-bin/c?Hello%20World%21+
Here%20I%20come%21
```

## UNDERSTANDING SERVER SIDE INCLUDES

Server Side Includes (SSI's) are commands that you give to your Web server by placing them inside your HTML code You can include a standard copyright disclaimer at the bottom of every page of your Web site, and if you need to change it, you only have to change it once.

When a browser requests a file from your Web server, the server can be made to look for Server Side Includes within HTML files and execute them. The SSI programs provided below are programs which are run via the exec SSI command. The SSI command within your HTML code will be replaced by the results of the SSI program. (Even if you use the View Source function of your Web browser, the SSI will look like it was actually part of the page!)

SSI's are very powerful. They're better than Java for the functions they perform, since everyone cannot use Java, but anyone capable of downloading an HTML page will see the results of a Server Side Include.

## USES FOR SERVER SIDE INCLUDES

The functions you can perform with Server Side Includes range from simple counters and current time displays on your page to rotating banners and the ability to show different content, depending on the type of browser someone's using, or where they came from.

While standard HTML files are fine for storing pages, it is very useful to be able to create some content dynamically. For example, you night want to add a footer or header to all files, or to insert document information such as last modified times automatically. This can be done with CGI, but that can be complex and requires programming or scripting skills. For simple dynamic documents, there is an alternative: server-side-includes (SSI).

SSI lets you embed a number of special commands into the HTML itself. When the server reads an SSI document, it looks for these commands and performs the necessary action. For example, one SSI command inserts the document's last modification time. When the server reads a file with this command in, it replaces the command with the appropriate time. Other uses include date insertion, page changed date insertion, and any of the typical variable types that might be used in CGI scripting, all of which is transparent to the user as if it was hard-coded into the page.

## CREATING AND USING SERVER SIDE INCLUDES

If you have access to an Apache style server, ask your administrator if SSIs are enabled. They are disabled by default. Due to the differences in server configurations, the commands described in this section may not work on your server. Contact your Web Server administrator for the exact commands used on your server.

All SSI commands are stored within the HTML in HTML comments. A typical SSI command looks like this:

```
<!-#flastmod file="this.html" ->
```

In this case, the command is **flastmod**, which means output the last modified time of the file given. The arguments specify the file this.html (which might be the name of the file containing this command). The whole of the command text, including the comment marker <!— and —>, will be replaced with the result of this command.

In general, all commands take the following format:

```
<!-#command arg1="value1 arg2="value2 ... ->
```

where arg1, arg2, and so on, are the names of the arguments and value1, value2, and so on, are the values of those arguments. In the flastmod example, the argument is file and its value is this.html. Commands can often take different argument names. For example, flastmod can be given a URL with the argument virtual, to get the last modified time from the server. For example, use:

```
<!-#flastmod virtual="/" ->
```

to get the last modification time of the home page on the server (this is useful, for example, if the page being accessed might have a different file name).

Besides flastmod, there are SSI commands which get the size of a file or URL, the contents of a variable (passed in by the server), the contents of another file or URL, or the result of running a local file.

When SSI commands are executed, a number of environment variables are set. These variables include the CGI variables (REMOTE_HOST etc), and others, such as DOCUMENT_NAME and LAST_MODIFIED. These can be output with the echo command so a better way of getting the last modification time of the current file would be:

```
<!-#echo var="LAST_MODIFIED" ->).
```

HTML page samples incorporating SSI include,:

## Example 1: A Simple Server Side Include

```
<HTML>
<HEAD>
<TITLE>Server Side Includes HTML Sample</TITLE>
</HEAD>

Example of a server side include inserting a block of text
onto a Web
page:

<!-#include  virtual="directory/insertpage1.html"->

</BODY>
</HTML>
```

## Example 2: Using SSI and CGI

```
<HTML>
<HEAD><
TITLE>Server Side Includes CGI Sample</TITLE>
</HEAD>
<BODY>

Example of a server side include inserted a script on a Web
page:

<!-#exec cmd="cgi/myscript.cgi"->

</BODY>
</HTML>
```

The first example prints the first line of text (Example of a ...) and adds the text or HTML in the insertpage1.html file to the page. This is completely transparent to the client.

The second sample prints the first line of text (Example of a ...), then embeds whatever process executed from the myscript.cgi script to the page. This is also transparent to the client.

Server Side Includes can be tremendous time savers in a large Web project. Consider the amount of time saved if every page on your 1,000 page Web Site had the same footer and you needed to modify a graphic in that footer. Normally, you would have to go into each

page to the do the modification (that is, if you are not using an elaborate HTML publishing program). Using SSI, you simply have to change one HTML file and all of the pages on your site are instantaneously changed.

Although SSIs are easy to set up, they do have some drawbacks. For example, many Web servers require you to name your pages with the *.shtml* extension. First, many Web servers require you to name your pages with the *.shtml* extension. Next, some security issues are involved in the exec cmd call, thus some servers have script execution turned off. Lastly, extensive use of SSIs can affect server performance.

There are additional advantages to using SSIs. SSIs have some fairly advanced functions, such as browser detection, CGI environment variables display, and more. For Apache Servers, there is an Extended SSI module (XSSI). This SSI enhancement allows for if-then-else statements, user-defined variables, and other commands similar to those used in CGI/PERL scripts.

## INTRODUCING XML

XML stands for **Extensible Markup Language**. XML is a system for defining, validating, and sharing document formats. XML uses custom developed **tags**, for example:

```
<em>emphasis</em> for emphasis
```

to distinguish document structures, and **attributes** (for example, in **<A HREF="http://www.URL.com/">**, HREF is the *attribute name*, and **http://www.url.com/** is the *attribute value*) used to encode extra document information. XML will look familiar if you know about SGML and HTML.

XML has been carefully designed with the goal that every valid XML document should also be an SGML document. There are some areas of difference between XML and SGML (which are discussed later), but these are minor, should not cause practical problems, and will hopefully reconcile with SGML in the near future.

XML is not the same as HTML. An XML processor can read clean, valid HTML, and with a few small changes, an HTML browser, like Netscape Navigator or Microsoft Internet Explorer, can read XML. The biggest difference between XML and HTML is that in XML, you can define your own tags for your own purposes, and if you want, share those tags with other users. XML is not a single, predefined markup language: it's a metalanguage—a language for describing other languages—which lets you design your own markup. (A predefined markup language like HTML defines a way to describe information in one specific class of documents. XML lets you define your own customized markup languages for different classes of

document.) It can do this because it is written in SGML, the international standard metalanguage for markup.

## UNDERSTANDING HOW XML WORKS

XML documents are made up of storage units called *entities*, which contain either parsed or unparsed data. Parsed data is made up of *characters*, some of which form the *character data* in the document, and some of which form *markup*. Markup encodes a description of the document's storage layout and logical structure. XML provides a mechanism to impose constraints on the storage layout and logical structure. A software module called an XML processor is used to read XML documents and provide access to their content and structure. It is assumed that an XML processor is doing its work on behalf of another module, called the application.

## DIFFERENCES BETWEEN XML AND HTML / SGML

In considering the differences between HTML and XML, remember the following:

- XML is not a replacement for HTML.
- XML and HTML were designed with different goals.
- XML was designed to describe data and to focus on what data is.
- HTML was designed to display data and to focus on how data looks.
- HTML displays information, XML describes information.

When comparing XML to SGML, the main differences include:

- XML's white space handling rules are much less elaborate than those of SGML. One effect is that in a few, rarely-encountered cases, an XML processor will pass through a some white space (mostly line-ends) that an SGML processor will suppress. It is unlikely that an XML author or user will ever notice this.
- XML defines, for documents, the property of being *well-formed*; this does not correspond to any SGML concept.

- XML has a specific built-in method for handling international (non-ASCII) text. It is compatible with SGML, but at this writing, few SGML processors are properly internationalized.

## THE STRUCTURE OF AN XML DOCUMENT

The basic structure of an XML document is similar to most other applications of SGML, including HTML. XML documents can be simple, with no document type declaration, and straightforward nested markup of your own design:

```
<?xml version="1.0" standalone="yes"?>

<conversation>

  <greeting>Hello, world!</greeting>

  <response>Stop the planet, I want to get off!</response>

</conversation>
```

They can be more complicated, with a DTD specified, and maybe an internal subset, and a more complex structure, as shown below:

```
<?xml version="1.0" standalone="no" encoding="UTF-8"?>

<!DOCTYPE titlepage SYSTEM "http://www.myurl.com/dtds/typo.dtd"

[<!ENTITY % active.links "INCLUDE">]>

<titlepage>

  <white-space type="vertical" amount="36"/>

  <title font="Baskerville" size="24/30"

        alignment="centered">Hello, world!</title>

  <white-space type="vertical" amount="12"/>

  <!- In some copies the following decoration is
```

```
        hand-colored, presumably by the author ->

   <image location="http://www.foo.bar/image.eps" type="URL"
alignment="centered"/>

   <white-space type="vertical" amount="24"/>

   <author font="Baskerville" size="18/22" style="italic">Domos
Tomonus</author>

</titlepage>
```

They can also be anywhere in between. Whether an XML document is simple, complicated, or in between, will depend on how you want to define your document type (or whose you use) and what it will be used for. Several factors may stand out between the foregoing examples:

- The documents begin with a processing instruction: <?xml ...?>. This is the *XML declaration*. While it is not required, its presence explicitly identifies the document as an XML document and indicates the version of XML to which it was authored.

- There is no document type declaration. Unlike SGML, XML does not require a document type declaration. However, a document type declaration can be supplied, and some documents will require one in order to be understood unambiguously.

- Empty elements have a modified syntax. While most elements in a document are wrappers around some content, empty elements are simply markers where something occurs (for example, a horizontal rule for HTML's <hr> tag,. The trailing /> in the modified syntax indicates to a program processing the XML document that the element is empty and no matching end-tag should be sought. Since XML documents do not require a document type declaration, without this clue it could be impossible for an XML parser to determine which tags were intentionally empty and which had been left empty by mistake. XML has softened the distinction between elements which are declared as EMPTY and elements which merely have no content. In XML, it is legal to use the empty-element tag syntax in either case. It's also legal to use a start-tag/end-tag pair for empty elements: <applause></applause>. If interoperability is of any concern, it's best to reserve empty-element tag syntax for elements which

are declared as EMPTY and to only use the empty-element tag form for those elements.

XML documents are composed of markup and content. There are six kinds of markup that can occur in an XML document:

- elements
- entity references
- comments
- processing instructions
- marked sections
- document type declarations

## THE MOST COMMON MARKUPS OF THE XML DOM

Elements are the most common form of markup. Delimited by angle brackets, most elements identify the nature of the content they surround. Some elements may be empty, as seen above, in which case they have no content. If an element is not empty, it begins with a start-tag, <element>, and ends with an end-tag, </element>.

Attributes are name-value pairs that occur inside start-tags after the element name. For example,

```
<div class="preface">
```

is a div element with the attribute class having the value preface. In XML, all attribute values must be quoted.

To introduce markup into a document, some characters have been reserved to identify the start of markup. The left angle bracket, < , for example, identifies the beginning of an element start- or end-tag. To insert these characters into your document as content, there must be an alternative way to represent them. In XML, entities are used to represent these special characters. Entities are also used to refer to often repeated or varying text and to include the content of external files.

Every entity must have a unique name. Defining your own entity names is discussed in the section on entity declarations. To use an entity, you simply reference it by name. Entity references begin with an ampersand and end with a semicolon.

For example, the lt entity inserts a literal < into a document. Thus, the string <element> can be represented in an XML document as &lt;element>.

A special form of entity reference, called a character reference, can be used to insert arbitrary Unicode characters into your document. This is a mechanism for inserting characters that cannot be typed directly on your keyboard.

Character references take one of two forms: decimal references, &#8478;, and hexadecimal references, &#x211E;. Both of these refer to character number U+211E from Unicode (which is the standard Rx prescription symbol).

Comments begin with < ! − and end with −>. Comments can contain any data except the literal string −. You can place comments between markup anywhere in your document.

Comments are not part of the textual content of an XML document. An XML processor is not required to pass them along to an application.

Processing instructions (PIs) are an escape hatch to provide information to an application. Like comments, they are not textually part of the XML document, but the XML processor is required to pass them to an application.

Processing instructions have the form <?name pidata?>. The name, called the PI target, identifies the PI to the application. Applications should process only the targets they recognize and ignore all other PIs. Any data that follows the PI target is optional, it is for the application that recognizes the target. The names used in PIs may be declared as notations in order to formally identify them.

PI names beginning with xml are reserved for XML standardization.

## CDATA Sections

In a document, a CDATA section instructs the parser to ignore most markup characters.

Consider a source code listing in an XML document. It might contain characters that the XML parser would ordinarily recognize as markup (for example, < and &). To prevent this, a CDATA section can be used:

```
<![CDATA[

*p = &q;

b = (i <= 3);

]]>
```

Between the start of the section, <![CDATA[ and the end of the section, ]]>, all character data is passed directly to the application, without interpretation. Elements, entity references, comments, and processing instructions are all unrecognized and the characters that comprise them are passed literally to the application.

The only string that cannot occur in a CDATA section is ]]>.

## XML SYNTAX

Take a look at the following XML document:

```
<?xml version="1.0"?>

<note>

<to>Rick</to>

<from>Bob</from>

<heading>Notice</heading>

<body>Don't forget about this weekend!</body>

</note>
```

The first line in the document, the XML declaration, should always be included. It defines the XML version of the document. In this case, the document conforms to the 1.0 specification of XML. The next line defines the first element of the document (the root element). The next lines define 4 child elements of the root (to, from, heading, and body). The last line defines the end of the root element.

You must adhere to certain rules when creating an XML document. First, unlike HTML, XML elements must have a closing tag or a tag pair for every element. In HTML, singular tags are allowed, such as the paragraph <p> or break <br> tags.

Another important rule to remember is that tags are case sensitive. Opening and closing tags must therefore be written with the same case, as shown in the following example:

```
<Message>This is incorrect</message>

<message>This is correct</message>
```

XML elements can have attributes in name/value pairs just like in HTML. In XML, the attribute value must always be quoted. Study the two XML documents shown below. The first one is incorrect, the second is correct:

**Example 1:**

```
<?xml version="1.0"?>

<note date=12/11/99>

<to>Tove</to>

<from>Jani</from>

<heading>Reminder</heading>

<body>Don't forget me this weekend!</body>

</note>
```

Example 2:

```
<?xml version="1.0"?>

<note date="12/11/99">

<to>Tove</to>

<from>Jani</from>

<heading>Reminder</heading>

<body>Don't forget me this weekend!</body>

</note>
```

## ELEMENTS VERSUS ATTRIBUTES

XML attributes are normally used to describe XML elements, or to provide additional information about elements. From HTML, you can remember this construct: <IMG SRC="some.gif">. In this HTML example, SRC is an attribute to the IMG element. The SRC attribute provides additional information about the element.

Attributes are always contained within the start tag of an element, as shown in the following examples:

HTML examples:

```
<img src="some.gif">

<a href="examples.asp">
```

XML examples:

```
<file type="gif">

<account id="3344">
```

Attributes are normally used to provide information that is not a part of the content of the XML document. To be more clear, attribute data is often more important to the XML parser than to the reader. In the example above, the account id is a counter value that is irrelevant to the reader, but important to software that wants to manipulate the account element. Consider the following examples:

Using an Attribute for martial status:

```
<person mstatus="married">

  <firstname>Ann</firstname>

  <lastname>Smith</lastname>

</person>
```

Using an Element for marital status:

```
<person>

  <mstatus>female</mstatus>

  <firstname>Ann</firstname>

  <lastname>Smith</lastname>

</person>
```

In the first example, martial status is an attribute. In the last example, martial status is an element. Both examples provide the same information to the reader. There are no fixed rules about when to use attributes to describe data, and when to use elements, however, attributes

are handy in HTML, but in XML you should try to avoid them, as long as the same information can be expressed using elements.

The following XML documents demonstrate how elements can be used instead of attributes. These documents contain the same information. A date attribute is used in the first, a date element is used in the second, and an expanded date element is used in the third:

```
<?xml version="1.0"?>

<note date="1/1/00">

<to>Rick</to>

<from>Bob</from>

<heading>Notice</heading>

<body>Don't forget about this weekend!</body>

</note>

<?xml version="1.0"?>

<note>

<date>1/1/00</date>

<to>Rick</to>

<from>Bob</from>

<heading>Notice</heading>

<body>Don't forget about this weekend!</body>

</note>

<?xml version="1.0"?>

<note>

<date>
```

```
    <day>1</day>

    <month>11</month>

    <year>00</year>

  </date>

  <to>Rick</to>

  <from>Bob</from>

  <heading>Reminder</heading>

  <body>Don't forget about this weekend!</body>

  </note>
```

The following list shows some of the problems using attributes:

- attributes cannot contain multiple values (elements can)
- attributes are not expandable (for future changes)
- attributes cannot describe structures (like child elements can)
- attributes are more difficult to manipulate by program code
- attribute values are not easy to test against a DTD

If you start using attributes as containers for XML data, you might end up with documents that are both difficult to maintain and manipulate. In other words, you should use elements to describe your data. Use attributes only to provide information that is not relevant to the reader. Try to avoid this:

```
  <?xml version="1.0"?>

  <note day="1" month="1" year="00"

  to="Rick" from="Bob" heading="Notice">

  body="Don't forget about this weekend!">

  </note>
```

Of course, there are always exceptions to any rule. Sometimes assigning ID references to elements in XML documents can help to define the element. These ID references can be used

to access XML elements in much the same way as the NAME or ID attributes in HTML, as shown in the following example:

```
<?xml version="1.0"?>

<messages>

  <note ID="501">

    <to>Rick</to>

    <from>Bob</from>

    <heading>Notice</heading>

    <body>Don't forget about this weekend!</body>

  </note>

  <note ID="502">

    <to>Bob</to>

    <from>Rick</from>

    <heading>Re: Notice</heading>

    <body>You Bet!</body>

  </note>

</messages>
```

The ID in these examples is a counter, or a unique identifier, to identify the different notes in the XML file.

## INTERNET BROWSER ISSUES

The supportability of the two major browsers on the market today, Netscape Navigator and Internet Explorer, will be addresses in the following sections.

### XML in Netscape Navigator 5

Netscape has promised full XML support in its new Navigator 5 browser. Your option at the moment—if you want to work with Netscape and XML—is to work with XML on your server and transform your XML to HTML before it is sent to the browser. You can read more about transforming XML to HTML in the section on XSL.

### XML in Internet Explorer 5

Internet Explorer 5 fully supports the international standards for both XML 1.0 and the XML Document Object Model (DOM). The World Wide Web Consortium (W3C) sets these standards. Internet Explorer 5.0 has the following XML support:

- Viewing of XML documents
- Full support for W3C DTD standards
- XML embedded in HTML as Data Islands
- Binding XML data to HTML elements
- Formatting XML with XSL
- Formatting XML with CSS
- Support for CSS Behaviors
- Access to the XML DOM

## UNDERSTANDING MORE ABOUT DOCUMENT TYPE DECLARATIONS

It is important to note that full SGML uses a Document Type Definition (DTD) to describe the markup (elements) available in any specific type of document. However, the design and construction of a DTD can be a complex task, so XML has been designed so it can be used either with or without a DTD. DTDless operation means you can invent markup without having to define it formally, with the penalty of losing automated control over the structuring of additional documents of the same type.

To make this work, a DTDless file, in effect, defines its own markup informally by the simple existence and location of elements where you create them. However, when an XML application, such as a browser, encounters a DTDless file, it needs to be able to understand the document structure *while it reads it*, because it has no DTD to tell it what to expect, so some changes have been made to the rules. For example, HTML's <IMG> element is defined as empty, that is, it doesn't have an end-tag. An XML application reading a file *without a DTD*

and encountering <IMG> would have no way to know whether or not to expect an end-tag, so the concept of well-formed files has become necessary. This makes the start and end of every element, and the occurrence of empty elements completely unambiguous.

## Document Type Declarations

A large percentage of the XML specification deals with various sorts of declarations that are allowed in XML. If you have experience with SGML, you will recognize these declarations from SGML DTDs (Document Type Definitions). If you have never seen them before, their significance may not be immediately obvious.

One of the greatest strengths of XML is that it lets you create your own tag names. But for any given application, it is probably not meaningful for tags to occur in a completely arbitrary order. Consider the following example:

```
<gracie><quote><oldjoke>Goodnight,

<applause/>Gracie</oldjoke></quote>

<burns><gracie>Say  <quote>goodnight</quote>,

</gracie>Gracie.</burns></gracie>
```

This document is so far outside the bounds of what you normally expect that it's nonsensical. It doesn't mean anything. However, from a syntactic point of view, there's nothing wrong with this XML document. If the document is to have meaning, and if you're writing a stylesheet or application to process it, there must be some constraint on the sequence and nesting of tags. Constraints can be expressed in declarations.

More generally, declarations let a document communicate meta-information to the parser about its content. Meta-information includes the allowed sequence and nesting of tags, attribute values and their types and defaults, the names of external files that may be referenced and whether or not they contain XML, the formats of some external (non-XML) data that may be referenced, and the entities that may be encountered.

The four kinds of declarations in XML are: element type declarations, attribute list declarations, entity declarations, and notation declarations.

### Do I need a Document Type Declaration?

As you have learned, XML content can be processed without a document type declaration. However, there are some instances where the declaration is required:

- Authoring Environments

  Most authoring environments need to read and process document type declarations in order to understand and enforce the content models of the document.

- Default Attribute Values

  If an XML document relies on default attribute values, at least part of the declaration must be processed in order to obtain the correct default values.

- White Space Handling

  The semantics associated with white space in element content differs from the semantics associated with white space in mixed content. Without a DTD, there is no way for the processor to distinguish between these cases, and all elements are effectively mixed content. For more detail, see the section called *White Space Handling*, later in this book.

In applications where a user composes or edits the data (as opposed to data that may be generated directly from a database, for example), a DTD will probably be required if any structure is to be guaranteed.

### Including a Document Type Declaration

If present, the document type declaration must be the first thing in a document after optional processing instructions and comments.

The document type declaration identifies the root element of the document and may contain additional declarations. All XML documents must have a single root element that contains all of the content of the document. Additional declarations may come from an external DTD, called the external subset, or be included directly in the document, the internal subset, or both:

```
<?XML version="1.0" standalone="no"?>

<!DOCTYPE chapter SYSTEM "dbook.dtd" [
```

```
<!ENTITY %ulink.module "IGNORE">

<!ELEMENT ulink (#PCDATA)*>

<!ATTLIST ulink

   xml:link        CDATA   #FIXED "SIMPLE"

   xml-attributes CDATA   #FIXED "HREF URL"

   URL             CDATA   #REQUIRED>

]>

<chapter>...</chapter>
```

This example references an external DTD, dbook.dtd, and includes element and attribute declarations for the ulink element in the internal subset. In this case, ulink is being given the semantics of a simple link from the XLink specification.

Note that declarations in the internal subset override declarations in the external subset. The XML processor reads the internal subset before the external subset and the *first* declaration takes precedence.

To determine if a document is valid, the XML processor must read the entire document type declaration (both internal and external subsets). However, for some applications, validity may not be required, and it may be sufficient for the processor to read only the internal subset. In the example above, if validity is unimportant and the only reason to read the doctype declaration is to identify the semantics of ulink, reading the external subset is not necessary.

You can communicate this information in the *standalone document declaration*. The standalone document declaration, standalone="yes" or standalone="no", occurs in the XML declaration. A value of yes indicates that only internal declarations need to be processed. A value of no indicates that both the internal and external declarations must be processed.

### Element Type Declarations

Element type declarations identify the names of elements and the nature of their content. A typical element type declaration looks like this:

```
<!ELEMENT example (burns+, allen, applause?)>
```

This declaration identifies the element named example. Its *content model* follows the element name. The content model defines what an element may contain. In this case, an old joke must contain burns and allen and may contain applause. The commas between element names indicate that they must occur in succession. The plus after burns indicates that it may be repeated more than once but must occur at least once. The question mark after applause indicates that it is optional (it may be absent, or it may occur exactly once). A name with no punctuation, such as allen, must occur exactly once.

Declarations for burns, allen, applause, and all other elements used in any content model must also be present for an XML processor to check the validity of a document.

In addition to element names, the special symbol #PCDATA is reserved to indicate character data. The moniker PCDATA stands for parseable character data.

Elements that contain only other elements are said to have *element content*. Elements that contain both other elements and #PCDATA are said to have *mixed content*.

For example, the definition for BURNS might be:

```
<!ELEMENT BURNS (#PCDATA | quote)*>
```

The vertical bar indicates an or relationship, and the asterisk indicates that the content is optional (may occur zero or more times); therefore, by this definition, burns may contain zero or more characters and quote tags, mixed in any order. All mixed content models must have the following form: #PCDATA must come first, all of the elements must be separated by vertical bars, and the entire group must be optional.

Two other content models are possible: EMPTY indicates that the element has no content (and consequently no end-tag), and ANY indicates that *any* content is allowed. The ANY content model is sometimes useful during document conversion, but should be avoided at almost any cost in a production environment because it disables all content checking in that element.

The following is a complete set of element declarations for Example 1:

## Example 2. Element Declarations for Old Jokes

```
<!ELEMENT oldjoke   (burns+, allen, applause?)>

<!ELEMENT burns     (#PCDATA | quote)*>

<!ELEMENT allen     (#PCDATA | quote)*>

<!ELEMENT quote     (#PCDATA)*>

<!ELEMENT applause EMPTY>
```

## Attribute List Declarations

Attribute list declarations identify which elements may have attributes, what attributes they may have, what values the attributes may hold, and what value is the default. A typical attribute list declaration looks like this:

```
<!ATTLIST oldjoke

    name

ID

    label

CDATA

    status ( funny | notfunny ) 'funny'>
```

In this example, the oldjoke element has three attributes: name, which is an ID and is required; label, which is a string (character data) and is not required; and status, which must be either funny or notfunny and defaults to funny if no value is specified.

Each attribute in a declaration has three parts: a name, a type, and a default value.

You are free to select any name you wish, subject to some slight restrictions, but names cannot be repeated on the same element. The six possible attribute types include:

## CDATA

CDATA attributes are strings, any text is allowed. (CDATA attributes and CDATA sections are unrelated).

## ID

The value of an ID attribute must be a name. All of the ID values used in a document must be different. IDs uniquely identify individual elements in a document. Elements can have only a single ID attribute.

## IDREF or IDREFS

An IDREF attribute's value must be the value of a single ID attribute on some element in the document. The value of an IDREFS attribute may contain multiple IDREF values separated by white space.

## ENTITY or ENTITIES

An ENTITY attribute's value must be the name of a single entity (see the discussion of entity declarations below). The value of an ENTITIES attribute may contain multiple entity names separated by white space.

## NMTOKEN or NMTOKENS

Name token attributes are a restricted form of string attribute. In general, an NMTOKEN attribute must consist of a single word, but there are no additional constraints on the word, it doesn't have to match another attribute or declaration. The value of an NMTOKENS attribute may contain multiple NMTOKEN values separated by white space.

## A list of names

You can specify that the value of an attribute must be taken from a specific list of names. This is frequently called an enumerated type because each of the possible values is explicitly enumerated in the declaration.

Alternatively, you can specify that the names must match a notation name (see the discussion of notation declarations below).

The four possible default values include:

## #REQUIRED

The attribute must have an explicitly specified value on every occurrence of the element in the document.

#IMPLIED

The attribute value is not required, and no default value is provided. If a value is not specified, the XML processor must proceed without one.

"value"

An attribute can be given any legal value as a default. The attribute value is not required on each element in the document, and if it is not present, it will appear to be the specified default.

#FIXED "value"

An attribute declaration may specify that an attribute has a fixed value. In this case, the attribute is not required, but if it occurs, it must have the specified value. If it is not present, it will appear to be the specified default. One use for fixed attributes is to associate semantics with an element. A complete discussion is beyond the scope of this book, but you can find several examples of fixed attributes in the XLink specification.

## Entity Declarations

Entity declarations let you associate a name with some other fragment of content. That construct can be a chunk of regular text, a chunk of the document type declaration, or a reference to an external file containing either text or binary data.

A few typical entity declarations are shown in Example 3:

**Example 3. Typical Entity Declarations**

```
<!ENTITY

ATI

"Bison Books, Inc.">

<!ENTITY boilerplate      SYSTEM

"/standard/notice.xml">

<!ENTITY ATIlogo

SYSTEM "/standard/logo.gif" NDATA GIF87A>
```

The three kinds of entities—internal, external, and parameter—are discussed below.

Internal entities associate a name with a string of literal text. The first entity in Example 3 is an internal entity. Using &ATI; anywhere in the document will insert ArborText, Inc. at that location. Internal entities let you define shortcuts for frequently typed text or text that is expected to change, such as the revision status of a document.

Internal entities can include references to other internal entities, but it is an error for them to be recursive.

The XML specification predefines five internal entities:

- **&lt;** produces the left angle bracket, <

- **&gt;** produces the right angle bracket, >

- **&** produces the ampersand, &

- **'** produces a single quote character (an apostrophe), '

- " produces a double quote character, "

External entities associate a name with the content of another file. External entities let an XML document to refer the contents of another file. External entities contain either text or binary data. If they contain text, the content of the external file is inserted at the point of reference and parsed as part of the referring document. Binary data is not parsed and may only be referenced in an attribute. Binary data is used to reference figures and other non-XML content in the document.

The second and third entities in Example 3 are external entities.

Using &boilerplate; will insert the *contents* of the file /standard/legalnotice.xml at the location of the entity reference. The XML processor will parse the content of that file as if it occurred literally at that location.

The entity ATIlogo is also an external entity, but its content is binary. The ATIlogo entity can only be used as the value of an ENTITY (or ENTITIES) attribute (on a graphic element, perhaps). The XML processor will pass this information along to an application, but it does not attempt to process the content of /standard/logo.gif.

Parameter entities can only occur in the document type declaration. A parameter entity declaration is identified by placing % (percent-space) in front of its name in the declaration. The percent sign is also used in references to parameter entities, instead of the ampersand. Parameter entity references are immediately expanded in the document type declaration and their replacement text is part of the declaration, whereas normal entity references are not expanded. Parameter entities are not recognized in the body of a document.

Looking back at the element declarations in Example 2, you'll notice that two of them have the same content model:

```
<!ELEMENT burns      (#PCDATA | quote)*>

<!ELEMENT allen      (#PCDATA | quote)*>
```

At the moment, these two elements are the same only because they have the same *literal* definition. In order to make more explicit the fact that these two elements are semantically the same, use a parameter entity to define their content model. The advantage of using a parameter entity is twofold. First, it lets you give a descriptive name to the content and it lets you change the content model in only a single place, if you wish to update the element declarations, assuring that they always stay the same:

```
<!ENTITY % personcontent "#PCDATA | quote">

<!ELEMENT burns (%personcontent;)*>

<!ELEMENT allen (%personcontent;)*>
```

## Notation Declarations

Notation declarations identify specific types of external binary data. This information is passed to the processing application, which may use it in any manner it wishes. A typical notation declaration is:

```
<!NOTATION GIF87A SYSTEM "GIF">
```

# WHAT IS XSL?

HTML pages use predefined tags, and the meaning of these tags is well understood: <p> means a paragraph and <h1> means a header, and the browser knows how to display these pages.

With XML, you can use any tags you want, but the meaning of these tags is not automatically understood by the browser: <table> could mean a HTML table or maybe a piece of furniture. Because of the nature of XML, there is no standard way to display an XML document.

To display XML documents, it is necessary to have a mechanism to describe how the document should be displayed. One of these mechanisms is Cascading Style Sheets (CSS), but XSL (eXtensible Stylesheet Language) is the preferred style sheet language of XML. XSL is far more sophisticated than the CSS used by HTML.

## UNDERSTANDING XSL

XSL consists of two parts:

- a method for transforming XML documents
- a method for formatting XML documents

If you don't understand the meaning of this, think of XSL as a language that can transform XML into HTML, a language that can filter and sort XML data, and a language that can format XML data, based on the data value, such as displaying negative numbers in red.

XSL can be used to define how an XML file should be displayed by transforming the XML file into a format that is recognizable to a browser. One such format is HTML. Normally, XSL does this by transforming each XML element into an HTML element.

XSL can also add completely new elements into the output file, or remove elements. It can rearrange and sort the elements, test and make decisions about which elements to display, and a lot more.

## RESOURCES ON XML AND XSL

The best place to find almost anything these days is on the Web. With XML and XSL still in the emerging technologies category, this could not be truer. The following list of Web sites are excellent resources for exploring further the ins and outs of XML and related technologies:

| | |
|---|---|
| W3C | *www.w3c.org/xml* |
| Builder.com | *www.builder.com* |
| The XML FAQ | *www.ucc.ie/xml* |
| The XML Zone | *www.xml-zone.com* |

Several excellent published works are available, one of the best being XML by Example by Benoit Marchal. As always, it pays to get on a book site such as *Amazon.com* and do some homework as well.

## WHAT IS ELECTRONIC COMMERCE?

Many users think e-commerce means online shopping—workaholics pointing their browsers to *Amazon.com* to order an emergency present because they forgot another birthday.

Web shopping, however, is only a small part of e-commerce. The term also refers to online stock and bond transactions and buying and downloading software without ever going to a store. In addition, e-commerce includes business-to-business connections that make purchasing easier for big corporations.

As for the hottest areas of e-commerce, in terms of tangible goods sold via the Internet and other electronic means (such as interactive TV), the biggest sellers are computer products, consumer products, books and magazines, and music and entertainment products.

Clearly, e-commerce is here to stay. International Data Corporation has projected that 46 million Americans will buy $16 billion worth of goods annually by next year, and $54 billion by 2002. Forrester Research predicts e-commerce sales of almost $7 billion by 2000. Looking further ahead, Morgan Stanley Dean Witter estimates sales of anywhere between $21 billion to $115 billion annually by 2005.

## UNDERSTANDING E-COMMERCE

In its simplest form, the e-commerce is really no different than any other physical store, retail or otherwise, that you might visit. Some elements, however, are different, such as the issue of security and the fact that e-stores are catalog based. This section discusses the primary pieces of an e-commerce site to better understand how the system works.

To begin, there is a site containing HTML pages that are hosted on a Web server. These pages typically contain the catalog and commerce software, such as the shopping cart and credit card pre-processor. Typically, there is a database file or server within the architecture that allows for dynamic product updates and stock quantity reports. These systems are connected directly to the Internet via a large pipe, such as a digital T-1 line or greater. The server name is registered with two DNS servers for name resolution to the site, such as *www.myecommsite.com*. These pieces comprise the physical site and code.

Outside of this realm, usually at a merchant system or bank, credit cards are verified and processed once submitted at the site then the confirmation is sent back to the e-commerce

system. Most e-commerce systems will attach to some external system for this type of verification and the transmission is almost always secure using SSL encrypted data or SET communication (see below).

Of course, there are variants on this architecture. As you will see, the possibilities within the digital world are endless and so too are the architectures that may exist from site to site.

## SETTING UP AN E-COMMERCE SITE

From cheap and simple to expensive and complex, there's a wide range of products designed to get your e-commerce site up and selling in a matter of days or weeks. Small businesses may not have to look beyond their local Internet service providers for a bare-bones solution. For example, many smaller ISPs offer e-commerce packages for less than $150 per month. Many of these canned Web software front-ends use a series of wizards to help you create secure pages for selling your product. Electronic payments may be accepted by credit card or by check sources like via CheckFree.

Moving up the scale a bit, you can use Yahoo's Yahoo Store, which lets you create a transactional business Web site from your browser. Yahoo hosts the site, and the cost to you is based on the number of items sold: $100 per month for a store selling 50 items and $300 per month for up to 1,000 items.

Most e-commerce development tools targeted at small and midsize businesses cost $5,000 to $10,000. They generally include templates for online catalogs and databases, so it's easy to change items and prices. Dynamic database searches can serve different information when an item is out of stock or on special, and they can be hooked up to existing back-end systems for order fulfillment and a range of automatic payment options.

Companies that have a high volume of sales—especially those that deliver soft goods such as articles, reports, software, or music over the Net—require industrial-strength solutions costing anywhere from $10,000 to $100,000 or more. See the More Resources section below for examples of tools from all price ranges.

The software sticker price is only a small fraction of what it costs to run an e-commerce site. Many high-end e-commerce products are used by third-party companies to provide services for individual merchants. Most companies take advantage of e-commerce hosting services run by companies such as AT&T, MCI, and GTE's BBN Planet. This is a low-risk, low-cost way of finding out how to do it.

## USING A SITE YOU DEVELOPED

You do have other options—in fact, as many as a creative mind can come up with. For example, if you have an ISP that supports Active Server Pages (ASP) and an ODBC connection (such as Intermedia at *www.intermedia.net*) you can develop your own e-commerce site complete with catalog, then use scripting to incorporate the commerce options, such as GoeMerchant's (*www.goemerchant.com*) "Buy Me Buttons commerce system. For example, refer to the site Earthpharm.com (*www.earthpharm.com*), in the figure below. The page represented at this site has a list of products that are presented as hyperlinks to the actual product page. All of the product information is dynamic from a SQL database and the surrounding Web page is a template (basically the same for all pages).

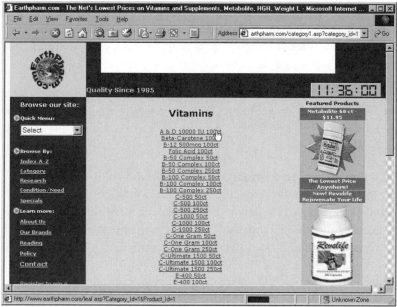

*A list of products from the database is generated dynamically.*

Below, we have clicked on the link for a product and are brought to the product page. Notice the Add to Cart icon on the right and the View Cart icon below. The two links are represented by an external commerce system that acts as if it was incorporated within the site. The links are as follows:

> **Add to Cart:** *http://www.goemerchant2.com/nscgi-bin/earthpharmcombuyme/orders.cgi?*
> Merchant=earthpharmcombuyme&Quantity=1&PartNum=1&Add=1

View Cart: *http://www.goemerchant2.com/nscgi-bin/earthpharmcombuyme/orders.cgi?*
Merchant=earthpharmcombuyme&View=View

In this example is a custom built solution that is easy to maintain (there are only about 10 real HTML pages to manage with the incorporation of ASP technology) and an external secure shopping cart system that work in harmony.

If you have the ability to use your own skills to develop your own commerce system, you can save thousands of dollars on development costs and software, giving your online business a head start in a competitive world.

## USING WEB-BASED STOREFRONT SOLUTIONS

One of the most popular options today for small businesses is to set up a storefront via a built-in-Web based front end that comes as part of an e-commerce hosting package. This is true regardless of the size of the ISP, though ISP's such as Verio, Mindspring, Earthlink, and AOL will often offer services and bandwidth beyond what their smaller competitors can offer.

Fortunately, the Web is a competitive marketplace with places where you can build a Web-based storefront through a Web front end for FREE. Visit the Freemerchant site at *www.freemerchant.com* for a robust free solution.

Most of the free sites offer an intuitive Web-front end that requires little or no programming at all.

## GETTING NOTICED

You have probably heard the hype about the Web being a bustling electronic village, connecting millions of strangers from around the world. But it's a lonely world for most Web sites. For every site that pushes the bandwidth limits of a T1 line, thousands of others languish in obscurity—unnoticed and unprofitable.

Fortunately, tinkering a bit with your HTML and filling in a few online forms can ensure your site gets the attention it deserves through search engines and directories. If you're willing to invest a little more time (and money), you can try ad banners, link exchanges, and promotion software to shepherd traffic to your site. The offline world is also a valuable source

of publicity: many print publications that review Web sites are ripe for a well-written press release about your online offerings. The right promotion on your own site is the best way to bring visitors back.

Ultimately, the quality of your site will determine its success or failure. To give yourself a fighting chance, you need to engage in some Web PR.

The fastest and easiest way to start drawing attention to your site is to register it with the major search engines and Web directories.

Search engines use automated software (known as robots or spiders) to follow Web hyperlinks, harvesting information about sites as they go. When a user submits a query to a search engine, the engine returns a list of sites, ranking them on their relevance to the keywords used in the search. How search engines assess your site and determine the relevance of the words is difficult to predict, as it often depends on how the specific engine works. Some engines, such as Excite, use artificial intelligence to recognize concepts that frequently appear together. If you search for animal health, for example, Excite also returns sites devoted to veterinary medicine. Other search engines, such as WebCrawler, first list more popular sites—those its database shows are more frequently linked.

Web directories have the modest task of being the yellow pages for the World Wide Web. Unlike search engines, which can find an unregistered site if other sites link to it, directories list your site only after you submit certain pieces of information: the title, the URL, a description, a few keywords, and sometimes a contact e-mail address. (Although it is not necessary, it's a good idea to register your site with search engines to ensure that your site comes up in queries.) Typically, a directory's reviewers decide whether a site meets their standards and where the site should be placed in the directory's hierarchy of categories.

Make sure each of your pages has a descriptive title. Search engines usually give the most weight to the words between a page's title tags. You can use this to your advantage by adding a short, descriptive phrase in the title of each of your pages, which will ensure certain keywords get the attention they deserve. Search engines return their results in the form of titles linked to each site, so descriptive titles draw users to your site. A page with just the name of the site in its title is less compelling than one with a description. If you don't include title tags at all, your site will be listed in search results as No Title or something similarly uninteresting.

You can control how search engines catalog your site with two types of <META> tags. <META> tags are part of the HTML code that some search engines, such as AltaVista and Infoseek, look for but most visitors to your pages never see. <META> description tags let you specify a short summary that appears below the page's title on a search response. (If a page doesn't have a <META> description, search engines usually list the page's first dozen or so words instead.) <META> keyword tags let you specify the keywords that a search robot should give precedence to when cataloging the page. <META>

keywords are typically given less importance than words in the title, but more importance than words found in the page's body.

Repeating keywords—whether in the title tag, in the <META> keyword tag, or hidden against a colored background—has long been a popular ploy to convince search engines to list a site high on keyword searches. The tactic worked when search engines were unsophisticated and judged a word's relevance only by the number of times it appeared on a page. Now, most search engines are hip to the trick and count only the first few occurrences of a keyword or phrase. Thus, hundreds of repetitions of Pamela Anderson on your celebrity models Web page will probably have no greater effect on the search engines than would ten repetitions. Search engines also rely more on word density (frequency relative to the total size of the page) or distribution (how well the word is spread throughout the page) than on the number of occurrences when they judge relevance. Some search engines, such as Lycos, even penalize your page (by placing it further down the list or not listing it at all) if they suspect you of repeating words to improve its ranking.

Following these simple rules will help you list higher than other sites and hence bring more traffic to your site.

## SHOPPING CARTS

Unless you are selling a singular product or are not accepting electronic payment for your products, you must have a vehicle by which your customers can add items to a repository and then later buy those items from you, much the way you add items to the shopping cart in the grocery store and then take them to pick up items in your store.

Today, there are two types of shopping cart programs that you can use to accomplish this the local flavor that runs on the Web server itself (you own the server or the service is provided by your ISP) or the external variety that is called from an external link when an item needs to be added to the cart or checkout procedures need to be executed.

Local programs are available by the hundreds and most ISPs will offer the use of a free shopping cart program with an e-commerce hosting plan. For a list of shopping cart programs or ISPs, visit a Web Directory such as Yahoo! or Excite and search for shopping cart software or Web Hosting (a list is not prudent here as the features and lists of products and services change  so frequently).

External shopping systems are economical and will incorporate into almost any site, adding versatility and programmability. Products by Goemerchant.com and Americart.com are robust solutions and offer end-to-end commerce solutions. Make sure you compare features and prices before making a decision.

## UNDERSTANDING E-COMMERCE TERMS

E-commerce is rife with buzzwords and catch phrases, as shown below:

**Digital or electronic cash.** Also called *e-cash,* this term refers to any of several schemes that let a user pay for goods or services by transmitting a number from one computer to another. The numbers, just like those on a dollar bill, are issued by a bank and represent specified sums of real money. One of the key features of digital cash is that it's anonymous and reusable, just like real cash. This is a key difference between e-cash and credit card transactions over the Internet. For more information, see PC Webopaedia.

**Digital Money**. This is a grab-bag term for the various e-cash and electronic payment schemes on the Internet. Yahoo lists 21 companies offering a form of digital money.

**Disintermediation**. Disintermediation us the process of cutting out the middleman. When Web-based companies bypass traditional retail channels and sell directly to the customer, traditional intermediaries (such as retail stores and mail-order houses) may find themselves out of a job.

**Electronic** Check. Currently being tested by CyberCash, electronic checking systems such as PayNow take money from users' checking accounts to pay utility and phone bills.

**Electronic** Wallet. This is a payment scheme, such as CyberCash's Internet Wallet, that stores your credit card numbers on your hard drive in an encrypted form. You can then make purchases at Web sites that support that particular electronic wallet. When you go to a participating online store, you click a Pay button to initiate a credit card payment via a secure transaction enabled by the electronic wallet company's server. The major browser vendors have struck deals to include electronic wallet technology in their products.

**Extranet**. This extension of a corporate intranet connects the internal network of one company with the intranets of its customers and suppliers. This makes it possible to create e-commerce applications that link all aspects of a business relationship, from ordering to payment.

**Micropayments**. Transactions in amounts between 25 cents and $10, typically made in order to download or access graphics, games, and information, are known as micropayments. Pay-as-you-go micropayments were supposed to revolutionize the world of e-commerce, but many potential customers have been unwilling to use micropayments thus far.

**Electronic Data Interchange (EDI).** Created by the government in the early 1970s and now used by 95 percent of Fortune 1000 companies, EDI is a common document structure designed to let large organizations transmit information over private networks. EDI is now finding a role on corporate Web sites as well.

**Open Buying on the Internet (OBI).** This standard, created by the Internet Purchasing Roundtable, is supposed to ensure that all the different e-commerce systems can talk to one another. OBI, which was released by the OBI Consortium, is backed by leading technology companies such as Actra, InteliSys, Microsoft, Open Market, and Oracle.

**The Open Trading Protocol (OTP).** OTP is intended to standardize a variety of payment-related activities, including purchase agreements, receipts for purchases, and payments. It was created as a competing standard to OBI by a group of companies, including AT&T, CyberCash, Hitachi, IBM, Oracle, Sun Microsystems, and British Telecom.

**The Open Profiling Standard (OPS).** A standard backed by Microsoft and Firefly, OPS lets users create a personal profile of preferences and interests that they want to share with merchants. The idea behind it is to help consumers protect their privacy without banning online collection of marketing information.

**Secure Sockets Layer (SSL).** This protocol is designed to create a secure connection to the server. SSL uses public key encryption, one of the strongest encryption methods around, to protect data as it travels over the Internet. SSL was created by Netscape but has now been published in the public domain.

**Secure Electronic Transactions (SET).** SET encodes the credit card numbers stored on merchants' servers. This standard, created by Visa and MasterCard, enjoys wide support in the banking community. The first SET-enabled commerce is already being tested in Asia.

**Truste.** This partnership of companies seeks to build public trust in e-commerce by putting a Good Housekeeping-style seal of approval on sites that don't violate consumer privacy.

**Shopping Cart.** Shopping Cart is a program that lets users accumulate goods and/or services in a virtual shopping basket to later take to the checkout where the items are actually paid for by electronic means.

## E-COMMERCE RESOURCES

Several sites on the Internet are virtual storehouses of information about electronic commerce. Try the following sites for more information:

- Yahoo's E-commerce Directory: *http://dir.yahoo.com/Business_and_Economy/ Electronic_Commerce/*

- Infoseek's E-commerce Directory: *http://www.go.com/WebDir/ Electronic_commerce?lk=noframes&svx=related*

- Internet.com's Electronic Commerce Guide: *http://ecommerce.internet.com/*

- Business 2.0 Electronic Magazine: *http://www.business2.com*

- E-Commerce Times the E-Business and Technology Super Site: *http://www.ecommercetimes.com/*

## IS E-COMMERCE SAFE?

Although Internet security breaches have received a lot of press, most vendors and analysts argue that transactions are actually less dangerous in cyberspace than in the physical world because a great deal of credit card fraud is caused by retail sales employees who handle card numbers. E-commerce systems remove temptation by encrypting the numbers on a company's servers. For merchants, e-commerce is actually safer than opening a store that could be looted, burned, or flooded. The difficulty is in getting customers to believe that e-commerce is safe for them.

Consumers don't believe it yet, but experts say e-commerce transactions are safer than ordinary credit card purchases. Every time you pay with a credit card at a store, in a restaurant, or over an 800 number, and every time you throw away a credit card receipt, you make yourself vulnerable to fraud.

Since the 2.0 versions of Netscape Navigator and Microsoft Internet Explorer, transactions can be encrypted using Secure Sockets Layer (SSL), a protocol that creates a secure connection to the server, protecting the information as it travels over the Internet. SSL uses public key encryption, one of the strongest encryption methods available. You can tell that a Web site is secured by SSL when the URL begins with *https* instead of *http*.

Browser manufacturers and credit card companies are promoting an additional security standard called Secure Electronic Transactions (SET). SET encodes the credit card numbers that sit on vendors' servers so that only banks and credit card companies can read the numbers. No e-commerce system can guarantee 100 percent protection for your credit card, but you're less likely to get your pocket picked online than in a real store.

## ON THE HORIZON FOR E-COMMERCE

The future of e-commerce looks promising. After the details of online commerce are worked out, it and the Internet in general could reshape the structure of the business world. In fact, it is already happening. Internet commerce will certainly explode as the Internet becomes more accessible to everyone, everywhere, as evidenced by the huge growth of virtual communities, people getting together in ad hoc interest groups online, promises to shift the balance of economic power from the manufacturer to the consumer. At least, that's the view of McKinsey & Company, an international management-consulting firm.

Virtual communities are already making their presence felt. The investment site Motley Fool lets members exchange investment advice without the benefit of a stockbroker. ParentsPlace is a meeting ground for parents that give smaller vendors an avenue to reach potential customers for products such as baby food and shampoo.

If you are interested in moving your site into the mainstream, consider joining or advertising your products and site on one of these online communities. Many users use these portals with great allegiance and will buy from retailers associated with the site.

## WHAT ARE ACTIVE SERVER PAGES?

The technical definition of ASP from the Microsoft Internet Information Server (IIS is Microsoft's O/S bundled WWW server) site:

> *"Active Server Pages is an open, compile-free application environment in which you can combine HTML, scripts, and reusable ActiveX server components to create dynamic and powerful Web-based business solutions. Active Server Pages enables server side scripting for IIS with native support for both VBScript and Jscript."*

Files created with Active Server Pages have the extension *.asp*. With ASP files, you can activate your Web site using any combination of HTML, scripting such as JavaScript or Visual Basic Scripting Edition (VBScript), and components written in any language. Thus, your ASP file

is simply a file that can contain any combination of HTML, scripting, and calls to components. When you make a change on an ASP file on the server, you need only save the changes to the file—the next time the Web page is loaded, the script will automatically be compiled. It works because ASP technology is built directly into Microsoft Web servers, and is thus supported on all Microsoft Web servers: Windows 2000 Internet Information Server 5.0, Windows NT Internet Information Server (IIS) 3.0+, Windows NT Workstation, and Windows 95/98 Personal Web Server.

You can use ASP on IIS in various ways, as shown below:

- Put your employee handbook online, rather than printing copies that are soon obsolete. An added benefit is the reduction of administrative costs when employees can access and update their own records, such as address and health plan benefits.

- Tie your online store to your existing inventory database and order-processing system.

- Give every visitor to your site a personalized view of just the information he or she seeks, and automatically flag what is new since the last visit.

Although you can write CGI scripts that will let you update information and reload it next time the page is loaded, ASP runs as a service of the Web server and is optimized for multiple threads and multiple users. This means that it's fast, and it's easy to implement. If you use ASP, you can separate the design of your Web page from the nitty-gritty details of programming access to databases and applications.

You should have a good grasp of VBScript and the ASP object model before starting out, though the following sections offer a good primer to learning and understanding ASP. For more information on VBScript, visit the Microsoft Developer Network Scripting Web site at *http://msdn.microsoft.com/scripting/default.htm?/scripting/vbscript/default.htm*.

# UNDERSTANDING ASP

With the explosion of the World Wide Web in late 1995, Microsoft recognized the emergence of an enormous market, and that the Internet was coming of age, so in early 1996 it introduced Microsoft Internet Information Server (IIS) v1.0. While this early version of IIS was barely worth a letter home, Windows NT owners finally had a fairly decent platform that allowed access to the already familiar NT desktop interface, powerful NT security features, and a strong and flexible Internet Database Connector (IDC) for database access. Still, IIS lacked any real scripting interface that was easy both to install and utilize. In short, if you

did not have an experienced C programmer on staff or a Unix guru that was familiar with Perl, your Web site clients (and yourself) were extremely limited in even the basic and fundamental scripting abilities.

With the emergence of IIS 2.0, Microsoft included Active Server Pages (commonly known as ASP). The power and flexibility of ASP was a welcome addition to the NT community, a code which was easily created and implemented using any programming language that supported the ActiveX interface, including JScript, VBScript, and PerlScript. Since ASP was native to the NT operating system, it was readily available to all clients with Web sites being hosted on the server, and generally did not require much (if any) intervention from the administrator to access almost all of its resources.

Now, using ASP, it was easy to do simple and complex calculations and queries, all without calling your ISP for permission changes. Best of all, it was (is) not browser dependent like Javascript, making browser compatibility an issue of the past.

What ASPs did for Web sites is comparable to evolution of the car from jalopy to Indy car. The performance increase was phenomenal, getting the job done more efficiently (and faster) but there was a slight catch. Driving an Indy car was not quite as easy as driving a jalopy, as is the case in changing from static HTML to ASP. On the other hand, learning ASP is not as cryptic as is Perl.

The following example is a simple Perl script displaying the current system time and date:

```
#!/usr/local/bin/perl

print "Content-type: text/plain", "\n\n";

$time='/usr/bin/date' ;

print "The time is: ", $time;

exit(0);
```

ASP code is embedded right in an HTML page between special delimiters. Using Active Server Pages, the same information is displayed in the following example:

```
<html>

<body>

The time is: <% = time %>

</body>

</html>
```

All of the goodies that make ASPs work so well are built in, all you have to do is supply the proper code to accomplish the task at hand. ASP is a subset of Visual Basic Scripting, which is a subset of Visual Basic for Applications which, in turn, is a subset of Visual Basic, which is a product developed by Microsoft.

The way ASP works is simple. The ASP processor on the IIS server has a VB interpreter for the code embedded in the HTML page. When the page loads, the code is processed and the results are loaded along with the page in the client browser. It is important to note also that the data may come from any ODBC compliant database, including Microsoft Access. Therefore, if you have little or no experience in a product like Microsoft SQL Server, you could develop your database in Access and then use the automated features of SQL Server to transfer the data.

To incorporate ASP into your Web site, the following steps occur:

- The user brings up a Web site (like MSDN Online Web Workshop) where the default page has the extension *.asp*.

- The browser requests the ASP file from the Web server.

- The server-side script begins to run with ASP.

- ASP processes the requested file sequentially (top-down), executes any script commands contained in the file, and produces an HTML Web page.

- The Web page is sent to the browser.

Because your script runs on the server, the Web server does all of the processing and standard HTML pages can be generated and sent to the browser. This means that your Web pages are limited only by what your Web server supports. Another benefit of having your script reside on the server is that the user cannot view source on the original script and code. Instead, the user sees only the generated HTML as well as non-HTML content, such as XML, on the pages that are being viewed.

## ASP IS DYNAMIC

You have learned that ASP is created using HTML pages that have embedded scripting and the data comes from a database. A database is a collection of information organized in such a way that a computer program can quickly select desired pieces of data. You can think of a database as an electronic filing system. Traditional databases are organized by fields, records, and files. A field is a single piece of information; a record is one complete set of fields; and a

file is a collection of records. For example, a telephone book is analogous to a file. It contains a list of records, each of which consists of three fields: name, address, and telephone number.

An alternative concept in database design is known as Hypertext. In a Hypertext database, any object, whether it be a piece of text, a picture, or a film, can be linked to any other object. Hypertext databases are particularly useful for organizing large amounts of disparate information, but they are not designed for numerical analysis.

To access information from a database, you need a database management system (DBMS). This is a collection of programs that enables you to enter, organize, and select data in a database. An example of this is Oracle's DBMS, Sybase, and Microsoft's SQL Server.

An important fact to remember is that typically the information contained within databases are constantly changing with the addition, deletion, and modification of the records that are kept within. For example, suppose you work in a customer service position for your company and all of your customer records are kept on a DBMS. Everyone in customer service is busy answering customer calls via the toll-free number and pulling up customer information in the database at their workstation and modifying the data. The data in the database is constantly changing and therefore dynamic.

ASP provides a Web interface and development platform to such dynamic content, as well as, other dynamic functions included on the server, such as the system time, or through the IIS server itself, such as session information or HTTP header information. Server Side Includes would fall in this category as well. ASP content has the potential to change with every page hit or every page refresh, providing up-to-the-second updates from the data source and displaying information in any browser across any platform. Indeed, ASP is a versatile and robust technology that has managed to remain a vehicle of choice for many developers and corporations alike over the last four years.

## ASP LETS YOU MAINTAIN STATE

You have learned that the Internet is based on a client-server model, where your Web browser is the client, and the Web server is the server.

In the client-server model, the client opens up a channel of communication with the server and requests a resource. The server receives the request, locates the resource being requested, and sends it to the client, closing the channel of communication. This is an impersonal transaction between the client and server. The server does not keep open its channel of communication with the client. The server is not concerned with who it has talked to recently, what it has sent recently, or what it thinks a particular client will request next. The server does one job, and it does it well: wait for a request from the client and then process that request.

Due to this impersonal communication between a Web browser and a Web server, user information is not persisted from one request to another. Imagine that you wanted to create a form that would query the user for his or her name. After the user entered his or her name, it would be nice to display a personal greeting on each Web page on your Web site. To display a personalized welcome message, you would need some way of remembering each user's name. Saving such information is referred to as maintaining state, or persisting state.

Because the client-server model does not make maintaining state inherently easy, you must examine some advanced techniques to maintain state. No doubt you'll find that some of the methods that can be used to persist state seem rather obtuse.

In the section, "Passing Information Through the Querystring," you will learn how to maintain state by sending state information through the querystring. Using this approach can lead to a syntactical headache, and you may find yourself wondering why maintaining state through the querystring appears to be so confusing. Keep in mind that the client-server model does not lend itself to state persistence, therefore, some methods of maintaining state can be unwieldy.

Thankfully, ASP provides some built-in objects and collections to help maintain state. The Cookies collection, can be used to maintain simple state information over lengthy periods of time. The Session and Application objects, discussed in the sections "The Session Object" and "The Application Object," can also be used to maintain state. By using Active Server Pages, state maintenance is easier to understand.

## CREATING A NEW DATABASE IN SQL

There is a logical order to creating data-driven sites. Data-driven sites consist of pages that are created on the fly from a data source. Therefore, you must first have a data source in order to proceed with the creation of your ASP pages. For the sake of simplicity, you will use Microsoft's SQL Server product to create your data source primarily because, from a usability and availability standpoint, the product can be easily attained and will work on almost any Windows-based PC or server.

Before actually creating the database, it is important to design the tables first, even if your database only consists of a single table (as in this example). For example, suppose you are developing an intranet site for your company that lets users search, add, and delete customers from the database along with associated information. The table would need several critical columns, such as:

- Customer ID

- First Name

- Last Name

- Address

- City

- State

- Postal Code

- Phone Number

- Company Related Data

Each of the above items would be a column heading and a field in the database. The key is that the site should be developed around the data store, not the other way around!

After the database has been developed, you can begin the creation process. SQL server installs several tools through which you can manage your databases, the most important of which is the Enterprise Manager. Through this console you can manage nearly every function of the server, including the creation of databases. The figure below shows a typical SQL Server Enterprise Console.

*The SQL Server Enterprise Manager Console.*

To begin creating your database, open the SQL Server console and right-click on the Databases folder, then select New Databas, as in the figure below.

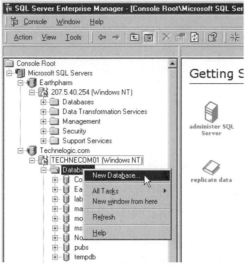

*Choosing the create new database option in the SQL Server EM console.*

The resulting Database Properties screen is displayed (see figure below). Notice that there are two tabs on this window, General and Transaction Log. Both of these tabs must be set either by you or you may accept the defaults. First, give the database the name like Customer Profile. Make sure that the Automatically grow file checkbox is clicked to avoid manually growing the file yourself should the database grow over its bounds. Once you are content with the settings, click your mouse on the "OK" button to continue.

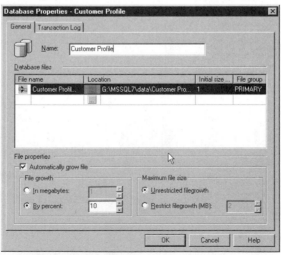

*Creating the database in the Database Properties window.*

The database has been created on the server but is an empty vessel. You need to add the column headings, which become your relevant fields. Expand the Databases folder to reveal the newly created database Customer Profile. Expand the Customer Profile Database to reveal the items for that database, then select Tables (see figure below).

*Selecting the Tables object in the SQL EM console.*

Several tables are created by default. These are system tables and they should not be altered. To create a new table, right-click on the Table object and select New Table (see figure below).

*Creating anew table in the SQL EM console.*

The resulting Choose Name window prompts you for a table name. Enter a name for the table, such as Customer Data, and click OK. You should now be looking at a design window for the new table with several columns (see figure below).

*The new table in design mode.*

Next, you will add the column names and data types for each of the relevant fields discussed above and as shown in the figure below. The first column will be set as the Customer ID filed and will have a data type of int, will not allow nulls (uncheck), and will be an identity field which means that the filed will automatically increment when a new record is entered. Enter the rest of the columns as shown in the figure below.

*Creating the columns for the database.*

When you have finished filling in the columns, click on the diskette icon to save the new table to the database. Next, you will populate the table with records. To accomplish this, you must right-click the new table and select the Retrieve All Row option from the resulting menu. From this window, you can enter records into the database. Do this now so that you have records to retrieve later.

You may now exit the table recordset window console. In the SQL EM console, verify the table exists. Congratulations, you have created the table and your database. This database will be used in several of the next few examples. If you do not have a copy of Microsoft's SQL Server 7.0, you can download or order a 120 day evaluation copy from the Microsoft Web site at *www.microsoft.com*. If you cannot secure a copy of SQL Server, try using Microsoft Access from the Microsoft Office Suite instead.

## SETTING UP AN ODBC DATA SOURCE FOR MICROSOFT PRODUCTS

In most cases, you will need to set up a connection to the ODBC source before you can access the data from a database. This is accomplished on Windows-based systems through the system Control Panel ODBC applet. This exercise should be done at the Microsoft Internet Information Server (IIS) server console as you willconnect from the IIS server to the SQL server database, regardless of the whether or not the SQL server resides on the same physical server or not.

To begin, open the ODBC Data Sources applet in Control Panel (see figure below).

*The ODBC Data Source Applet in the Windows Control Panel.*

The applet launches the ODBC Data Source Administrator. Select the **System DSN** tab from the Administrator (see figure below) and click on the **Add** button.

*Selecting the System DSN tab.*

From the Create New Data Source window, scroll down to the appropriate driver type, in this case SQL Server (Access if you are using a Microsoft Access database) and click finish, as shown below.

*Selecting SQL Server as the new Data Source.*

You will be prompted with a new window, Create a New Data Source to SQL Server. Enter the name of the connection, such as customer profile, a brief description, and then type in the name or IP address of the SQL server, as shown below. Click Next to continue.

*Creating the new SQL Data Source.*

You will be prompted for logon information to the SQL Server. In most cases, depending on how you set up the SQL Server, you will use the default SQL administrator account (usually sa) with the appropriate password. If you are using another account, enter it here as shown in the figure below.

Next, you will select the actual database on the server. In this case, select the Customer Profile database and click Next to continue (see figure below).

*Entering the SQL Server logon information.*

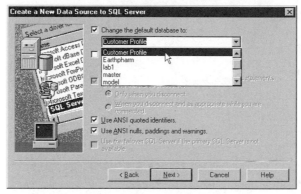

*Selecting the appropriate database for the ODBC connection.*

On the next screen, leave the defaults and click Finish (see figure below). You will be presented with a window that has a summary of the database options you selected.

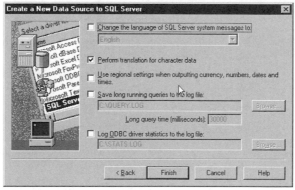

*Selecting database connection options.*

**433**

Choose the option to Test Data Source as shown in the figures below. You should receive a confirmation that the data source was successfully queried and the configuration is valid (see figure below). If you experience problems, consult your Database administrator or the ODBC troubleshooting guide for assistance.

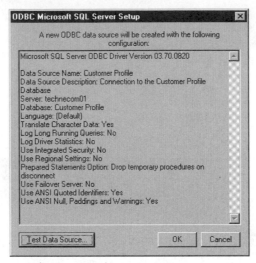

*Testing the Data Source connection.*

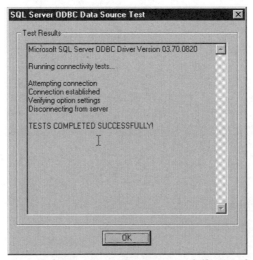

*The confirmation page showing the Data Source was successfully tested.*

## UNDERSTANDING ACTIVEX DATA OBJECTS (ADO)

Like all new technologies, dynamic pages using ASP has undergone a number of revisions over the past as has the method or vehicle used to access the data in databases. The preferred method when using ASP to access data from a data source is Microsoft's ActiveX Data Objects, or ADO. ADO is Microsoft's strategic, high-level interface to various data. ADO provides consistent, high-performance access to data, whether you're creating a front-end database client or middle-tier business object using an application, tool, language, or even an Internet browser. ADO is the single data interface you need to know for 1- to n-tier client/server and Web-based data-driven solution development.

ADO is designed as an easy-to-use application level interface to Microsoft's newest and most powerful data access paradigm, OLE DB. OLE DB provides high-performance access to any data source, including relational and non-relational databases, e-mail and file systems, text and graphics, custom business objects, and more. ADO is implemented with a small footprint, minimal network traffic in key Internet scenarios, and a minimal number of layers between the front-end and data source—all to provide a lightweight, high-performance interface. ADO is easy to use because it is called using a familiar metaphor—the OLE Automation interface, available from just most tools and languages on the market today. Since ADO was designed to combine the best features of, and eventually replace RDO and DAO, it uses similar conventions with simplified semantics to make it easy to learn for today's developers.

## CONNECTING TO YOUR DATABASE

You can use a number of options to connect your Active Server Pages to your database. Although there are preferred options, this section will examine the most common options. The examples shown in this section on data retrieval and modification will refer often to the SQL database created in the previous examples. If you are more at home using Access as your database provider, you may substitute that database (connections to both SQL and Access are provided).

To connect your ASP pages to a database, you have several options, as outlined in the following list:

- OLE DB Method for SQL
- DSN Less connection for Access
- OLE DB Method for Access
- File DSN Connection Method for Access

The following examples outline the usage of each of these types of database access:

## OLE DB Method for SQL

Example:

```
<%

set conn = server.createobject("ADODB.Connection")

conn.open "PROVIDER=SQLOLEDB;DATA
SOURCE=sqlservername;UID=username;PWD=password;DATABASE=databasename
"

%>
```

## DSN Less connection for Access

Example:

```
<%

set conn = server.createobject("ADODB.Connection")

conn.open "DRIVER={Microsoft Access Driver
(*.mdb)};DBQ=c:\anydatabase.mdb"

%>
```

## OLE DB Method for Access

Example:

```
<%

set conn = server.createobject("ADODB.Connection")

conn.open "PROVIDER=MICROSOFT.JET.OLEDB.4.0;DATA
SOURCE=c:\anydatabase.mdb"

%>
```

**File DSN Connection Method for Access**

Example:

```
<% set conn = server.createobject("ADODB.Connection")

conn.open "FILEDSN=AccessDSN"

%>
```

Of these connection types, the OLE DB method using Active Data Objects or ADO is the preferred method for connection to your database for speed and ease of use as it references APIs built into the operating system and SQL server.

The set command defines the connection variable conn. It is the vehicle by which you access the database by opening a connection to the database via the server.createobject object and the (ADODB.Connection) method. In using OLE DB, you open the connection using several identifiers, such as the database provider, in this case SQLOLEBB, the server name, the logon information (username sa and no password for this example), and the name of the database.

If you want more information on the ASP object model, see the next section below or visit *http://msdn.microsoft.com.*

# USING ASP TO RETRIEVE DATABASE RECORDS

The most basic action that you may perform using ASP is retrieving database records and displaying them in a Web page. First, you will create the retrieval page which begins with the connection to the database. This example will refer to the SQL database you created earlier. The retrieved page carries out the following actions:

- Connect to database
- Retrieve records
- Return the recordset as an HTML page

Remember that your database name is Customer Profile which is the code used to connect to the database (your SQL Server name and logon information may vary):

```
<%

set conn = server.createobject("ADODB.Connection")

conn.open "PROVIDER=SQLOLEDB;DATA
```

```
SOURCE=TechneHOUSQL001;UID=sa;PWD="";DATABASE=Customer Profile"

%>
```

Now that you understand how to connect to the database, you will tie it together within the actual ASP page to return the recordset of all customer information from the database. Of course, you must have data in the database to return any output verify this has been done. Realistically, this procedure would not work in a business solution as all records are being returned which could number in the millions. The intent of this approach is simply to show the process by which data is read from the database and returned to an HTML page. More apt solutions will be discussed later. The ASP page should be coded as follows:

```
<%

set conn = server.createobject("ADODB.Connection")

conn.open                         "PROVIDER=SQLOLEDB;DATA
SOURCE=TechneHOUSQL001;UID=sa;PWD="";DATABASE=Customer Profile"

%>

<HTML>

<Head>

<Title>Customer Database</Title>

</Head>

<Body>

<table border="0" cellpadding="1" cellspacing="1">

<tr>

<td width="100%" style="font-size: 8pt; font-family: Verdana">

'The SQL statement to retrieve the data goes here

<% sql="SELECT Customer ID, First Name, Last Name, Address,
City ,State, Postal Code, Phone Number, Company Related Data
FROM Customer Profile"

Set RS = Conn.Execute(sql)

    Do while Not RS.Eof
```

```
%>

<%

Rs.MoveNext

Loop

%>

</td>

</tr>

</table>
```

Name this page CustomerData.asp on the IIS server under a test Web. Run the page and check to see that the customer data is returned from the database. If you encounter ODBC errors or VBScript errors, check your typing as ADO, SQL, and VBScript are unforgiving of typographical errors. You should have returned your first ASP page containing dynamic information page with all of the data in a formatted table.

## ADDING RECORDS TO THE DATABASE

A somewhat more adventurous endeavor using ASP is modifying database contents. To accomplish this, you will create two separate ASP pages, the first to take the form information and the second to act as a post-processor for the form information that is input by the user. You should again use the SQL database Customer Profile to accomplish this. The first ASP page should consist of form fields that reflect the data in the database, as shown in the following code:

```
<html>

<head>

<title>Add Customer Information</title>

</head>

<body>
```

```
<form method="post" action="addcustomer-proc.asp">

<input type="text" name="Fname">

<input type="text" name="Lname">

<input type="text" name="Address">

<input type="text" name="City">

<input type="text" name="State">

<input type="text" name="Postal">

<input type="text" name="Phone">

<input type="text" name="DATA">

<input type="submit" value="Submit"><input type="reset"
value="Reset">

</form>

</body>

</html>
```

Name this form customeradd.asp. Next, you will need a receiving page to accept this form information. Start a new ASP page and name it addcustomer-proc.asp because this is where <form action="addcustomer-proc.asp"> from the previous code is going to send the form contents. The receiving code should look like this:

```
<%

'Create a connection to our database using OLEDB

set conn = server.createobject("ADODB.Connection")

set.rst = server.createobject("ADODB.Connection")

conn.open                    "PROVIDER=SQLOLEDB;DATA
SOURCE=TechneHOUSQL001;UID=sa;PWD="";DATABASE=Customer Profile"

sqltext = "SELECT * FROM Customer Profile"

rst.Open sqltext,conn,3,3
```

```
'Server Side form validation to keep our database clean and here
we also grab the form information

dim  fname,lname,address,city,state,postal,phone,data

fname = Request.Form("fname")

lname = Request.Form("lname")

address = Request.Form("address")

city = Request.Form("city")

state = Request.Form("state")

postal = Request.Form("postal")

phone = Request.Form("phone")

data = Request.Form("data")

if fname, lname, address, city, state, postal, phone, data = ""
then

error = "You have not entered all fields."

Response.Write error

Response.End

end if

'If we pass through validation then store the information in the
db

rst.AddNew

rst("fname") = fname

rst("lname") = lname

rst("address") = address
```

```
rst("city") = city

rst("state") = state

rst("postal") = postal

rst("phone") = phone

rst("data") = data

rst.update

Now lets redirect the user back to the Add Customer page

Response.Redirect "customeradd.asp"

%>
```

Save the files to the IIS server under your test Web. Check to see that the information was added by using the customerdata.asp file you created in the previous example.

## DELETING RECORDS FROM THE DATABASE

Just as you create records in the database, part of database upkeep involves removing data from the database.

To find the record that must be deleted, you will create a search page that finds the relevant record to be modified. Begin a new ASP page and code it as follows:

```
<html>

<body>

<%

'Create a connection to our database using OLEDB

set conn = server.createobject("ADODB.Connection")

set.rst = server.createobject("ADODB.Connection")
```

```
conn.open "PROVIDER=SQLOLEDB;DATA
SOURCE=TechneHOUSQL001;UID=sa;PWD="";DATABASE=Customer Pro-
file"%>

'retrieve the records

<%RS.Open "Select * From Customer Profile", Conn%>

<%Do While Not RS.eof%>

<table>

<tr>

<td>

<form action="deletion.asp" method="Post">

<INPUT Type=CheckBox Name="toDelete" Value="<% = RS("ID")%>"></
td>

'this puts a checkbox beside each record. You may then select
the record to delete and the value is the key field ID

<TD><% = RS("fname")%></TD>

<TD><% = RS("lname")%></TD>

</TR>

<%RS.movenext%>

<%Loop%>

</table>

<%RS.close%>

<%MyConn.close%>

<input type="submit" value="Delete">

</form>

</table>
```

```
</body>

</html>
```

Save this page as customerdelete.asp. Next, you will create an ASP page that processes the form information from the previous example, as shown in the following code:

```
<HTML>

<Head>

</Head>

<Body>

<%

Dim itemToDelete, RS, Conn, SQL

itemToDelete = Request.Form("toDelete")

'dump the value of the form field into the variable itemToDelete

Set Conn=Server.CreateObject("ADODB.Connection")

Conn.Open "demo"

SQL = "DELETE FROM Customer Profile WHERE ID = " & itemToDelete
& ""

Set RS = MyConn.Execute(SQL)

'The table uses ID as the key field and the corresponding
records are deleted

Conn.Close

Set Conn = Nothing

%>

<center>Record Deleted!</center>
```

```
</body>

</html>
```

Name this file deletion.asp and save both files to the IIS server. Test your pages as you did in the previous example.

## THE ASP OBJECT MODEL

The term object model refers to the Object Oriented Programming (OOP) model used with a certain programming language. In ASP, when a browser requests an ASP file from your Web server, your Web server calls Active Server Pages to read through the ASP file, executing any of the commands contained within and sending the resulting HTML page to the browser. An ASP file can contain any combination of HTML, script, or commands. The script can assign values to variables, request information from the server, or combine any set of commands into procedures. One of the most important things to remember about ASP is that it uses the delimiters <% and %> to enclose script commands. For example, the following code sets the value of the variable My Name in the user cookie to I Dream of Jeannie:

```
<%Response.Cookies("MyName")="Richard Schwartz"%>
```

The scripting languages supported by ASP, in turn, support use of the If-Then-Else construct. Finally, you can embed some real logic into your HTML. For example, the following code from the IIS documentation shows how you can set the greeting shown based upon the time of day:

```
<FONT COLOR="GREEN">

<%If Time >= #12:00:00 AM# And Time < #12:00:00 PM# Then%>

Good Morning!

<%Else%>

Hello!

<%End If%>

</FONT>
```

**Built-in Objects**

ASP includes five standard built-in objects for global use:

- **Request.** To get information from the user.

- **Response.** To send information to the user.

- **Server.** To control the Internet Information Server.

- **Session.** To store information about and change settings for the user's current Web-server session.

- **Application.** To share application-level information and control settings for the lifetime of the application.

The Request and Response objects contain collections, which are small pieces of information that are accessed in the same way. Objects use methods to do a procedure and properties to store any of the object's attributes (such as color, font, or size).

## The Request object

The Request object is used to get information from the user that is passed along in an HTTP request. As you have learned, the Request and Response objects support collections, as shown below:

- **ClientCertificate.** To get the certification fields from the request issued by the Web browser. The fields that you can request are specified in the X.509 standard

- **QueryString.** To get text such as a name, such as my favorite TV sitcom above

- **Form.** To get data from an HTML form

- **Cookies.** To get the value of application-defined cookie

- **ServerVariables.** To get HTTP information such as the server name

## The Response object

The Response object is used to send information to the user. The Response object supports only cookies as a collection (to set cookie values). The Response object also supports a number of properties and methods. The currently supported properties pported are:

- **Buffer.** Set to buffer page output at the server. When this is set to true, the server will not send a response until all of the server scripts on the current page have been processed, or until the Flush or End method has been called.

- **ContentType.** To set the type of content (such as text/HTML, Excel, etc.)

- **Expires.** Sets the expiration (when the data in the user's cache for this Web page is considered invalid) based on minutes (for example, expires in 10 minutes).

- **ExpiresAbsolute.** Lets you set the expiration date to an absolute date and time.

- **Status.** Returns the status line (defined in the HTTP specification for the server).

The following methods are supported by the Response object:

- **AddHeader.** Adds an HTML header with a specified value.

- **AppendToLog.** Appends a string to the end of the Web server log file.

- **BinaryWrite.** Writes binary data (for example, Excel spreadsheet data).

- **Clear.** Clears any buffered HTML output.

- **End.** Stops processing of the script.

- **Flush.** Sends all of the information in the buffer.

- **Redirect.** To redirect the user to a different URL.

- **Write.** To write into the HTML stream. This can be done by using the construct Response.write (Hello World) or the shortcut command:

```
<%="Hello World"%>
```

## The Server object

The Server object supports one property, ScriptTimeout, which lets you set the value for when the script processing will time out, and it supports the following methods:

- **CreateObject.** To create an instance of a server component. This component can be any component that you have installed on your server (such as an ActiveX ).

- **HTMLEncode.** To encode the specified string in HTML.

- **MapPath.** To map the current virtual path to a physical directory structure. You can then pass that path to a component that creates the specified directory or file on the server.

- **URLEncode.** Applies URL encoding to a specified string.

## The Session object

The Session object is used to store information about the current user's Web-server session. Variables stored with this object exist as long as the user's session is active, even if more than one application is used. This object supports one method, Abandon, which abandons the current Web-server session, destroying any objects, and supports two properties, SessionID, containing the identifier for the current session, and Timeout, specifying a time-out value for the session. One thing to bear in mind about the session identifier is that it's only good as long as the current Web-server session is running. If you shut down the Web-server service, the identifiers will start all over again. Therefore, it should never be used to, for example, create logon IDs.

## The Application object

The Application object can store information that persists for the entire lifetime of an application. Generally, this is the whole time that the IIS server is running. This makes it a good place to store information that has to exist for more than one user. However, since this object isn't created for each user every time, errors that may not show up when the code is called once may show up when it is called successfully.

# NEXT STEPS USING ASP

ASP is an extremely complex tool that may be used in conjunction with ActiveX and the extreme power of RDBMS systems to create complex and intriguing Web sites, intranets, and environments. Almost anything that can be accomplished with regular programming tools, such as Microsoft's Visual Basic, can also be accomplished using ASP. In fact, volumes have been written on the subject. There are a number of sites on the Web that can take your knowledge of ASP to the extreme. The best place to start is to actually learn the language model of VBScript and connection options using Microsoft technologies which can be found at *http://msdn.microsoft.com/scripting* and *http://www.microsoft.com/odbc*, respectively. See the following section for more resources on ASP.

# RESOURCES

The Web has an abundance of information on ASP and ASP technologies, some of which are shown in the following list:

- *http://msdn.microsoft.com*

- *http://www.15seconds.com*

- *http://activeserverpages.com*

- *http://www.aspin.com*

- *http://www.aspsite.com*

- *http://www.asp101.com*

You can use your favorite search engine to locate additional sites using a search for Active Server Pages.